British Watercolours
1750 to 1850

ANDREW WILTON

British Watercolours
1750 to 1850

PHAIDON *Oxford*

PHAIDON PRESS LIMITED, *Littlegate House, St Ebbe's Street, Oxford*
Published in the United States of America by E. P. Dutton, New York

First published 1977
© 1977 by Phaidon Press Limited All rights reserved

ISBN 0 7148 1713 9
Library of Congress Catalog Card Number: 77-71673

Printed in Italy by Amilcare Pizzi SpA, Milan

Contents

Preface

THE MAIN TEXT of this book originated as a series of lectures given at Leighton House in 1972, and I have preserved the form that I chose for the presentation of that course. In order to divide up the continuous story of watercolour in Britain for the purpose of the lectures it seemed to me best to approach it in terms of the achievement of particular artists, and I accordingly selected ten who not only are outstanding exponents of the medium themselves, but who also reflect in their careers and preoccupations the technical and theoretical history of the subject. I grouped other important artists around these ten central figures, and referred to a certain number of the lesser ones wherever they fitted naturally into my account. In modifying that material for publication I have felt justified in retaining the original plan, since it gives form and perspective to a subject that has all too frequently been reduced to a mere listing of names, with astonishingly little concern for the real significance of some of Britain's greatest artists in the wider context of the painting and aesthetic theory of the period.

I am aware that my approach is highly selective: it is intended to be. It is important, in discussing watercolour in Britain, to claim the universal greatness of its greatest practitioners, and to remember that they often worked in media other than watercolour: the traditional collector's uncritical philately has resulted in the subject appearing to consist entirely of minor and mediocre achievements barely related to the higher flights scaled by painters in oil. A group of artists that includes J. R. Cozens, Girtin, Constable and Cotman ought not to be treated so casually. Conversely, the old attitudes have allowed Turner's watercolours to be lumped with those of his contemporaries as 'mere watercolours', when in fact they are among the most wonderful and profound works of art ever produced.

The selection of minor artists has, I confess, been more arbitrary. Many people will no doubt feel that a history of watercolour that takes no account of J. C. Ibbetson, John Thirtle and J. D. Harding is wholly inadequate. I hope it will not be thought that I have no interest in these men; it is only that they do not seem to contribute significantly to the general picture that I have tried to draw. Very adequate information about them and all the other artists I have left out is available in the admirably encyclopedic works of Iolo Williams and Martin Hardie, to which every interested reader must turn for more particulars on all aspects of the subject. The Bibliography will indicate these and other fields for further study; and it is there, too, that the reader will find sources of all, or nearly all, my quotations. I have deliberately avoided footnotes to the text.

I must thank the many private collectors who have generously allowed their drawings to be reproduced here, and the following individuals for invaluable help of various kinds: Frances Butlin, Margie Christian, Michael Clarke, Judy Egerton, Shaunagh Fitzgerald, Ann Forsdyke, Francis Greenacre, Peter Moore, Anthony Reed, Peyton Skipwith, Dudley Snelgrove, Stephen Somerville, Marion Spencer, John Sunderland, Andrew Wyld; at Phaidon, Keith Roberts for much advice and encouragement, and Jane Rendel for all the care she has bestowed on editing the book; and, for unstinted moral and practical support at home, my wife Christina.

Paul Sandby

It is a long-standing tradition that accounts of watercolour painting in England should begin with Paul Sandby, calling him 'the father of English watercolour'. But watercolour had been frequently used for the finishing of drawings during at least a hundred years before Sandby's time; some of the finest drawings ever made in watercolour are those Van Dyck is thought to have done in this country in the 1630s (*Plate 10*). They show a fresh response to nature and a masterly handling of the medium, such as we might expect of any great artist at any time – Dürer, too, made beautiful landscapes in watercolour more than a hundred years before Van Dyck – but it seems fitting that Van Dyck's inspiration was the countryside of England. The wealth of detail, the abundance of green meadows, streams, well-grown trees, richly-leaved bushes and hedges in fully cultivated land, combined with smallness of scale and simplicity of form, have made English landscape especially apt to be rendered in watercolour; and watercolour, conversely, is a medium particularly suited to nature and the open air.

Paul Sandby's career is in itself an embodiment of the early evolution of watercolour. It sprang from the practical necessity of recording the lie of the land, in his case for military purposes. He was born in 1730, seven years after his brother Thomas, who was to play a considerable part in shaping his development. Thomas was also a draughtsman, and seems to have established himself as a specialist in architectural drawing before the two Sandbys moved from their native town of Nottingham to London in the 1740s. The drawing of buildings required first of all the ability to handle perspective, to translate by a purely mathematical process the appearance of a house, church or castle on to paper. At this Thomas Sandby excelled. He could capture the spirit and appearance of buildings, especially those of old London, with imagination and accuracy. In a period when great pride was taken in both private and public architecture, and interest was beginning to extend from new buildings to antiquities, craftsmen like Thomas Sandby were much employed. As the eighteenth century developed, portraits of buildings were more and more required to show not only the architecture but the surrounding landscape – especially in the case of gentlemen's country seats where a carefully landscaped garden was an integral part of the design. The architectural draughtsman became a complete topographer.

Both brothers worked in the drawing office of the Tower of London, where the Board of Ordnance was housed. Thomas was quickly launched on a career as draughtsman to the Duke of Cumberland, commander-in-chief of the army, who in the early 1740s was engaged in campaigns on the Continent

(Thomas was with him at Dettingen in 1743) and reached the climax of his military achievement at Culloden in 1746. In that year Paul also went to the Highlands, to take part in a survey conducted by Colonel David Watson. He was still a student, as his *Book of Figures with the Prospect of Edinburgh Castle* (1746–7, British Museum) shows. It was 'presented to the Board as a specimen of Mr. Paul Sandby's performance' and we must suppose that it represented his best work. It summarizes perfectly the state of mind of a young student of drawing at the time. The title-page, laboriously drawn in black ink to simulate an engraving (which might have been the source for the design), shows an artist seated beside his inkpot and pen-case, drawing from plaster casts of ancient Roman sculptures. The Augustan couplets from Du Fresnoy's *De Arte Graphica*, written out by Sandby below the title, are further evidence of the framework of his training. The rest of the book consists of copies from engravings by the seventeenth-century Dutchman, Abraham Bloemart. They show soldiers in decorative uniforms, presumably as being relevant to the military context of the exercise; otherwise, they might equally well have been of cows or sheep, after Cuyp, or groups of peasants, after Berchem. They are characteristic of the copying exercises set to art students throughout the eighteenth century. The *Prospect of Edinburgh Castle* likewise imitates the technique and appearance of an engraving, with its cross-hatched pen lines and neatly inscribed border. Edinburgh Castle was, of course, a military subject, and there is another in the same series – a *West Prospect of Sandham Fort* – which illustrates the military significance of the landscape it depicts. It is a semi-aerial view, ornamented with a tree at one side, a formula in general use among topographers employed in making views of country houses. The making of a well-thought-out picture was less important than getting all the facts in. The rather prosaic simplicity of this bird's-eye approach derived from the practice of Dutch artists working in England, late exponents of the landscape school of Holland such as Jan Siberechts, or Leonard Knyff, whose famous aerial views of houses, engraved by Jan Kip, are almost as much maps as landscapes. With these men the tradition of Ruysdael and Koninck had run practically dry.

But Paul Sandby applied himself to less artificial models than these. He spent a number of years in Scotland, centred in Edinburgh, and drew on the spot the varied and rapidly-moving life of the city. The numerous sketches of figures that he made are the reverse of his tidy imitation-engravings. They are freely drawn, often with a supple humour that brings the subject-matter vividly to life; and they are heightened with washes of delicate watercolour (*Plate 5*). These are certainly not Sandby's first coloured drawings; they already show marked accomplishment, and there is an old attribution to Sandby on a watercolour of *Beauchief Abbey*, in the British Museum, which must predate them, as it is childish work. But they are among the earliest to show him using colour expressively to enhance the observed scene; the greens and

blues of *Beauchief Abbey* are applied formally to sky, trees and grass as custom dictated: it is easy to apply such a blanket of colour to a landscape drawing and attain a general appearance of reality, since we accept the colour convention. But the colours are not *seen* in the subjects, any more than the rather woolly trees are closely observed from nature. Sandby's Edinburgh subjects are observed both in colour and line.

The spontaneity of his drawing now must owe something to the fact that in Edinburgh he learned to etch under the instruction of an artist named Bell. Etching is a stringent test of draughtsmanship, forcing the artist to refine the coordination of his eye and hand until a combination of fluency and accuracy is achieved which will stand up to the process of reversal and printing in ink. Unlike engraving, which involves gouging out lines from the copper plate itself with a sharp burin, etching requires only that a drawing be made with a needle-point on a plate coated with a film of melted wax. Where the point runs, the wax is cleared to expose the plate, which is then put in a bath of acid. This bites the lines of the drawing into the metal. Hence, etched lines can be as free as drawn lines, while engraved lines are limited by the physical difficulty of cutting the metal. Sandby became such an adept in the medium of etching that he used it almost as readily as watercolour; characteristic landscape subjects by him, etched in outline, with or without washes of colour added by hand, appeared throughout his career. Some of his etched views in Scotland were on the market by 1747. And he produced a series of etchings, some highly scurrilous, directed at the great master of English satire, William Hogarth, and published anonymously in 1753 and 1754. Sandby later withdrew this attack when he came to appreciate the nature of Hogarth's genius. The vigour and humour of his own Edinburgh figure studies suggest that he had already learned something of Hogarth's approach to humanity.

In general, Sandby's figures have a charm, too, which is not Hogarthian but closer to the more graceful work of the Frenchman Hubert-François Bourguignon, known as Gravelot, a designer and engraver mostly of illustrations who lived in England from 1732 to 1755, and who taught Gainsborough. Gravelot was largely responsible, with some others of his countrymen working in England at the time, for spreading a taste for the slightly melancholy prettiness of fashionably dressed people which was the watered-down residue of the legacy of Watteau. When, as he sometimes did, Sandby drew a finished large-scale figure subject, he combined the fresh delicacy of Gravelot with the more robust spirit of Hogarth's middle-class interiors. Human figures often take up a large proportion of his picture-space, and he depicts costumes and gestures so lovingly that we should hardly need to see examples to tell that he made many studies of individuals – often charming likenesses of friends – that have the sprightly insouciance typical of all his work.

Sandby's studies of figures, especially of figures in action, introduce a note of life that does not belong to the cold, static world of military topography. But although his art broadened into more rewarding channels, he maintained his contact with Ordnance drawing. In 1768 he was appointed chief drawing master at Woolwich Academy, where once again he had to apply his military training. The subject of drawing was taught there under these headings: 'Landscapes, with Indian Ink; Large and more difficult Landscapes, Coloured; Landscapes, Coloured from Nature; Perspective, applied to buildings, fortifications, etc.' His assistant taught 'Landscape and Military Embellishments', and 'Theory and Practice of Perspective'. Later there are references to aerial perspective, lights and shadows, and 'Measures and Proportions of Figures at Different Distances'; but in all the thorough rulings of the master-general of Ordnance, no provision is made for life drawing as such. To add figures other than the most generalized staffage for compositional purposes was to transform topography into living landscape, to relate the natural world to the human beings who inhabit it.

Military topography, as well as being somewhat inhuman, dispensed too with the formal language of landscape which had evolved in the art of the last hundred years. Since Ordnance drawings were intended, in the technical phrase, to 'break ground', and were not seen as objects of art in their own right, they had no need of subtle design. Indeed, it was inevitable that a properly designed picture should be inaccurate. The great French painter, Claude Lorrain, had established in the middle of the seventeenth century a system of landscape design which was *de rigueur* in Sandby's youth for pictures aspiring to quality as distinct from being merely functional. A landscape subject must be composed in such a way that the eye was formally directed down a central vista, between two groups of objects near at hand – trees or buildings – which pushed back or set off the view and were called *repoussoirs*. In the distance a concentration of light was aided by the presence of a lake or a river, or a suitably reflective hillside. Claude, bathing Italian landscapes composed with great subtlety and a deep knowledge of nature in a wonderfully controlled sunlight, could produce masterpieces which are convincing in spite of their formality. Minor Englishmen, substituting mannerisms for understanding and formulae for technique, expelled life and conviction from their imitations. One of the best of them, George Lambert, painted passable furniture pictures in this manner; but he was happier making unaffected views of nature as he found it in the English countryside, often using watercolour in conjunction with a wiry, nervous pen outline in drawings of cottages among trees, with cart-tracks and streams that owe more to the Dutch school than to Claude's idealism. But Claude's formula was so perfectly suited to landscape painting that it became, not merely fashionable, but an inescapable preconception, which underlies a great deal of subsequent landscape art and has remained with us even until today. It is common to find elements of both the naturalistic Dutch style and the classical manner of Claude in the same design. Numerous examples of both schools were available to students in the collections of English noblemen and connoisseurs by the early eighteenth century, and many more were given wide circulation by means of engravings.

In spite of his training, and his natural inclination to make his designs informal, the Claudian vision underlies much of Sandby's work. During his early years, particularly, he deliberately aped many of the continental styles, making chalk studies in the rococo style of Boucher, or watercolour drawings of imaginary landscapes with brigands, castles, and

fantastic mountains like those in the pictures of Claude's more romantic contemporary, Salvator Rosa, or of the eighteenth-century Frenchman, Claude-Joseph Vernet. For Englishmen, perhaps the most important of those who stood between them and the tradition of Claude was Richard Wilson (?1714–82). After a visit to Italy of some eight years in the 1750s, he changed his whole profession from that of portrait painter to landscapist. He made many drawings of a highly-charged, atmospheric kind rare in the English art of the period. They make use of grey paper, either prepared with a wash or ready tinted, on which he worked with black, and sometimes white, chalk. The results are far removed from the precise topographical drawings of Sandby's usual practice; nevertheless Sandby copied or imitated them, exploring the possibilities of combinations of media and of atmospheric effects, which, as his career progressed, he introduced more and more into his original work.

But although he made use of a wide range of technical methods Sandby's output largely conformed, throughout his career, to the accepted practice of the topographers. Watercolours were called 'tinted drawings' or 'stained drawings' – a perfect description of the pen outlines palely coloured with pink or green that were made by the topographers of the previous century – men such as Francis Place of York or the Dutchman Hendrik Schellincks. Sandby would draw his subject in outline with a black lead or chalk point, and then apply a wash of grey tone to all those parts of the design which required to be given weight or shadow, so that a complete monochrome drawing resulted. To this he added colour wherever it was appropriate, leaving those areas blank which he wished to show as white. This process gave great luminosity to the design since it was, as it were, lit from behind by the white paper. The drawing would be finished by touching in the details and perhaps adding outlines with a pen and ink. Obviously, it was a method well adapted to making views out of doors, since the watercolour could be applied rapidly and was not bulky to carry around. On the whole, the artists who used it in the eighteenth century probably preferred to add the colour indoors after a day of sketching simply with a pencil; but there is evidence that Sandby regularly made watercolour drawings in the open air, and many of his views have all the spontaneity of this procedure, unpretentiously showing exactly what he saw in front of him.

The main function of the topographer, however, was more formal. He was a professional view-maker. His views were commissioned for the purpose of engraving either as individual plates, to be sold in the many printsellers' shops, or as illustrations to books showing the country houses of the nobility and gentry (Plate 6), monuments and other places of interest. Both the new houses with their landscaped grounds, and the old ones with their ruined wings and weathered masonry, were valid objects of interest for the artist with an eye to pictorial charm: these types of subjects figured largely in the aesthetic theory and practice of the time, and were given quite specific status by the new philosophy of the Picturesque. This was advanced in the 1760s by the Rev. William Gilpin, prebendary of Salisbury, and developed later by him and others, notably Uvedale Price and Richard Payne Knight.

Gilpin at first seemed only to be stating certain rules which he had observed to govern our appreciation of nature, and, secondarily, of works of art representing nature. But his rules, once they had been formulated, struck a chord of sympathy in many artists, and his rather slight little illustrations were widely imitated (Plate 47). Gilpin took as his starting point the definition of beauty given by Edmund Burke in his *Philosophical Enquiry into the Origin of our Ideas of the Sublime and Beautiful*, published in 1757. 'Mr. Burke', says Gilpin, 'enumerating the properties of beauty, considers *smoothness* as one of the most essential. . . . But in *picturesque representation* it seems somewhat odd, yet perhaps we shall find it equally true, that the reverse of this is the case; we do not scruple to assert, that *roughness* forms the most essential point of difference between the *Beautiful* and the *picturesque*, as it seems to be that particular quality, which makes objects chiefly pleasing in painting.'

Gilpin, in fact, distinguishes between our experience of life, for which he agrees that Burke's rules apply, and our experience of art, where we do not, he says, obtain pleasure from the same causes. Picturesque beauty is essentially that beauty which is most effective in pictures. 'In *landscape-painting*', he goes on, 'smooth objects would produce no composition at all. In a mountain scene what composition could arise from the corner of a smooth knoll coming forward on one side, intersected by a smooth knoll on the other; with a smooth plain perhaps in the middle, and a smooth mountain in the distance? The very idea is disgusting.'

But Gilpin's ideas on landscape were formulated as much for real nature as for paintings, and he recommended that tourists and connoisseurs of natural scenery should judge the landscape through which they travelled as if it were a painting by Claude. One could even, at this time, take a 'Claude glass' on one's journeys, and squint through its smoked lens in order to see the view compressed and darkened like a varnished picture.

At the beginning of Sandby's career this theory had not overwhelmed his practice, and in general his work is free of the self-conscious overtones that characterize topography of the 1780s and 1790s. Even so, we can trace the gradual development in his output of a more artificial, perhaps a more ambitious style. One sign of this is his adoption of the medium of bodycolour, for which a coloured ground is used with colours mixed with Chinese white, an opaque powdery substance which gives 'body' and renders the transparent watercolour more like oil paint in the handling. In particular it eliminates the possibility of allowing the white paper to shine through the colour. Instead of working down to the darkest tones by adding layers of watercolour, the artist using bodycolour began with a sheet already tinted or primed with colour and worked up to the brightest lights which he put in with pure Chinese white at the end (Plate 8). This medium was favoured by continental artists more than English ones, and was especially used for the explicitly decorative purpose of fan-painting. It was also in general use in Italy for tourists' views of ruins, and several Italian artists, notably one, Marco Ricci, may have popularized it here. Sandby began to use bodycolour quite early in his career, and one development in the artistic life of England had enormous importance in

promoting the medium. This was the advent, in 1760, of a public exhibition in London.

Although artists had attempted to create a permanent place of public exhibition at various times in the century, they had remained dependent on the engravers for obtaining publicity for their work, and their pictures were only exhibited in the privacy of their patrons' houses, except for a rare occasion when a more public place, such as an inn parlour, was available to them. In 1753 some of the leading artists in London forgathered at the Turk's Head Tavern in St Martin's Lane to plan some means of obtaining for themselves the facility of regular public exhibition. Various efforts were made thereafter, and in 1760 the Society of Artists was formed and held its first exhibition in Spring Gardens. It was well patronized, for the public was suddenly made aware of the possibility of enjoying original works of art in large numbers, at small expense; and the exhibits were generally for sale, so that everybody benefited. Another society with similar aims was set up in rivalry with the first, but both were almost completely eclipsed when in 1768 the Royal Academy of Arts was founded, under the patronage of George III. Thomas Sandby was the first of the Academy's professors of architecture, and Paul was also a founder member. This institution really altered the status of the visual arts in England. For Sandby and the topographers it signified an important change of direction, for producing pictures to be shown in an Academy exhibition, along with hundreds of others, is very different from making drawings to be turned into engraved book illustrations. The drawing became an end-product, instead of being a stage in a process – a stage which might, sometimes, be destroyed when the process was complete. The strength that bodycolour lent to watercolour made it a valuable weapon in the watercolourist's struggle with his fellow exhibitors, and so it was, naturally, employed a good deal. On the whole, drawings tended to become larger and more elaborate, too, to catch the eye of the visitor. A development began here which was to modify the character of English watercolour almost unrecognizably, and which established two separate and distinct traditions within the school.

Paul Sandby was in London in 1753 and present at the Turk's Head conference of that year; by this time he evidently enjoyed some reputation in his profession. Almost as soon as he came to London from Edinburgh in 1751, the career of his elder brother Thomas again affected his own. Thomas, having served the Duke of Cumberland in war, followed him in his peaceful office of ranger of Windsor Forest. He was named draughtsman to the duke, in 1751, at a salary of £100 per annum, and eventually, in 1764, took the post of deputy ranger. He was accommodated by the duke at Windsor, in an attractive little house in the Great Park which Paul frequently drew; but he also occupied houses in Great Pulteney Street and Great Marlborough Street in London. Paul always lived nearer London in a house in St George's Row, Bayswater (*Plate 7*), from which he drew many views of the idyllic countryside in the neighbourhood. In the evenings the brothers would meet at each other's houses to draw – a habit we shall be able to follow among their successors in the early nineteenth century. One invitation to a friend for such an evening session has sur-

vived, embellished with a drawing by Paul, and these verses:

Receive this humble Sketch and Scrawl
From Poet Tom and Painter Paul
Sent to inform you we at night
Intend to deal in shade and light
Or you may call it Light and Shade
No matter which if both be made
So you (like a good boy) prepare
To Sit or Sketch a figure here
We'll study hard from Six till Nine
And then attack cold Beef and Wine . . .

One of Thomas Sandby's principal undertakings at Windsor was the construction of the Duke of Cumberland's scheme for Virginia Water, some of the views of which are by him, but completed with figures by his brother Paul. There has always been some argument as to the authorship of the figures in such drawings as these. It is possible that in some cases Thomas himself added them, but they have a relaxed ease of grouping and detail which suggests that Paul is the father. Generally, where Thomas's hand can be identified fairly certainly, the figures are less happily drawn and composed. But some subjects – *View from the terrace of Somerset House looking east* (*Plate 2*), for instance – were evidently common property to the two brothers, who perhaps had equal access to some prototype which they traced and used for their several purposes. An urban subject such as this was possibly Thomas's originally, but it now exists in versions by both brothers, working either separately, or in combination. The simple, spacious design of the Somerset House views immediately recalls similar scenes by the Italian, Canaletto, who worked in England in the 1740s (*Plate 3*). His clearly-lit architectural compositions must have exerted a considerable influence on Thomas Sandby, and it may be that the style of his figure groups affected Paul's.

Once a sketch from nature had been made, it could be used repeatedly, as the Somerset House view was, either in some kind of adaptation, or as a tracing worked up with watercolour and pen. Sometimes a repetition betrays its origin in a tracing by being reversed from another drawing of the same subject. Some of these repetitions may be by other hands: members of Paul's family, as well as his many pupils, produced a large number of drawings which are very similar to his in style, and often still mistaken for his. Nevertheless, Paul's output was very considerable. At Windsor alone he made hundreds of drawings, including a fine series of large finished watercolour views of the town and castle in his limpid style of the 1770s, and a group of noticeably more romantic scenes on the terrace there, in bodycolour, which date from around 1800.

He also made studies of the Great Park in all its aspects: general views of rolling pasture; notes of the activities of fellers and sawyers; details of the structure of carts and wagons; and endless drawings of the superb trees with which the park is planted. These sketches of trees are often elaborate explorations of the formation of branches and the play of light in foliage. He developed free, loose rhythms and a preference for bodycolour when he was engaged in this most fascinating of landscape exercises. At this time, few men studied trees with such thoroughness and understanding; only Gainsborough, a

portrait painter who preferred landscape, gave them such thought (*Plate 11*). He spent much of his youth sketching trees in Suffolk, and much of his maturity inventing trees out of his head: almost as Claude had distilled the Italian countryside into ideal classical scenes, Gainsborough evolved a theatrical, yet never merely conventional, equivalent of the scenery of England. In his hands, the theory of the Picturesque found its ideal exponent, for Gainsborough could manipulate the properties of landscape – rocks, trees, pools, cows, peasants – with exquisite understanding of their real nature, and a highly sophisticated though essentially instinctive sense of their pictorial potentialities. Comparatively few of his many drawings are in watercolour proper – most are in chalks, pencil, and a variety of experimental media – but some examples show the breadth and subtlety of his use of colour washes. His drawing style is very allusive; it relies much more than Sandby's on suggestion, on the effectiveness of a masterly formula; but the formula is of his own devising, in tune with his own mind and vision. It is simple: a cloud-shaped outline with loose hatching diagonally across it; but it expresses an intimate knowledge of nature. It differs remarkably from the more finicky formulae used by most of Gainsborough's contemporaries in the representation of foliage, avoiding their fussy detail and more successfully conveying the mass of a tree in full leaf. Gainsborough's landscape drawings make us think of Van Dyck, whom he admired (both for his portraits and for his landscapes); they bring home the point that Sandby's drawings, beautiful as they are, remain views in spirit and rarely aspire to interpret, only to record, nature.

Paul Sandby lived long; he died at the age of seventy-nine in 1809, a decade after his brother who died in 1798, when not only Gainsborough but an important new generation had passed him in the technical evolution of landscape painting and drawing. As his career drew to an end his works became less and less the fresh and delightful things they had once been. They remained highly competent, but show a tired dullness of composition and are often uninspired reworkings of old subjects – some dating from as far back as his days in Edinburgh. He took to oil-painting in an attempt to create pictures which would have greater impact at exhibitions, but the few examples that are known are hot and dry in colour, and muddy in technique.

But if his watercolours were superseded, he was re-membered with gratitude for introducing English artists to the process of aquatint. In 1775 he published a series of *Twelve Views in Aquatinta from Drawings taken on the Spot in South Wales*, and later issued two more series of views in north Wales, as well as many other prints using the same technique. It is significant that these early aquatints publicized Wales, which Sandby must have been one of the first to appreciate. In the early nineteenth century it was to become a commonplace for watercolourists to sketch there, as we shall see. Sandby's aquatints were printed in brown ink only, any colour being added by hand. The value of the process was that it afforded a relatively simple way of reproducing the effect of washes of ink or watercolour, and was therefore often combined with an etched outline, just as a watercolour would have a pen outline. As soon as Sandby had demonstrated its merits it was taken up by artists and engravers alike, and flourished more and more as the watercolour school developed.

Sandby perfected a direct approach to the problem of representing attractively the immediately visible world, but it would be difficult to say exactly how far this was a personal achievement and how far it was the achievement of all his generation. A great many artists were employed on similar tasks and they nearly all share with Sandby his unaffected vision. What the majority could not accomplish in the same way is his brightness and freshness of colour, and his lively invention of figures, combined with a remarkable lack of mannerisms. He used simple conventions for the foliage of trees, it is true, and he relied on certain elementary principles of composition, but he handled these forms with the assurance of an artist who has created them to express exactly what he wishes to say. His drawings therefore have a sunny ease which makes them appear less impressive than they are.

He passed on some of these qualities to a younger generation. Michael Rooker, born probably in 1743, was placed by his father, an engraver, as pupil to Paul Sandby. Sandby nicknamed him Michael Angelo and he is always known as Michael Angelo Rooker. He too worked as an engraver, but preferred making his own topographical views, which seem to intensify the charm and prettiness that he found in Sandby's. He quickly mastered the simple directness and care in rendering detail that are typical of Sandby at his best, and went on to specialize in the rough, picturesque textures of old buildings and luxuriant trees, which he drew with lingering care, painting with much smaller brush strokes than were usual at the time (*Plate 9*). It is as though Rooker were trying to infuse into his colours more expression than was possible in the bland washes of the tinted drawing; indeed, his almost pointillist technique echoes the important technical developments that are apparent in the work of John Robert Cozens – the breaking up of colour washes in the interests of greater expression. We find a similar concern in the work of Thomas Hearne, who was a year younger than Rooker; he also learnt from an engraver and worked, as a number of topographers did, in the South Seas: he spent three years in the Leeward Islands, making views which were subsequently published, and a substantial part of the remainder of his life was occupied in making illustrations for William Byrne's *Antiquities of Great Britain*, a typical eighteenth-century survey, belonging very much to Sandby's world. Hearne tackles his architectural subjects squarely and directly, like Sandby, always presenting them as composed views, but laying greater stress on the structure of his designs than Sandby does, placing buildings with a firm sense of their function in the composition. He limits the range of his colour, often to a simple combination of blue and green, applied in short strokes so that the whole surface of the drawing is articulated, alive with the suggestion of form. When he deals with trees alone, the same interest prevails, and his woodland scenes are highly picturesque, but at the same time studies in the creation of a world of solid forms within a minimal colour range (*Plate 12*). We might compare the conscious plasticity and monochrome palette of the analytical cubists.

The sense of incipient change, almost of revolution, that lurks beneath the cheerful surface of the work of Rooker and Hearne, is less evident in the drawings of Edward Dayes, who is, nevertheless, the most conspicuous of the group of

topographers who flourished in the last two decades of the century. Dayes was born in 1763, a man of somewhat sour temperament but a master of the topographical view. He combined the elegance and simplicity of Sandby with a sense of scale which places him decidedly among the early romantics, imbuing his views of cathedrals and castles with an unforced grandeur that is enhanced by his firm, though reticent, colouring (*Plates 1 and 26*). His mannerisms are more obvious than those of Sandby, and can sometimes be rather crudely managed, with clumsily sketched foregrounds and *repoussoirs* of rather stagey trees. On the other hand, Dayes responded with enthusiasm to the challenge of the contemporary urban scene, and around 1790 made a series of views of London squares, with the human and animal life appropriate to them, which are among the best records of the metropolis that survive from the period. And he was capable, on occasion, of suppressing landscape or architecture almost completely in the interests of a lively crowd of figures: his view of *Buckingham House, St James's Park*, in the Victoria and Albert Museum, has a panache which reminds us of the pre-eminent observer of the everyday life of the time: Thomas Rowlandson.

Thomas Rowlandson

'Nowhere, even in his earliest and most careful days, are any of Rowlandson's characters or incidents studied with the depth and insight of his great predecessor, Hogarth. In all his work there is not a scene nor a personage which has found itself a place in the national consciousness.'

This was written by Paul Oppé in 1923, in a thorough and serious study of Rowlandson's work, which, for all its appreciation of many of Rowlandson's merits, stands as perhaps the most damning account of the artist ever written. Oppé puts the case against Rowlandson so clearly in his book, that it is almost surprising that he is still highly regarded as an artist. But in fact the attack seems to have had no effect. Rowlandson is as much admired as ever.

His sustained popularity may be attributable to the fact that Rowlandson is, first and foremost, a humorous artist. It is not an exaggeration to say that the word 'Rowlandsonian' conveys very precisely a certain rotund, ripe, bustling comedy in human beings and human situations which we all recognize. This, I think, can be opposed to Oppé's claim that Rowlandson did not create a scene or personage with a place in the national consciousness. As Martin Hardie says: 'To think of Regency England is to think in terms of Rowlandson.' We immediately call to mind such a drawing as *Skating on the Serpentine* (*Plate 21*), with its combination of buxom girls, tumbling men and scurrying dogs. It is the creation of that amiable, jolly character who is always referred to in a jovial way by his appreciators as 'Old Rowly', a nickname which survives from contemporary recollections of Rowlandson by his convivial friends. What dominates is the completely convincing action, the ebullient life. In looking at his work we

are not only convinced by his design: we are moved by its force, stirred into vitality ourselves by its own vitality, and drawn irresistibly into the life and movement of the drawing. The vehicle which expresses this vitality is the pen line that Rowlandson employs. It occurs almost invariably in his drawings, curling everywhere, lending life and sparkle to details, and twisting all the parts together into a rich pattern which bursts with energy. We can well believe reports that Rowlandson watered down his ink to procure a smoother, faster flow. Colour is by contrast quiet and gentle: generally, Rowlandson's colour decorates the drawing but does not contribute to the idea itself. It is, generically, the tinting or staining which Sandby and most of Rowlandson's contemporaries practised. Technically, his attitude to watercolour is conventional; it is in his drawing style that he speaks a unique language: only Rowlandson is 'Rowlandsonian', as the myriad attempts to imitate him by a group of his admiring friends, as well as by later forgers, clearly show. But we may trace something of the origins of his language and in doing so highlight certain interesting aspects of the English art of his time.

Rowlandson's time was the aftermath of Hogarth. He was born in 1756, eight years before Hogarth's death, and so his early training took place under the shadow of Hogarth's success and towering fame. It is surprising how little direct influence Hogarth had on the major artists of the generation which followed him; this can probably be accounted for by the rather different direction taken by the interests of Reynolds, Gainsborough and the early Royal Academicians. Rowlandson, on the other hand, with an innate gift for visual humour, had every reason to admire and learn from Hogarth. If we compare their styles of *drawing*, we shall find nothing in common. Hogarth works with a view to a picture or engraving, experimentally, altering as he goes along an angular wiry line which is wholly English in character, perhaps harking back to the pen drawings of certain Dutchmen and ultimately remembering Rembrandt. His method of adding a little monochrome wash to give body to an idea also belongs firmly to the early eighteenth century. In the paintings, these tentative steps give way to settled patterns. When the paintings were engraved – and it was as engravings that Rowlandson must have been most familiar with them – the patterns were transformed from implications of the paint and colour to veritable outlines, clear, strong and unambiguous. A subject such as the *Strolling actresses dressing in a barn* (*Plate 18*) is packed to its corners with life expressed as flickering line – line in such a complex and labyrinthine tangle that at first all we apprehend of the subject is that it is chaotic. The composition revolves round a central figure whose gestures are flamelike and in motion; her petticoat is a mass of crinkling, waving, flapping lines, and these characteristics pervade every part of the scene. Hogarth was famous for championing a delicate S-shaped curve as the 'Line of Beauty', and believed that such a curve, by keeping the eye in continuous but not too strenuous motion, was the proper unit from which pictures should be built up. A composition like this one of the *Strolling actresses* seems to be at least a partial enactment of the theory, although Hogarth's robust enjoyment of common life lends his line more of the strenuous than the graceful.

Rowlandson also took common life as his subject, but he did not adopt Hogarth's thematic preoccupations: the consistent density of thought, symbolism and moral argument which is so essential to Hogarth's conception of art is quite alien to Rowlandson. But Rowlandson borrowed Hogarth's notion of packing figures into a crowded composition in order to produce a chaotic and therefore a comic scene. Hogarth's etchings of the *Chorus in Judith* or the *Laughing audience* are series of caricatured heads loosely organized into a group, and Rowlandson frequently uses this device. Of all Hogarth's full-scale designs, perhaps his *Election entertainment* best illustrates the precedent which he set for Rowlandson's crowd scenes. It shares with them such incidents as rows of fat men, couples flirting, a clerk falling over backwards in his chair, and a man throwing a three-legged stool out of the window. This cramming together of lively, often coarse detail is the essential characteristic that Hogarth passed on.

But Hogarth's art, although it was popularized by his own engravings, was not primarily an art of line. Movement is always subordinate to meaning, whereas with Rowlandson the movement is the meaning. We must look to a more classical tradition of draughtsmanship for Rowlandson's origins. Old accounts of his life say that his first professional training was in Paris when he was fifteen. In fact he probably went there a little later, in 1774, to stay with the relatives of an aunt who was French by origin. Rowlandson himself spoke fluent French. One writer has pointed out that 'no impressionable and talented youth staying in Paris in the 1770s could have failed to catch something of the spirit of current French art – the works of Boucher, Fragonard, Baudouin, Lavreince, Augustin St Aubin, Janinet and Debucourt . . .' Of these, it is worth singling out Boucher, not as a draughtsman, nor even as a painter of round-limbed nymphs, but as a landscape painter. Boucher's oil-paintings of landscape subjects are conceived in terms of a rippling, unctuous texture which is akin to the rhythms of Rowlandson's own landscape drawings. The roundness and fleshiness, as it were, of the forms of natural objects, foliage, roofs and so on, are stressed by both artists, and it may well be that the sensuous qualities of Boucher's work made a direct appeal to Rowlandson.

In 1771 an artist came to London from France whose style was in every way continental and not English: this was Philippe Jacques de Loutherbourg. He came from Alsace and had studied under Boucher. His penwork is characterized by just such an over-all movement, a nervous vitality, as is Rowlandson's. Comparing de Loutherbourg's drawings with Rowlandson's we can get some idea of how very continental such fluency was; it is quite different from the drawings of Paul Sandby, which are wholly English in feeling. De Loutherbourg was a fine draughtsman, a thorough professional of a kind very rare among eighteenth-century English artists; but his invention is sharper, jerkier, less free and less full than Rowlandson's. His drawings illustrate the point that Rowlandson had a continental proficiency combined with a power wholly personal and unmistakably English. But de Loutherbourg comes close to Rowlandson's early figure drawing in some of his explicit caricatures: they have rather the same approach to the ensemble of costume, gesture and

expression, although generally milder in their humour, and less cursive in line; but at first Rowlandson's own style is somewhat angular, with thickenings of the pen line at corners which are not unlike de Loutherbourg's.

It was an English artist, however, who seems to have been responsible for giving Rowlandson's style its first important impetus. We have no drawings known to be of the period up to his visit to France, so can only guess as to the character of his early work. The influence which is all-pervasive in surviving designs of the 1770s is that of John Hamilton Mortimer. Mortimer was a rather exceptional artist. He was born in 1741 and died young in 1779. During the last decade of his life his reputation was considerable, and it is easy to see why he was admired. He was gifted with a clear, incisive drawing style which shared few of those elements of the haphazard and the amateur which are usually to be found in English drawings of the time (*Plate 16*). His vigorous, flowing line lent itself naturally to etching, and he published a great deal of work in this form, as Rowlandson himself was to do. His subject-matter, consciously Italianate, as was the fashion, ranged from the most serious history, through a very characteristic and popular line in bandits derived from Salvator Rosa, to burlesque and caricature of an exaggerated kind. This too can be traced to Italy, to the comic drawings of Annibale Carracci in the early seventeenth century, to contemporaries like Domenico Tiepolo, Francesco Guardi, and Pier Leone Ghezzi, whose work was well known to English artists in Italy, and imitated by many of them, not least by the serious-minded Joshua Reynolds. But in Mortimer's hands caricature, even when the subject-matter is coarse, takes on a richness of rhythm and fullness of invention which makes for poetry – a poetry anticipating the extravaganzas of James Gillray, who was heavily influenced by Mortimer, and, at the height of his powers in the 1790s, made great use of the broad, sack-like curves characteristic of Mortimer's satirical work.

In 1772, before he had been abroad, Rowlandson was admitted to the schools of the Royal Academy, which had opened in 1769 immediately after the establishment of the Academy itself, and which had at once become the almost invariable starting-point for young artists. They provided the complementary facility to that of exhibition for professionals, which had been the initial motive for the Academy's conception. Henry Angelo, one of Rowlandson's companions, states, 'his studies from the human figure at the Royal Academy were made in so masterly a style that he was set up as a rival to Mortimer, whom he certainly would have excelled, had his subsequent mode of study kept pace with the fecundity of his invention.' A drawing of *A Bench of Artists, Sketched at the Royal Academy in the Year 1776* (*Plate 15*) shows the liveliness of Rowlandson's observation even inside the sober walls of the Academy, and is an accomplished essay in Mortimer's manner, although executed with rather coarser penwork and less refinement of detail than we find in Mortimer. It illustrates his talent, and the easy, somewhat careless way in which he employed it, too.

We may assume that his first exhibit at the Royal Academy, in 1775, was also influenced by Mortimer. It was apparently an exercise in history painting, in which Mortimer was highly proficient, and which we do not associate at all with

Rowlandson; but there is something about the wording of the title as it appears in the Royal Academy catalogue which suggests that even here Rowlandson had his tongue in his cheek: the picture was called *Delilah payeth Samson a visit while in prison in Gaza*. In spite of the fact that he was only nineteen and was on Biblical ground, Rowlandson may have treated his subject with a light touch.

This historical picture may well have been a pen drawing, as Mortimer's exhibited works often were. In general, Rowlandson's entries to the Academy are stained drawings and small whole-length watercolour portraits. The loveliest of these, a likeness of the rustic genre painter George Morland, shows that he had an instinct for delicate beauty as well as for more generalized or coarsened effects; the colour is subdued, tender, and perfectly controlled, and the whole design holds the balance charmingly between humour and seriousness (*Plate 14*).

Early in his career, Rowlandson adopted the practice of both Hogarth and Mortimer, reproducing his designs in the form of etchings. His natural aptitude for satire drew him very quickly into the world of political caricature, and he acquired a remarkable capacity to draw on to the copper-plate a line as vigorous and characteristic as that which he produced on paper. He used one medium as readily as the other throughout his life, and frequently etched his successful drawings for issue as hand-coloured replicas. Rowlandson acknowledged no essential difference between etching and drawing, working naturally and freely with either, so we may expect to see devices characteristic of one medium appearing in the other, such as a system of intersecting diagonal hatchings, with small dots in the interstices – a mechanical means of obtaining even tone in the purely linear discipline of engraving, which is borrowed and employed freely as a purely calligraphic formula in drawings and etchings.

Rowlandson's facility with the etching needle extended to the imitation of other artists' styles. His first collection of plates was published in the 1780s under the title *Imitations of Modern Drawings*. As pastiches they are brilliant. The artists he chooses to reproduce include Gainsborough, whose fluid drawings of foliage and figures, though highly personal, are clearly related to Rowlandson's by their calligraphic freedom; Wheatley, another follower of Mortimer and interesting in this context as being the closest Englishman to de Loutherbourg in his wiry, competent drawing; Bartolozzi, an Italian engraver whose virtuoso pen drawings in the style of Guercino were much admired; Samuel Howitt, a sporting painter who became Rowlandson's brother-in-law and imitated his manner; and, of course, Mortimer himself. Various etching techniques were used in this series: soft-ground, roulette, and aquatint, all suggesting the different methods characteristic of the different artists. The group shows that Rowlandson's style was closely connected to current fashions in draughtsmanship; but it also shows that he could excel any one of them and always contribute his own note of brilliant life.

Such free invention made for an enormous output. Rowlandson built up a sort of one-man factory for the production of drawings and prints, either etching outlines and then working them up with colour added by hand, or taking impressions on damped paper from his ink designs. These,

though probably somewhat pale, could be worked over and sold as original drawings. A contemporary remarked, of slightly later in his career:

> The process of production was simple. Rowlandson would call in the Strand [Ackermann's Repository], ask for paper, vermilion, a brush, water, a saucer, and a reed; then, making of the reed such a pen as he liked, he drew the outline of a subject (generally taking care to reverse the arms of his figures), and handed the paper to Mr. Ackermann to be treated as if it were a copper-plate. This was taken to the press, where some well-damped paper was laid upon the sketch, and the two were subjected to a pressure that turned them out as a right and left outline. The operation would be performed with other pieces of damp paper in succession, until the original would not part with vermilion enough to indicate an outline; then the original became useless, and Rowlandson proceeded to reline the replicas, and to tint them according to the fancy of the moment.

It is notoriously difficult to trace the history of many of his subjects, which may have developed first as drawings and later as prints, or the reverse; and it is almost impossible to tell which of several versions of a design was the original. Often each has its full share of Rowlandson's handiwork, merely relying on an initial reproduced outline as a guide for quicker production. Rowlandson added his signature at random, sometimes to imitations by other people; and sometimes his name was forged by others on his own work. Dates are equally confusing, as his own dating of his works is rather arbitrary and a date added by him to a drawing may have little to do with the actual time of its execution.

All this illustrates vividly the sort of artist Rowlandson was – extremely careless of details, but anxious to make drawings and prints as fast as possible, relying on his fertility of invention and rapidity of technique. At an early moment in his career, about 1780, he inherited several thousand pounds from his French aunt, and lived extravagantly until his legacy was exhausted. It seems to have established his style of living, for Rowlandson remained a gambler all his life, and paid for the luxury with his drawings. 'I have played the fool, but here is my resource,' he said, referring to his pen. The recklessness of his draughtsmanship, which is really what is most exhilarating about it, is the exact visual counterpart of his temperament. And the subjects which he chose for his larger and more important designs – that is to say, for those into which he seems to be putting most of himself, and which are not mere pot-boiling – form a running commentary on the life he took part in, and his tone in such major drawings of the 1780s as *The English Review* or *Skating on the Serpentine* is not satirical in the full sense. He does not offer strong criticism of the society to which he himself belonged: it is inaccurate to lump Rowlandson together with the eighteenth-century satirists, from Swift to Gillray, who attack rather than laugh at society and its foibles. He is capable of laughing at people, including himself, but not of drawing a moral conclusion from the fact that he finds them amusing.

Although they show many points of strong resemblance to Hogarth, in the way the figures are organized in a sweep across the paper, carrying the eye with small gestures and incidents

from group to group, these subjects are not scenes bristling with disgust. There is a sense in which Rowlandson is inviting his audience to identify with the subject as much as to criticize it. The series of drawings he later published, depicting *The Comforts of Bath*, is clearly directed at people who were familiar with Bath and therefore not altogether unlike the characters represented. Hogarth often seems to say: 'try to avoid becoming like these people; you recognize only too well how like you are;' his contrasting histories of the *Industrious* and *Idle 'Prentice* were much imitated in Rowlandson's time by sentimental artists like Wheatley, Northcote and Morland; the advantages of virtue and the disadvantages of vice were easily taught in homely modern parables. Rowlandson himself steered away from this kind of preaching.

Some of the figures in his compositions represent well-known characters of the day, and this aspect of his large designs is quite important in our estimate of their effect on his contemporaries. Several prominent personalities appear in the most famous of all Rowlandson's large scenes, *Vauxhall Gardens*, including Dr Johnson and Boswell, and, unmistakably with his garter star, the young Prince of Wales (*Plate 13*). The drawing was shown at the Academy in 1784, so no very serious disrespect can have been intended. It really records the flavour of the most popular place of entertainment in London at that time. The print made from it, with outlines etched by Robert Pollard and aquatint colour by Francis Jukes, must have been regarded by many people as a kind of souvenir of Vauxhall, and the humour with which the figures are treated as an appropriate way of conveying the atmosphere of levity which characterized it.

Behind these scenes of human activity, Rowlandson's backgrounds tend sometimes to be perfunctory, sometimes are even neglected altogether; but they often achieve exactly what is required in the way of framework for the human action. There are examples of landscapes drawn by Rowlandson which are evidently planned to serve as backdrops for figures intended to be filled in afterwards: but more often, having devised a crowd of people he added a few touches to give them a context. There is an almost complete study for a scene of *Skating on the Serpentine* showing only figures; in the final composition he has added only a few misty trees; but they perfectly complement the action, and create a marvellous atmosphere of frosty sunlight. This is not carelessness. It is the reverse: the restraint of a great artist who knows exactly how much – or how little – is required to stimulate the imagination of his audience. Rowlandson studied landscape in its own right, and made numerous studies of natural details which are surprising for the variety and originality of their technique, with warm, richly textured pen lines evoking fully the variegation and boskiness of the true picturesque landscape (*Plate 23*). Sometimes simple washes of grey and brown are applied with masterly certainty to give weight and depth, light and shade; on other occasions, Rowlandson's soft colouring is enlisted to convey the lushness and gentleness of the English countryside.

Having been to Paris early in his career, Rowlandson frequently travelled on the Continent throughout his life, in company with his friends. His expeditions seem to have been entertaining, and his travelling companions, like his associates in London, were always anxious to enjoy themselves thoroughly. Rowlandson's numerous drawings made on journeys through France, the Low Countries and Germany, as well as in all the regions of England and Wales, often give glimpses of the sociable life he led; but it is clear too that he spent much time in the observation of natural scenery, for we have a number of sensitive drawings devoted to that alone, or to the curiosities of local architecture, rendered with an extraordinary sense of the organic structure of old buildings.

By the end of the 1780s Rowlandson's practice had expanded so much that he had little need to advertise himself by means of the Royal Academy exhibitions, and his work did not appear there after 1787. The publication of the *Imitations of Modern Drawings* was the beginning of a long series of books illustrated by him, especially for the publisher and bookseller Rudolph Ackermann, who employed him from 1798. But curiously enough, during the few years prior to 1800 there is rather a slackening off in production – fewer prints are dated to this time, and Rowlandson seems to be gathering his energies for a new bout of creative effort. In the early nineties there are signs that his hand is tiring: the pressure of his one-man industry tells in a rather hurried (as opposed to rapid) line, from which some of the nervous edge has gone. There is less tension in the invention of details, a certain emptiness. The Rowlandson who resumes full production at the turn of the century deals in suaver, rounder curves. There are a lot of drawings of pink nymphs bathing, where the emphasis is not on the peculiarity of odd details of the human figure, but on the generalized effect of ideally plump, pretty female bodies. There are also several outline copies, of a very free kind, from famous paintings by old masters. These provide evidence that Rowlandson, for all his apparent spontaneity, was also concerned with the more intellectual aspects of his art, and prepared to learn from the great masters of the past.

And now Rowlandson launches into the most fertile period of his life, at least in terms of the amount produced, if not in terms of quality. In 1798 he made drawings of military uniforms for the *Loyal Volunteers of London*; by 1808, an assortment of anecdotal designs etched by him for *The Miseries of Human Life*; and from 1809 onwards for some years the extraordinarily successful series of *Tours of Dr. Syntax*. Few of these illustrations can be said to rise much above the level of pot-boiling; the ease with which Rowlandson performed his craft conducing to slovenly and uninteresting work, which, in the hands of hack colourers, is insufferably crude into the bargain. But the drawings which Rowlandson made as preliminaries to these etchings are frequently as vital as ever.

Perhaps the most artistically satisfactory of Rowlandson's later publications is the *Microcosm of London*, published by Ackermann in 1808. For this long series of scenes of London life and society, the architectural backgrounds – in a sense the more important aspect of the subjects – were drawn by Augustus Pugin, an eccentric Frenchman who specialized in architectural drawing. Rowlandson's figures are remarkably tactful; they do not dominate the designs, but, wherever appropriate, they add warmth and movement – a sense of life. The published aquatint of Christie's auction room is a delightful example of this restrained energy, and compares

interestingly with a drawing by Rowlandson of the same scene (British Museum). Even more than the fact that the figures are larger and more expressive in this drawing, we notice that the pictures on the walls are too: they have great gilded plaster frames which curl all over the sheet in a riot of moving line, crammed together so that the surface of the paper has no breathing-space. This is a more vivid and personal account of the scene than the aquatinted one; although so similar, they illustrate two surprisingly different aspects of Rowlandson's mind.

He was, for all his joviality, both in life and in his art, a serious thinker, at least at times, and could, as the *Microcosm of London* shows, temper his imagination to suit the requirements of a commission with tact, and retain at the same time his own individuality. He was not entirely an artist of instinct, although so much of his work seems to rely on that; we have seen that he looked seriously at other draughtsmen, both in England and on the Continent, and that he copied the old masters even quite late in his career. During the last few years of his life – he died in 1827 – he almost stopped drawing. The great flow of energy dried up. He became interested in a more theoretical aspect of his lifelong subject: the formal relationships between human beings and animals. He made a number of drawings caricaturing human features to make them resemble those of various birds and beasts; but there is a dryness about these which does not make us laugh. It is a strangely academic speculation for such a pre-eminently non-academic artist, and harks back to similar experiments by Leonardo and others from the Renaissance onwards.

By 1827, Rowlandson's art was, technically, even more out-of-date than Sandby's had been at his death in 1809. It survived as a current form of expression into the new century, first of all, because of the vigour with which Rowlandson continued to observe and record changing manners and habits; second, because, in the region of satire, the technical changes which had overtaken watercolour landscape had less force. Well into the 1830s political and social satires went on being produced in exactly the way that Rowlandson had churned them out in the 1780s: that is to say, they were still hand-coloured etchings. A whole generation of artists specializing in these arose about the turn of the century, dominated by the great figure of James Gillray. In a way, Rowlandson and Gillray have little in common as artists, in spite of obvious similarities and the fact that they both owe so much to Hogarth. Gillray was born in 1756, the same year as Rowlandson, and was brought up by his Moravian parents in their own strict way. He too went to the Academy Schools, at the age of twenty, and was subjected to the influence of Mortimer and to all those formative experiences which Rowlandson encountered. But Gillray used satire for a more hostile purpose than Rowlandson – he intended to inflict injury. He did not want to make a moral point as Hogarth did; he simply wanted to enforce a particular point of view, right or wrong. To this apparently menial task he brought a rich imagination, which, because it was working in the wake of Hogarth, Mortimer and Rowlandson, in some ways is a consummation of this line of development and fittingly rounds off an account of these artists.

Rowlandson's essential characteristic is the vibrant pattern of his line; Gillray's, perhaps, consists more in the ability to exaggerate until a certain point is reached at which the exaggeration is embodied in a poetically apt linear pattern. It is an ability to create single figures of great potency, figures which lie firmly and heavily on the mind, not merely because they are gross, but because the grossness (or whatever quality it is that Gillray wants us to be aware of) is perfectly expressed in visual terms. There is no element of the haphazard, the thoughtlessly vulgar, about it. A good example is *The Fall of Icarus*, in which a crude joke (originally jotted down in pencil by one of Gillray's associates) is given a vividly felt realization in line and form (*Plate 29*). Similarly, the debauched Prince of Wales is caricatured in several prints to the point at which self-indulgence takes on a beauty of its own – the marvellously rich line which encloses the figure has a completeness and a rhythm which express '*The Voluptuary, or the Horrors of Digestion*' (for example) as art. This is the rhythm we found in some Mortimer drawings, but which occurs in Rowlandson only rarely – one example is a drawing of three cavalrymen on parade: they too are defined by a wide, baggy line which conveys exactly their stolid fatigue, and creates a wholly original and memorable image (*Plate 24*).

Rowlandson's abounding verve and the animal force of Gillray's rough style must also be seen in the context of a humorous art that does not have its origins in satire: the drawings of Edward Francis Burney, initially a portrait painter, were mostly designs for the illustrations to sentimental novels, but he also made some elaborate watercolours showing social gatherings – a country ball, or a glee-club – in which the poetic virtue of exaggeration plays an important part (*Plate 30*). Compared with Rowlandson or Gillray, or indeed most of his contemporaries (he was born in 1760), Burney is a draughtsman of exceptional suavity and grace, and his elegant, clear-cut line never deserts him, even when he depicts the most Hogarthian confusion of tumbling figures. His colour is richer than Rowlandson's, but it is always subordinate to his lucid outline. There is a Neo-classical clarity and control in Burney's work that marks him out from almost all the comic artists of his generation.

We may note a cerebral quality about Burney's neat design, and Gillray's often surrealist humour, which is the very opposite of Rowlandson's unphilosophical and unliterary art. When Rowlandson made drawings for books, like the *Tours of Dr. Syntax*, it was usually the writer who followed his illustrations, and not the other way round. This is another reason why he places a much less explicitly moral emphasis than Hogarth. Rowlandson's morality consists in his all-embracing satisfaction with life. Let us return, finally, to Paul Oppé's account. Oppé says:

> Even for satire and real caricature, a greater heat of detestation, or a deeper understanding, is wanted than he ever showed. He is perfectly contented with the powers that be, pours out his scurrility on either side as he was paid; smiles at fashion when it knew itself ridiculous, laughs at vice or crime when it is impotent or ugly, but indulges his chief mirth at such safe game as Frenchmen, Dissenters, and other accepted baits or even the misery of the rabble.

The reply to this trenchant attack is, I think, plain from what

we have seen of Rowlandson in this survey. He did not, as Oppé rightly says, participate in a great heat of detestation: hatred is not a characteristic of his work, as it can be said to be of Gillray's. He is objective, but not callous: there is never any doubt that he, in every line, admits himself to be a human being of the same stuff as all his characters. Like his unfailing line, there flows through all his work a warm sympathy with life which is the foundation of his creative energy, and which, despite Oppé's comments, is the ruling spirit behind his art.

William Blake

The subject of one of Rowlandson's etchings is *The historian animating the mind of the young painter* (*Plate 28*). It shows a young artist pausing in the middle of painting a canvas on which several figures can be seen making exaggerated gestures; he is listening to an old man who reads to him from a thick book. Rowlandson himself, as we have seen, had exhibited a biblical subject at the Royal Academy, *Delilah payeth Samson a visit while in prison in Gaza*, and I have suggested that this may not have been as serious an exercise as it at first sight seems. He could afford to take the matter lightly, and to publish satires on it, because he was so completely at home in a different and very lucrative genre: that of social comedy. But for those who had no such decisive speciality, history painting was the natural and proper form of serious expression.

This idea was stated in its conclusive form by Sir Joshua Reynolds in his famous annual Discourses, given in his capacity as president at the Royal Academy prizegivings between 1769 and 1790. In the Discourses Reynolds outlined his theories of art and aesthetics, and offered advice to students as to the right way to go about becoming an artist, and his views both crystallized the aesthetic theory of the late eighteenth century, and established a canon of belief which dominated artistic life in England for nearly a hundred years. Reynolds referred back to the Baroque painters of Italy and Flanders for the examples to be followed, and just as landscape artists admired and imitated Claude and Salvator Rosa, so practitioners of what was known as 'The Highest Branch of Art' sought inspiration from Guido Reni, Poussin, Rubens and their great predecessors of the Renaissance, Michelangelo, Correggio, Raphael and so on.

Although Reynolds himself admitted, sadly, that he was incapable of the heights of historical painting, his successor as president of the Academy, Benjamin West, was perhaps the outstanding example of a painter who actually made and held a reputation by producing history pictures. West was an American, a Pennsylvania Quaker by upbringing, and came to England via Rome in 1763. He quickly attracted the favour of George III, who appointed him his personal Historical Painter. His work was inspired by Roman or Greek history, and by contemporary notions of the art of those civilizations. Even his small landscapes and genre scenes, in bodycolour rather than watercolour, are suffused with the classicism of Poussin.

As West developed, and as he had to cover larger and larger areas with his designs, he adopted the scale of the Italian Baroque: life-size figures arranged in complex, often dramatically violent groups are his basic stock-in-trade; biblical events, including scenes from the Apocalypse, occur; and mythologies ancient and modern form staple subject-matter. The figures in these works gesticulate with an exaggeration which derives from two sources: first, from Italian Mannerist and Baroque paintings themselves, which were executed for the Mediterranean Church and exploited the emotional possibilities of gesture to an unsurpassed degree; and second, from the eighteenth-century theatre, which depended on a highly artificial language of gesture and expression. In the late seventeenth century, Charles Lebrun, Louis XIV's court painter, published a work standardizing facial expressions for the depiction in art of pride, anger, joy, jealousy and the whole gamut of the passions. John Caspar Lavater's *Treatise on Physiognomy designed to promote the Knowledge and Love of Mankind*, widely read in England after its translation was published in 1789, later had a similar influence. And it is clear from Reynolds's instructions in the Discourses that the main aim of the history painter was to ennoble and idealize by the use of suitable facial expressions and gestures the actions he chose to represent. Edmund Burke's *Enquiry into the Origin of our Ideas of the Sublime and Beautiful* was a philosophical development of this general interest in the emotions which was applied to all aspects of experience. Because of Burke's insistence that the Sublime evokes the strongest human feelings, painters ambitious of producing great art sought to create sublime images, and the term became the greatest compliment one could hope to earn. Its companion quality, the Beautiful, was associated by Burke with the passion of love. He listed the following characteristics as belonging to the Beautiful: 'Smallness, Smoothness, Gradual Variation, Delicacy, Sweetness; and these belong to the Sublime: Terror, Obscurity, Privation (Vacuity, Darkness, Solitude, and Silence); Vastness, Infinity, Succession and Uniformity, Difficulty, Magnificence; Light, Loudness, Suddenness, Intermitting.'

The ennobling of history, the religious seriousness it claimed from the artist and the public, called for a cast of character rare in English artists. West did not have it; his work, for all its success, remained basically prosaic, and his contemporaries seem to have been aware of this. His followers, men like Richard Westall, who was prolific and technically highly proficient, show how the elements of West's message could be picked up and used over and over again by any competent but unimaginative hand; although, of course, in the interpretation of the fashionable subjects much value was attached to imagination. On the whole, Westall and his kind were best on a fairly small scale, as illustrators to books, while their full-size, often outsize, paintings are lifeless, though Westall's attempts to create with rich washes of watercolour and bodycolour something of the dramatic power of oil-painting gained him much praise as a technical innovator (*Plate 36*).

Imagination, vivid, eccentric imagination was the only element which could effectively weld together into a meaningful visual entity the ideological and art-historical

complexities demanded of the history painter; but eccentricity itself presented problems and two of the men who most fulfilled the required conditions were never able to fit happily into the artistic world of their time. One, George Romney, was a fashionable portrait painter who seems to us now to have expressed more in his wild, almost abstract sketches of allegorical or literary subjects than in his sometimes insipid portraits. He suffered from a strain of madness, which undermined his work as his life progressed, but gave it character and force. It is a strain which recurs in the art of the period. The second was James Barry, a farouche Irishman who ultimately earned the distinction of being the first artist to be expelled from the Royal Academy. His most famous achievement was the series of vast wall-paintings on canvas that he made for the assembly room of the Royal Society of Arts. Barry took as his subject the progress of civilization. His method of presentation is an extraordinary blend of quotation from the classics with portraiture and fantasy. He made use of Reynolds's principle of incorporating motifs from Bolognese or Venetian art, and strove to make his grandiose visions relevant by including portraits of Englishmen past and present.

Barry's theatricality, though it derives from the generally known language of theatrical gesture of the time, is more striking than the empty poses to be found in most historical pictures. He infuses a weird, rather awkward originality into the intense inhabitants of his world, which, even if ultimately unsuccessful, at least suggests the effort made by the artist to use the medium for personal expression. This quality will emerge more clearly if we compare Barry's work with that of Henry Fuseli, who takes idiosyncratic fantasy a stage further.

Fuseli, a Swiss born in 1741 and trained for the Church, spent the better part of his long career in England, and, like Barry, became a member of the Royal Academy. His work from his earliest years was utterly distinctive, and as professor of painting at the Academy between 1799 and 1825 he impressed a whole new school of young artists with his exotic imagination and eccentricity. He was for history painting what Reynolds was for portraiture. His pre-eminence lay in the vigour of his conception. He almost alone of the history painters could bring his figures to life; not to the life of reality or even of the artificial contemporary stage, but to a life electrically charged with super-energy, so that even in repose they express physical exertion. And when in action, they seem composed of muscles stretched to a pitch of intolerable tension, elastic, athletic, and iron-hard. Limbs are flung, not merely moved, across the scene; figures writhe, in postures that contemporaries doubted were possible, into every corner of his designs (*Plate 34*). The titanic energy of Michelangelo was evidently an important influence on Fuseli, but even more, perhaps, the exaggerated, strained mannerism of Michelangelo's followers in Italy and the Low Countries. Like West and Barry, Fuseli painted enormous canvases using Homer, Milton and Shakespeare as sources for subjects; he accepted commissions from John Boydell, a print dealer and publisher who set himself to stimulate English art until it achieved European pre-eminence, and planned a 'Shakspeare Gallery' as a patriotic attempt to glorify Shakespeare and modern art simultaneously. All the paintings, submitted by a large number of leading artists, were engraved and published in a folio volume which accompanied a fine edition of the text of the plays. But Boydell's scheme epitomized the fate of the Grand Style in England: it was admired in theory, but was a commercial failure. Fuseli's canvases are among the few that remain convincing today. But he often explored themes of his own invention, involving the supernatural world of demons, fairies, and giants. He made large numbers of drawings, often in a wiry pen and ink, lit with floods of dramatic lighting. His work has a durability lacking in that of most of his contemporaries: we can accept it on its own energetic terms, without making allowances for the aesthetic or philosophical climate of the time.

We do not attach much importance nowadays to Fuseli's subject-matter; we enjoy his work for its intrinsic life. But we must bear subject-matter in mind when we compare Fuseli's success with the failure of a friend and in many ways a very similar artist: William Blake. Blake was born nearly two decades after Fuseli, in 1757. It was not until 1809 that he held a public exhibition of his paintings, by which time he had already accomplished a considerable amount of work and published some of his books. Blake's catalogue for this exhibition explained that it showed 'The Grand Style of Art restored; in FRESCO, or Water-colour Painting, and England protected from the too just imputation of being the Seat and Protectress of bad (that is blotting and blurring) Art. In this Exhibition will be seen real Art, as it was left us by *Raphael* and *Albert Durer, Michael Angelo*, and *Julio Romano*; stripped from the Ignorances of *Rubens* and *Rembrandt, Titian* and *Correggio*; BY WILLIAM BLAKE.'

These last-named artists were much admired at the time, as they are now; but Blake's own worship of Michelangelo, Raphael and Dürer was quite orthodox; his use of the phrase 'the Grand Style of Art' chimes perfectly with Reynolds's own terminology and with the fashion for histories. Furthermore, his patriotism is precisely comparable with that of Boydell. Like his, Blake's exhibition failed. The tone of his advertisement, and of the catalogue as a whole, suggests at least partially why: Robert Hunt, Leigh Hunt's brother, wrote in a review: 'The Catalogue is a farrago of nonsense, unintelligibleness, and egregious vanity; the wild effusions of a distempered brain.' Blake was in the eyes of most of his contemporaries mad, and we should have reacted similarly to such an exhibition if it had been mounted today. Blake's version of the Grand Style was strangely muted, in some ways naïve, as was his self-advertisement. Compared with Fuseli, his compositions are stiff and cold; compared with Barry, his subject-matter is obscure to the point of raving.

Some exceptional men, like Samuel Taylor Coleridge, saw more in Blake's work than incoherence and technical weakness. Coleridge, the author of the *Ancient Mariner* and a highly imaginative and personal poet, could announce: 'I am in the very mire of common-place common-place compared with Mr. Blake, apo- or rather ana-calyptic Poet, and Painter!' But this was the judgment of a poet, a man who approached Blake from the literary point of view and was therefore able to interpret his paintings as expositions of abstract or literary ideas and not as purely visual statements. In order to understand Blake's paintings we too are compelled over and over again to resort to his philosophy, to his literary

productions, for the key to them. We need to know that Blake was trying always to express his belief in the spiritual life of man as sharply antagonistic to that of the contemporary materialized world. 'Spirits', he said, 'are organized Men.' He used the name of Albion, with its symbolic connotation of England, as a personification of the eternal spirit of humanity, which embodied itself in the true God of Scripture, the object of his own sincere worship. Against this the established Church, and indeed all established forces, were pitted as the instruments of social law and falsehood, inhibiting the life of the imagination, the spirit, which is manifested in human creative energy. Blake called energy 'Eternal Delight'. 'Exuberance', he said, 'is beauty.' These assert the vitality of the spirit, the positive purpose of human existence. The contemporary admiration of Greece and Rome was a submission to pagan materialism; in the early part of his life he admired Greek culture, but later became stricter in dismissing it: 'Grecian is Mathematic Form, Gothic is Living Form,' he thought. Hence the recurrence of Gothic motifs in his work, and the affinity of many of his figures with the sinuous personnel of medieval manuscripts and carvings.

The progress of the soul of Albion from innocence to a state of materialized brutality and its subsequent attainment of purity in 'Jerusalem', Blake's state of Heaven, constitutes an elaborate mythology, making use of cross-references to other mythologies and involving a large number of characters with very confusing names. I am not concerned with expounding this fascinating and still amazingly satisfying personal religion of Blake's; but its immediate relevance to his visual productions must always be remembered.

Executed in a strange, muddy tempera, Blake's fantasies cannot have made much of an impression on visitors at his exhibition. Allegories like the *Spirit of Nelson*, although very much in tune with current tastes, must have summoned up comparisons with West's *Apotheosis of Nelson* of 1807, and other pictures, not to Blake's advantage. We can now see these works as interesting experiments by a man who was constantly evolving new means of expression for himself. In other media, he was far more successful: the Royal Academy, which always refused to hang his tempera works, seems to have accepted a fair proportion of his submitted watercolours. He was, in fact, throughout his life a highly competent professional engraver. In 1772, at the age of fifteen, he was apprenticed to a successful engraver, James Basire, under whom he became fully proficient in the medium. His career as a 'visionary hermit' did not lead him to real success, and he never ceased to undertake commissions to illustrate books or even, as late as 1815, to engrave plates for Wedgwood's catalogue of domestic pottery. These tasks he performed with remarkable patience and reliability, putting aside his pretensions to greater fame with moving humility.

A nude pencil study in the British Museum, possibly drawn from his beloved brother Robert, and therefore dating from before 1787 when Robert died, is another work which could have been done by any academic artist of the time. Or rather, it could not, for it is, though completely simple and direct, in every way a more sensitive and subtle rendering of the nude than the usual life drawings of the period. It makes one important point very well: Blake was as good a draughtsman as his Academic colleagues. He did in fact enter the Academy Schools in 1779. While he was there, Reynolds told him that he ought to 'mend his drawing'; but this need not be taken to show that Blake's draughtsmanship was incompetent, only that, in general, he was not concerned with Academic forms of expression. If his drawings have an air of naïvety about them, this reflects, not his technical ability, but his idiosyncratic vision. What he wishes to say dictates the strange language he uses. An early engraving by Blake, after one of his own paintings, *Elinor sucking the poison from Edward's wound*, shows that he was not only a professional engraver, but a capable executant of historical compositions of the kind that West specialized in. In 1780 he exhibited a historical watercolour at the Royal Academy, his first work to be hung there: *The death of Earl Godwin*. Only the preliminary sketch for this is now known; its rather angular drawing reminds us of Hogarth's composition studies, and it is again not far removed from West's sketches for pictures in ink and wash. Its colouring, on the other hand, is remarkably sweet, with harmonies of lavender, pink and yellow, and suggests Blake's close association with the tradition of illustration going back to the rococo. In the early 1780s Blake worked on several projects with Thomas Stothard, who in a long lifetime produced a vast quantity of book illustrations and designs for decorations of all sorts (*Plate 31*). Although his style inevitably altered during his career, it was always very facile, flowing and charming. Stothard's coloured drawings are particularly graceful and attractive; after about 1800 they reflect the strong influence of Watteau. Blake no doubt owed something to Stothard for his own delicate but forceful colouring.

In the 1780s, however, Stothard's work has a rather more austere, Neo-classical character, which brings it closer in mood to that of Blake. Blake took the Neo-classical conventions of frieze-composition, rhetorical gesture and so on, and instinctively simplified them in order to concentrate in individual figures the intense feeling he needed to convey. His drawings illustrating a symbolic narrative, *Tiriel*, produced in the late 1780s, are conspicuous for this simplification, using grey washes only, and plain backgrounds, against which figures move with quietly hieratic gestures. Even more personal works appeared in 1788: with the *Songs of Innocence*, combined in 1794 with the *Songs of Experience*, the sequence of Blake's masterpieces began. These collections of poems were not his first; he had, in fact, published or attempted to publish numerous literary exercises during the eighties, and in 1788 had brought out his first book in a process which was designed to enable him and his ever-helpful wife, Catherine, to act as unassisted publishers of his works. This was a form of etching which Blake called 'illuminated printing' and which he claimed to have learnt in a vision from his dead brother Robert; although the method was a subject of general discussion among artists at the time. Blake drew his design, including the text, on to the plate, in a varnish which prevented acid biting the metal; the design thus became a raised stereotype, rather like a woodblock or a modern lineblock, of which the surface could be inked or coated with colour and printed off in the usual way. The colour would print in thick, puckered areas of dense ink, and inevitably tended to be a little blurred or coarse in outline; details were picked out with more colour on a

brush, wielded either by Blake himself or by the diligent and faithful Catherine.

All the 'Prophetic Books' in which Blake expounded, at great length and often incomprehensibly, his complex philosophy and world-view, were produced like this, as well as the *Songs of Innocence and Experience*. Illustrations and text are combined on each page, somewhat in the manner of medieval illuminated manuscripts; the books are usually known as Blake's 'Illuminated Books'. The cursive text is ornamented with running linear forms which animate every part of the sheet, and often help to establish the mood of the lines they decorate. As for the illustrations themselves, ideas which were clumsy when executed on a larger scale in tempera are reduced to a tiny area; the majority of the designs are only an inch or two in height, but, printed and then touched with details by hand, they achieve great intensity. The *Book of Urizen*, for instance, dating from 1794, contains examples of jewel-like compactness of form and richness of colour; here, Blake's printing is at its most elaborate. But it is not simply the colour, powerful as it is, which gives these designs their force. I have already pointed out that the basic language that Blake used was not far from the histrionic style of his fellow artists; but the core of originality in these illustrations is unmistakable. All the figures in the *Urizen* designs are bursting out of their frames. They nevertheless do so without the physical effort of Fuseli; their energy is less muscular than spiritual; how Blake contrives to suggest that it is difficult to analyse; partly, I think, his colour conveys it – conveys strength, positive life, dynamism and action without specific relation to the forms – and partly the sinuous quality of the line: bodies accomplish contortions as odd as Fuseli's but by means of gentle curves, not violent angles.

This feeling of tranquillity in action is the opposite of Fuseli's agitation in repose. Nevertheless, it is clear that the visual language of the artists largely coincides. Fuseli is well-known for having said that 'Blake is damn'd good to steal from,' and Blake cannot but have been influenced by Fuseli's all-pervading fame. They were friends and Blake made engravings from Fuseli's designs. A similar reciprocity exists between Blake and John Flaxman, the leading sculptor of his time, born two years before Blake in 1755, but on account of his success always rather paternal towards the struggling engraver. Flaxman was responsible for putting a lot of work in Blake's way, both of a hack variety and of a more stimulating description; it was Flaxman, for instance, who commissioned a series of illustrations to Gray's *Poems* in 1797. Blake's feeling for the sculptor is vividly expressed in his exclamation, 'You, O dear Flaxman, are a sublime archangel, my friend and companion from eternity!' Flaxman's work epitomizes the Neo-classical style in England at about 1800 (*Plate 32*). He was an international figure, publishing outline engravings of illustrations to Homer, Aeschylus and Dante, which were admired and imitated all over Europe. His cool, precisely composed memorial reliefs and monumental groups occur in churches throughout England; there are fine examples in Westminster Abbey and Chichester Cathedral in particular. He could hardly be further removed in temperament from Fuseli, the other presiding genius of the movement: serenely calm, consciously adopting the idealized figures and static poses of Greek reliefs and vase-paintings, yet doing so, unlike West, with complete conviction, as though he were himself a Greek new-born. We find plenty of movement, even violent movement; but even in action Flaxman's figures are graceful and relaxed.

Being a sculptor, Flaxman was fond, even in his drawings, of evolving figures which are enclosed in simple, enveloping outlines, outlines suggestive of the mass of stone from which they might be carved. We find Blake exploiting the same effect in several of the *Urizen* plates. The cool, simplified designs of Flaxman's groups embody, in spite of their abstracted quality, a human sympathy which makes him one of England's greatest artists; he is very underestimated today, considering the modernity of his vision.

Flaxman's refined and highly-charged pen drawings are the extreme examples of significance concentrated in line. Blake believed strongly that it was in line only that the spirit could be expressed; this is why he referred so scathingly to the 'Blotting and Blurring' of the painters who stressed colour and plastic form – Rubens, Titian and Rembrandt. He therefore responded positively to the masters of Florentine *disegno* – that is to say, drawing; and himself developed a linear style dependent on swirling, flamelike lines, which reminds us of the mannerist followers of Michelangelo and is necessarily allied also to the work of Fuseli. His nude figures undoubtedly derive, in inspiration, from Michelangelo's own, but he allows the line to take control, to do more than simply suggest form: it has the additional task of investing form with the visionary life he perceived in it. It has been jokingly remarked that Blake's nude figures seem to have been skinned; there is more meaning in this than we might suppose. Blake does seem to see through the skin – to strip off the external layer of his characters – and depict the tense, energy-filled inner being, the spirit of his idea.

Blake made numerous highly finished, elaborate compositions in true watercolour. Sometimes they were for specific patrons: apart from Flaxman, the most prominent are William Hayley and Thomas Butts. Hayley, a friend of Flaxman and Romney, and near whose home at Felpham in Sussex Blake and his wife took a cottage from 1800 to 1803, went to endless pains to find him employment, and Butts was always willing to pay for Blake's most personal productions. Blake engraved illustrations for Hayley's uninspired poems; for Butts, he made drawings, prints and tempera paintings which are among his finest works; and Butts became the owner of a series of remarkable 'Colour Printed Drawings' made in 1795 in a technique not unlike that of the Illuminated Books. Among them, *Naomi entreating Ruth and Orpah to return to the Land of Moab* (*Plate 37*) has some of the directness of the *Tiriel* designs; but it exploits gesture with such a sure sense of what is telling that the white figures against their simple green background, offset only by the delicate flutter of drapery, have a grandeur and conviction far removed from the bombast of West and Co. The figure of *Nebuchadnezzar* crawls along the ground not for narrative reasons alone, but symbolically; his nearness to the earth, and the blending of his rock-like body with the forms about him, are indicative of his spiritually earthbound state. And *Sir Isaac Newton*, who seems to grow out of the submarine rock he sits on, is for Blake a symbol of the mathematical, scientific state of mind which denies the immeasurable

freedom of the human spirit; it is confined, cramped within the boundaries of logic and drowned in the sea of materialism. The aphoristic conciseness of these images is further testimony to the influence of the linear and formal refinement of Flaxman.

In these prints Blake applied much of the hot, dense colour by hand, and did not in any case use the printing process primarily to make replicas – only about three impressions of each of the plates are known. For him, the method was a means of obtaining the rich colour that he wanted for his powerful visions. He seems to have used a sheet of millboard, smeared with colour, combined with glue, instead of a metal plate. The 'Colour Printed Drawings', like Blake's work in tempera, are really another manifestation of his inventive use of watercolour. We shall see that other artists too could blur the distinction between media in this way, and Cotman was to mix glue with his pigments very much as Blake did in order to enrich and intensify his colour.

When he turned to pure watercolour Blake could create designs of almost equal power: his extraordinary paraphrase of a Renaissance *Transfiguration*, the *Satan rousing the rebel Angels* in the Victoria and Albert Museum, achieves great sonority and depth of tone simply with ink and watercolour washes. But in general, he employed watercolour to express the aerial otherworldly nature of the spiritual life. One of the most impressive is a design for a border showing *The Resurrection of Pious Souls* (Plate 19). Here the characteristic undulating lines stream upwards, the faces are idealized but radiant with purpose, and the bodies, revealed through diaphanous raiment, scintillate with reflected glory. Blake achieves this with small touches of clear colour – red, yellow, blue – which enliven the surface of the drawing and give us a sense of witnessing the amazing scene through an aura of prismatic light.

Blake seems to have become more and more aware of the possibilities offered by watercolour for leaving his meaning vague, implicit rather than stated, and in his latest important series of drawings, the medium is used with a restraint which is, strangely, very appropriate to its material. This was a group of some hundred illustrations to Dante begun for Blake's young admirer, John Linnell, in 1824, and done mostly in bed, as he had scalded his foot. Dante's *Divine Comedy* was studied closely and with great sympathy by Blake towards the end of his life, in a translation made by Henry Carey and published between 1805 and 1819. The grandeur and humanity of Dante's vision appealed to Blake even though he disputed much of Dante's philosophy. In the finest of these drawings his clear colours are applied in rainbow sequences of red, orange, yellow, green and blue which are built up to form a shimmering, brilliantly lit world of spiritual reality. For Blake the spirit was true reality (Plate 25).

Flaxman the sculptor was an artist of the human figure; Fuseli too expressed all his energies in the energy of the human body. Blake's energy, a slightly different commodity, a more refined and spiritual quality, was, as I have said, capable of narrowing itself into the production of hack-work to keep the artist and his devoted wife alive. It overflowed in his illuminations, all over the etched plates, in varied decoration, flowers and plants, animals, planets, even in Blake's lettering, with the fecundity of the medieval draughtsmen. In the *Songs*

of Innocence we find shepherds depicted in tightly-designed little landscapes; and although they are apparently mere backgrounds, we know from Blake's poetry that the countryside had an intense meaning for him. The first important event of his life was his vision at the age of eight or ten, of a tree full of angels on Peckham Rye. Ever afterwards he drew trees as if they might have angels sitting in them. *The Laughing Song* from *Songs of Innocence* gives us his intense delight in, and identification with, nature – we are reminded of the Psalms:

> When the green woods laugh with the voice of joy,
> And the dimpling stream runs laughing by;
> When the air does laugh with our merry wit,
> And the green hill laughs with the noise of it.

That is an early expression of the feeling; it recurred in a famous group of woodcuts which Blake made towards the end of his career to illustrate a translation of Virgil's *Pastorals* by a Dr Thornton who was later to receive his strictures for mistranslating the Lord's Prayer into what Blake considered were materialistic terms. The acrimony of Blake's comments on the Lord's Prayer translation may at least partly have been caused by Thornton's treatment of him over the Virgil illustrations. When he saw them, Thornton suggested that 'they display less of art than genius' and that the deficiency be made up by a lithographer. In the end, three of Blake's subjects were recut on wood by a hack engraver. But what was published was in many ways Blake's most influential contribution to English art. In the confined space of these tiny woodcuts he crammed all the characteristic intensity of his response to nature, giving it such a memorable form that in spite of what Thornton thought of as its crudity, it gives final form to a certain aspect of landscape, and, perhaps more important, rural life – since man, his purpose and occupations, are at the centre of Blake's concern.

Landscape became in the early nineteenth century the most important medium of visual expression in England. History painting remained the highest form of art; but, as I have explained, it remained for most people an unattainable ideal – it was really only a passing intellectual fad. The list of great painters of the period consists almost entirely of landscape artists; and even those who practised other branches proved to be sensitive landscapists too. It is therefore not surprising that Blake should have had most influence in this field. The young artists who gathered round him in the last years of his life became a school of landscape artists working along the lines he had shown them. Their leader was John Linnell, who first met Blake in 1818 when he was twenty-six. Linnell became a close friend of Blake, buying his Prophetic Books and introducing Thornton and others, and was responsible for many of Blake's late enterprises, including the series of illustrations to Dante and a set of original engravings, *Illustrations of the Book of Job*. By 1824 Blake had also met the young Samuel Palmer, and it was Palmer who, after Blake's death, became the central figure of the group of Blake's followers who called themselves 'The Ancients'. They included Francis Oliver Finch, Edward Calvert and Henry Tatham and are associated particularly with Shoreham in Kent. But already in 1824 Palmer was an artist of extraordinary

individuality; he worked in those days nearer to London, in the valley of Dulwich, and his early, and I think most intense masterpieces, including a sketchbook of that year, really belong not to Shoreham but to the Dulwich period (*Plate 39*). Although he was throughout his life a landscape artist, he follows Blake in filling his landscapes with humanity; he is interested in the countryside which men make for themselves – the fields of corn, the neat woods and cottages, orchard trees and spired churches. The basic vocabulary – the hints from which his vision springs – can be found in Blake's Virgil designs: the reclining shepherd and philosopher; the humped hill and crescent moon; the ivy-covered tree trunk and closely packed flock of sheep. It is a human-centred landscape. Palmer seems to have tried consciously to whittle down the part played by human figures in his designs; but they recur and take a vital place in his view. The sweetness and richness of his fields full of giant-eared wheat and intensely alive and growing plants is the sweetness of Blake's poem, *Laughing Song*, where human beings are the shaping force: 'The air does laugh with our merry wit.' Most of the Dulwich period Palmers are in pen and ink alone; when he went to Shoreham, in 1828, after Blake's death, Palmer more regularly used colour, often body-colour or thick dark sepia, obtaining rich effects rather akin to Blake's Illuminations (*Plate 40*). Another of the 'Ancients', Edward Calvert, developed in a similar way, also starting from the Virgil woodcuts. He too made wood-engravings, of a minute delicacy which is breathtaking; and his diaphanously draped figures, flitting through mottled and dappled lights and shades, have a grace which recalls the Italian Renaissance inspirations of Blake himself. His little drawing, in pen and ink and watercolour, of *The primitive city* (*Plate 41*), perfectly sums up the idealism, the romantic humanism, and the visionary mysticism which Blake inspired, and which mark out both him and his immediate followers from the rest of their contemporaries.

John Robert Cozens

John Robert Cozens's father, Alexander, was born in Russia about the year 1717; he died in 1786. He was thought of in the nineteenth century as 'the father of the school-masters': just as Paul Sandby taught the boys at Woolwich Military Academy, so Alexander Cozens taught at Eton and Christ's Hospital. Like Sandby, too, he had private pupils as well, and it is true that the pattern of his career was more that of a teacher than that of a professional view-maker as Sandby's was. His drawings never allow us to lose sight of a general theory of art behind them – they seem to exemplify certain didactic principles of landscape. This may be the reason for their wide influence on the generation of draughtsmen and watercolour painters which grew up at the end of the eighteenth century.

Cozens did not let his activities as an instructor end with the tuition of schoolboys or private gentlemen and lady amateurs; he was an active writer on his subject and published a number of works: in 1771 *The Shape, Skeleton and Foliage of Thirty-Two Species of Trees for the Use of Painting and Drawing*, which makes it clear that, however general the effects he strove to obtain himself, he recognized that landscape painting is founded as much on specific knowledge as on abstract principles. In 1778 there appeared *The Principles of Beauty relative to the Human Head*, showing the scope of his theorizing to cover figure drawing as well as landscape, and indeed implying the Renaissance theory that the human body contains the elements, and represents the perfection, of absolute beauty. He also proposed a scheme for a 'Great Work, Morality, illustrated by representations of Human Nature in Poetry and Painting', a vast project uniting the arts of painting and literature in the most high-flown style of the period which never materialized. This kind of abstract theorizing occurs in Cozens's last and most important book, *A New Method of Assisting the Invention in Drawing Original Compositions of Landscapes*, which seems to have come out not long before his death in 1786. Here, he prefaces his work with the outline of a precept which we can easily recognize as characteristic of its age:

> Composing landscapes by invention, is not the art of imitating individual nature; it is more; it is forming artificial representations of landscape on the general principles of nature, founded in unity of character, which is true simplicity; concentrating in each individual composition the beauties, which judicious imitation would select from those which are dispersed in nature.

Ideas such as these had already been expressed in various places (William Mason's *The English Garden*, for example, of 1783); but most influentially of all by Sir Joshua Reynolds. A famous passage from the third Discourse, delivered in 1770, will give the broad idea from which Cozens was working (it is a passage which particularly aroused the fury of Blake):

> Ideal perfection and beauty are not to be sought in the heavens, but upon the earth. They are about us, and upon every side of us. But the power of discovering what is deformed in Nature, or, in other words, what is particular and uncommon, can be acquired only by experience; and the whole beauty and grandeur of the Art consists, in my opinion, in being able to get above all singular forms, local customs, particularities, and details of every kind.

By 'Nature' Reynolds of course means all aspects of life and the visible world, while Cozens refers more specifically to landscape. Reynolds would, however, invoke Claude's idealized landscapes as showing generalized beauty in natural scenery just as he would invoke Raphael for the same qualities in human beings. Claude provides, in fact, a clue to the unusual and unexpected art of Alexander Cozens. His drawings in sepia wash are generally careful records of details of the Roman Campagna which he used in his paintings; but he could also suggest a whole broad landscape with a few strokes of a well-inked brush, achieving precisely the sort of generalization that Cozens in his *New Method* was trying to explain to his students.

Such generalization was very new in England at the time, but if it were not for the comments of a critic writing in 1782

we might miss the fact that Cozens's work marked a new technical departure as well:

> The drawings of this artist have a peculiar excellence in which they resemble painting, for the effect is not, as is usually the case, produced from outline filled up; but is worked into light, shade and keeping by a more artful process, the masses being determined in the first working out or designation of the parts, and afford a harmonious effect unlike the ordinary compositions of scratches and lines just connected by a flimsy washing.

In his concern for the rendering of masses of light and shade, seeing landscape as a distillation of natural phenomena into their purest forms, Cozens had very little use for colour. The early drawings by him which have come down to us, mainly done in Rome in the 1740s, are tinted drawings, or pen outlines, at their best very clear and pure in their effect; but they rarely make any attempt to explore the realms of tonality which he was later to become obsessed with and which brought him close, at least in spirit, to the painters in oil. Their rather formal black ink outlines derive from Baroque engravings after, say, Gaspard Poussin; they are, if anything, more formal than the Italianate landscapes done in England by George Lambert or his associate William Taverner (*Plate 46*), and lack the warm colouring that we find in the views that Lambert's pupil Jonathan Skelton infused into the paintings he made before his early death in Italy in 1759 (*Plate 45*).

We find the same lack of interest in colour when we turn to Alexander Cozens's later drawings. For these, a brush loaded with black or brown ink was all he required, and he worked on paper which was either white or prepared with a creamy or pale brown tone. Some of the fine penwork of the Róman drawings recurs from time to time; he often goes to some pains to contrast a generalized mass with an area of fine detail; but the overall effect is emphatically one of a generalized mood, rarely of a specific identifiable scene (*Plates 44 and 48*).

The 'New Method' which Cozens finally published served to popularize (and to bring a good deal of ridicule to) his vision of landscape. In order to arrive at a landscape form of sufficient universality, sufficiently freed from the connotations of particular places, he hit on the idea of starting, not from a view to be copied, but at random from a casual mark on a sheet of paper. He called such a mark a 'blot' – 'a true blot', he said, 'is an assemblage of dark shapes or masses made with ink upon a sheet of paper, and likewise of light ones produced by the paper being left blank. All the shapes are rude and unmeaning, as they are performed with the swiftest hand.' He insisted that 'a blot is not a drawing', but contemporary critics seized on the word and reacted to the implications of carelessness very much as their successors were to do before Turner's later work (and even some of his early work), and before Impressionist paintings in the 1870s.

The blot was the starting-point for an ideal landscape. Cozens made it clear that 'a person must have genius in order to be able to make out designs from blots', genius being for him 'strength of ideas; power of invention; and ready execution'. It is certainly possible to recognize something like genius in the strength and power of Cozens's own inventions. They have a personal quality which is almost visionary and quite unlike any other landscapes produced in Europe up to this date (*Plates 49 and 50*).

One of Cozens's pupils, and one with whom he was intimate, was William Beckford, an eccentric millionaire of extravagant and exotic tastes. He was the author of a fantastic novel, *Vathek*, and builder of a vast Gothic Abbey at Fonthill in Wiltshire, in which he lived as a dilettante hermit and became a legend in his own lifetime. The close connection between Cozens and this extraordinary figure adds an extra dimension to our interpretation of Cozens's work. No documents survive which give us much indication of the artist's personality, but if he was receptive to Beckford's imaginative outlook he may well have been, himself, a man of highly-coloured fancies. Beckford wrote of him at one time as 'very happy, very solitary, and almost as full of systems as the universe'. We have seen that Cozens was fond of inventing 'systems' – his 'Great Work, Morality' was one; and his habit of methodically categorizing the processes by which to work is typical: his early sketchbooks were carefully annotated with stage by stage instructions for carrying out his drawings and paintings; and the 'New Method' seems to spring from the same impulse to theorize, the 'school-master' mentality.

Beckford was also closely connected with Cozens's son, John Robert, the pupil of his father and the possessor of an even less well-documented character, but one which nevertheless seems to have contained the seeds of a fully-fledged romantic artistic personality: solitary, brooding, and ultimately insane. John Robert was born in 1752, a few years earlier than Rowlandson and Blake, and was exhibiting in London by 1767. In 1776 he showed an oil-painting at the Royal Academy, a landscape evidently inspired by Claude, whose subject was *Hannibal in his march over the Alps showing to his army the fertile plains of Italy*. Apart from the fact that this was one of the only two oil-paintings which he is recorded as having done, it would be interesting to know how much attention Cozens devoted to the landscape of the Alps as opposed to the 'fertile plains of Italy'. A wash drawing of the same subject (American private collection) is very much in his father's manner, and bears a resemblance to the brown 'rugged' scenes invented by the Rev. William Gilpin to illustrate his conception of the picturesque landscape (*Plate 47*): the figures are small and the rock formations generalized; the distant plains suggested by a few economical touches. Mountainous subjects were new to English artists then – in the 1770s – but were to become John Robert Cozens's most typical preoccupation (*Plate 51*).

One of the earliest men to study the Alps seriously, and to exhibit his drawings of them in London, was William Pars, who accompanied the 2nd Viscount Palmerston on a journey through Switzerland to Lake Maggiore, and back along the Rhine valley in 1770. The views which he showed at the Royal Academy exhibition in the following summer were lucid, vivid portrayals of the verdure of mountain valleys and the icy rocks of the peaks; they make use of a range of blues and greys which anticipates John Robert Cozens's mature work of a decade later (*Plate 57*). Pars had already shown an extraordinary intensity of response to landscape on a journey made between 1764 and 1766 to Turkey and Greece. He was a very young artist of twenty-two when commissioned by the Society of Dilettanti, a

body of noblemen and gentlemen formed to further the arts and their appreciation, to accompany an archaeological research party, making records of the sites and sculptures and buildings studied. His function was, in a sense, purely scientific – exactly the same kind of topographical job which Sandby did – but Pars brought to many of these views a delicacy of perception and atmospheric subtlety which may have been stimulated by the novelty of his surroundings, and which make them among the finest works of topography to have been produced in the eighteenth century (*Plate 56*). Such abilities were well employed on Lord Palmerston's Swiss tour, and it is interesting to compare the young Pars's response to Greece and Turkey with his impressions of the contrasting scenery of Switzerland. The lapse of a few years has brought about a certain loosening of handling, a greater freedom in putting on the bright washes of watercolour; but the clarity of vision remains and the views of the valley of Chamonix are among his most successful drawings.

In the year after his visit to Switzerland, Pars was taken by Palmerston to Ireland, and his style took another step in the direction of a broader, softer manner; perhaps the gentle hazy atmosphere of Killarney and Roscommon affected his sensitive response as the brighter, clearer air of Greece and Switzerland had done. His wide expanses of mild Irish landscapes are seen in an almost monochrome range of greys, applied in woolly masses without as much careful pen outlining as previously. This is the colouring we find in much of Alexander Cozens's work, and in that of John Robert as well. It seems to have signalized that moment in English landscape painting when artists transferred their main interest from the objects they saw to the atmosphere – climatic or emotional – in which they saw them. But Pars did not develop any further in this direction.

In 1775 he went to Rome, and remained there until his early death in 1782. He became the friend and sketching companion of other Englishmen, in particular, of John Smith, nicknamed John 'Warwick' Smith, after the city in which he lived, or perhaps after his patron the Earl of Warwick, and Francis Towne, an Exeter drawing master whom he had known for some years in London. These three made drawings of the same views in and around Rome, and evidently saw a good deal of each other's work; no doubt they were influenced by each other's ideas and experiences (*Plates 66, 67 and 68*).

Towne was forty when he travelled to Rome in 1780. He had been taught at the same London drawing school as William Pars, and established himself as a teacher in Exeter, painting local views in oil for the county gentry and making sketching tours in Wales and the south-west. He exhibited in London from 1775. But, like Pars and Cozens, he seems to have responded most strongly to the stimulus of foreign scenery, and it is in the Swiss and Roman drawings of 1780 and 1781 that his talent expresses itself at its finest (*Plates 62 and 63*). In his use of medium and materials, Towne does not differ essentially from Smith: both artists use the traditional grey wash which defines shadows, underlying a layer of local colour: the old tinted drawing method. Smith gained a great reputation in his day for dispensing with this system and applying local colour initially, working it up with added layers of intenser pigment to produce an almost legendary brilliance

of colour; but in fact Towne experimented with the same technique, and so did many of their more progressive contemporaries. Towne's drawings are frequently inscribed 'Drawn on the Spot'; and it may be that not only the outlines and the monochrome washes, but the colour as well, was applied in the open air, rather than being added later at home. Towne often adds a note of the time of day, leaving us in no doubt that he was as concerned to catch particular effects of light as to record a view. Towne makes maximum capital out of the luminous colour and sharp outline characteristic of eighteenth-century topography. He is the end of that line, even though as a designer he seems to be at the beginning of a new one. In a different way, Towne approached the problem which preoccupied Alexander Cozens – the problem of generalizing from nature in order to produce a perfect, ideal landscape. His answer is given in terms of line and pattern; he abstracts his landscapes from nature.

The alpine views which Towne did on his way home from Italy with Smith show him continuing to exploit the subtlety of watercolour wash (*Plate 63*). Confronted by vast areas of bare rock, which reflected and transmuted the light in a wide range of delicately varied greys, browns and blues, he deliberately isolated and emphasized the vastness, the formlessness, as it were, of the mountains, and their accompaniment of fleeting colour. We know that Towne did not mind loading his compositions with unconventionally large masses, and we cannot be altogether surprised by the startling layout of his Swiss compositions. Their format is upright, and the foreground detail dwarfed by soaring peaks. But it is not only in their compositions that these drawings are surprising. The gently shifting colour, green, grey, brown, white, is Towne's principal means of conveying the hugeness – the sublimity – of the scene. This expressive harmonization of restricted colours was to be the keynote of the next phase in the development of romantic landscape.

The feature which puts these drawings at such a distance from Sandby and his world is the utter exclusion of the human figure. Even in his Roman scenes Towne avoids figures. He shows public places empty of people; brightly coloured, trim, and tidy – but deserted. The effect is one of slight mystery; we should be tempted to use the word surrealist nowadays. In the Alps figures are less expected; but Towne still presents a more barren world than Pars's valleys, where fine vistas are specially prepared by nature to delight the tourist. Towne does not paint fine views; he faces and records grim reality, and it is beautiful because he distils its grimness and gives us the aesthetic essence of it.

The human figure is not so rare in the work of John Robert Cozens; but he did not often produce a subject with a human incident as its main motif, like *Hannibal showing to his army the fertile plains of Italy*. His figures are usually introduced to point up the smallness of man in his natural surroundings, and to show the large scale of Cozens's wide spaces. Unlike Towne, Cozens does not move in close to his subjects, filling his paper with enormous, oppressive forms. He stands back and generally interposes a vista, some kind of perspective of air or countryside, between the viewer and the sublime object he witnesses. Often the drawing is bordered on one side by a firmly inked rock or tree, a survivor from Claude through the

medium of Alexander Cozens, and given a new lease of life in the theory of William Gilpin. We shall notice that John Robert is in many respects far more dependent on the conventions of his day than Towne was; but despite this, his achievement is more considerable.

It was Richard Payne Knight, who championed the theory of the Picturesque in a long didactic poem, *The Landscape*, who seems to have sponsored some of John Robert Cozens's first continental drawings, when he 'inspected' a series of Swiss views made in the same year that *Hannibal* was exhibited in London, 1776. Whether these rather pale and sketchy drawings, in light wash with pen outlines, were done on the spot as has been supposed from their slightness, or were worked up from pencil studies made out of doors, is uncertain. The most forceful of them are of rocky details, with splashing waterfalls and much incident (*Plate 52*): the medium Cozens uses is not yet sufficiently developed to express and maintain the interest of broader, more atmospheric sweeps. Nevertheless, some of the views of mountains have a remarkably rich gamut of grey washes in which the brilliance of light reflected from rocks and snow is fully explored; they anticipate all the subtlety of his later mountain views, and already display a fully developed sense of scale.

Cozens went on to Italy, and remained there until 1779, in the English circle of Pars and his friends, but always somewhat reserved and distant from them. He went sketching in the Campagna, on a donkey; amused himself in his spare time by playing the cello, a melancholy, contemplative occupation, which fills in something of the enormous gap in our knowledge of Cozens with suggestive images. On his return to England, his father's young friend William Beckford, then only nineteen, commissioned him to turn a number of his Italian pencil sketches into finished watercolours, which he was to mount up, after the habit of artists at that time, on lined card mounts, all the same size.

In 1782 Cozens accompanied Beckford along the Rhine and again over the Alps to Venice, making drawings all the way, and, at Venice, sketching for Beckford 'some of my favourite Isles with their Morisco Towers and waving cypresses'; he fell ill, and when the party reached Naples was taken into the country villa of Sir William Hamilton, the British consul, and remained in the area until the following summer, when he travelled homewards. He made many more drawings of the countryside and islands round Naples, revisited Rome and other parts; and played chamber music with Sir William, who found him 'a good stick upon the violoncello, which was a fine discovery. . . . He is a lover of Handel which suited me. He has made some charming sketches,' Hamilton goes on, 'but I•see by his book that he is indolent as usual.' Cozens cannot really have been very indolent, although he was probably unable to work for long periods at a stretch because of his physical weakness, and was also very likely distracted by his fits of melancholia.

When he returned home he took with him Beckford's commission, as before, to make finished watercolours of many of the sketches he had done, and was occupied with this and with producing replicas for other customers, sometimes as many as eight or nine versions of a popular subject, as well as with teaching. But he was gradually becoming insane, and by

1794 had suffered 'a total decay of the nervous system. He appeared to be of a silent, hesitating disposition, and of grave manners,' Farington wrote; 'Some time since a total change took place, he became childishly noisy and talkative on trifles.' He died in December 1797, quite happy but totally deranged, leaving a 'young woman who calls herself Cozens wife' and a little daughter.

The melancholy sensitivity which eventually overcame him lies at the base of Cozens's approach to nature. He was heavily indebted to his father, his principal instructor, not only technically with regard to details of palette and procedure, but also as far as outlook is concerned. Alexander Cozens, too, was a quiet retiring personality; he loved to immerse himself in an unreal world of imaginary, exotic open spaces. His son found enough inspiration in the scenery which he could see and record about him, and does not seem to have needed the stimulus of abstraction to achieve the sublime. But he worked for similar ends. For him, every view was an expression of the melancholy beauty of the world. He drew it in a delicate pencil outline in a sketchbook, and later, perhaps only when asked to do so by a patron, elaborated it – in the earlier drawings with pen and wash as we have seen, but later almost always with watercolour alone. When the sketches were transferred to the large – often very large – sheets of the finished watercolours, the whole design was magnified, its scale expanded and its proportion made grander. The new emphasis is made, not by means of outline, but by means of finely applied strokes of local colour, building up all the areas near to the eye so that they gain strength and solidity. Plain washes, of simple blue for sky or of infinitely delicate grey for misty distances, are reserved for the far background. The tinted drawing has all but vanished, and tonality is tackled as if the medium were oil; we recall the remarks of the critic of 1782 discussing Alexander's work: 'the masses being determined in the first working out or designation of the parts'; the same flouting of 'the ordinary composition of scratches and lines just connected by a flimsy washing' occurs in John Robert's. The use of many slim strokes of grey, green, blue and brown is very close to the practice which we have already noticed in the work of Thomas Hearne; here, too, brilliant colour is sacrificed to a dense building-up of related shades. But Hearne is not concerned with the representation of the air which surrounds his trees; Cozens sees form and colour through atmosphere. It is an atmosphere partly unreal; at its simplest, it consists of broad distance, the blue air intervening between us and the objects which Cozens chooses as the background. The intervening landscape is not, like Towne's, indicated by coloured strips: it is densely alive with tiny detail; not put in with microscopic accuracy, but just indicated to give texture and atmosphere and, most important, the sense of scale: the tiny marks of Cozens's pen are trees and variations in the terrain which catch and reflect the light (*Plate 74*).

This close attention to the details of landscape is often overlooked in Cozens's drawings because they so perfectly achieve the generalization of mood that Alexander sought. We are led to believe that they are simple, misty and vague. But precision is the secret of Cozens's wonderfully powerful and evocative simplicity. He achieves a poetic effect even by his choice of such traditional details as *repoussoirs*: a gathering of

spindly trees, or an overhanging pine, may serve as a kind of regretful introduction to the melancholy beauty of what lies beyond. Richard Wilson had shown the value of such effects, and indeed his drawings, in rather blurred black chalk on grey paper, are in some ways the true precursors of Cozens's work: they have the same broad, wistful atmosphere although technically they are so different.

A comparison with the prosaic work of one of Cozens's pupils, Thomas Sunderland, who also made mountain views in pale greys and blues (*Plate 54*), will clinch the point that it is not the subject-matter but the unique artistic personality of Cozens which makes his work so outstanding. It is some indication of the heights of evocation Cozens achieved that Fuseli, the arch-fantasist, could say of him: 'He followed the arrangements of nature which he saw with an enchanted eye and drew with an enchanted hand.' Constable, a very different brand of artist, and one who revered above all the simple truth of nature, declared that Cozens was 'all poetry'.

Thomas Girtin

John Robert Cozens was touched with a strain of lunacy, and his work seems to reflect this. It is perhaps not simply coincidence that he was one of the favourite artists of a doctor who specialized in mental cases. Dr Thomas Monro was physician to the Bethlem Hospital, in which London's insane were confined, and was one of the team of specialists called in to attend George III during his illness. He took charge of Cozens after the onset of his insanity in 1794, and this may have given him an opportunity to acquire his drawings and sketches. Like many successful doctors he became rich, and was able to indulge to the full his interest in the visual arts. He was a gifted, if limited, draughtsman in his own right (*Plate 58*), and an enthusiastic collector, not only of works of art, but of artists.

His property was sold in 1833, the year that he died; in June Christie & Manson sold 'The very capital collection of that well-known and Intelligent Collector, Dr Monro, deceased'. It was advertised as including 'A landscape by S. Rosa, an historical picture by Rembrandt; and a camera obscura, with transparencies beautifully painted on glass, by Gainsborough'. Gainsborough was one of the principal figures in Monro's collection; Monro had known him, and was said to have gone sketching with him. At any rate, his drawings often imitate, and sometimes copy, Gainsborough, and evidently owe much to his free style of drawing landscape in black chalk and wash. Of the old masters, Monro had, in addition to Salvator Rosa and Rembrandt, work by the Dutchmen Roelandt Savery, Ostade, Potter, Van de Velde; by Canaletto and Titian; by Claude and Boucher. All the principal names of the eighteenth-century English landscape school are also to be found: Wilson, Sandby, de Loutherbourg, Dayes, Hearne and Cozens.

It is then likely that Monro acquired works by Cozens because he was an artist whose drawings recommended themselves to a man of taste as among the finest of their time, and not merely because Cozens was mad. Monro thought highly enough of him, at least, to make regular use of his work as material to be copied by his young artists. In 1793 or early 1794, he bought a house in Adelphi Terrace, where he installed a number of double desks, and invited promising young artists to take advantage of the facilities. He made them copy works in his possession, and paid them for what they produced. This little academy must have been a valuable addition to the meagre assortment of drawing schools in London at this period; but it provided a rather different curriculum from the stern fare of drawing from the life and from the antique at the Royal Academy, where landscape as such was relegated to a subordinate status among the branches of painting. Monro, in a sense, provided an alternative institution at just the moment when it could be of greatest service. Exactly how Monro chose his students is not clear, but he proved again and again, in his choice, that he had a sharp eye for talent, and, having singled out his protégés, gave them generous encouragement. He drove them out to his house in the country, in the early days to Fetcham in Surrey, later to Bushey in Hertfordshire, and made them draw the countryside, paying them half-a-crown and supper. He kept their drawings.

Among those that he kept, and which appeared in his sale, were 'Three, by Girtin, after Cozens'. Girtin was one of several artists who later achieved fame and demonstrated Monro's eye for talent in the 1790s. The strict Monro regimen of copying from accepted masters, especially Cozens, Hearne and Dayes, made for a uniformity of approach, which, for a year or two in the mid 1790s, brings his students confusingly close together. In particular, Girtin and his fellow pupil William Turner went through a phase of working in very similar manners. It was a style based on the work of Edward Dayes, who had been Girtin's master before he was taken up by Monro.

Turner and Girtin were born in the same year, 1775, both the sons of small tradesmen in London – Turner the son of a barber in Maiden Lane, Covent Garden; Girtin the son of a brush-maker in Southwark. Girtin may have had another teacher before he was apprenticed to Dayes in 1788, but there is little evidence for this. He certainly worked for Dayes, learning the trade of a topographical draughtsman of the traditional school, probably employed mainly in the mechanical work of colouring in Dayes's outlines. At the same time Turner was receiving a similar training under Thomas Malton, whose topography was almost exclusively architectural (*Plate 64*). Girtin too seems to have coloured Malton's delicate etchings of buildings and Malton's style and approach set a clear stamp on the early work of both artists. After his apprenticeship ended, Girtin went on to Dr Monro's, where he and Turner both attended for about three years. Farington records that 'they went to Dr Monro's house at six and stayed till ten. Girtin drew in outlines and Turner washed in the effects. They were chiefly employed in copying the outlines or unfinished drawings of Cozens, etc. etc., of which copies they made finished drawings. Dr Monro allowed Turner 3s 6d each night. Girtin did not say what he had'. A neighbour of Monro's in Adelphi Terrace, the collector John Henderson, gave them similar work, copying old and modern masters, including

drawings by himself, executed in the blue and grey washes over pencil outlines which Dayes had made particularly his own. Henderson seems also to have encouraged Girtin to make watercolour copies of pictures by Canaletto, and it has been suggested that Canaletto's drawing style had a considerable influence on the draughtsmanship of Girtin, Turner and the other young artists who drew for Monro. This was apparently handed on to them by Joseph Farington, a rather prosaic landscape painter who had studied under Wilson and made a reputation for himself as 'the Dictator of the Royal Academy', taking an active part in its affairs over many years. His diary, kept between 1793 and his death in 1821, is an important source of information about art and artists in the period. He made many drawings for publications such as *Views of the Lakes, etc. in Cumberland and Westmoreland* of 1789 and Boydell's *History of the River Thames* of 1794 and 1796. These rely for their success very largely on the skill of the engravers; Farington's designs are slight in themselves. They are direct topographical drawings sometimes washed with a little colour, but made distinctive by their brown ink outlines, which derive from the characteristic manner of Canaletto's pen views of London, using short lines interrupted by dots, which give a sense of the broken texture of old masonry (*Plate* 59). Farington employed the device neatly to make his rather stiff drawings; in the hands of Girtin and Turner it became the basis of a vigorous and expressive system of recording buildings, plants, water and all the elements of landscape.

Girtin's early watercolours are, then, firmly anchored in a strictly disciplined outline that nevertheless allows more latitude for atmosphere than the uninterrupted pen line of, say, Francis Towne. We can already sense that Girtin needed broad, complex areas to draw, rather than the confined, precise forms of city buildings and the cultivated country round London. He may have encountered the scenery of more remote regions of England as early as 1792, with another collector and amateur draughtsman, James Moore, who supplied a number of sketches from which both Girtin and Dayes made watercolours, and who published a book of *Monastic Remains and Ancient Castles in England and Wales* in 1792 with help from Girtin. Girtin and Moore were certainly together in Peterborough, Lichfield and Warwick in 1794. And though Girtin's preoccupation is still, of necessity, with buildings, we feel that his interest lies as much in the landscape that surrounds the monuments as in the antiquities themselves, which he often sets in noble expanses of hills, into which the eye is led by a subtle use of interlocking diagonal stresses, creating an effect of space and unimpeded recession. When he tackles a building by itself, without a landscape context, he does so from very close, filling his sheet of paper with a dramatically soaring pile of masonry (*Plate* 65). He must have absorbed this trick from the work of Thomas Malton; but unlike Malton he is concerned to render the quality of the rough stonework, the picturesque mossiness and dilapidation of roofs and walls. He could indicate with amazing vividness the physical characteristics of buildings – not as objectively understood styles of architecture, but as inwardly felt structures with their own history, fabric and purpose.

It was when he visited Yorkshire, Durham and the Scottish lowlands in 1796 that Girtin first came into contact with a type of landscape that offered full scope to his by now highly sophisticated technique. It is possible to follow his travels by referring to the sketches he made, and to the subjects he exhibited at the Academy in the spring following an expedition. These finished works were painted subsequent to the tour, or at least to the day's outing, from pencil sketches. They were founded on the system of working direct on to the paper that we have already met in connection with Smith, Towne and Cozens. 'Girtin', wrote an early historian of English watercolour, 'prepared his drawings on the same principle which had hitherto been confined to painting in oil, namely, laying in the object upon the paper, with the local colour, and shadowing the same with the individual tint of its own shadow. . . . It was this new practice, introduced by these distinguished artists [Turner and Girtin], which acquired for designs in watercolours upon paper, the title of paintings.' The same writer gives a lengthy account of the colours which Girtin used to render skies, clouds, trees, buildings and so on; it was claimed that 'his palette was covered with a greater variety of tints than almost any of his contemporaries'. He also considered the effect of his choice of paper on the finished watercolour; and 'was the first to introduce the custom of drawing upon cartridge paper, by which means he avoided that spotty glittering glare, so common in drawings made on white paper. . . . He chose this material as his aim was to procure a bold and striking chiaroscuro, with splendour of colour, and without attention to detail.'

The most impressive aspect of this highly developed and innovatory technique is indeed its boldness, its lack of concern for detail. Girtin seems deliberately to choose the broadest subjects, moorland or mountain scenes, in which generalization is essential to the rendering of mass and atmosphere. The surface retains the broken texture which builds up form, assisted by touches of brown derived from the interrupted line of Farington; but now large sweeps of reintegrated colour are laid on with a single application of the full brush; they are controlled in so masterly a way that they can embody the whole expanse, the shape and form of a wide landscape. In spite of the range of colour which Girtin made available to himself, his watercolours are usually constructed within a deliberately limited colour gamut; he restricts himself to an eloquent scale of browns, dark greens, greys and ochre, with a fine clear blue used sparingly for water and sky. It is the new intensity that he brings to his colouring, rather than any special brilliance, that makes for expression; even so, his muted, mellow harmonies were new: they belong very much to the romantic world of sublime landscape that was only beginning to be explored by watercolourists (*Plate 72*).

One patron in particular helped Girtin to come into full contact with the countryside of northern England: Edward Lascelles, son of the Earl of Harewood, who took drawing lessons from him, made a room permanently available for him at Harewood House, near Leeds, and commissioned watercolours from him almost until the end of Girtin's life. Girtin visited Harewood every year from 1798 to 1801, and even more significant than the regular and assured employment which his connection there implied was the opportunity it gave him to become intimate with the countryside with which he had most affinity. In 1797 he toured the west country,

adding a vast amount of valuable material to his stock of subjects; but he was most at home among the misty hills and rugged stone buildings of the north, and it was there that he returned. Girtin's technical development expresses this predilection: it is based on his need to delineate views in which atmosphere, and the play of light on mist and cloud, as well as on rocks and rough country, are his real subject: topography itself is no longer important (*Plates 71 and 76*).

Even so, the patronage of men like Lascelles was vital for Girtin, Turner and their fellows in the 1790s. Girtin's large, brooding views of Harewood House are different in atmosphere from the house-portraits of Sandby, but they are the same genre, suffused only with the mood of a new generation and liberated by an infinitely more expressive technique. Topography was still the starting-point for landscape, and was to remain so throughout the early nineteenth century. The most ambitious illustration of Girtin's interest in atmosphere combines an equally impressive feat of topographical realism: this was his panorama of London, a complete circle, probably nine feet high and covering 1,944 square feet of canvas, painted to represent an unbroken view of London from the roof of a building just south of the Thames, at Southwark. There was a considerable fashion for such panoramas in London, indeed in Europe generally, by the 1790s. Robert Barker, a Scottish artist, is said to have invented the idea, although in one form or another it had, of course, been known for a long time before he brought his panoramic view of Edinburgh to London in about 1789. In 1792 he showed a view of London, apparently only three-quarters circular, taken from the roof of Albion Mills, close to Girtin's point of vantage. This was evidently the immediate inspiration for Girtin's work. Many of the early panoramas were executed in some kind of tempera, that is, a water-based, rather heavy powder paint, perhaps mixed with oil or varnish to give the medium the body required for work on so large a scale. But the notices of Girtin's panorama describe it as being painted in oil, a superior and more durable technique; he produced only one other recorded oil-painting, a view of *Bolton Bridge, Yorkshire*. It is difficult to believe that he did no more work in this medium: his powerful remodelling of watercolour technique seems to imply a familiarity with the more opulent quality of oil paint. The panorama itself – the 'Eidometropolis' as he named it – no longer exists, or if it does, is unrecognized. Tradition has it that the enormous canvas was rolled up and sent to Russia.

We do have, however, Girtin's preparatory studies for the over-all view, which he divided into seven sections. There are careful pencil drawings worked over in ink and wash, and there are drawings in full watercolour. They constitute, in spite of their usually unfinished state and preliminary nature, some of his finest works (*Plate 70*). They show us Girtin working on a truly colossal scale. The theme is really very similar to that of his Yorkshire views: distance; misty (or smoky) air; sombre light. The basic drawing of such a panorama is of course complex and makes considerable demands on the artist's understanding of perspective, and the section showing Southwark Bridge and St Paul's, still at the stage of pen outline with a most expressive grey wash, shows the mechanics of Girtin's draughtsmanship at grips with a testing subject and yet achieving a sense of space with great

simplicity. In the sections that are in watercolour Girtin deliberately uses drifts and veils of smoke to make the city atmosphere more palpable. It is interesting to compare his use of smoke with Farington's reaction when he was drawing a view of London: he agreed that the smoke from the chimneys was most picturesque, but decided to omit it from his drawing because it obscured the truth. For Girtin, the grey smoke was part of the truth of London, and he did not flinch from including it. His intention was to create an illusion of reality, and this was not to be done by painting a sterilized, architect's vision of London in absolutely even, full sunlight.

The panorama was probably executed shortly before Girtin went to Paris in the autumn of 1801; it was not exhibited until after his return in the following year, and was on display in Spring Gardens when he died, at work in his room in the Strand, on 9 November 1802. His death may well have been hastened by the exhausting work that he put in on this vast scheme; but it seems that earlier in the year he was actually planning another enterprise of equal proportions: a panorama of Paris. He left England in November 1801, leaving his new wife with her mother in Islington, where their son Thomas was born during his absence. He is said to have gone away in search of a cure for his consumption, and perhaps to rest from the immense labour in which he had been engaged; but probably his motives were like those of many artists and tourists in that year, to take advantage of the Peace of Amiens, which had opened the Continent to Englishmen for the first time after ten years of war. He was then planning the exhibition of his London panorama, and toying with the idea of another, as a letter to his brother of April 1802 indicates:

> Dear Jack . . . what I have most particular to say is, will you contrive to find out whether Haward is or is not painting the view of Paris what sort of thing it is like to be, & so on, but don't let your enquiries be known. If tis not doing or doing but Badley – which I think it must be – then enquire about the Ground West of Temple Bar opposite to it . . . you can make enquiries as it is the very Best spot in all London & I might then have a tuch at Paris – What sketches I do are done from the windows of Hackney Coaches of course they cost a little. I altered my plan directly I got your letter for I had then begun to sketch on a large scale & to Colour on the spot. this would have been very tedious. But now I am getting the Best views I can. & merely skeches.
> [The postscript adds: 'I think the panorama here does not answer.']

His two superb drawings of the *Rue St Denis* (*Plate 75*) and *Porte St Denis* may be examples of the large-scale drawings coloured on the spot to which he refers; the 'skeches' are in pencil, splendidly grasped sweeps of the Seine between groups of fine buildings along the *quais*, or bordered by woods beyond the city's suburbs. Although they did not result in a panorama, their long low format suggests very strongly that they were done with a panorama in mind; in the event they became the basis for a series of fine soft-ground etchings, in which the rather woolly line characteristic of this technique is used to convey something of the airy breadth of the views. Some impressions of these prints are enhanced by an application of warm grey washes, in which all the atmospheric feeling of

Girtin's watercolours is concentrated into a monochrome design. The etchings occupied much of his time between his return to England in May 1802 and his death in November.

It is no accident that the most successful of the many prints after his work which appeared during the following decades are in the rich medium of mezzotint, where tone rather than outline is the dominant element. Girtin's bold, suggestive washes of warm colour are essentially different from the unarticulated, defined tints of the stained drawing. They are applied to suggest form, to build up a concrete world in which all the parts are related by the enveloping air and by the light which makes one colour interact with others. This achievement had immense influence on those who continued to work in watercolour after his untimely death. Some artists seem to have followed his path almost independently: Thomas Daniell and his nephew William, who made several tours of India in the 1780s and 1790s and published aquatints of their views in India and China, can be seen evolving out of the traditional eighteenth-century wash style an expressive method of handling distances which resembles the flecked technique of J. R. Cozens, and later, in the early years of the nineteenth century, working in the 'sublime' colours of Girtin which they could apply with exceptional skill, producing some of the most satisfying watercolours of the period (Plate 78); and this masterly technique was reproduced with equal brilliance and accuracy in their aquatints – a fine set by William Daniell was published in the eight volumes of a Voyage round Great Britain, issued between 1814 and 1825.

But perhaps the most influential of the men who spread a knowledge of Girtin's methods was John Varley, who became one of the most prolific artists of his generation, and had many pupils. He was born in 1778, three years after Girtin, and entered Monro's academy in 1799, just after Girtin left it. He was a member of Girtin's sketching club. He already had a considerable amount of training and experience behind him; he had had some professional tuition at a drawing school, he had been taken on sketching tours, and he had exhibited at the Royal Academy. Like Girtin, he was patronized by Edward Lascelles. He achieved with great success the fullness and depth of colour that Girtin had pioneered, and at his best, particularly in the very early years of the nineteenth century, could produce atmospheric landscapes of an intensity similar to Girtin's, choosing the same kind of subject-matter (usually the north Welsh mountains) and a comparable range of colours (Plate 79). But Varley was not capable of sustaining such strong feeling; by temperament he was a remarkably cheerful, placid man, much loved and admired by his pupils and friends, not only for his personality and his art but for his reputation as an astrologer. He once said: 'I thank God for my troubles; if it were not for my troubles I should burst for joy.' In spite of his technical skill and the assurance and charm of his designs, they tend to be repetitive, and rely heavily on classical formulations for their starting-points. These schematic compositions make us realize how much Girtin had freed himself, in his search for a new approach to romantic landscape, from conventional layouts; but they can be most attractive when treated freely, and Varley produced innumerable small studies, rather in the style of Claude, in which he exploits the alluring effect of trees seen in contre-jour against

delicate sunsets (Plate 80). These informal pieces were very popular among his imitators, and were turned out competently by a number of hands, probably including the more talented members of his own family, such as his son, Albert, and brother, William Fleetwood Varley. John Varley was also a capable architectural draughtsman, and made many excellent, if slightly dry, drawings of picturesque buildings. He combined these with formal landscape in a way that became quite typical of him and his pupils, a sort of signature for the Varley school, recurring in the work not only of his own family but of men like William Havell (Plate 92), George Barret the younger (son of an Irish Royal Academician) and the young Anthony Vandyke Copley Fielding. There is always water in the foreground, a tree at one side, and a building or mountain beyond; the colour is laid on with a suavity which detracts from its Girtinesque richness and gives very often a slick, too facile impression. Sometimes, however, Varley worked more loosely and with his eye more directly on nature, and, especially in the years about 1820, made many very charming drawings along the Thames near London, using delicate pinks, blues and greys (Plate 81); but away from his classical prop, the Claude principle, Varley can find little that is really striking or new in his subjects and in spite of his finely controlled colour we feel we are back again in the world of Paul Sandby.

Varley's schematic solutions to the problem of picture design, and his simplified version of Girtin's subtle watercolour technique, were popularized in his instructive publications, A Treatise on the Principles of Landscape Design, A Practical Treatise on the Art of Drawing in Perspective, and Precepts of Landscape Drawing, all of which appeared (the first in several parts) between 1815 and 1821. These were characteristic of the large number of books which began to be produced in the aftermath of Girtin's revolutionary impact on watercolour, and which resulted in the wide dissemination of the rudiments of watercolour technique among enthusiastic amateurs and minor professionals. Another prominent theorist was Francis Nicholson, born at Pickering, Yorkshire in 1753 and, like the Daniells, a well-established practitioner of the older school. His manual, The Practice of Drawing and Painting Landscapes from Nature, in Water Colours, published in 1820, gave an account of a method of stopping-out highlights which earned him some fame, but which was hardly as advanced as the techniques that Girtin and Turner evolved for themselves in the 1790s; and although Nicholson produced an impressive output of well-designed picturesque landscape views, he never rose to great heights of individual expression (Plate 88). Artists who could make real use of Girtin's profound innovations were rare. A fine draughtsman, mainly an animal painter, who could turn his hand to a first-rate imitation of Girtin, was James Ward, R.A. He, like Nicholson, was of a slightly older generation, having been born in 1769, and trained in the rustic genre school of Morland and Wheatley. But he took in with characteristic ease and dexterity the ideas that developed during his long life. His drawings are essentially those of a painter, usually pen or chalk studies with an ulterior object; but when he worked in watercolour, he used it with masterly understanding of its potential (Plate 77). He had a natural ability to create pastiche – Rubens was his favourite model – and some watercolours can hardly be told apart from Girtin's.

Of Girtin's true and creative followers the most important is certainly Peter De Wint, who took the technique to its logical extreme of virtuosity. His work illustrates admirably the full possibilities of the new manner. He was the son of a Dutchman, a doctor who had settled in Staffordshire. He was born in 1784 and gathered some of his earliest knowledge of drawing and painting from the portrait draughtsman and mezzotinter John Raphael Smith (for whom Girtin is also said to have worked). He was a resident pupil and assistant with Smith from 1802 for four years, and set up on his own in Broad Street, Golden Square, where he came into close contact with Varley, and become known to Dr Monro. Monro had by this time, of course, acquired many examples of Girtin's work, and De Wint had every opportunity to study them. He showed oil-paintings at the Royal Academy in 1807, and began to exhibit his watercolour drawings the next year elsewhere in London. In 1809 he became a student at the Royal Academy Schools, and was, we are told, 'receiving many commissions'. His life was one of solid but modest success, and he remained a teacher until his old age, making the regular sketching tours which were customary, usually in the north of England and Wales, but on one occasion in Normandy – this was in 1828, by which time northern France was a fashionable resort for artists interested in picturesque Gothic architecture. But De Wint was most at home in England, and particularly among lush pastureland, ripening crops and thick-leaved copses. His watercolour expresses the richness of English pastoral life, the solidity of country things. His favourite, broad view of a harvesting or haymaking scene allows him maximum scope for a bright, cloud-patterned sky, and a receding perspective of hills (*Plate 86*). These subjects were tackled by Girtin, but we do not think of them as characteristic of him; De Wint lends them a warmth and brilliance of colour which seem to spring from a gentler, happier view of nature. It may be that his Dutch descent prompted him to a preference for unaffected pastoral scenery: he places frequent emphasis on the country folk who inhabit his views, and made sensitive drawings in black chalk of their attitudes and clothes, their labour and their leisure. These have a sturdiness combined with an exquisite accuracy, which again reminds us of the Dutch realists. We can see from these studies that he made of specific objects – an old house, a still-life (*Plate 85*), a figure – that his grasp of formal drawing technique was complete. He could build up his extraordinarily broad washes of colour on a groundwork of impeccable form. His understanding of the structure of trees and buildings is responsible for his strongly organized, convincing compositions, which he makes lovely by delicate overlayings of colour which owe much to Girtin: they are predominantly sombre, vibrant and full like Girtin's, but they have a lushness, a warmth that is very different, and they are opalescent with pinks and yellows which would never occur in Girtin's more sublime inventions. On a large scale, in his oil-paintings, or in the large watercolours that he frequently made, De Wint achieves grandeur; but the grandeur is always tempered with homeliness. He records so much beautiful and fascinating detail, and relates all the parts to the whole with so well-controlled a distribution of light, that he is successful both in his big exhibition pieces and in his more intimate drawings; few of his contemporaries mastered both.

As his life progressed, his opulent style became slightly attenuated: he adopted a drier brush, thereby depriving himself of the main instrument of his magical success: his loose wet flowing colour; his favourite warm browns and dark greens change to a sandy, dry beige and a rather mannered dark red; the texture of his later drawings is sometimes striated with the lines of his brush, introducing an effect of broken light that complements the denseness of his typical style. These are tokens of the flowering of technical innovation which was to affect watercolour in the nineteenth century, and take it far beyond the unaffected topography, the inspired expression of direct feeling which had been its characteristics until now. The apprenticeship of the English watercolourists had come to an end and the age of their professional maturity had begun.

John Sell Cotman

An interesting by-product of Dr Monro's domestic academy was an institution known as the Sketching Society. In 1799 some of Monro's early pupils, inspired perhaps by his method, formed themselves into a group who met weekly in each other's houses, drawing and criticizing subjects chosen by the host of the evening, who was designated the president. The members and constitution of the society changed as time went by, but the general principle survived until the middle of the nineteenth century, and came to attract some of the most distinguished names of the period. The leading spirit of the group, who at first called themselves 'The Brothers', was Thomas Girtin; and their official subject-matter was 'Historic Landscape', a characteristic notion of the time, and symptomatic of the attitudes of watercolourists to their art. It was a sort of compromise between the fashionable historical painting, with all the connotations of literature and heroics that Reynolds had insisted upon, and the natural bent of these artists for simple landscape. So they would sit down to illustrate a text like 'The flood leaps: the mill dam dashes in the restless wheel' from Cowper's poem *The Task*. They worked as a rule only with a monochrome wash – grey or brown, perhaps over a slight underdrawing in pencil or chalk. Being landscapes created expressly out of the imagination, these hurriedly made drawings are often deficient in solidity and structure; they lack conviction and tend to look alike: no one has yet successfully identified all the examples that survive. Girtin's undoubtedly achieve a greater weight than most; but before he left the society to go to Paris in 1801, never to rejoin it, he left in his place a young man who was able to bring comparable power to purely imaginary romantic landscapes: John Sell Cotman, aged nineteen. Immediately after Girtin's departure the society seems to have stopped functioning, but in May 1802 it was active again, with Cotman so prominent in it that having been known as 'Girtin's club' the group was now called 'Cotman's Drawing Society'. Cotman was fond of setting subjects from the supposedly ancient Celtic poet, Ossian – written, though in theory only translated, by the Scot, James

Macpherson – and this throws some light on his character both as a man and as an artist. Ossian ranked with Homer and Virgil as an inspiration for imaginative artists like Fuseli; and if Cotman was in some ways the greatest of all exponents of the monumentally classic in English landscape, an undertone of extravagance, of real romanticism, runs through his life and work.

Cotman came to the Sketching Society, as its other members did, from Dr Monro. He had been taken up by Monro in about 1799, having only the previous year come up to London from his native Norwich. Like Turner, he was the son of a barber; as with Turner and Girtin his first apprenticeship in art was the colouring in of prints. But while they were Londoners, Cotman came from a provincial town whose agricultural economy and traditional way of life divided it as by a gulf from the metropolis. Cotman was always a country bumpkin *vis-à-vis* his London colleagues, and, in spite of his technical prowess and inspired vision, could never overcome the sense of inferiority which his provincial upbringing induced in him.

He was employed, on his arrival in London, by Rudolph Ackermann at his famous Repository of the Arts in the Strand. Although he had no prior training, it is clear from his earliest identified work that he was filled with a creative power quite incompatible with the hack print-colouring set him by Ackermann. He seems to have quarrelled with his employer, and it was after this that Monro found him and, with his remarkable clarity of judgement, invited him to stay at his house at Fetcham. Another friendship, with an art dealer named Norton, led to a visit in the summer of 1800 to Norton's brother at Bristol, and from there Cotman travelled on to Wales, sketching the spots which were becoming obligatory for the watercolourist: Chepstow, Llanthony, Conway, Beddgelert, Llangollen. The sketches that Cotman made on this trip were in pencil only, since the object was to fill sketchbooks with as much material as possible; drawings could be worked up in wash or full bodycolour subsequently, and were indeed used over and over again by Cotman throughout his life.

At Conway he met yet another patron and encourager of young artists, Sir George Beaumont. Beaumont was an informed amateur artist of some talent, although his range was limited; he adhered to the 'rules of taste' based on Claude and Poussin with a rigidity which as he grew older became pure bigotry; but he was influential in forming public opinion and was a director of the British Institution, founded in 1805 as a kind of unofficial extension of the Royal Academy for the encouragement of sound modern art. Like Monro, he collected old master paintings which he made available to students. These were later to become an important nucleus of the new National Gallery collection. It seems likely that Girtin too was in north Wales at this time; he and Cotman may well have sketched together. We know they were both at Sketching Society meetings for a short time. At all events, it emerges clearly from Cotman's earliest drawings that Girtin's style exerted a considerable influence on him. As far as perception of form is concerned, there is already a bold and individual approach, a willingness to simplify in the interests of strong pattern, a tendency to see things in abstractions, the reverse of Girtin's fully rounded reality, which emphasizes space and the undefined view of vast nature. But in the application of tone Cotman uses Girtin's methods, delicate washes of grey or brown ink reinforced by being worked up in spots, into a strong system of tonal contrasts which at the same time creates the atmosphere and scale of the design (*Plates 100 and 101*).

If Cotman's perception of form was unique, he did make the acquaintance of one man at this early period whose own vision shared something of his linear clarity, and who may have confirmed him in his development: this was John Varley's younger brother, Cornelius, with whom he toured in Wales and elsewhere, possibly in 1802. Cornelius was born in 1781 and was another protégé of Monro's. At its best his work is characterized by clear, singing outlines of great individuality and character. They are indeed so self-sufficient that Cornelius apparently had difficulty in bringing himself to finish the colouring-in of his designs, often leaving his drawings half-completed with a few telling washes of carefully chosen colours, or even only of grey monochrome (*Plate 82*). Nevertheless, he nearly always put his signature on them, and occasionally brought one to a state suitable for exhibition. His fully wrought works are rather heavy and fussy; the purity of his original thought is obscured by too much attention to changes of texture and detail. Although he lived until 1873 he exhibited only about sixty drawings, and he is today most highly regarded for his studies of mountains, revealing an extraordinary perception of geological structure, and his rapid but often ravishing sketches of clouds, in which his usual rather scientific accuracy gives way to a rare and masterly handling of subtle washes on damped paper. Here his colour is frequently as rich as his brother John's and his evocation of space among the most accomplished from any romantic draughtsman. Cornelius detracted to some extent from his own reputation by publicizing the machine that he invented to help him make his drawings: a sort of camera obscura which he called the Patent Graphic Telescope. This involved the tracing of outlines from an image projected on to the paper; the camera lucida and camera obscura had already been regularly used by topographers, and Cornelius's invention had some success. Later on, Cotman himself did not scorn to use it, though at the outset of his career he was at leisure to choose his own subjects and had no need of mechanical aids.

One of the most impressive features of Cotman's early monochrome drawings is their precision. Both in his carefully composed outlines and in the application of wash, he shows a calm assurance and control over his materials which marks a new phase in the history of British art – the emergence of the virtuoso draughtsman. Ironically enough, the country bumpkin from Norwich was far more sophisticated aesthetically than most of his London colleagues; even today his drawings seem breathtakingly original. Unlike Girtin, who was happy to draw what others had drawn, but who saw the world more intensely and invested it with his own powerful meanings, Cotman actually chose to draw things that others had ignored. This is not to say that his subjects are always novel, but his presentation of them is usually so original that we seem to be seeing them for the first time.

His talents raised him, within a few months of his arrival in London, to a position among the most eminent of the younger

artists. He exhibited six subjects at the Royal Academy in 1800, all either watercolours or wash drawings. Among them were some lowering and dramatic evocations of the Welsh mountain mists; and in 1801, when he visited Bristol for the second time, he made an almost Girtinian drawing of the city wreathed in industrial smoke at daybreak (now in the British Museum). But curiously enough, this kind of subject, in which climate is more important than physical objects, was not to preoccupy Cotman much. Nearly all the major romantic landscape artists concentrated on climate as the main vehicle of expression. Cotman, with his instinct for line and pattern, chose subjects that yielded other, more linear matter. He never ignored weather and light, and indeed used them tellingly in his compositions; but he was often content to draw a solid piece of architecture and allow it – translated into his own eloquent language – to speak for itself. To this extent he learnt from the topographers of the older school.

In 1802 he worked in Bond Street, in the studio of a topographical artist, Paul Sandby Munn, who was nine years older than Cotman and the godson of Paul Sandby himself. Munn toured north Wales with him in 1802, and in the following year accompanied him to Yorkshire. His own work was done largely for sale to amateurs as copying models, and at his best, especially when influenced by Girtin or Cotman, is elegant and sometimes even succeeds in being grand (*Plate 99*); more often it is simply pretty, with a mixture of traditional picturesque details and some of the more expansive elements of Girtinian mountain scenery. In July 1803 Cotman set out with Munn for his customary summer tour, and by chance met in Yorkshire some patrons who were to provide him with a summer home and touring headquarters for the two following years as well. These were the Cholmeley family, of Brandsby near Ripon, who employed him as drawing master to the ladies of the house and introduced him to their local friends and to the beauties of Yorkshire. Francis Cholmeley, a young man of Cotman's own age, became his good friend and kept up an interest in his activities for many years. Cotman seems also to have stayed, as Girtin did, with Edward Lascelles at Harewood. Yorkshire affected Cotman as powerfully as it did Girtin. He had already marked himself out from his contemporaries and the watercolours of 1801 and 1802 are wholly original, so it is not true to say, as some have done, that Yorkshire was responsible for forming his style; but the north of England certainly sparked off a response which was to prove highly creative.

On the whole the drawings that survive from this period – 1803 to 1805 – are finished watercolours which were apparently completed on the spot. This was a slightly unusual procedure for Cotman, who generally sketched in pencil out-of-doors and made his finished drawings later. It is an indication of the importance these works had for him that they represent such direct contact with nature: line, colour, everything was seized immediately and forged into a design in the heat of the moment. This picturesque metaphor is merely an attempt to express how Cotman evolved his strangely beautiful, wholly real yet half dreamlike world from the Yorkshire countryside. We are impressed with the apparent inconsequence of what he chose to draw: a boulder in the River Greta, a bank of weeds, a few trunks of trees, or a bit of fence. He himself took such details seriously because they were aspects of the English scene. 'My chief study', he wrote of this Yorkshire tour, 'has been colouring from Nature . . . close copies of that fic[k]le Dame, consequently valuable on that account.' This recognition of the true value of nature enabled Cotman to create of simple things monumental and beautiful objects, ennobled by his own sincerity and enthusiasm. It is a quality that marks him as a member of the Norwich school of painters, with whom in general he had, at this date, little in common.

The Norwich school, an unusually unified group of artists and drawing masters in Norfolk, had been in existence for several years, and just now, in 1803, had consolidated itself into the Norwich Society of Artists. This was an exhibiting body comprising a number of gifted men. Their leader was John Crome, the son of an innkeeper and a much older man than the others, having been born in 1768. His approach to landscape therefore partook to a great extent of an older convention; but, in keeping with his stature as an artist, of the best and most serious in that convention. Crome had learnt much from the example of Gainsborough, and even more from the Dutch masters, Hobbema and Wynants, from whom Gainsborough himself had learnt. He combined a rough realism appropriate to Norfolk with a sense of the picturesque, and these two elements balanced each other, making for a strong and sensitive, original and unaffected view of the rustic world in which he lived. Few of Crome's drawings can be surely identified, but those we do know illustrate well his countryman's love of the details of nature and his delicacy of touch in rendering small natural objects (*Plate 97*). His distinguished output of etchings, more robust than the drawings but equally sensitive, gives a very good idea of his instinctive yet carefully disciplined response to natural life. The searching out of interesting detail in the countryside is characteristic of Crome and pervades the work of the Norwich school as a whole. The delight which Crome discovers, for example, in a rough tree-trunk by water is very close to Cotman's own reaction to similar schemes, and the delicacy of many of Cotman's Greta subjects belongs very much to Crome's world of breathtaken enchantment in the face of unadorned nature.

When Cotman fills a sheet of paper with a drawing of a few leaves or of a stone he shows his Norwich spirit; but he draws with such an economical clarity, and colours with such fresh, clean sweeps of green, ochre or blue that these little details attain great scale and dignity. Of all the many studies that he made of the woods at Rokeby and of the Greta, each has this finished, achieved individuality. Sometimes, as in the famous view of *Greta Bridge*, of which he made more than one version, he tackles a conventionally organized scene, but here too he simplifies and balances line and colour so that the drawing comes to embody a noble tranquillity impossible to define in any single part of it. This is perhaps less remarkable than his performance in the face of a more insignificant object such as *The drop-gate, Duncombe Park* (*Plate 98*), in which the whole area of vision included in the design cannot be more than a few feet in each direction. It has the majesty of scale and weight of design that Cotman could bring to his studies of, say, the Welsh mountains or Durham Cathedral, and at the same time

represents with honesty and accuracy a simple, humble subject. The grandeur is not inappropriate, as one might have imagined: it is the real grandeur of any object, which Cotman sees and brings out. To make clear what I mean, let me compare the *Drop-gate* with a design for a monument by Claes Oldenburg which consists of a hot dog sixty feet high, to be erected in a public park. Here too a simple, homely object is subjected to an enormous increase in stature; but in the case of the hot dog the honour done it is somehow out of proportion: it jars with the truth. That is one of the points of the monument, but it reduces the conception to mere satire, whereas Cotman avoids any such idea. He retains a suitable scale – uses an ordinary sheet of paper – and within those limits makes his subject as monumental as possible, eliminating all superfluous detail. 'Leave out, but add nothing', he was later to advise his son. Cotman was a master of relevant omission.

Another Yorkshire drawing, also in the British Museum, shows a sarcophagus in the park at Duncombe; it shares the monumental quality of the *Drop-gate*, and with more evident reason, for the subject is a monument. Here the classical relief carved on the stone seems to have triggered off a new train of thought and the whole drawing is organized in a more rigorous, classical way than usual. Instead of the air of delicate, tangible reality which bathes the Greta woods drawings, there is a theatrical atmosphere. This is a manifestation of the romantic side of Cotman that responded so readily to Ossian, but which expresses itself all the same in rather brittle, hard patterns less subtle and flexible than those inspired by unpretentious nature. The strain of romantic classicism crops up throughout Cotman's career and indeed can never be far away from the work of so disciplined and controlled a designer. Cotman drew a number of entirely imaginary scenes, often in an austere sepia wash, which show his interest in deliberately classical, formal composition. They are usually groups of trees and buildings invented and organized to form a satisfying structure according to the example of Poussin and Gaspard. In his later works these fantasies are increasingly common. It is as though, as he became more and more committed to particular enterprises involving the representation of specific places, he sought an outlet for his instinctive love of abstract design in these independent, formal creations. Sometimes, in addition to the Italianate buildings and carefully balanced trees, we find fully developed historical subjects after the manner of Wilson, more rigid in their design and at the same time more dreamlike in their abandonment to fantasy than anything of the Yorkshire period.

Cotman exhibited fairly regularly in London at the Royal Academy, and had become well known among the more discerning for his novel and beautiful work. But there was a limited market for drawings such as his, and he felt himself a failure, especially in comparison with a meteoric genius like Turner, who was in these years at his first peak of success. Cotman was already suffering from the bouts of depression which were to make such a tragic mark on his career, and the combination of circumstances led, in 1806, to the almost unbelievable eventuality of a young artist of exceptional powers, respected by his colleagues, retiring at the start of his career to the provincial city from which he had come. But the foundation of the Norwich Society was an indication that art flourished there, and a hint that if in London he might have to struggle, in a smaller place he would be an acknowledged leader. He would teach as Crome had done, exhibit at the annual exhibitions, and his prowess would ensure a good income. He failed to take into account that his art, which had already puzzled the London public, would be virtually incomprehensible to a provincial audience. Besides, Norwich's wool trade had been hit by the wars with France and the area was not as affluent as it had been a short time before. Drawing masters were not in such great demand. Cotman began to experiment with other activities to further his career. His ventures into oil-painting and portraiture, which began about this time, are, however, more symptoms of his unsettled, restless mind than of any specific physical requirement.

In 1810, the year following his marriage to a local girl, Ann Miles, he set up a lending library of 'SIX HUNDRED DRAWINGS, consisting of Landscapes, Compositions on Design, and Figures, Coloured Sketches from Nature, Sketches in Claro Obscuro, and his original Pencil Sketches from the Saxon, Norman and Gothic Architecture, chiefly from the counties of Yorkshire, Lincolnshire, Essex and Norfolk'. He numbered all the drawings in this library chronologically, and they were hired out to amateurs who traced from them; the system was in fact very like the one at which Cotman had assisted in the days when he worked with Munn. Cotman went on providing this service for his pupils all his life; his spare time – and that of his first son, Miles Edmund, when he became old enough – was taken up in making copies, versions and variants of all the subjects he had ever sketched, for use and reuse by students, whose handling must have destroyed many. Cotman's distinctive vision, which gave everything he saw a clear, vigorous outline, made his drawings eminently suitable for such use; but, as the surviving drawings show, his sense of design was reinforced, informed and vitalized by understanding and sympathy for what he drew, and could not be reproduced by rote.

His ability to pick out and express the significance of detail in whatever he saw made him a particularly acute draughtsman of architecture. He could grasp over-all structure and yet give substance to incidentals. Around 1810, he made a number of watercolours of Norwich Cathedral, taking individual details and recording them with the same love and sureness of draughtsmanship that he had brought to the natural phenomena of Yorkshire. The simplicity of his abstractions in these works may recall the flat patterns of Francis Towne; both explored aspects of seeing that were not to be fully appreciated until this century. But they are separated by the very significant change of technique which had overtaken the tinted drawings of Towne – which he was still making and exhibiting, poor, hack stuff compared with his inspired work of the 1780s. It is true that Cotman's work is characterized by a broad, suave wash of colour remarkable for its *lack* of articulation: after the disintegration of Cozens and the reintegration of Girtin, watercolour is once more applied in flat, unbroken masses. But as we saw with De Wint, the new awareness of its expressive potential made it impossible for artists to handle watercolour with their former innocence. Cotman relies not on picturesque outline but on structural

analysis, expressed not only in masterly drawing but in the relation of colours of a most subtle order.

Cotman found one patron in Norfolk who was prepared to give him steady and regular support: a Yarmouth banker named Dawson Turner, whose wife and daughters all needed drawing lessons. Turner was the recipient of a large number of letters from Cotman which record the vicissitudes of his career and Turner's constant moral support. In 1812 he encouraged Cotman to remove from Norwich to Yarmouth and work closely in association with him there. He was an amateur architectural historian with a great interest in the Gothic architecture of Norfolk and Cotman made drawings of the ecclesiastical buildings in the county for his projected publication on the subject, *The Antiquities of Norfolk*, which appeared in two volumes in 1818, after some eight years work. Cotman etched sixty plates for it, feeling his way with the new medium, but eventually coming to terms with it and producing some designs of great beauty. It is interesting that he should have used as a model the sumptuous architectural etchings of Piranesi (1720–78); Turner had lent him some of these lavish plates and Cotman took their lessons to heart. 'Feeling myself so little against the first-rate Piranesi', he wrote to Turner as he began work on the book, 'I expect everyone may do so too. I try to follow him, but feel myself further and further behind.' This is the diffidence that dogged him and undermined his achievement all along. In fact his plates are entirely original in conception, rather austere in composition, and do not exploit Piranesi's wide range of tone from rich black to delicate feathery greys and white. They could almost have been executed as engravings with a burin, so economical is the effect. But, as in the drawings, each building or detail of a building is invested with a character, almost a personality of its own. In both his prints and his oil-paintings Cotman preserved the crisp firm style of design which appears in his water-colours, and he is one of the few artists whose manner is recognizable and basically the same in whatever medium they use.

Cotman made plates for another of Turner's antiquarian publications, a treatise on *Sepulchral Brasses of Norfolk and Suffolk*. This took a stage further the subordination of his creative faculty to the mere reproduction of facts for historical or scientific purposes. The next step in the kindly-meant but unfortunate path which Dawson Turner prepared for him led to his employing a mechanical aid – Cornelius Varley's Graphic Telescope or some similar camera lucida, which a superlative draughtsman like Cotman should not have needed if he had been employed in a less repetitive and soulless activity. The project was a lavish work on the *Antiquities of Normandy*, a pioneer survey of a field which became immensely popular at about this time. Cotman made dozens of drawings of the Romanesque and Gothic details of Rouen, Caen, Coutances, Mont-Saint-Michel and so on, which were published as etched plates in four large volumes in 1822, perhaps the earliest and finest of a host of works on the subject. In 1817 Cotman made the first of three journeys abroad. It was attended with some difficulty and discomfort. His French was bad, and the English were disliked in France immediately after Waterloo; especially in that part of the country. The first tour of Normandy was illuminating but far from complete. Pressed

on by Turner, Cotman returned there in the following year, when he had not only to make his survey but also to teach the Turner ladies to sketch Gothic. A final visit, in 1820, was happier: he was free to go where he liked, and by now felt more at home in the place. In particular he discovered the rugged beauty of Domfront and Mortain, which he called the 'Wales of France'. It was a relief to be able to draw landscape after so much drudgery with buildings, of which he complained, 'the curious churches here are not beautiful, and the beautiful ones are not considered curious.' Nevertheless, his etchings for the *Antiquities of Normandy* reach great heights of beauty, and show Cotman coping with subjects far larger and grander than most of his English churches. They are based on workmanlike drawings made on the spot and worked up with pen and ink and a reticent grey wash. But the panoramic landscape studies that he made 'off duty', for a scheme he had in mind for a 'picturesque tour' of the region, never published, are among his finest works. They take to new extremes of refinement the lucid systems of outline patterns that characterize his approach, and are at the same time brilliantly evocative views of towns or castles set in extensive landscapes, a mass of detail comprehended in a pure, pithy line and perfectly regulated and balanced areas of brown wash.

His visits to France opened Cotman's eyes to new forms, people, colours, types of architecture and countryside, which were to recur in his drawings for the rest of his life. When he returned to Yarmouth he embarked on a period of enthusiastic production fired by a fresh sense of purpose. His colour range had been widening through the preceding decade, and now his work began to incorporate brilliant blues, yellows and greens employed as vehicles of expression in their own right, increasing the significance of his always spare and thoughtful designs. He turned now to the sea for inspiration, as every artist in Yarmouth must. It was as though he were experiencing a complete reaction against the discipline of working entirely in monochrome on static subjects. His brilliant skies, warm pink or orange sails, swirling waves or lush seaside meadows may signal a desire to attract attention, though that alone cannot explain a development so much in tune with the integrity of Cotman's style (*Plate 95*). Cotman was very conscious that his abilities were not fully recognized and he would have been willing to make certain gestures in the direction of popular taste, but this could never have dictated his procedure as an artist. He relied still on his teaching for an income; his regular appearances at the Norwich exhibitions and his undisputed leadership of the school availed little. After the publication of the *Antiquities of Normandy* he was quickly brought to the realization that his work on it had not materially changed his position. In 1823 he was back in Norwich, struggling to run his school with the assistance of his eldest son, Miles Edmund, who was becoming an astute and deceptive copyist and imitator of his father's work. That he was anxious to get away from the humdrum provincial backwater is indicated by his application in 1824 for the post of drawing master at the Naval College at Chatham; this was turned down, adding to his gathering disillusionment. Every summer he was attacked by violent fits of depression, verging on madness, and could work at nothing. But when he was well, his art advanced, he put out new shoots, and

developed astonishingly. He experimented with various new media, and in particular returned to oil-painting. He even succeeded in obtaining a few commissions.

He started to mix his pure watercolour technique with pen and ink, or with coloured chalks; he drew some highly finished and dramatic scenes in pencil only; and he began to mix a sort of flour paste or glue with his colour so that the paint took on a heavy viscous texture and was capable of being worked on the paper into a highly expressive impasto – an idiosyncratic and tricky medium which he used to great effect in many of his late drawings. He increased the size and brilliance of his exhibition pieces, largely because he felt that 'City & Town scenery, and splendid architecture, mixed up with elegant scenery, make up the compositions of the day'. His work around 1830 suggests that, like his rivals in London, he was absorbing the new style of Bonington; and in his humble, self-denigrating view, his work seemed 'faded' beside the younger artists, J. F. Lewis's Spanish views especially appearing to put him in the shade. But armed with his drawings of Normandy he could meet the picturesque artists on their ground (*Plate 96*), and his work compares favourably with that of a typical popular exponent of the genre like Samuel Prout. But his sensitive, subtle and highly original mind could not, at bottom, reconcile itself to the superficial pyrotechnics of fashionable painters, even though he possessed the technical ability to rival them. When he succumbed to the temptation to imitate them, this incompatibility revealed itself in awkwardness and loss of conviction.

But he produced a great deal of work which in no way betrays this uneasiness. In search of new subjects, he borrowed sketches by his friends, mostly amateurs who made records of their foreign tours, and made many superbly imaginative drawings of places, like the Via Mala in Switzerland, that he had never visited. He voyaged by boat with Miles Edmund to the Thames estuary and along the north coast of Kent, accumulating scenes of wherries and barges and the bright, wide expanses of water in the rivers and coastal roads.

For the last eight years of his life Cotman was drawing master to about two hundred boys at King's College, London. The post was not very rewarding, but it was for him the fulfilment of a great ambition, and he was much respected there. It brought him permanently back to London, which he felt was vital for his well-being: 'I *must* come in contact with the first men in the country for talent, intellect and integrity', he said. 'In all this I live, I breathe and feel a man. This is what I have ever loved and tried to realise.' The fineness and greatness of Cotman's spirit reveals itself in words like these. It sought its true level with complete certainty, and was driven to distraction by the long failure to find it. To the end of his life, despite increasing frustrations and financial difficulties, and the growing evidence of madness in his two younger sons, he went on producing fine work, and indeed some of his loveliest drawings date from the final spate of creativity that immediately preceded his death in 1842. Much as he needed London, he was tied eternally to Norfolk, which for better or worse had claimed the greater part of his career, and during the cold, stormy autumn of 1841 he visited it for the last time. He worked there entirely in black chalk, noting the fitful light on old familiar scenes. Twelve of these drawings were later lithographed and published by Miles Edmund. They combine Cotman's well-known boldness and firmness of line and design with prophetic hints of the mannerisms of *art nouveau*, and with a strange, nervous delicacy which imparts shades of new meaning to the straightforward chalk technique and renders it passionate and mournful at once: the valediction of an artist whose life had never fulfilled his just demands of it.

John Constable

John Constable was a miller's son, born and bred in a very rural corner of England, the border country between Suffolk and Essex. He lived there from his birth in 1776, a year after that of Turner and Girtin, until his first move to London, in 1799, to attend the Royal Academy Schools. He even spent a year in his father's mill, training to follow the same career. And his paintings reflect this country environment with a love and accuracy which show vividly that he belonged to it. He wrote to his sweetheart, Maria Bicknell, in 1812: 'You know I have succeeded most with my native scenes. They have always charmed me & I hope they always will – I wish not to forget early impressions.' Yet at the same time, Constable is one of those rare artists whose intellect is sophisticated beyond the level normally found coupled with creative genius. He is remarkable not merely for the fine quality of his landscapes, but for his articulating, in letters and lectures, exactly what it was that he felt made for fine quality.

Most artists' biographies begin with stories of how they drew amazing things on the walls of their parents' house, or in their school exercise books. There is a clear assumption that the first manifestation of artistic genius will be in an instinctive manipulation of a drawing or painting tool. With Constable, a most unusual process occurred. He once wrote of the scenes of his childhood: 'I had often thought of pictures of them before I had ever touched a pencil.' In other words, the abstract possibility of communicating his response to the countryside through a visual medium existed in Constable's mind before he had become aware of the methods by which this might be done. He was gifted with a rare intellect which could conceive the general significance of the subject of a picture as clearly as the particular detail of it. This intellect, in addition, was not that pompous kind which, in order to give art significance, imposes grand, intellectual ideas upon it. Constable ridiculed the fashionable art cults of his day and the 'High-minded members [of the Academy] who stickle for the "elevated and noble" walks of art; i.e. preferring the shaggy posteriors of a Satyr to the moral feeling of a landscape'.

'The moral feeling of a landscape.' What, we may ask, is that? And we can suppose that his contemporaries did too. But since English art is largely concerned with landscape, and we have at last reached an artist who has formulated a central issue of landscape painting, it is worth while to study Constable in the light of this attitude.

Constable's great friend in later life, Charles Robert Leslie, also an artist, wrote in his *Memoirs of the Life of John Constable*:

'I have heard him say the solitude of mountains oppressed his spirits. His nature was peculiarly social and could not feel satisfied with scenery, however grand in itself, that did not abound in human associations. He required villages, churches, farm-houses and cottages; and I believe it was as much from natural temperament as from early impressions that his first love, in landscape, was also his latest love.'

This is an important idea. The presence of human life, or its presence implied by signs of the cultivation, ordering, and bending of nature to serve human ends, is an aspect of the 'moral feeling' which landscape can convey. Morality is essentially a human affair. A landscape which does not reflect human activity will be moral to that negative extent; but a painting of such a subject will be moral only as it demonstrates the artist's own (and obviously human) response. The grandeur of Girtin's perception of moorland and mist translated those natural features into important emotional events; and we might describe John Robert Cozens's melancholy brooding over endless plains and grey-blue hills as 'moral', though with its fey, self-absorbed introspection Cozens's morality does not seem to be so sturdy and admirable as that of more outward-turned artists. More is involved in this point than the mere humanization of landscape; Constable, in attacking history painting, singled out its irrelevance, its dependence on theory and out-dated ideas: the 'shaggy posteriors of a Satyr' cannot have much to do with life as we know it. Landscape can. It is an intimate part of our experience, and Constable celebrates in his work the intimacy with nature which he knew to be shared by everyone.

He was nevertheless very willing to learn from those of the old masters who had themselves achieved this intimacy – whose rich experience of nature could teach him something important. While he was still in Suffolk, he impressed Sir George Beaumont with his work. Beaumont's mother lived near the Constables at Dedham, and Constable was invited to make copies from works in his collection. Beaumont, as I have already mentioned, was no supporter of the new movements in landscape, clinging to his beloved Claude, a small work by whom he carried with him wherever he went. This painting of *Hagar and the Angel* had a profound effect on Constable, and influenced his vision of the Stour Valley even late in his career. Beaumont befriended and patronized Constable when he execrated and denounced Turner; and yet, ironically, Constable was as revolutionary as Turner, and in some ways, perhaps, more so. When Beaumont averred as a general truth that in painted landscapes trees should always be brown – the rich colour of a Cremona fiddle – Constable took an old violin on to the lawn at Coleorton (Beaumont's home) and laid it on the grass. Nevertheless, Beaumont thought highly of his abilities, and when he went to London in 1799 Constable seems quickly to have impressed men there too. There are accounts of Joseph Farington and Benjamin West, both experienced judges of young artists, expressing high opinions of his work. Farington in particular became a valuable friend. Another friend whom Constable met at this early stage was John Thomas Smith (1768–1833), an etcher of old buildings

and other picturesque items, mainly famous now for his gossipy account of *Nollekens and his Times*. Constable seems to have made drawings of old cottages which Smith used for one of his antiquarian publications. Smith, though not a great artist, had an instinctive sense of the purpose of landscape art which must have chimed exactly with Constable's. He put his finger on one aspect of the 'morality' problem: 'Do not', he said, 'set about inventing figures for a landscape taken from nature; for you cannot remain an hour in any spot, however solitary, without the appearance of some living thing that will in all probability accord better with the scene and time of day than will any invention of your own.' This points to the idea that any given landscape has its own integrity, which must be perceived, felt, understood by the artist who wishes to record it with any significant end in view. It was no longer possible, as it had been in the eighteenth century, to place well-designed little groups of picturesque figures in the foreground of a view, simply for the sake of decoration. The figures are themselves part of the landscape, expressing a principal aspect of it. This is evident in all Constable's major works.

At the Academy Schools, the human figure was of paramount importance, and we find, interestingly enough, that instead of resenting this Constable took a particular pleasure in anatomy. He wrote in 1802, 'Excepting astronomy, and that I know little of, I believe no study is really so sublime, or goes more to carry the mind to the Divine Architect. Indeed the whole machine which it has pleased God to form for the accommodation of the real man, the mind, during its probation in this vale of tears, is as wonderful as the contemplation of it is affecting.' Leslie speaks of 'many extremely accurate and beautiful coloured drawings, of a large size' made from dissections by Constable at this time, which corroborates the idea that he took the matter seriously. He began, in fact, at about this date, 1802, to make portraits. He would have become aware in London of the secondary place in the hierarchy of the arts which contemporary opinion accorded to landscape, and his parents were anxious that, if he was to be a painter at all, he should at least pursue a profitable line. Portraiture was, if not a field as highly regarded as history, certainly the most remunerative. Farington's diary for 1 June 1804 records that Constable was then making likenesses 'large as the life for which he has *with a hand* 3 guineas, without 2 guineas. This low price affords the farmers etc. to indulge their wishes and to have their children and relatives painted.' Constable continued to produce portraits at odd times throughout his life, usually of his family and particular friends; but the phase of intensive portrait production lasted only until about 1810. He made many attractive studies in pen, pencil or watercolour of groups of his friends, evidently with a view to training himself for this kind of a career; and he even executed altarpieces – among them a *Christ blessing little children* and *The Saviour blessing the Bread and Wine* – but these were not conspicuously successful.

He must have regarded it as all grist to the mill when in 1807 he was asked by a nobleman living in Suffolk, the Earl of Dysart, to make copies of his family portraits. There can have been no great attraction for him in such a task, neither landscape nor even original portraiture being involved. But he must have come into close contact with the technique and

materials of Sir Joshua Reynolds, who had been responsible for many of his models. This cannot have been wasted on Constable, who knew well the value of copying, and often mentions his activities in copying from Gaspard Poussin, Claude, Ruysdael and other great masters. He had done so from an early age, as we know from surviving specimens of drawings after Claude prints; and of course Sir George Beaumont had encouraged him in this, introducing him not only to Claude and the old masters, but to the watercolours of Girtin. These, naturally enough, being the work of a contemporary, had a great effect on Constable, whose first appearance as a watercolourist is in the guise of a follower of Girtin.

In 1806 he spent about two months touring the Lake District, making a large number of drawings. They are in pencil, frequently enlivened with a muted, rather powerful wash of watercolour. They treat of broad, dark, steep slopes across which sunlight, clouds and rain make changing patterns, and Constable captures the dour mood and wet atmosphere of Westmorland with remarkable accuracy (*Plate 108*). He had made a sketching tour to Derbyshire in 1801, using Sir George Beaumont's pencil and grey wash technique; the Lake District series are considerably more mature, and owe a lot to the intelligent study of Girtin's work. From Girtin Constable must have discovered the value of breadth, both of vision and of handling, and the large scale of this scenery gave him an ideal opportunity to experiment and perfect that approach. He had already in the 1790s tried to approach Suffolk scenery broadly, as is illustrated by the panoramic view covering four wide sheets of paper now in the Victoria and Albert Museum and the Whitworth Art Gallery, Manchester; but this drawing suffers from a niggling, tight style of treatment based on the techniques of eighteenth-century topographers. The colour, too, is thin and wan. The Lake District drawings are limited in their colour range, as might be expected from outdoor work, done in conditions hardly suited to the carrying about of elaborate materials; but they are nevertheless rich in tonal variety and in the climatic effects they present. They are among the earliest evidence of Constable's special ability to observe rapidly-changing weather conditions, and of his speed in capturing them on paper. They are often carefully annotated with relevant meteorological information: 'clouds breaking through after a rain-storm', and so on. But, as Leslie said, such wildernesses were not Constable's preferred ground, and unlike Girtin and so many others he did not make annual pilgrimages to the highlands of the north or of Wales. He could make equally lovely studies in Suffolk, delicate, reticent statements of intimate details of natural beauty that impressed him. On the whole, his watercolours give an impression of slightness; they were hardly ever made, as Girtin's were, to be regarded as finished paintings, to be framed and hung. They were notes made as part of the never-ceasing process of intense response to nature. Their exact form therefore depended on what materials Constable had available, and they are often pencil studies taken home and worked up in colour from memory, or from tiny sketches crammed into a small pocketbook. Their spontaneity is important, because they are the records of particular moments, fully understood by the artist and transcribed in what might almost be described as a trance of concentrated creative effort. The story of the fieldmouse, which crept into Constable's pocket while he sat quite immobile drawing, illustrates this vividly.

The technique of Constable's watercolours shows how effective his willingness to respond directly could be. It varies enormously from drawing to drawing. Constable had no preconceived idea of what a drawing should look like; and because his sketches were not for public display, it was not necessary for him to cater for anyone else's preconceptions. The only factor which dictates the form of a drawing is the scene he is recording. His method of putting down what he sees on the paper is remarkably free of mannerisms. Beside his work, the dots and dashes of Girtin, the finely balanced linear patterns of Cotman, seem artificial. He plunges in, naïvely, it seems, with his pencil, and uses whatever method is most appropriate to achieve the likeness of his subject. He once said: 'My pictures will never be popular for they have no *handling*. But I do not see *handling* in nature.' Sometimes a drawing, recording a general disposition of trees, buildings and water, is a rough note with colour added in a few quick strokes of blue, pink and green; but even in such a case, Constable uses the rapidity of his execution to express the freshness of open daylight, the subdued movement of water and foliage, the pervading sense that what he is looking at will change and look different in a few moments. The pencil, when he works with it alone, may be made to record so much that at times it has to function instead of watercolour. The completeness and precision of many of his pencil drawings are unlike the practice of most professional artists; so much information, so much delight in natural beauty is rarely conveyed by means of the unaided pencil. But his drawings in pen are jotted with a nervous, flickering, disjointed line that embodies the shimmer of leaves and movement of clouds in a much more allusive way.

Constable became more and more conscious of the importance of the sky in his work; though he had early learned from the Dutch masters – men like Philips Koninck, for instance – that the flat landscape which he preferred depended for its quality and mood very largely upon the sky. He observed that certain skies suit certain scenes and made notes of many which he felt he could reuse in new contexts. In 1819, three years after he had finally achieved his long-delayed marriage to Maria Bicknell, he moved to a house in Hampstead, and on the windy heights of the heath where there were fewer trees than in the Stour Valley to enclose the view, he developed his love of horizontal compositions in which clouds play a major part. He was inspired too by the view from his new home, a panorama of London which he called 'a view unsurpassed in Europe, from Westminster Abbey to Gravesend'. It was dominated by the dome of St Paul's Cathedral, which provided a constant focal point for the sketches he loved to make of weather over London.

From here, he made many studies of the sky for its own sake, both in oil and in watercolour. Their purpose was twofold: to improve his ability to observe and render cloud forms and effects of light, and to form a kind of library of climatic circumstances. They vary from bland, calm blue skies with hardly and cloud to violent and highly romantic storm effects, with shafts of sunlight, rainbows (*Plate 111*), and squally

showers. As his career progressed, Constable made considerable use of the rainbow, exploiting more and more emotive contrasts of storm and sunshine. As for Turner, the rainbow was for him a symbol of the rich variety of the English climate, or indeed of all temperate climates. He singled out as a *locus classicus* the rainbow in the work of Rubens, a landscape painter he enormously admired and evidently learned much from. Yet, 'By the rainbow of Rubens', he said, 'I do not allude to a particular picture, for Rubens often introduced it; I mean, indeed, more than the rainbow itself, I mean dewy light and freshness, the departing shower with the exhilaration of the returning sun, effects which Rubens, more than any other painter, has perfected on canvas.'

The attraction which Constable found in Hampstead must have consisted partly in its proximity to London; it was a rural landscape intimately associated with the lives of thousands of town dwellers. Just as, in his large pictures of scenes on the Stour, he introduced incidents showing the life of the local people – a barge-horse leaping a gate on the towpath; boys fishing in the millpond; a barge lying on the stocks in the process of being built – so, on the heath, he found men quarrying in the gravel-pit there, people strolling and relaxing in the sun, and incorporated them into his account of the scene (*Plate 105*). Again, when he found it necessary for the sake of his wife's steadily declining health to spend his summers in Brighton, he linked his studies of sea and sky with the life of the shore, and usually his Brighton drawings include boats, groups of fishermen or other figures, with fully detailed studies of fishing tackle on the beach. He was inspired to paint a large picture of the scene, with the Chain Pier, which was hung at the Royal Academy in 1827. But even so he gave vent to comments which remind us that an awareness of the human context, even of its moral importance, may not necessarily entail acceptance or love of it; there was, indeed, an element of the supercilious, the intolerant, in Constable which many people noticed and criticized. It is, perhaps, a mark of his exceptional sensitivity. 'I dislike the place', he wrote in 1824, '. . . Brighton is the receptacle of the off-scouring of London. The magnificence of the sea, and its . . . "everlasting voice", is drowned in the din and tumult of stage coaches, gigs, flys, etc., and the beach is only Piccadilly or worse by the seaside.'

London itself, whose crowds Constable must have found as irritating at times as those of Brighton, persisted in its attraction for him, and although he preferred the fresher air of Hampstead for his family home, he retained his studio in Charlotte Street all his life. A picture of the *Opening of Waterloo Bridge*, projected in 1816, was finally exhibited in 1832, and can therefore be said to have provided a constant undercurrent of concern with urban life throughout the central years of his career.

Until about this date, 1832, Constable's watercolours were executed only occasionally; usually, as I have said, as elaborated pencil sketches – part of the general process of absorbing information and exploring ideas. But in the 1830s he began to produce far more, with a greater interest in them as achievements in their own right. In 1834 he even exhibited at the Royal Academy a finished watercolour, *Old Sarum* (*Plate 112*), which was derived from earlier pencil sketches just as an oil-painting might have been, and which was not envisaged as

a halfway stage towards an oil-painting (on the occasions when he made such a preliminary study for a picture, he generally worked in pencil or ink and wash without colour). It is almost as if his previous concentration in oil was a preparation for this long final phase of watercolour, for although he never stopped making oil-paintings they became more and more mannered in the last decade of his life, repeating the trick of scumbled white paint to obtain an effect of dewy brilliance which had reached its apogee of success in the *Leaping horse* of 1825, and usually having clumsily manipulated paint put on in somewhat muddy sweeps with a palette-knife. It is in the smaller oil sketches and in the watercolours that we find the most satisfying late Constable, and after a lifetime of slowly maturing technical and aesthetic wisdom he was able to make works in watercolour of a stature that places him with the greatest of those artists whose chosen medium it had always been. In 1828 his wife died of tuberculosis, and in the following year he was elected a Royal Academician – an honour that had long been resolutely denied him by his colleagues. In these years before his death in 1837 he was, therefore, a sad and resigned man, aware that general recognition would not come in his lifetime, in spite of the acclaim which some discerning men accorded his work. His colours became darker, more sombre and melancholy, and his skies stormier. But in watercolour he worked on uninhibitedly making studies with his old freedom and clarity, unimpeded by the necessity for any of the more obviously moral connotations of landscape.

He retained his simple, fact-finding approach. Even in consciously elaborate drawings like *Old Sarum* and *Stonehenge*, which were built up from early sketches made on a visit to his friends the Fishers at Salisbury, he never lost the immediacy which distinguishes his work from that of most other landscape artists. A comparison of two stages in the development of *Stonehenge* illustrates this: one is a small sketch; it has been ruled with a grid of squares for use in the process of transferring the outlines to a larger sheet (*Plate 103*); the second is considerably larger. But in spite of this mechanical process of transfer, and indeed the great distance in time between the recording of the subject in pencil and the making of the final watercolour, the large version still has light, movement, and space. There are new responses to all the details of the scene – the placing of the subject on the sheet is modified; light, shade, the movement of clouds, have all been thought out afresh. Even when a mere replica was called for, Constable, unlike many of his great contemporaries, would explore new effects of climate and so create a new picture. The set of mezzotints which were made by the young engraver David Lucas after Constable's compositions and published by the artist in 1830 and 1833 as *Various subjects of Landscape, Characteristic of English Scenery* provides several examples of this process. Poor Lucas was driven to despair by repeated demands for alterations to the plates in accordance with Constable's changing notions of how the subjects might be interpreted.

Constable's preface to the series *English Landscape* gives a concise summary of the principal features of his attitude to nature in his own work. 'The immediate aim in this publication is to promote the study, and increase the love, of

the delightful Home Scenery of England, with all its endearments, all its amenities and even in its most simple localities; England with her climate of more than vernal freshness, and in whose summer skies, and rich autumnal clouds, the observer of Nature may daily watch her endless varieties of effect.' Constable goes on to declare it his intention 'to mark the influence of light and shadow upon Landscape, not only in its general impression, and as a means of rendering a proper emphasis on the parts, but also to show its use and power as a medium of expression, so as to note the day, the hour, the sunshine, and the shade'.

In other words, landscape as a form of art derives its expressive potential from the weather, the climate, in which the artist represents it; Constable made a habit of recording the time of day and weather conditions in words on his drawings, a fact which testifies to this preoccupation. At the same time, it was not enough to suggest a fleeting effect; that effect had to be invested with a breadth and permanence appropriate to its condition as art. The preface goes on: 'In some of the subjects an attempt has been made to arrest the more abrupt and transient appearances of the CHIAROSCURO OF NATURE; to shew its effect in the most striking manner, to give "to one brief moment caught from fleeting time" a lasting and sober existence.' This seems to describe very well the aim of Constable's landscape and if we can allow that he achieved his stated object, we have perhaps explained something of his greatness.

His old friend, Archdeacon John Fisher, objected to the mezzotints on the ground that Constable's 'charm is colour' Some of the late drawings are coloured with a richness almost equalling that of oil paint; the subjects, showing cottages and groups of trees organized in a decidedly picturesque way, are often reminiscent of late canvases, sometimes even executed in conjunction with oil-paintings like miniature replicas of them. Occasionally, as in the *Stonehenge*, the watercolour is dense while retaining its freshness, in no way imitating oil but giving a strong, fully wrought effect close to that of the Girtinian watercolourists. But more often, Constable's watercolour remains the spontaneous sketching that it had always been; only in his last few years did he tackle his subjects with a broader sense of the self-sufficiency of his medium, and could take watercolour to great expressive heights while keeping within his customary limits of plain blues and greens, sometimes articulated with short flicks of a pen dipped in brown ink. In these drawings we really feel the importance of the fleeting moment, its beautiful effect transformed into a permanent memorial to dappled sunlight or wind-driven clouds (*Plate 106*).

Whether we choose to talk in terms of moral feeling or not, Constable's landscapes do embody an intensity of response which takes them far beyond the unaffected realism which at first sight they seem to be. Blake, whose mind moved in very different directions, exclaimed to Constable on seeing one of his tree studies, 'Why, this is not drawing, this is inspiration!' Constable, in reply, asserted clearly what he understood as the business of the artist: 'I never knew it before; I meant it for drawing.' Drawing was for him the expression of his love of nature, and consequently conveys it with the vividness we expect from great art – 'the sense of felt life', as Henry James

defined it. Fuseli told a fellow Academician, Sir Augustus Callcott, that Constable 'makes me call for my great-coat and umbrella'. Constable would have taken that as a compliment.

'How fond you are of painting *wind*, Mr. Cox! There is always a breeze in *your* pictures! I declare I shall take cold, and must put on my shawl!' This, equally, was a complimentary remark. It records precisely the direct impact of David Cox's studies of climate, in which he operates along lines very similar to those of Constable. It can hardly be said that Constable had a school of followers in England, although his approach was imitated by numerous minor painters and draughtsmen; here and there among the more prominent men we can trace the influence of his fresh, fluent approach, which, for all his sporadic use of the medium, sums up its quintessence. In the later work of Samuel Palmer, for example, Constable's spirit sometimes appears; and, surely, in the evolution of Cox's mature manner.

Cox's early work was very much influenced by John Varley, and although Varley gave him only a few lessons, he imitated the suave style and sonorous colour of the typical Varley landscape extremely closely. This was in about 1804, the year of his arrival in London from Birmingham, where he had worked as an assistant scene-painter at the theatre. It may be that painting scenery gave Cox a feeling for large-scale work and freedom of handling which was responsible for his remarkable stylistic development. But at first he seems to have done everything he could to make neat, precise watercolours in the best Varley manner, which was at the same time being copied by Samuel Prout, a young artist of exactly Cox's age: they were both born in 1783. In some of the drawings that Cox made as a result of a tour in north Wales in 1805, the combined influence of Varley and Prout is strong. He returned to north Wales in the following year, and instead of working only in outline made a few drawings in colour, having taken with him three or four colours ready ground, in bottles. These two tours preluded the intimate association with north Wales that he was later to establish. As a young artist, married in 1808, Cox lived in a cottage at Dulwich and taught drawing to amateurs. He showed his work at the usual London exhibition places, and gradually acquired a solid reputation, already producing watercolours of considerable variety and individuality, and bringing great breadth to his interpretation of the formulae of his teachers (*Plate 109*).

In the period between 1815 and 1827 he lived in Hereford, teaching drawing at a girls' school. His landscapes are characterized at this time by an openness, a frank simplicity allied to the Dutch qualities of De Wint; there is usually bright clear colour combined with the masterly evocation of air and light, and well-observed figures engaged in country activities (*Plate 110*). The sound basis of draughtsmanship on which Cox relied is demonstrated in his *Young Artist's Companion or Drawing Book*, of 1825, which contains numerous soft-ground etchings by Cox himself, based on pencil drawings of academic neatness, yet informed by a sensitivity to texture and a grasp of structure which gives them great charm. Their charcterful accuracy explains the exceptionally high quality of the draughtsmanship which throughout his life Cox employed as a supporting structure for his increasingly free watercolour technique. It is especially clear in the brilliant architectural studies that recur in his work.

Shortly before he returned to London, Cox took his son David, a promising pupil, on a trip to Calais and Brussels, and gathered together a mass of useful material for his expanding output of pictures (*Plate 116*). Although most of these conformed to a standard, fairly small format, he also made many more ambitious watercolours for exhibition, which, however, like Constable's, rarely lose spontaneity and the exhilarating effect of a sketch; and he began to work in oil, which he took up seriously in about 1839, as a natural extension of his experiments with ever-broadening technique. The experience of the open sea which his continental journey offered him seems to have blown a breath of fresh wind into his work. We see it not only in the seascapes but in his inlandscapes as well. His windmills, having stood still and statuesque on the heaths, begin to turn their sails to the stiff breeze. Even a calm summer's day is a thing of fluttering movements – the shimmer of leaves, the whirl of birds through the air. Cox could produce these effects well on a smooth white Whatman paper, but he often deliberately introduced an additional sparkle and vitality by using coarser, slightly coloured paper which provoked his brush to brisker, friskier movements and received the colour brokenly from it. This resulted in a more effective suggestion of air and movement than the comparable dry-brush work in De Wint's later drawings. It is Cox's personal equivalent of Constable's scumbled white paint; unlike Constable he very rarely had recourse to scratching-out.

After about 1830 Yorkshire became, like Wales, an important inspiration; and in 1841 Cox moved closer to the north country when he retired from London to Birmingham, where he remained until his death in 1859. His career continued to hold its placid course, manifesting change only in the significant modifications that his style underwent in these last two decades. Perhaps the most important single event was his discovery in 1844 of Bettws-y-Coed, a village to which he returned thereafter almost every year for the rest of his life. The colour of Welsh landscape, dominated by slatey skies and slate rock, pervades much of his later work, in which the evocation of the elements becomes increasingly vivid (*Plate 121*). It is linked with the evolution of Cox's method of applying his materials; first, a rough, free drawing, perhaps in black chalk, made on paper which is even coarser than before, taking colour very unevenly and giving an aerated texture. If the dark spots in the paper were too obtrusive in areas designated for the sky, Cox would add wings to turn them into birds, and this apparently arbitrary device frequently has a marvellous effect of filling the upper spaces of his drawings with movement. Apart from this, Cox's ability to suggest his paint has been blown on to the sheet by a gust of wind is nearly always impressive.

The final phase of Cox's development is one of astonishing freedom; a style we have difficulty in refraining from calling Impressionist. It was indeed much admired by progressive French artists of the succeeding generation. But, unlike them, Cox was not denounced for his advanced ways. He was highly thought of, especially by the Birmingham businessmen who bought his work for considerable sums, and commissioned oil-paintings from him. One, a Mr Charles Birch, asked him to paint two to hang on either side of Constable's *Lock on the Stour*, which he then owned. The connection of the two artists in this context is illuminating; it shows that, to some eyes at least, they were both working towards the same ends. Cox certainly looked to Constable for guidance in handling his favourite themes; he advised his son, for instance, that 'white . . . must be cautiously used, only in such sparkling touches as Constable did'.

Richard Parkes Bonington

One of Constable's greatest successes in his own lifetime was at the Paris Salon of 1824 when he showed his pictures *The Hay Wain* and *View on the Stour*. These were admired by artists and critics alike, and in 1825 the king, Charles X, presented him with a gold medal. Some of his work had already been seen in Paris; a dealer named Regnier acquired several pictures which he showed to young painters in Paris. Among these was an Englishman, already a settled member of the French artistic community: Richard Parkes Bonington.

One could not imagine a greater contrast between two artists than that between Bonington and Constable. Constable was a slow, self-critical developer, constantly pausing to enquire what other men had thought and said, and moulding for himself a means of expressing his intense responses to nature out of his elementary, unformed reactions. He never lost a certain naïvety, almost clumsiness of technique. Bonington gives the impression of having sprung fully armed into the world. He was consumptive and lived only to the age of twenty-five, a life-span romantically brief and romantically productive. Although he was an important figure in European romanticism, his work does not show the typical romantic oscillation between ecstasy and despair. Romantic artists prided themselves on the wide range and intensity of their feelings; yet Bonington displays very little passion. The emotion conveyed by his work is predominantly that of the assured master revelling in his medium. Sheer facility seems to be the guiding force of his art. Constable himself summed this up in terms of his own very different outlook: 'You do me an injustice', he wrote to a friend in 1830, 'in supposing I despise poor Bonnington [*sic*] . . . but there is a moral feeling in Art as well as everything else – it is not right in a young man to assume great dash – great compleation – without study – or pains – "labor with genius" is the price the Gods have set upon excellence –.' Thrown by accident not into the English world of painting but into the French, which suited his artistic personality far better, Bonington was precocious enough to absorb the continental approach, and at the same time to shed the influence of his own manner on his French contemporaries.

By a curious irony, his first master was a Frenchman who had spent many years in England and become a follower of Girtin and John Varley. His name was François Louis Thomas

Francia; Bonington probably met him in 1818, and the ensuing friendship was the start of Bonington's mature career. In that year he was sixteen. He had been born in 1802, in a small town near Nottingham, and must have learnt at least the elements of drawing from his father, who was a busy and apparently competent artist, fulfilling any local commissions for portraits, views, decorations, or celebration prints which might come his way. He seems to have been a Micawberish character, pursuing a career of different optimistic enthusiasms one after another. After going to sea he succeeded his father as county gaoler, then took to painting and teaching drawing, which, after his marriage to Eleanor Parkes in 1801, he was able to do at his wife's genteel seminary for young ladies. He kept a print shop and will certainly have given his son Richard some tuition, since the boy showed such a precocious ability in this direction. But he was unable to maintain this way of life; his wife's school closed down and there was evidently a general decline in the popular demand for education in the polite accomplishments. Mr Bonington eventually set up in partnership as a lace-maker, and smuggled the machines, in parts, to Calais. The firm of Clarke, Bonington and Webster was established there in 1817, and it was in Calais that Francia found the young Richard Bonington, already sufficiently able as a draughtsman to attract his attention and prompt him to offer his services as a teacher. Before long their roles seem to have been reversed, as Francia's later watercolours take on much of the character of Bonington's.

In the following spring the triple partnership was dissolved and Mr and Mrs Bonington moved to Paris as lace retailers. They took a shop in the Rue des Tournelles, and Richard was now able to sketch all over the capital, making pencil drawings of its architecture, especially the Gothic. The place which attracted him most, however, was the Louvre, where he could copy figures and details of costume and furniture from the works of the masters; and where he acquired a thorough knowledge of period style. He was already establishing the pattern of his output, which divides itself into two main sections: first, landscapes taken from the French countryside and from the towns he visited on his sketching tours; second, small scenes, often interiors, containing figures in exotic or historic costumes, sometimes illustrating history or historical novels. For these, the contents of the Louvre provided the raw material. While he was working in the Louvre he first encountered Eugène Delacroix, who recalled many years later: 'I was myself very young and was making studies in the Gallery of the Louvre: . . . I could see a tall adolescent who was also making watercolour studies, mostly after Flemish landscapes. He already had a surprising facility in the medium which at that time was an English novelty.' Delacroix with his liking for all things English and his instinctive admiration for natural talent was quickly alive to Bonington's value, and although they did not at once become friends they eventually came to share a studio and to work together on a number of subjects.

The vigorous sketches which Bonington made in Paris and on his early tours are evidence of his warm and intelligent response to antiquities and objects of beauty; they have a conviction which brilliantly communicates his joy in acquir-

ing knowledge and technical mastery. The drawings which he did contemporaneously at the Ecole des Beaux-Arts display less enthusiastic involvement. He went there from 1820 to 1822, to take part in classes given by Baron Gros. Gros was a celebrated and successful painter who had carried the classical tradition of David into the region of huge propaganda pictures idealizing Napoleon. Bonington as a foreigner was not allowed to attend the life drawing classes, and spent his time making careful but dry studies of casts from classical sculpture. Gros seems to have recognized his unsuitability for this basic training, for there is a story of his finding out about Bonington's watercolours, on display at a dealer's, and asking him: 'Why do you come here? You have nothing to learn and are wasting your time.'

Gros was not the only man to be impressed. Bonington attracted the friendship of a circle of young artists, in particular Alexandre Colin (1798–1873) and Paul Huet (1803–69) – who, we are told, imitated both Constable and Bonington with alarming accuracy. With such friends as these he drew in the surrounding countryside, and in 1821 travelled, probably with Colin, to the Channel coast, visiting Le Havre, Rouen, Boulogne, Calais and Dunkirk, making pencil sketches of buildings, shipping and landscape.

He was equally able to inspire confidence in the dealers, who willingly took the watercolours and oil-paintings which he made from these sketches; two in particular sold a great deal of his work: Claude Schroth and a Mlle Hulin. Schroth also handled a number of pictures by Constable. Bonington's drawings at this period are so assured that it is not difficult to understand the enthusiasm of the dealers. The pencil is manipulated with complete authority, and, in comparison with Constable, without delicacy. The typical Bonington line is one of great verve, clear and unconfused in placing and varying from a soft grey tone to a heavy, shiny black, an emphasis applied for shadows and other strong features. It bears all the marks of certainty, and does not seem to be pausing over the more subtle issues of mood, climate and atmosphere which Constable was at pains to capture even in his pencil drawings. Equally, this style of draughtsmanship belongs to a different convention from that of Girtin and the early Turner – the line of the eighteenth-century topographers transformed by a knowledge of Canaletto – which Monro had encouraged.

At about the moment when Bonington was becoming known in France, another English artist was establishing a reputation for drawings of the architecture of Normandy, Brittany and the Low Countries which follow the older tradition and therefore provide an instructive comparison. Samuel Prout, although much older than Bonington – he was thirty-six when he first left England in 1819 – became a friend of the young artist and was eventually appointed his executor. He and Bonington painted together in Normandy in 1822. As a child Prout was rather frail and suffered from migraine which was to affect him all his life; in his early efforts at topography around his native Plymouth he followed the precepts of the antiquary, John Britton, for whose series *The Beauties of England and Wales* he made illustrations. During the early years of the new century he came under the influence of Cozens, Turner and Girtin. His work, which at this time centred on scenes of

seashore life, belongs to the general circle of Varley; as we have seen, he was associated with the young David Cox. He published a manual, the *Rudiments of Landscape in Progressive Studies*, in 1813 and subsequently produced many more. But it was his discovery of the Continent in 1819 which directed him to his principal and abiding theme. His first drawings in Normandy were therefore made at about the time when Cotman was working there on Dawson Turner's antiquarian tomes; but no connection between the two men is recorded. Certainly, Prout did not approach his architectural subjects from the archaeological point of view. The abundant flow of arabesque detail, the curls, dots and dashes executed fluidly with a reed pen, are concentrated on the expression of the linear complexity, the picturesqueness, of mouldering Gothic architecture. His drawing is always sturdy and expressive, and the pencil records that he made on the spot bear some resemblance to Bonington's earlier work; but his characteristic style is a combination of bright colour, only rarely strengthened with bodycolour, with elaborate, flowing pen outlines which reach a decorative pitch far beyond the mere statement of form (*Plate 122*). In a drier, less human way, this is the line of Rowlandson; it is certainly close to that of Girtin.

Bonington made drawings of individual buildings as Prout did, but his rapidly-moving eye and facile hand grasp and note the broader qualities of form, light and shade in preference to the intricacy of texture and ornament. The convention is quite different from Prout's; a new convention, which Bonington himself may be said to have been in the process of forming; but at the same time it does owe something to the drawing style currently practised by his French associates. Nevertheless, if he made pencil drawings which show affinities with France, his early work in watercolour seems much more reliant on what he had learned from the anglicized Francia; and it may be that Bonington imported an Englishness of his own which Francia was perhaps the first to modify: too few dated drawings by the two artists exist for us to make categorical assertions as to what happened to them both at this moment. Bonington's watercolours of about 1821, such as the view of *Rouen from the quais* (of which he made a lithograph), have the soft, slightly granular texture that we associate with Francia in his Girtinesque phase, together with an unemphatic colour scheme of subdued greys and browns (*Plate 129*). In a view of the church at Dives (now in the Walker Art Gallery, Liverpool), which cannot date from much later, we see the typical Bonington colour asserting itself, with fresh, crisp handling and halcyon atmosphere. But the layout is not far removed from that of the old topographers – Thomas Malton, for example; even the predominant blue suggests his work, or that of the young Turner. These are merely indications that Bonington's knowledge of watercolour was informed by a fairly wide experience of existing achievements in the medium, which, endowed as he was with a visual intelligence far beyond his fifteen years, he probably acquired before he left England.

He exhibited views from his Normandy journey of 1821 both at the Paris Salon of the following year and in the showrooms of dealers. His tour of 1822, which he spent partly in the company of Prout, included a prolonged excursion to Belgium, Flanders, Picardy and Normandy, which yielded a mass of new architectural material highly appropriate to his interest at this stage in Flamboyant Gothic ornament. In 1824 he made a long stay on the Normandy coast, producing drawings in pencil, chalks or watercolour of local views and figures. He made many impressions of the broad flat sweeps of the north French countryside, or the open expanses of the coast. Most of these have a directness, a simple candour that, for all their differences, brings Bonington close to the spirit of Constable and Cox; it is indeed unusual for him to dwell on sad or sombre, or otherwise emotionally loaded moods, though there are a few paintings and watercolours which have a rare poignancy, making use of a favourite device: boats or trees seen dark in the foreground against a luminous, melting distance of pale sky and floating mist (*Plate 125*). Even when he leans towards such romantic effects of light, he invests the details of his watercolours with a sinewy vigour, expressed in terms of a wiry line of brown pigment akin to the drawing of his pencil work, giving the whole design a balanced, positive mood very expressive of a young man's exultation in his strength.

By 1825, Bonington's characteristic landscapes had crystallized. Oils and watercolours alike have compositions with low horizons, large grey clouds, and isolated upright stresses – trees or boats or figures – to give the simple view a focal point (*Plate 126*). In his instinctive grasp of the essence of these scenes as vehicles for art Bonington is much nearer to the English than to the French artists of the time. Delacroix's reference to Bonington's copies of Flemish landscapes in the Louvre suggests that Bonington's mind was working along lines similar to those of Englishmen, and indicates an important source of inspiration for his informality and diffused light: the unpretentious views of Teniers and Ruysdael and other artists of the Low Countries. Creamy white, often applied with a heavy and luscious impasto, is the dominant colour of the oil-paintings, and in the watercolours an exhilarating contrast between clusters of foliage, painted with a slightly dry brush filled with brownish-green colour, against a pale bright sky.

The extent of Bonington's ascendancy by 1825 can be gauged by the concern which French critics began to show at his influence over other painters. It was complained that Colin and those men who had come most closely into contact with Bonington were suffering from the evil effects of his fresh, breezy style. This circumstance makes it difficult to argue that his breadth and assurance of technique were qualities he had learnt altogether from the French themselves. Nevertheless, in spite of these attacks, his work continued to be bought and sold by the dealers and was circulated even more widely in the form of lithographs, many of which he executed himself, and some of which, especially later in his career, were made by French lithographers after his designs. The publications he illustrated were of the picturesque-cum-archaeological kind which Cotman and Prout were beginning to popularize in England. They included a series entitled *Restes et Fragmens d'Architecture du Moyen Age*, and some plates for Baron Taylor's *Voyages Pittoresques et Romantiques dans l'Ancienne France*, which both appeared in 1824. Some sixty lithographs are known to be his.

The following year, 1825, marks a watershed in Bonington's brief career. It was the year of his first visit to England since the family's removal to Calais, and from this moment onwards he seems to have made every effort to

establish his reputation in English art circles. The following year he exhibited at the British Institution, where he at once made an impression, although his absence hitherto from England had been so complete that one newspaper critic wrote: 'Who is R P Bonington? We never saw *his name* in any catalogue before, and yet here are pictures which would grace the foremost *name* in landscape art. Sunshine, perspective, vigour, a fine sense of beauty in disposing of colours, whether in masses or in mere bits – these are extraordinary ornaments to the rooms.' In the next year, 1827, he showed at the Royal Academy, and in the last summer of his life had work hung in both exhibitions.

Another important development from his English visit of 1825 was the growth of his friendship with Delacroix, whom he met in London and may have travelled with in this country. At all events, they returned to Paris together and for some time afterwards Bonington shared Delacroix's studio. Delacroix found that 'there was a terrific lot to be gained from the company of such a splendid chap'. He told Bonington: 'You are the king of your own domain and Raphael himself couldn't have done what you do. Don't worry about the merits of other people, or about the size of their pictures – since yours are masterpieces anyway.'

Delacroix's interest in history and romance, the novels of Scott and the plays of Shakespeare, which profoundly affected many young artists, writers and composers in France at the time (Berlioz even went so far as to declare that Shakespeare was the only true 'living and loving God'), led him to produce brightly-coloured little studies in oil or watercolour, of scenes containing figures in historical costume, and this type of small, colourful picture very much appealed to Bonington himself. As Delacroix's comment, just quoted, suggests, Bonington had made the small format his speciality. In 1824 he had started producing small subject-pictures developed from ideas gleaned from history and literature, and Delacroix's own penchant for such things must have strengthened this predilection. They visited the Meyrick collection of armour together in London – Delacroix called it 'the most beautiful collection of armour, perhaps, which has ever existed' – and worked together on a series of studies of Greek Souliote costume, which reflect the fascination of the oriental world for the young romantics.

Whereas Delacroix, like David, Gros, and Géricault before him, seems to have been most at his ease when working on a fairly large scale, Bonington never abandoned the miniature quality on which so much of his effect depends. He handled oil-paint and watercolour alike with great verve and breadth, but was never tempted to cover large areas. He painted only one elaborate dramatic subject of serious pretensions, *'Quentin Durward at Liège'*, and this was not really successful. Otherwise, he confined his loose touch to fields of only about two or three square feet. As a result, his historical subjects have none of the pretensions to importance which so many of his contemporaries were anxious to suggest in their work. They are unassuming genre scenes, deliberately, it seems, exploring the unheroic, the non-historical by-ways of history, pointing out without any overt satire that painting does not require momentous themes in order to communicate something visually valuable. The subjects are chosen first for the richness of texture, colour and tone to be found in an assortment of clothes and furniture from the past. In all these matters, Bonington's sense of period is impeccable; he presents his characters as real people, of their time yet understood and seen as vividly present, not as most of his contemporaries did, as nineteenth-century artists' models uncomfortably attired in slightly inaccurate clothes. These works are, in short, conceived as *visual* and not as *literary* objects, and are therefore the more effective. He allows the warm light which plays on sumptuous fabrics, the contrast between fresh faces and deep shadows, to speak for themselves, and the mood is closer to those pregnant glimpses of everyday life afforded by de Hooch, Terborch and Vermeer, than to the elaborate sentimental genre of current fashion. Sometimes with the straightforward ingredients of a single figure, dressed richly in the costume of a distant period – that of Henry VIII or Charles I, or Francois 1er, or as a Turk or an Odalisque – he achieves an atmosphere of delicate poetry almost matching that of Watteau's figure studies, which he knew and admired (*Plate 127*).

This increasing preoccupation with brilliant light and rich colour, developing out of Bonington's earlier, more pallid schemes, leads naturally enough to a visit to Italy. A journey there took place in the spring of 1826, and Bonington was accompanied by his friend the Baron Charles Rivet. He made drawings in Switzerland *en route*, and when he arrived in Venice made many studies in pencil and watercolour as well as in oil on millboard. Needless to say, he devoted a considerable amount of time to the works of the Venetian masters, Veronese, Titian and so on, in the Accademia. He also visited Verona, Florence, Pisa and Genoa before returning via Turin to Paris, having been three months away.

After these experiences, Bonington worked with the added energy which the revelation of such a new world naturally provided for an artist of his temperament. He did not materially alter his direction, however. Views of Venetian and other scenes appear, of course, among the French ones. His handling of architecture becomes more dexterous and the application of paint rather less heavy; there is a greater delicacy and a clean, crisp finish to his work which may have been the result of his acquaintance with the views of Canaletto (*Plate 124*). And his costume pieces have more luminosity and richness, derived from his close study of the sixteenth-century Venetian masters.

He was impelled forward not only by the excitement of his Italian discoveries but by the demands created by his mounting reputation. He produced more lithographs, including some after Scottish subjects by a Frenchman, Pichot; he sent work to the Salon as well as to the London exhibitions. He revisited England in 1827 and the spring of 1828, and on the second of these trips took advantage of an introduction to Sir Thomas Lawrence, whom Delacroix had already met in 1825. He was planning a visit to the south of France in 1828 when he was overtaken by the final stages of his consumption, precipitated by the increasingly hectic pace of his activity. His father took him to London for a Harley Street cure, and he continued to make drawings as hard as he could, even though his condition became quickly more and more enfeebled. Under these circumstances he produced some of his most dramatic and vigorous sketches, in pen or brush and brown ink (thought to be walnut juice). Their technique suggests that

Bonington was responding to the drawings of Rembrandt, and echoes the sepia sketches of David Wilkie (1785–1841), an eminent contemporary; but in their calligraphic freedom these last works still belong wholeheartedly to the world of Colin and Delacroix. His early death was inevitable and occurred on 23 September 1828.

The fashion for Bonington, which had developed so rapidly in his lifetime, boomed immediately after his death, and it was remarked that 'in 1834 a painting is worth £300, which, in 1828, would have been gladly given for £30'. His work was bought by many artists, as well as by connoisseurs and gentlemen. Among the artists to fall immediately under his influence in England were Clarkson Stanfield and James Holland, both painters who specialized in marine subjects and who are particularly associated with Venice. Stanfield was seen by some as a rival and successor to Turner, and his principal works were in oil, but he made many watercolours, which, rather than sharing the heightened and dramatic vision of Turner, tend to record the world rather staidly, with solid technical proficiency and a liking for simple compositions; often the subject is lit by whitish light from a cloudy sky, and altogether the mood is very much of that restrained, unemphatic kind which Bonington expressed so positively (*Plate 131*). In some of these watercolours, Stanfield imitates the technique of Bonington very closely, but this was a stage in his development, and not a steady or permanent influence on his style. Holland, on the other hand, shows Bonington's influence in every aspect of his work. His subjects, marine, Venetian or generally architectural, are those of Bonington, and his drawing is free and incisive, giving an air of the virtuoso, which recalls the Bonington flair, though we are also reminded of Cox at his freest and finest (*Plate 133*). These two men represent only a fraction of the generation of artists, French, English and even Italian and German, who practised what came to be known as 'Le Boningtonisme'.

The arch-Boningtoniste, Thomas Shotter Boys, who was a year younger than Bonington himself, went to Paris in 1825, and was said to have been persuaded by Bonington to abandon the career of engraver, on which he was already launched, for painting; he was also asserted to have shared Bonington's studio. A drawing by him of Bonington's studio does exist, but Boys's own studio-companion in Paris, William Callow, denied that Boys had ever referred to Bonington as a friend. There is no doubt, however, that Boys's watercolour manner, and his style of drawing as well, is based very closely on that of Bonington. The two men were at least sufficiently intimate to have worked together to a considerable extent. In Paris, Boys made a number of views of the city remarkable for their scale and power. Their preoccupations are generally the unpretentious ones of the relation between street architecture and the crowds jostling beneath the buildings; but they are conceived boldly and strongly coloured, achieving great breadth and decorative force. In his prints, these qualities are even more evident: the portfolio of colour printed lithographs of *Picturesque Architecture in Paris, Ghent, Antwerp, Rouen, etc.*, published in 1839, is an exceptional work of its class; its technique was entirely new in its own time, and the book was full of striking designs in which Boys displays a sense of the formal personalities of buildings that is almost as vivid as Cotman's. In his watercolours he was less consistent in achieving the dignified and restrained colouring that distinguishes these prints; but at his best, when he is closest to Bonington, he uses the typical bland cool light, and rather dry brushwork contrasting with clear liquid washes, to great effect (*Plate 114*). In 1842 he published *Original Views of London As It Is*, a famous series of London street scenes, which have the crisp architectural drawing of his earlier work, but less evidence of a unique personal vision.

Technical tricks similar to those of Boys appear in the early watercolours of William Callow, which perfectly capture the serenity that Bonington evoked with such mastery, and often involve impressive feats of compositional organization; Callow frequently chose subjects of panoramic breadth, and worked on a fairly large scale. But in the course of a long life – he died in 1908 at the age of ninety-six – he developed away from the precise meticulous style of his early years towards a freer, airier manner, rather akin to Holland's (*Plate 115*); whereas Boys did not, and with his trained engraver's hand, remained the careful craftsman of slightly rigid views. In his later years he paid the penalty of so many artists whose style does not develop: he became a hack engraver of cheap illustrations. He died in 1874.

The broader handling that characterizes the watercolours of the mature Callow and Holland represents the influence of Bonington at its most fruitful, producing a new, accomplished and flourishing style which at its best does not rely merely on imitation for its merits. It combines the coarseness and nervous energy of Cox's rustic studies of climate with a highly sophisticated development of watercolour technique along lines which exploit its potentialities in a number of fresh ways. The work of William James Müller embodies the style in its most professional and versatile form. Müller was born in Bristol in 1812 and died young in 1845; his work shares with Bonington's that quality of technical professionalism which seems to accompany a precocious development of talent terminated by early death. Quite late in his life, Cox went to Müller for tuition in oil-painting. Müller did not, however, have Bonington's consistency of style, and painted, both in oil and watercolour, works of a surprisingly varied character. He travelled widely in Europe and the Middle East, and it was in Turkey that he made what is in many ways his finest group of watercolours. In these, the range of colour is subtly controlled, from the warm oranges and browns of foregrounds to the cool bluish purples of hills and sky (*Plate 134*). In the confident application of the broken washes we can see the example of Bonington at work; but more particularly in the crisply drawn detail, trees and rocks boldly outlined with the brush. Compare this fresh easy quality with another artist who worked in the Middle East: Edward Lear. Lear's drawing is harder, more tightly defined than Müller's, and his use of clear, sharply seen outlines put in with a pen and brown ink recalls the style of Francis Towne. But colour is added with the same dry brush that Callow and Boys used for their silhouetted trees in the days of their greatest dependence on Bonington.

Lear's professional career began in the aviary of Lord Derby at Knowsley, where he drew accurate and finely-coloured studies of birds for ornithological purposes. His landscape drawings made in Italy in the 1840s are often in black chalk

alone, and bear a close resemblance to the work of another Boningtoniste, James Duffield Harding, though they are crisper and neater and betray Lear's scientific training. Later, he became fond of subjects consistently more expansive than any of Bonington's; his deployment of subtly graded washes of ochre and purple to convey the gradual recession of the valleys, plains and deserts of Greece, Turkey or Egypt, viewed from commanding heights, is most exhilarating (*Plate 113*). But much of his drawing lacks air: it is perhaps no accident that he was attracted by the dry Middle East; he has none of Bonington's fresh wind, and his most genuinely vital work remains the comic pen drawings that were published as lithographs in illustration of his Nonsense.

It was not only the outdoor scenes of Bonington which affected the development of watercolour. A large school of historical genre painters sprang into being, nurtured by the demand for escapist art in the form of engravings for the annuals, such as the *Keepsake*, that began to appear in the mid 1820s.For these lavishly produced books, endless pretty girls in period costume, and unlimited scenes of carousal, love-making or looting in panelled interiors, were produced by men such as George Cattermole (1800–68), whose crowded subjects are drawn with wiry strokes of the brush dipped in brown colour, derived directly from Bonington's technique, as is a dramatic use of red, emerald green and the flash of white bodycolour on armour or pewter tankards. Cattermole also drew landscapes, usually with an item of picturesque architecture as their focus, owing something to the sophisticated freedom and muted colour of Müller. Another exponent of the same combination of genres was Frederick Nash (1782–1856), to whose work an extensive practice as an architect's draughtsman lends a clarity and sureness of expression that is often very satisfying.

It is not my intention to list all the artists of the period who shared the new style; these examples give some idea of the scope of Bonington's influence. Because it was essentially a matter of technique, his followers are not necessarily to be remarked on for copying his subjects, though, as we have seen, many did. At any rate, Bonington gave a new currency to sheer virtuosity in the handling of watercolour, and it is an irony that in the hands of another great technician his achievement should have been turned on its head and the thriving school of English watercolourists confronted with the unexpected question: was watercolour really necessary at all?

John Frederick Lewis

There is a watercolour by John Frederick Lewis of a *Girl in an interior* (*Plate 142*) which might almost be called 'Homage to Bonington': on the floor, in a gilt frame, is a little picture that is obviously a Bonington; it is actually copied from a subject, the *Venetian balcony*, now in the Glasgow Art Gallery (*Plate 143*). This detail draws attention to the close technical association between Lewis's work and that of the school of historical genre painters who came under Bonington's influence in the 1830s.

As a piece of virtuoso draughtsmanship and handling of watercolour, however, this example of Lewis is more impressive than the majority of such productions, and we may well regard Lewis, of all the Boningtonistes, as the true heir to Bonington's particular brand of genius: the arch-professional of the next generation.

Lewis was actually born within three years of Bonington, in 1805, but lived much longer – until 1876 in fact; so that he came to full maturity after Bonington's precocious career had ended. Nevertheless, he too had his share of precocity, and his early drawings display not only accomplishment of technique but a surprising individuality of style. Lewis began as most young draughtsmen did, by copying prints, which he did not only with a pencil or chalk, but also with an etching needle on copper. His efforts as a print-maker are as impressive for their assurance as are the drawings of this student period. Etchings and drawings alike reflect an overriding interest in animal life; many of his subjects were taken from the famous menagerie at Exeter 'Change, in the Strand, the forerunner of the London Zoo (*Plate 147*). His particular associate was the equally gifted young Edwin Landseer (1802–73), whose father, like Lewis's, was an engraver, and who showed the same enthusiasm for drawing animals.

It is not surprising that Lewis's confident and purposeful talent was demonstrated at public exhibitions as early as 1820; and in 1821 a painting appeared at the Royal Academy itself. Lewis was quickly noticed by the Academicians, one of whom, James Northcote, brought his work to the attention of the new president, Sir Thomas Lawrence, who had succeeded West in 1820. Lawrence forthwith employed Lewis to sketch in landscape and other background detail for his portrait canvases, an exacting job which proved exhausting for Lewis, at least partly because of the enthusiasm and conscientious-ness with which he threw himself into it. He was meanwhile trying to keep up the production of work on his own account, sending animal portraits and subject pictures involving animals to the Academy every year. A large oil-painting of his was bought by a firm of engravers, Hurst & Robinson, who were the Boydells of their day, and whose patronage was consequently of much value, especially since engravings were relied on almost solely to spread popular knowledge of current work. These marks of professional and commercial favour culminated in 1824 when Lewis was appointed by the king, George IV, to paint sporting subjects in the Great Park at Windsor.

In the same year, some of Lewis's prints were published. These were a series of six *Studies of wild animals* executed in a combination of etching and mezzotint; their appearance marks the moment at which Lewis's career reached the first of a sequence of sudden changes of direction. He had distinguished himself publicly now both as painter and as print-maker, and we are told that he would have continued to divide his energies between oil-painting and etching if he had not been commissioned to make some illustrations to Shakespeare in watercolour, and, on experimenting, found that the medium was ideally suited to his needs as a draughtsman – a swift, simple process which responded well to masterly handling. Lewis was evidently equipped to make the most of it, and it seems unlikely that he had really not used

watercolour before this. Drawings of animals in full watercolour have been dated to the years about 1820, and may therefore prove that he worked in the medium at that time; though I do not know what evidence exists to confirm the fact, beyond the rather less than bold handling which suggests that they are not the work of his maturity. At all events, in 1827 he became an associate of a society which existed specifically for artists in watercolour, and to which he had been sending drawings since 1820. This was the Old Water-Colour Society, an institution of great importance in the history of English watercolour. It had been founded in 1804 and was the most tangible outcome of the influence of Girtin and his confrères.

Among the artists who met in November of 1804 to bring the society into being were John and Cornelius Varley, and a group of accomplished watercolourists of their calibre, who were anxious to provide for watercolour painters exhibition facilities and honours comparable to those afforded by the Royal Academy to artists in other media. Watercolours had, it is true, always been shown at Academy exhibitions, but it was claimed that they suffered from being placed in close juxtaposition to large oil-paintings. Even so, watercolours increasingly attracted the public, and this fact gave further impetus to the movement for independence. One artist, recalling the foundation of the society thirty years after the event, wrote that during Academy exhibitions at that time 'the council-room, instead of being . . . a place of retirement from the bustle of the other departments, was itself the great point of attraction. Here crowds first collected, and here they lingered longest, because it was here that the imagination was addressed through the means of an art which added the charm of novelty to excellence. It was the fascination of this room that first led to the idea of forming an exhibition entirely of pictures in water-colours.'

The original plan of the 'Society of Painters in Water-Colours' echoed the instrument of foundation of the Royal Academy in its insistence on members of 'moral character' and 'professional reputation' who were 'resident in the United Kingdom'. The first exhibition was held in 1805, by which time other distinguished young artists had joined the original group. Its reception was encouraging, and a gauge of the timeliness of this new publicity for watercolour: 12,000 visitors came during the seven weeks of the exhibition, and much work was bought. This success prompted the establishment of a rival society, the Associated Artists in Water-Colours, which came to nothing; but in 1831 a New Water-Colour Society was set up and remained until late in the nineteenth century a competitor for professional and public favour.

Almost at once, the existing tendency for watercolourists to rival painters in oil was confirmed and strengthened. Havell, Nicholson, and an artist rather akin to Nicholson in his enjoyment of dappled light effects, John Glover, as well as the later arrivals Copley Fielding and George Fennel Robson, all borrowed John Varley's classical formula to impart solidity and weight to pure landscape on a large scale. Their work is clearly recognizable as that of a school with its own identity. Even the ambitious figure subjects, pastoral or mythological, of Joshua Cristall, and the delicately executed animal compositions of Robert Hills (*Plate 90*) partake of the corporate style. One of the most idiosyncratic of the group was William Turner of Oxford, who joined as an associate in 1808 and continued to exhibit with the society until his death in 1862. Turner's work varies considerably in style and type, but his original, clear-coloured, open landscapes often strike a fresher and less academic note than the finished works of the other members (*Plate 91*).

In the context of larger and richer watercolours, treating more frequently of elaborate figure subjects, the suggestion that oil-paintings should be admitted to the exhibitions was natural. But it provoked a storm which, in 1812, brought the society to a premature end. It was reestablished, however, in the following year – a further sign of the momentum that had been created – and continued its existence on much the same terms as before, but with the altered title of the Oil and Water-Colour Society, and until 1818 a number of members, including John Varley, submitted works in oil. This practice died out completely after that date, and the old title was resumed. But as if to compensate for the loss of weight at exhibitions the presentation of pictures became increasingly elaborate. By 1823 it was noted that works were 'displayed in gorgeous frames, bearing out in effect against a mass of glittering gold, as powerfully as pictures in oil'. George Barret, one of the founder members, was voted £1,000 to paint a watercolour that would conclusively demonstrate the fallacy of the view that oil-painting was necessarily a stronger medium: he produced a classical landscape, expanded vastly and enclosed in a fine, heavy gilt frame (English private collection). It was a satisfactory performance, and many of his colleagues executed similar feats; but they were almost invariably more successful working on a more modest scale.

These developments are reflected in Lewis's career, which is, in many ways, almost a parable of the history of watercolour in the early nineteenth century. Having become an associate of the society in 1827, he made his first continental tour, through the Alps and the Tyrol to Venice. After this we find him exhibiting subjects such as the *Chamois, sketched in the Tyrol*, and *A gondolier, sketched at Venice*. When, two years later, he achieved the status of a full member of the society, he abandoned oil-painting altogether, and forsook the Academy's walls. His work did not appear there between 1830 and 1855, and when it did once more, it had undergone a complete change. Occasional figure subjects had appeared among his animal compositions in the 1820s, but now, studies of figures, and scenes involving figures, occupy all Lewis's attention. He visited Devon in 1829 and the Scottish Highlands in 1830, and the fresh, informal studies that he made on these and other trips show how strikingly personal his vision was, and how accomplished his technique in the mixture of watercolour and bodycolour, applied direct to the paper without pencil underdrawing, which was becoming his rule for work of this kind.

One result of the trip to Scotland was *Highland hospitality*, exhibited in 1832. This was a large, fully worked-up subject picture containing a number of figures and presented as a work comparable not only in size and tone, but in significance, with oil-painting. Landseer was beginning to show such subjects, in oil, at the Academy, but Lewis, having forsworn the depiction of animals, does not introduce that element as

prominently as Landseer did. The picture recalls the domestic interiors of David Wilkie, who had revived and integrated into British practice the peasant subjects of Jan Steen and David Teniers. *Highland hospitality* was the first of a long series of similarly elaborate works which grew more complex as Lewis's career progressed. In the 1830s they were inspired by his experiences in Spain, where he travelled in 1832 and 1833 (*Plates 144 and 146*). The vivid colour, the brilliant light, the animation of religious ceremonies, peasant life, the architecture with its Arab connotations, were well suited to Lewis's preferences in colour and design, and offered endless challenges to his supple, analytical draughtsmanship. He made many small copies of the paintings by Spanish masters which he found in the Prado, at Toledo and at Seville. A fine series of coloured lithographs of *Sketches & Drawings of the Alhambra* appeared in 1836, and another volume, *Lewis's Sketches of Spain and Spanish Character*, in 1837.

Suddenly, in 1839, Lewis ceased to send pictures to the exhibitions. As before, his interest was undergoing a radical change of direction. His whole energy seems to have been concentrated on the assimilation of new sensations, for which this time he travelled much further afield; his rupture with England, the Water-Colour Society and all established art being almost complete. He had published, in 1837, a group of lithographs under the title *Lewis's Illustrations of Constantinople made during a Residence in that city in the years 1835–6, arranged and drawn on stone from the original Sketches of Coke Smyth by John F. Lewis.* Coke Smyth's crisp, professional outline pencil drawings seem to have ignited in Lewis the enthusiasm for things Arabic, or Eastern, which had been prepared by his experiences in Spain. He was in Rome in 1839, and reached Greece and Constantinople in 1840. In 1841 he travelled in Asia Minor and finally came to Egypt. Cairo was his home for the next ten years, and Lewis carried his divorce from European life to the extent of dressing like an Arab and living a wholly Arab existence.

As he had done in Spain, he drew the people in their picturesque costumes and the fascinating intricacies of Egyptian architecture. Apart from endlessly sketching in pencil, chalks or watercolour, he spent his time 'like a languid lotus-eater – a dreamy, hazy, tobaccofied life. . . . The great pleasure of pleasures was life in the desert, under the tents, with still *more* nothing to do than Cairo; now smoking, now cantering on Arabs, and no crowd to jostle you; solemn contemplation of the stars at night, as the camels were picketed, and the fires and the pipes were lighted.'

This account of Lewis in Egypt was written by Thackeray, who described his visit of 1844, when he remarked that 'there is a fortune to be made for painters in Cairo, and materials for a whole Academy of them. I never saw such a variety of architecture, of life, of picturesqueness, of brilliant colour, and light and shade. There is a picture in every street, and at every bazaar stall. Some of these our celebrated water-colour painter, Mr. Lewis, has produced with admirable truth and exceeding minuteness and beauty.'

The account was published in 1846, and Lewis's pictures of the Middle East had not been seen in England at that date; Thackeray's comment provided perhaps the first clue that Lewis was still at work, and the first indication of the quality of the watercolours which were to astonish everyone in England when he started to exhibit again. The Water-Colour Society had in fact despaired of him, and in 1848, as he had not shown there for nearly a decade, 'his name was ordered to be withdrawn from the list of members'; but Lewis wrote to protest – an interesting sign of his concern for his future reputation, even while he remained in voluntary exile in Cairo – and was re-elected. About this time he was married to a young woman, Miriam Harper, in Cairo, and the event, coupled with his anxiety to maintain good relations with the society, may have precipitated his return to England in the spring of 1851. But he had prepared the way for himself by sending to the society's 1850 exhibition the first of his new works: *The Hhareem.*

Even if they had been noticed, Thackeray's hints of the 'exceeding minuteness and beauty' of Lewis's work cannot have prepared people for the wealth of exquisitely rendered detail which Lewis offers in this picture. But in spite of the breathtaking minuteness of its technique, the broad effects of light and pattern are what make the most striking impression in this picture. The subtle play of design in the trellises and panels that form the background to the figures is varied and amplified by the cross-play of sunlight from the left of the composition. Indeed, one of his friends learnt from Lewis that 'his object had been to paint intense light' in Cairo, and this is evidently the principal theme of most of his Middle-Eastern works. From a very different point of approach, he tackles the same problems which occupied Constable and Cox.

Lewis's attention to detail was nevertheless an important aspect of his achievement in the eyes of his contemporaries. One of the most perceptive and articulate of them was John Ruskin, who even recommended that to appreciate a picture by Lewis one should 'take a magnifying glass to it, and examine it touch by touch'; in a famous notice of the *Frank encampment in the desert of Mount Sinai* (*Plates 145 and 149*), which Lewis showed at the Water-Colour Society in 1856, he pointed out that 'in the eyes of the camels . . . there is as much painting beneath their drooping fringes as would, with most painters, be thought enough for the whole head'. Ruskin qualified this by saying that 'marvellous as this quantity of detail is, the quantity is not the chief wonder, but the *breadth*'. But his preferences were for the finely observed – he referred artists always to nature, and admired them if they had the ability to render forms as intricately as they were found in nature. The injunction to examine something 'with a magnifying glass' is common in his writings, and his own drawings tend to express his analytical interest in botany, geology and architecture, serving as records and observations on natural or man-made phenomena (*Plate 140*); when he allowed himself greater freedom of expression he tended to imitate the breadth of the late Turner. In the 1830s, he took lessons from the Water-Colour Society's president, Copley Fielding.

Although he rated Turner supreme among landscape painters, Ruskin was careful in his epoch-making defence of Turner, *Modern Painters*, which appeared in 1843 when he was twenty-four, to expound and justify contemporary English art generally, and to allot to men like Clarkson Stanfield or David Roberts such praise as was their due. This,

he elsewhere admitted, went against the grain, since there was plenty to attack in their somewhat limited outlook; and he also published some *Notes on Prout and Hunt*, which record his enthusiasm for two men very different from Turner and Lewis.

Prout had been an early exponent of the school of picturesque architectural view-makers which held the interest of the public throughout the first half of the century, and of which the Scotsman David Roberts was one of the most talented representatives in the 1830s and 1840s, combining Prout's approach with the fresher and more incisive manner of Bonington. Roberts, like Lewis, is associated with Spain and the Middle East, but the human figure appears only in a subordinate role in nearly all his work (*Plate 132*). He merited Ruskin's moderate praise, but did not earn such encomiums as Prout himself, whose views of French churches and other florid European antiquities had provided some of Ruskin's earliest models.

Although William Henry Hunt was in almost every way quite different from Prout, Ruskin dealt with them together in his *Notes*; and his own preoccupations explain the unexpected coupling. Just as Prout explored minutely the intricacies of Gothic detail, so Hunt painstakingly reconstructed the textures and colours of moss, twigs, blossom or fruit as he saw them (*Plates 137 and 138*). Here indeed was something to satisfy Ruskin's delight in magnifying glasses! Subjects like these earned the artist the name of 'Bird's-nest Hunt', which is a useful way of distinguishing him from several other painters of the same name. But bird's-nests were far from being Hunt's only or earliest preoccupation.

He was, in fact, trained as a watercolourist very much as many of his predecessors had been. He was born in 1790, and his father, a tinsmith of Covent Garden, made him assistant to John Varley as the boy was crippled and 'fit for nothing'. Already there were reports of his attempts to imitate objects 'minutely', but his early work is in general of the broad, bold kind we should expect from a young student of Varley (*Plate 135*). His views of the Thames from Calvert's Brewery even suggest the direct influence of Canaletto which is so often associated with Dr Monro and Girtin. Hunt did indeed become a friend and protégé of Monro's; the doctor by this time had moved from his house at Fetcham to another at Bushey in Hertfordshire, where he was a neighbour of the Earl of Essex at Cassiobury. Hunt made drawings of the park, and taught drawing to the earl's niece; he had already been commissioned to make views at Chatsworth for the Duke of Devonshire, so his professional career may be said to have begun. In 1807 he started to show work at the Royal Academy, and the next year entered the Academy Schools. Monro treated him even more generously than he had treated Girtin and Turner. Hunt 'often stayed with the Doctor for a month at a time', we are told, 'and was paid by him 7s 6d a day' for the drawings he produced. As he was lame, the doctor had him 'trundled on a sort of barrow with a hood over it, which was drawn by a man or a donkey, while he made sketches'. Monro retained the right to criticize or alter Hunt's work, apparently sponging out 'the parts which displeased him'.

The landscapes that Hunt drew in the neighbourhood of Bushey are simple, direct studies from nature characterized by a wiry, nervous outline in brown ink which enlivens the forms and gives the figures great immediacy. They bear a resemblance to the work of another of Monro's associates, Henry Edridge, who was born in 1769 and made his reputation as a portrait draughtsman of great delicacy and grace. His landscapes (*Plate 60*) are much more robust than his portraits, however, and his pencil studies of buildings, especially those made on a visit to Paris and Normandy in 1817, have a Prout-like vigour and flair. He seems to have influenced the most gifted of Monro's own family, his son Henry, who died in 1814 aged twenty-two having tried his hand quite successfully at history painting, portraiture, and pen-and-wash landscapes which compare well with those of Edridge and Hunt (*Plate 61*).

Hunt's free, lively style of drawing is at its most sympathetic in his studies of people. He gives his subjects humour, gaiety, and a natural, frank insouciance that is charming (*Plate 136*). He showed portraits at the Water-Colour Society from 1814, sometimes executed in the tight, neat manner of traditional miniature painting, with colour applied in numerous tiny strokes, laid one beside another, with minute attention to all details, and the cheeks, lips and eyes made to glow as much as possible. Edridge, too, excelled at this, using the technique often only for faces and hands, drawing the rest of his figures in simply with a pencil. Hunt gradually broadened the style, creating his own elegant, much looser variant on it, and deploying very personal and refined schemes of colour – soft beige, mushroom-browns and pinks being his favourites. As in Cox's case, a spell of scene painting for the theatre – Hunt was at Drury Lane for a time in 1809 – may have contributed to this process of evolution away from a tightly controlled manner; but he gradually returned to it. Although he went on drawing portraits and figure subjects he largely abandoned landscape and took, instead, to still-life. At first he chose plain, homely subjects to draw, harmonizing them with warm, violin-like tones of brown, and indoor lighting; but he developed more and more towards the virtuoso rendering of complicated surfaces, the bird's-nests, the apple-blossom, and above all the peaches and grapes that he could imitate with mouth-watering fidelity.

Hunt's realism immensely appealed to the middle-class mind (as it still does); Ruskin's own philosophy of aesthetics made it possible for him to approve too – in many ways his approach is quintessentially that of the nineteenth-century middle class:

The great people always bought Canaletto, not Prout, and Van Huysum, not Hunt. There indeed was no quality in the bright little water-colours, which could look other than pert in ghostly corridors, and petty in halls of state; but they gave an unquestionable tone of liberalmindedness to a suburban villa, and were the cheerfullest possible decorations for a moderate-sized breakfast parlour, opening on a nicely mown lawn. . . . Nor was this adaptation to the tastes and circumstances of the London citizen, a constrained or obsequious compliance on the part of the kindly artists. They were themselves, in mind, as in habits of life, completely a part of the characteristic metropolitan population. . . . Mr Hunt . . . never painted a cluster of nuts without some expression, visible enough by the manner of their presentation, of the pleasure it gave him to see them in the shell, instead of in a bag at the greengrocer's.

The artists themselves belonged to the same newly-emerged, newly-prosperous bourgeois society whose tastes they catered for, and the Water-Colour Society's love of gold frames and elaborate subjects and ostentatious realism reflects all this. As Ruskin implies, such preoccupations are not necessarily bad ones, or those only of the vulgar and uninformed. They can be the genuine interests of serious artists. The work of Hunt and Lewis illustrates how fine such attention to detail can be in the hands of men who can fix their minds firmly on general issues, on the 'breadth' as Ruskin called it, and do not lose sight of the wood among the trees. Ruskin in fact laid such stress on the broad meaning of art that his writing in *Modern Painters* inspired the important movement in which the search for realism and truth found its culmination: Pre-Raphaelitism.

When Ruskin found the youthful Pre-Raphaelites, Dante Gabriel Rossetti, William Holman Hunt and John Everett Millais, striving to achieve worthwhile, sincere and serious ambitions he sprang to their defence; for needless to say they were savagely attacked. 'Look around at our exhibitions', he wrote, 'and behold the "cattle pieces" and "seapieces" and "fruit pieces" and "family pieces"; the eternal brown cows in ditches, and white sails in squalls, and sliced lemons in saucers, and foolish faces in simpers; – and try to feel what we are, and what we might have been.' He evoked vividly the dreary monotony, the total lack of inspiration that had overcome English art. Even Hunt – I mean William Henry, 'Bird's-nest Hunt' – received his strictures: 'It is hardly necessary to point out the earnestness or humility in the works of William Hunt, but it may be so to suggest the high value they possess as records of English rural life, and *still* life . . . [and yet] . . . why should he be allowed continually to paint the same bunches of hot-house grapes, and supply to the Water-Colour Society a succession of pineapples with the regularity of a Covent Garden fruiterer?'

The Water-Colour Society itself was suffering from the malaise. It is significant, in the light of this, that Lewis had withdrawn himself from its ranks for so long, and that when he returned his work was heralded, both by his fellow artists and by Ruskin, as of major importance. It is significant too that Ruskin lumped him with the other men engaged in work he could admire – the Pre-Raphaelites. He declared that Lewis was in fact 'the fourth Pre-Raphaelite'; and in his notes on the Royal Academy exhibition of 1858 expanded this:

When, some time ago, I claimed him as a Pre-Raphaelite, I never meant that he had been influenced in his practice by any of the other members of the school; but that he was associated with it . . . as all true painters for ever must be, by the mere fact of their painting truth instead of formalism and idealism; while Lewis is still more closely connected with the present nominal masters of the school by his completeness of finish, to the utmost corners of his canvas.

Ruskin is, I am afraid, talking about oil-paintings by Lewis, not watercolours, and about an Academy exhibition, not a Water-Colour Society one. What has happened? Lewis had gone on making his exquisite Middle-Eastern watercolours; in 1856 he exhibited the famous *Frank encampment*, Ruskin's comments on which I have already mentioned. This was really the climax of his reputation: 'I have no hesitation in ranking it

among the most *wonderful* pictures in the world,' Ruskin insisted in his great enthusiasm. In 1857, Lewis showed at the Water-Colour Society *Hhareem life – Constantinople* (*Plate 150*), which is perhaps the most ravishing thing he ever did, greatly benefiting from the restraint with which the subject is handled. In this same year, 1857, he was elected president of the society for the second time; his first appointment had been in 1855. But in the following February he resigned. In 1859 he became an A.R.A. and in 1865 a full Academician. The clue to this extraordinary volte-face is perhaps to be found in a comparison of *Hhareem life* with another of his subjects, *Indoor gossip, Cairo* (*Plate 151*). The second is an oil-painting. It dates from 1873, three years before Lewis's death. There is no essential difference between his approach in the watercolour and that in the oil, although they are in contrasting media. Holman Hunt recollected a meeting with Lewis shortly after his return from the Middle East, when Lewis

had found English art in the woefullest condition, its only hope being in the reform which we [that is to say the Pre-Raphaelites] were conducting, and he had told Millais to speak to me of his appreciation of my work. . . . 'You should know that although I think your painting much better than most of the artists exhibiting, I am sure that oil painting could be made more more delicate than either of you make it; not sufficient pains are taken to make the surface absolutely level. Why should it ever be more piled up than in water-colour?'

Lewis had the application to solve this odd problem for himself, and found that he could achieve satisfactory results in oil without the amount of labour that was demanded by watercolour. He did not lack zeal: 'I work always from before 9 in the morning till dusk, and from half-past 6 till 11 at night, always', he said. But since his conception of the nature and function of watercolour had, like that of so many of his contemporaries, ceased to differentiate it from that of oil, there was no reason why he should continue 'to get by water-colour art 500 £ a year, and this too when I know I could with less labour get my thousand'.

Lewis's defection to the Academy was the logical outcome of his attitude to watercolour. It is a fitting and symbolic conclusion to the history of watercolour in this period, and would perhaps be a sad one if there were not one figure who rode over the declining standards of the day, and achieved so much that other men's failings may be forgiven on his account. That figure was, of course, Joseph Mallord William Turner.

*　　　*　　　*

Joseph Mallord William Turner

Ruskin, writing about Pre-Raphaelitism in 1854, described an artist 'quiet in temperament', but with 'a feeble memory, no invention, and excessively keen sight'. He pictured him at work, seeing everything vividly, 'mountains and grasshoppers alike; the leaves on the branches, the veins in the pebbles, the bubbles in the stream.' This artist, who could 'remember nothing, and invent nothing', Ruskin suggested, would patiently record with perfect fidelity everything that he saw. In order to explain the advantages and limitations of the Pre-Raphaelite approach, he equated this schematic artist with the young Millais, and contrasted him with another sort of artist, 'impatient in temperament', with 'a memory which nothing escapes, and invention which never rests, and', he added to increase the contrast, 'comparatively near-sighted.' This artist observes nature in all its details until 'there is not one change in the casting of the jagged shadows along the hollows of the hills, but it is fixed on his mind for ever. . . . Not only so, but thousands and thousands of such images, of older scenes, remain congregated in his mind, each mingling in new associations with those now passing before him, and these again confused with other images of his own ceaseless, sleepless imagination.'

The artist whom Ruskin puts forward as the greatest Pre-Raphaelite, the most faithful and imaginative recorder of nature, is, not Millais, Rossetti or Holman Hunt; not Lewis; but – Turner. For Ruskin, Turner, like these other artists, is a painter of the visible world in all its diversity and minuteness of changing detail. The element that Turner adds to the standard Pre-Raphaelite approach is that he sees and depicts nature *in motion*: his art is about the inherent dynamism of nature. But technically, his watercolours belong as much to the school of Lewis and W. H. Hunt as to the more obviously dynamic manner of, say, David Cox. Turner, in fact, represents the fusing together of the two opposing movements in the history of English watercolour – the movement towards greater breadth and freedom, and the equally strong compulsion towards precision and finish. As we have seen, in the case of an artist like Lewis, the pull towards minute finish involved, in the end, a compromise with oil-painting; for the true Pre-Raphaelites there was bound to be a loss of spontaneity. Turner was the only artist who succeeded in embracing the two extremes of static and dynamic simultaneously and creating from their combination wholly satisfactory works of art.

He set himself the task of doing so at an early age. As we have already seen, he was trained in the school of architectural topography that flourished in London in the 1790s, and by the age of twenty had perfectly mastered the current forms of expression in watercolour. It was therefore inevitable that he should now begin to paint in oils; from the start his ambition had not been confined to one medium. His first exhibited oil-painting was a masterly work in itself, and, like the watercolours, it looked competitively at other masters for comparison. From this time (1796) onward, his watercolours began to borrow more of the characteristics of oil-paintings. As we know, it was part of the spirit of the time that artists in watercolour should try to improve their works towards greater weight and significance; Turner was not alone in this. But his methods were unique, and quickly marked him out from his contemporaries, who circulated with fascination the accounts of his technique that they were able to glean.

This technique was evolved with great brilliance to achieve a balance between the strong effect that Turner required and the delicacy of touch appropriate to watercolour. Whereas, when Barret or Fielding or Lewis paints a very elaborate watercolour we find ourselves wondering why the artist did not use oil, in the case of Turner there is never any suggestion that the medium is unsuited to his intention. And yet he imported into the hitherto rather circumscribed field of the watercolour ideas that had previously belonged almost exclusively to oil: the year after his picture of *Fishermen at sea* appeared at the Academy, he showed there an *Interior of the ruins of Ewenny Priory*, which invokes the grand sombre chiaroscuro of Rembrandt and explores a dramatic pattern of lighting as thoroughly as if the medium *were* oil. There are hints of this interest in earlier drawings – the *Ruined refectory of St Martin's Priory, Dover* of about 1792 has the beginnings of a similar idea, though less fully realized in the comparatively simple technique of that period; and the Dayes-like scene of *The Pantheon, Oxford Street, on the morning after the fire* (Plate 156), also of 1792, betrays an interest in subtle and dramatic light that competes with the lively figures in the foreground for attention as the focus of the design.

The well observed figures in this drawing, which belong to the tradition of Rowlandson's *Vauxhall Gardens*, prelude a lifetime's concern, on Turner's part, for the contribution of human beings to landscape. Just as Constable felt that any natural scene had its proper staffage – the evidence of human life appropriate to it – so Turner conceived his landscapes as records of the natural world both as it looks to the viewer and as it feels to its inhabitants. Whereas Constable gives us figures that are, as it were, casually observed in their setting, Turner invents human incident that will enhance and explain the significance of the scenery. The firemen, the casual onlookers, the early-morning passers-by, are all essential to an account of what Oxford Street was like on the winter morning after the fire in the Pantheon, and we may go so far as to say that it would have been pointless to draw the icicles hanging along the ruined cornices if there had been no one on the spot to see the early sun lighting them, or to feel the frost in the air.

This combination of human experience and landscape derives in essence from the philosophy of historical painting which Reynolds expounded and which gave rise to so much large-scale figure painting and psychological drama in the art of the late-eighteenth century. Turner, no less than any figure painter, admired Reynolds and aspired to create art of an elevated order, concerned with the most serious aspects of life. His most immediate master in the branch of historical landscape was Richard Wilson, whose compositions he both copied and imitated. In the large oil-paintings that he began to

send regularly to the Academy at the end of the century, such schemes could of course be presented on the grandest scale. Turner's elaborate watercolour technique made it possible for him to do exactly the same with that medium, and about 1800 he showed, together with his first big 'History', the *Fifth plague of Egypt*, two views of Caernarvon Castle that are effectively imitations of Claude in watercolour. One is a broad, open, day-time view, with complex shifts of sunlight across a wide panorama framed by trees and rocks, with an historical group of figures listening to a bard in the foreground; the other is a glowing golden sunset, with strong contrasts of light and shade, like one of Claude's famous *Seaports*.

To create these grand watercolour paintings – they can no longer be described as drawings – Turner would make, in addition to the usual pencil sketches, colour studies that were sometimes as big as the finished works. They anticipate the full-size oil-studies that Constable was to make of his Academy pictures around 1820. As early as 1800 Turner executed marvellously free, schematic sheets in which the over-all colour plans of his projects were worked out. These were to be a standard method throughout his life for reducing to order the diversity and complexity of his visions of the ever-changing face of nature. Having established a firm underlying colour structure he could transfer this solid foundation to the final sheet, and overlay it with any amount of varied detail, applied with a fine brush, or by rubbing out areas of damp colour, or by using a fingernail or the end of a brush to scratch out highlights. Most of these were processes that other artists used in their larger-scale watercolours; the Daniells, for example, were masters of many of them; but Turner adapted and developed them with an inventiveness that took him far beyond anyone else in flexibility and expressive power.

Turner's work in watercolour, then, falls into several distinct categories, which must be distinguished according to their function in the process of producing a finished work of art to be exhibited on the walls of the Academy or elsewhere. He not only accepted but whole-heartedly identified himself with the concept of public art that the Royal Academy embodied; to that extent he was never a part of the rather anti-Academic mainstream of the English watercolour school. In 1799, when he was only twenty-four, he became an associate member of the Academy, and he was a full Academician in 1802. He justified the election at once by executing a series of large pictures inspired by his experiences among the masterpieces in the Louvre, which he visited in the same year, on his way back from a tour in the Swiss mountains. These paintings proclaimed unequivocally his admiration for the Dutch and Italian old masters, and varied from inspired reinterpretation to direct pastiche. Even in middle age Turner was capable of making unashamed imitations of artists, young or old, who impressed him; and his whole output is so imbued with the consciousness of what great men had achieved before him that it may be said to constitute an immense sequence of variations and reinterpretations of time-honoured pictorial precedents. And he took much time and trouble to do honour to his post as professor of perspective at the Academy, preparing lectures that were witness to a wide reading of books on art theory, and illustrating them with superb diagrams and drawings specially made in watercolour for the purpose.

But he did not pour his inventiveness only into the creation of techniques suited to the perpetuation of Academic tradition. As Ruskin pointed out, he was dependent as much on nature as on art for his inspiration, and his observations were recorded with breathtaking directness and truth in hundreds of drawings, usually noted on the spot in pencil alone and coloured afterwards in the studio, or at his lodgings if he were on tour, as he so often was. During the 1790s he explored large areas of England and Wales, and in 1801 he went to Scotland (*Plate 157*). Between 1802 and 1817 he was unable to return to the Continent on account of the war, but worked up and down England, under the impetus provided by various projects which were for publication; a series of engravings after water-colours showing *Picturesque Views on the Southern Coast of England*, published between 1814 and 1826, took him to Devon, Cornwall and Somerset, as well as to his familiar Kent and Sussex; a *History of Richmondshire* (Yorkshire and Lancashire) planned by a Dr Whitaker drew forth some beautiful watercolours of those regions, based on drawings made while Turner stayed with his patron and close friend, Walter Fawkes, who lived at Farnley, near Leeds. Fawkes had bought a large number of Turner's works, both pictures and drawings, including nearly twenty Swiss subjects derived from studies he had made in 1802. When Turner returned to the Continent in 1817, he sold Fawkes a series of fifty-one studies (they are not, properly speaking, finished and would probably not have been sold to anyone other than a close friend) of views on the Rhine. At about the same time, he made a group of views of Fawkes's home and grounds, and the surrounding countryside. These are, like the Rhine views, fresh, free and spontaneous, though often worked out with a loving attention to the details of the architecture and appointments of a house that was obviously dear to him. The series is unusual in Turner's output as being a truly finished performance, yet having an informal air that his public works do not often possess.

In 1819 he fulfilled a long-standing ambition to visit Italy, and the experience had a marked effect on both his oils and his watercolours: for ten years afterwards he seems to have had real difficulty in evolving original oil-paintings, labouring at subjects which reflected something of the high seriousness of the Italian tradition, and nearly always under the influence of some specific master – not necessarily Italian: Watteau and Rembrandt both figure prominently among the inspirations of the decade. In his watercolour studies, Turner began to think differently about colour and the ways in which it can be manipulated: he had taken to Italy, as he did to Switzerland in 1802, sketchbooks carefully prepared with grey washes as a ground for his drawings – a method of tonal organization dating back to the lessons learned from his earliest experiments in oil; after the Italian journey, he hardly ever again had recourse to it. And the over-all palette of his watercolours became gradually lighter, more airy and increasingly characterized by unexpected colour shifts and combinations. Whereas hitherto Turner had used colour to some extent traditionally, deliberately seeking the dark, resonant tones of oil-painting, now he started to work out his ideas as orchestrations of pure colour, so that each finished watercolour is a carefully balanced system of colour contrasts,

reliant hardly at all on the traditional chiaroscuro, and often penetrating utterly new areas of expression in which nature is recreated so imaginatively that apparently alien ranges of colour are introduced and made to seem not only necessary but natural and inevitable. The development can be seen clearly if we compare a finished watercolour of about 1818, *The Crook of Lune (Plate 163)* with the view showing Caernarvon Castle from the great series of *Picturesque Views in England and Wales (Plate 159)*. The first, for all the intricacy and subtlety of its detail, is conceived in terms of naturalistic colouring, the landscape green, fading to blue, with brown tones in the foreground which recall the traditional Claudian *repoussoir*. In the later work, *Caernarvon*, this adherence of the colour plan to the strict contours of the subject has been abandoned in favour of a schematic disposition of basic colour areas which is independent of the forms in the design. To the left is a wedge of blue, which partly divides an area of yellow and red at the top right from an area of yellow and green at the bottom. Within these broad divisions the colours of the different areas echo one another in endless reverberations; but the composition as a whole rests on that simple, firm tripartite foundation.

The *England and Wales* series, from which the *Caernarvon* comes, was begun in 1826, and occupied Turner until the late 1830s; it constitutes the longest and in many ways the most ambitious of the sequences in which he so often worked, and although all ninety-six watercolours have a character that sets them apart from Turner's other drawings and marks them as a set, considerable technical changes took place during the decade or so during which he was engaged on them. The sort of colour organization that is so brilliantly disguised in the *Caernarvon* can be found in nearly all of them, and Turner's efforts to resolve his compositions in terms of chromatic balance can be traced in the many 'colour-beginnings' and 'colour-structures' that are connected with the *England and Wales* project.

At the same time, he was involved in several other sets of watercolours for engraving and publication – in addition to the oil-paintings that he regularly showed either in the Academy's exhibitions or in his own private gallery, attached to his house in Harley Street. A scheme almost as extensive as the *England and Wales* was intended to illustrate the scenery of the principal rivers of Europe; for this Turner made hundreds of small colour studies on blue paper in which the expressive quality of colour alone is brought to startling extremes of distortion (*Plates 166 and 167*). Only a small proportion of these was worked up and engraved: three volumes, dealing with the Loire and the Seine, appeared in 1833–5; other rivers, of which we have preliminary studies – the Rhine, the Meuse and the Moselle, with possibly the Rhone, the Danube and others – were never published. Although these illustrations were on a comparatively small and intense scale, they are exceeded in miniature size and brilliance of colour by the vignettes that Turner designed for a number of books, beginning with his friend Samuel Rogers's poem *Italy* in 1826, and continuing with illustrations to Byron, Scott, Thomas Campbell, Milton and others. This work went on into the late 1830s; the little designs for Scott and Byron in particular are astonishing in that they contain all the multitudinous detail and expansive scale of the *England and Wales* watercolours, within the space of about four

to six inches. Turner's combination of breadth with a miniaturist's technique made it possible for him to work equally grandly and effectively on any scale.

The book illustrations were a form of public communication very different from that of the Academy exhibitions; Turner embraced both with equal enthusiasm, and supervised the engravers who worked for him so fastidiously that he evolved, through them, yet another medium by which he could express himself. He was strongly impelled by the need to make contact with a public; even though his paintings were often very experimental and prompted ridicule, he intended to communicate and to be understood. But there was a private side to his output; he made many watercolours that were not designed to be exhibited or sold, and which may not even have been executed with some other finished work in view. The little studies of interiors at Petworth, Lord Egremont's house in Sussex, are in this category: like the *Rivers of Europe* series they are on small sheets of blue paper, many of them carried out in rich colour alone; they record intimate scenes of conversation, social groups, family discussions, the artists who were Lord Egremont's constant guests at their easels, the household at chapel, the furnishings of sitting-rooms, halls and bedrooms. Their intensity, their brilliant colour and their fascination with rich fabrics and groups of handsomely dressed figures make one think of the luscious little interiors of Bonington; Turner may have seen examples of them in dealers' shops, and imitated the new young talent, just as he imitated the historical pictures of Charles Robert Leslie, whom he met at Petworth, and who also made little watercolours of the house. But very few of these masterly evocations of intimate and immediate life ever left Turner's hands, and little of their content was incorporated into paintings or other public works.

The same sense of exhilaration in the face of a very personal experience is to be found in many of the drawings that Turner made during his continental tours in the later part of his life. He travelled widely across Europe in the 1830s, going, probably in 1833, as far afield as Berlin, Dresden, Ratisbon and Venice. He usually took with him now, in addition to his little pocket notebooks, soft-covered drawing books which could be rolled and put into a pocket. These provided him with fair-sized sheets of white paper on which he could make brief pencil notes, occasionally colouring them on the spot, but more often improvising colour afterwards. He produced in this way an enormously long series of beautiful watercolour drawings, of all degrees of finish, the majority of which he kept. Some, however, were sufficiently complete to be sold or given away; his agent, Thomas Griffith, seems to have distributed a large number of them to clients. A visit to Venice in 1840 gave rise to a supremely beautiful group of meditations on the dazzling light of the Mediterranean on the lagoon, the shipping and the ancient buildings of the city, all of which seem to dissolve in its brilliance. Turner summons up vividly the atmosphere of the place, sometimes with the most evanescent and slight washes of pale colour (*Plate 169*). A similar personal involvement can be felt in his watercolour studies of Lake Lucerne, the fruit of a visit to Switzerland in 1841. This time he went so far as to present Griffith with fifteen of the more complete of these, offering to make finished watercolours of ten subjects chosen by his clients. Griffith got nine commissions, according to

Ruskin, who was by this date an ardent collector of Turner's works. Turner made all ten drawings, and the following year, after another visit to Switzerland, made six more. A further ten followed in 1845. The number of his patrons was reduced to only two – his friend H. A. J. Munro of Novar and Ruskin – but Turner could not dam up the spring of his invention or his need to communicate. Even at this late date, the fine colour studies that he produced in such quantities could not, though wrought to a high degree of completion, take the place of the fully evolved, finished work of art – an entity essentially different from the study, however inventive, that preceded it in the creative sequence. The great finished Swiss watercolours of the 1840s are as much formal works of high art as any of the earlier historical landscapes: they seek to convey a sense of the grandeur of the natural world in a language that is artificial and yet at the same time poetically true to observed life. In almost every case they speak of broad panoramas swept by vast patterns of opalescent light, at dawn, dusk or midday. Turner's ability to convey the huge scale of the open air is manifest in every one of them; it is an ability that few other landscape artists have had, and rests on precisely that close observation of detailed effects of light and colour which Ruskin singled out.

Within these splendid visions men play an essential role. Although Turner could engage in a private, Wordsworthian relationship of stillness and contemplation in the face of the Swiss lakes and mountains, he was equally alive to the fact that Switzerland is a country with its own social, architectural and economic features; these too he recorded – his views of Zurich show crowds participating in public activity; his lakeside towns are busy with hotels and tourists and water-craft. The sketchbooks that he used on his tours are full of carefully noted details of costume, buildings and trades, all of which he drew on for the peopling of his finished watercolours, as much as for his paintings.

Ruskin suggested that after 1845 Turner's art declined rapidly and that between then and his death he produced little work. In fact, he made two more Swiss watercolours for Ruskin in 1848, and was probably engaged on a further set when he died. And he went on showing pictures at the Academy until 1850; one of the last of these was from a favourite source, the *Aeneid: Mercury sent to admonish Aeneas*. Nothing could more aptly illustrate his adherence, all his life, to the classic tradition in which he had been brought up. It is not surprising that he had few followers: he belonged to the old rather than the new school and his revolutionary contributions to art were hardly capable of being appreciated at the time. All he could bequeath to the immediately following generation was some sense of his inexhaustibly variable watercolour technique; without his imagination this could only lend itself to stiff, finicky work in which the Pre-Raphaelite marble stillness prevails over movement and variety.

It is no coincidence that one of the most successful of the watercolourists who worked according to Turner's method was an illustrator whose best work was all on the small scale of book decorations. Myles Birket Foster pursued a career rather like that of William Henry Hunt in that he became associated more and more with a tight, miniaturist's manner capable of giving very rich and satisfactory effects within a limited scale of reference. His rustic scenes seem to carry on the fashion that Hunt set for pretty, slightly sentimental rural genre (*Plate 141*). They are technically brilliant and were very popular; but, like the majority of the exhibitors at the Water-Colour Society, his invention did not serve him for the larger-scale views of Venice or the Rhine that were considered his most serious contributions to art.

On the other hand, artists who imitated Turner's subject-matter rather than his technique can usually be grouped more readily with the post-Bonington school: the handling of watercolour that we find in the work of James Baker Pyne (*Plate 118*) or Thomas Miles Richardson (*Plate 155*), for example, is a somewhat facile, though often brilliant, variant on the manner of Callow and Holland. Pyne's work is sometimes extremely successful in suggesting open space and warm sunlight, and on the whole avoids overtly Turnerian effects, which, however, he did love to produce on occasion, with a free use of creamy bodycolour that suggests his inspiration came from Turner's paintings rather than his drawings. Richardson, the son of another Thomas Miles who belongs to the school and tradition of John Varley, was a very able draughtsman who rather too frequently succumbed to the pressures of the market to turn out vividly blue Italian lakes or purpled Scottish hillsides, all remarkably free of real feeling of any kind. Many other artists who were not primarily concerned with the dramatic view of nature put forward by Turner could nevertheless quite often turn their talents to theatrical panoramas of Italy, lit by vortexes of bursting sunshine: even an old diehard of the Water-Colour Society like Copley Fielding, whose early drawings were shaped by the careful classicism of John Varley, betrays an influence of the bolder, more heroic motifs of Turner – rolling vistas of downland, rings of mountains or swirling seas, created with impressive, if rarely inspired, professionalism (*Plate 123*).

Fielding was usually more successful when he treated gentler, more intimate subjects, and was excelled in the grand Turnerian style by the Durham artist, George Fennel Robson, who moulded the simple classicism of Varley into an art of exceptional strength and individuality. Robson's ability to apply watercolour in deep, intense and vibrant masses suited him particularly to the large-scale landscape of mountainous spaces that Turner made so much his own (*Plate 119*); and although there is a similar meticulousness in his technique its effect is quite different: Robson's most characteristic subjects are sublime mountain scenes, in which bare peaks rise opaquely against a translucent sky, and rich valleys are variegated with grazing flocks and luxuriant foliage. All these elements are presented in heavy, glowing colour worked not in washes but in close, tight stipplings that make for maximum density and strength. There is in Robson's best work a stillness that brings him close to the Pre-Raphaelite vision of the world, but it is combined with a grandeur to which it lends a quite different quality of dreamlike surrealism. This surrealism of Robson's has sometimes been confused with the rather similar atmosphere of the work of the Bristol artist, Francis Danby, who was best known for his apocalyptic subjects in the manner of 'Mad' John Martin. Neither Martin nor Danby can really claim to have a Turnerian view of the world, but their

visions of cataclysm were an important popular expression of the taste for extreme pictorial drama which prevailed in the 1820s and which was a significant element in Turner's creative consciousness.

Danby grew up in Bristol, surrounded by a group of well-read and enthusiastic artists who were principally inspired by the lovely scenery that surrounded the city; in particular by the wooded gorge of the Avon at Clifton (*Plate 154*). Danby's early watercolours are executed in the precise, measured style of the classical John Varley, with something of the verdant richness of William Havell's work in the same vein. Because he was able to record directly his impressions of a naturally grand spot, he could combine simplicity and sublimity in a way which is very beguiling. His best work of this early period (about 1820) is in oil, where his clear, crisp colouring and unaffected naturalism bring him nearer than any other English artist to the German realists of the Biedermeier. His watercolours, though, can on occasion achieve a rather similar atmosphere, and are shot through (perhaps partly because they have often faded) with reminiscences of the sombre colour schemes of Girtin (*Plate 152*).

In fact, Danby did not make many watercolours of the grandiose mountain subjects that Robson specialized in, though a number of monochrome compositions in dark-brown or black ink, making use of Robson-like *contre-jour* effects, are attributed to him. It is more often in the oil-paintings of his later period that the theatricality of Turner is apparent; and then, again, it is presented in a crisp, almost photographically vivid way that is the opposite of Turner's elusive atmosphere. But Danby's associate on many Bristol sketching expeditions, Samuel Jackson, produced a large number of watercolours in which the Avon Gorge is rendered in a variety of conditions and with great technical range, suggesting an unusually receptive sensibility. In his large-scale work for exhibition, Jackson approached Robson in the resonance and fullness of his colouring and the meticulousness of his technique (*Plate 153*). These men brought to the by now somewhat threadbare tradition of the sublime a visionary power that brings them close, at times, to the work of Samuel Palmer; indeed Palmer's later drawings, especially those of the hot Italian sunsets which occur so often after his honeymoon in Italy in 1838–40, share much of their technique and colouring, and may be said to represent the last important flowering of Turnerian landscape in English watercolour.

One touching illustration of Turner's continuing interest in his art and the world that was changing so rapidly around him is an account of his frequenting the shop of the photographer Mayall in the late 1840s, asking questions and displaying the greatest curiosity about the new science which, it was already becoming clear, might have an important effect on the representational arts. It was appropriate that the ageing Turner should be aware of this development: he himself had taken the forms in which he worked to the limits of their expressive capacity; there was, in a sense, no more to be done along that path – the dilemma of Lewis and the rest was understandable. Something new was about to happen; the next great artist in the story is Whistler, the only man who could supply a language of true abstraction – an abstraction that belongs to the tradition of Towne and Cotman, not to that which Turner brought to a close. It leads naturally on to the twentieth century, to an art which is concerned more with problems of art itself than with the natural world.

Select bibliography

GENERAL

JOSEPH FARINGTON, *Diary*, 1793–1821, unpublished manuscript in the collection of Her Majesty the Queen (typescript in the British Museum Print Room); selections ed. J. Greig, 7 vols, 1922–8

COSMO MONKHOUSE, *The Earlier English Water-Colour Painters*, 1890

J. L. ROGET, *History of the Old Water-Colour Society*, 2 vols, 1890

C. E. HUGHES, *Early English Water-Colour*, 1913; revised ed. by Jonathan Mayne, 1950

LAURENCE BINYON, *English Watercolours*, 1933

A. P. OPPÉ, *English Drawings . . . at Windsor*, 1950

IOLO A. WILLIAMS, *Early English Watercolours*, 1952

MARTIN HARDIE, *Watercolour Painting in Britain*, 3 vols, 1966–8

JEAN HAMILTON, *The Sketching Society, 1799–1851*, Exhibition Catalogue, Victoria and Albert Museum, 1971

BASIL TAYLOR, *The Old Watercolour Society and its Founder Members*, Exhibition Catalogue, Messrs Spink, 1973

H. L. MALLALIEU, *The Dictionary of British Watercolour Artists up to 1920*, 1976

*　　　*　　　*

BLAKE

ALEXANDER GILCHRIST, *The Life of William Blake*, 2 vols, 1880

ANTHONY BLUNT, *The Art of William Blake*, 1959

DAVID BINDMAN, *William Blake: Catalogue of the Collection in the Fitzwilliam Museum, Cambridge*, 1970

RUTHVEN TODD, *William Blake the Artist*, 1971

MARTIN BUTLIN, *William Blake, a complete catalogue of the works in the Tate Gallery*, 1971

BONINGTON

A. DUBUISSON and C. A. HUGHES, *Richard Parkes Bonington, His Life and Work*, 1924

HON. ANDREW SHIRLEY, *Bonington*, 1940

MARION SPENCER, *Richard Parkes Bonington*, Exhibition Catalogue, Nottingham Museum and Art Gallery, 1965

BOYS

JAMES ROUNDELL, *Thomas Shotter Boys*, 1974

ALASTAIR SMART, *Thomas Shotter Boys*, Centenary Exhibition Catalogue, Nottingham University Art Gallery and Messrs Agnew's, 1974

CALVERT

SAMUEL CALVERT, *A Memoir of Edward Calvert*, 1893

LAURENCE BINYON, *The Followers of William Blake*, 1925

RAYMOND LISTER, *Edward Calvert*, 1962

CANALETTO

HILDA F. FINBERG, *Canaletto in England*, Walpole Society, vol. IX, 1921–2, pp. 21–76

K. T. PARKER, *The Drawings of Canaletto . . . at Windsor*, 1948

CONSTABLE

C. R. LESLIE, *Memoirs of the Life of John Constable*, 1843; new edition ed. Jonathan Mayne, 1951

GRAHAM REYNOLDS, *Constable, the Natural Painter*, 1965

GRAHAM REYNOLDS, *Catalogue of the Constable Collection in the Victoria and Albert Museum*, 1961

LESLIE PARRIS and IAN FLEMING-WILLIAMS, *Constable*, Bicentary Exhibition Catalogue, Tate Gallery, 1976

IAN FLEMING-WILLIAMS, *Constable Landscape Drawings and Watercolours*, 1976

COTMAN

F. DICKES, *The Norwich School of Painting*, 1905

A. P. OPPÉ, *The Water-Colour Drawings of John Sell Cotman*, The Studio, 1923

SIDNEY D. KITSON, *The Life of John Sell Cotman*, 1937

DEREK CLIFFORD, *Watercolours of the Norwich School*, 1965

MIKLOS RAJNAI, *J. S. Cotman in Normandy*, Catalogue of works in Norwich Castle Museum, 1975

COX

NEIL N. SOLLY, *A Memoir of the Life of David Cox*, 1873

W. HALL, *Biography of David Cox*, 1881

F. GORDON ROE, *David Cox*, 1924

TRENCHARD COX, *David Cox*, Catalogue, Birmingham City Art Gallery, n.d.

ANTHONY REED, *David Cox, Drawings and Paintings*, Exhibition Catalogue, Manning Gallery, London, 1976

ALEXANDER and JOHN ROBERT COZENS

A. P. OPPÉ, *Alexander and John Robert Cozens*, 1952

FRANCIS HAWCROFT, *Watercolours by John Robert Cozens*, Exhibition Catalogue, Whitworth Art Gallery, Manchester and Victoria and Albert Museum, 1971

CRISTALL

RANDALL DAVIES, *Joshua Cristall*, Old Water-Colour Society's Club, vol. IV, 1926–7, pp. 1–20

BASIL TAYLOR, *Joshua Cristall*, Exhibition Catalogue, Victoria and Albert Museum, 1975

CROME

(*see under Cotman*; DICKES *and* CLIFFORD)

RALPH H. MOTTRAM, *John Crome of Norwich*, 1921

DANBY

ERIC ADAMS, *Francis Danby: Varieties of Poetic Landscape*, 1973

FRANCIS GREENACRE, *The Bristol School of Artists . . . 1810–1840*, Exhibition Catalogue, Bristol City Art Gallery, 1973

DANIELL

THOMAS SUTTON, *The Daniells, Artists and Travellers*, 1954

MILDRED ARCHER, *Artist Adventurers in Eighteenth-Century India: Thomas and William Daniell*, Introduction to Exhibition Catalogue, Messrs Spink, London, 1974

DE WINT

WALTER ARMSTRONG, *A Memoir of Peter De Wint*, 1888
WALTER SHAW SPARROW, *The Life and Work of Peter De Wint*, 1903
RANDALL DAVIES, *Peter De Wint*, Old Water-Colour Society's Club, vol. 1, 1923–4
MARTIN HARDIE, *Peter De Wint*, The Studio, 1929

FARINGTON

F. GORDON ROE, *'Dictator of the Royal Academy'. An Account of Joseph Farington and his Brother George*, Walker's Quarterly, vol. V, 1921
FRANK RUTTER, *Wilson and Farington*, 1923

COPLEY FIELDING

S. C. K. SMITH, *Copley Fielding*, Old Water-Colour Society's Club, vol. III, 1925, pp. 8–30

FLAXMAN

DAVID IRWIN, *English Neo-Classical Art*, 1966
ROBERT R. WARK, *Drawings by Flaxman in the Huntington Collection*, 1970

BIRKET FOSTER

FRANK LEWIS, *Myles Birket Foster, 1825–1899*, Leigh-on-Sea, 1973

FUSELI

PAUL GANZ, *The Drawings of Henry Fuseli*, 1949
FREDERICK ANTAL, *Fuseli Studies*, 1956
GERT SCHIFF, *Johann Heinrich Fuseli*, 2 vols, 1973
TATE GALLERY, *Henry Fuseli*, Exhibition Catalogue, 1975

GAINSBOROUGH

W. T. WHITLEY, *Gainsborough*, 1915
ELLIS WATERHOUSE, *Gainsborough*, 1958
JOHN HAYES, *The Drawings of Thomas Gainsborough*, 1970

GILLRAY

DRAPER HILL, *Mr Gillray, the Caricaturist*, 1965

GILPIN

IOLO A. WILLIAMS, *The Artists of the Gilpin Family*, Old Water-Colour Society's Club, vol. XXIX, 1951, pp. 16–24
CARL PAUL BARBIER, *William Gilpin: His Drawings, Teaching, and Theory of the Picturesque*, 1963

GIRTIN

JONATHAN MAYNE, *Thomas Girtin*, 1949
THOMAS GIRTIN and DAVID LOSHAK, *The Art of Thomas Girtin*, 1954
FRANCIS HAWCROFT, *Watercolours by Thomas Girtin*, Exhibition Catalogue, Whitworth Art Gallery, Manchester and Victoria and Albert Museum, 1975

GLOVER

BASIL S. LONG, *John Glover*, Walker's Quarterly, vol. XV, 1924

HAVELL

ADRIAN BURY, *William Havell*, Old Water-Colour Society's Club, vol. XXVI, 1948, pp.1–18
ERIC J. STANFORD, *William Havell, 1782–1857*, Exhibition Catalogue, Reading Museum and Art Gallery, 1970

HILLS

BASIL S. LONG, *Robert Hills*, Walker's Quarterly, vol. XII, 1923

HOLLAND

RANDALL DAVIES, *James Holland*, Old Water-Colour Society's Club, vol. VII, 1929–30, pp. 37–54
M. TONKIN, *The Life of James Holland*, Old Water-Colour Society's Club, vol. XLII, 1967

HUNT

JOHN RUSKIN, *Notes on Samuel Prout and William Henry Hunt*, 1879
F. G. STEPHENS, *William Henry Hunt*, Old Water-Colour Society's Club, vol. XII, 1934–5, pp. 17–50

LEAR

ANGUS DAVIDSON, *Edward Lear*, 1938
PHILIP HOFER, *Edward Lear as a Landscape Draughtsman*, 1967

LEWIS

Old Water-Colour Society's Club, vol. III, 1925–6, pp. 31–50 (contemporary notices and sales lists)
RICHARD GREEN: *John Frederick Lewis*, Exhibition Catalogue, Laing Art Gallery, Newcastle on Tyne, 1971

LINNELL

A. T. STORY, *The Life of John Linnell*, 1892
MESSRS COLNAGHI, *Drawings, Watercolours, and Paintings by John Linnell and his Circle*, Exhibition Catalogue, 1973

DE LOUTHERBOURG

RUDIGER JOPPIEN, *Philippe Jacques De Loutherbourg, R.A. 1740–1812*, Exhibition Catalogue, Kenwood House, London, 1973

MONRO

W. FOXLEY NORRIS, *Dr Monro*, Old Water-Colour Society's Club, vol. II, 1924–5, pp. 1–8
F. J. G. JEFFERISS, *Dr Thomas Monro and the Monro Academy*, Introduction to Exhibition Catalogue, Victoria and Albert Museum, 1976

MORTIMER

BENEDICT NICOLSON, *John Hamilton Mortimer*, Exhibition Catalogue, Kenwood House, London, 1968

NICHOLSON

RANDALL DAVIES, *Francis Nicholson, Some Family Letters and Papers*, Old Water-Colour Society's Club, vol. VIII, 1930–31, pp. 1–39

PALMER

(*see under Calvert;* BINYON)
A. H. PALMER, *Life and Letters of Samuel Palmer*, 1892
GEOFFREY GRIGSON, *Samuel Palmer, The Visionary Years*, 1947

PARS

ANDREW WILTON, 'William Pars and his Work in Asia Minor', in Richard Chandler, *Travels in Asia Minor*, ed. Edith Clay, 1971

PROUT

(*see under Hunt;* RUSKIN)
C. E. HUGHES, *Samuel Prout*, Old Water-Colour Society's Club, vol. VI, 1928–9, pp. 1–30

ROBERTS

J. BALLANTINE, *The Life of David Roberts*, 1866

ROWLANDSON

JOSEPH GREGO, *Rowlandson the Caricaturist*, 2 vols, 1880
A. P. OPPÉ, *Thomas Rowlandson, Drawings and Watercolours*, 1923
BERNARD FALK, *Thomas Rowlandson; His Life and Art*, 1949
JOHN HAYES, *Rowlandson Watercolours and Drawings*, 1972
ROBERT R. WARK, *Drawings by Thomas Rowlandson in the Huntington Collection*, 1975

RUSKIN

W. G. COLLINGWOOD, *The Life of John Ruskin*, 2 vols, 1893, cheap ed. 1911
Arts Council, London, *Ruskin and his Circle*, Exhibition Catalogue, 1964

PAUL and THOMAS SANDBY

WILLIAM SANDBY, *Paul and Thomas Sandby*, 1892
A. P. OPPÉ, *The Drawings of Paul and Thomas Sandby . . . at Windsor*, 1947

SKELTON

BRINSLEY FORD, '*Letters of Jonathan Skelton from Rome,*' Walpole Society, vol. XXXVI, 1956–8
S. ROWLAND PIERCE, *Jonathan Skelton and his water-colours – a check list*, Walpole Society, vol. XXXVI, 1956–8

'WARWICK' SMITH

IOLO A. WILLIAMS, *John 'Warwick' Smith*, Old Water-Colour Society's Club, vol. XXIV, 1946, pp. 9–18

STOTHARD

A. C. COXHEAD, *Thomas Stothard*, 1906

TOWNE

A. P. OPPÉ, *Francis Towne, Landscape Painter*, Walpole Society, vol. VIII, 1919–20, pp. 95–126
ADRIAN BURY, *Francis Towne, Lone Star of Water-Colour Painting*, 1962

TURNER

A. J. FINBERG, *Turner's Sketches and Drawings*, 1910. New edition with introduction by Lawrence Gowing, 1968
A. J. FINBERG, *The Life of J. M. W. Turner, R.A.* 2nd edition, 1961
MARTIN BUTLIN, *Turner Watercolours*, 1962
JACK LINDSAY, *J. M. W. Turner, his Life and Work: a Critical Biography*, 1966
GRAHAM REYNOLDS, *Turner*, 1969
GERALD WILKINSON, *Turner's Early Sketchbooks*, 1972
GERALD WILKINSON, *The Sketches of Turner, R.A., 1802–20*, 1974
GERALD WILKINSON, *Turner's Colour Sketches, 1820–34*, 1975
Royal Academy, *Turner*, Bicentenary Exhibition Catalogue, 1974
ANDREW WILTON, *Turner in the British Museum*, Exhibition Catalogue, 1975
JOHN RUSSELL and ANDREW WILTON, *Turner in Switzerland*, 1976

TURNER OF OXFORD

MARTIN HARDIE, *William Turner of Oxford*, Old Water-Colour Society's Club, vol. IX, 1931–2, pp. 1–23
LUKE HERRMANN, *William Turner of Oxford*, Connoisseur, vol. CLXII, August 1966

CORNELIUS VARLEY

MESSRS COLNAGHI, *Cornelius Varley*, Exhibition Catalogue, 1973

JOHN VARLEY

RANDALL DAVIES, *John Varley*, Old Water-Colour Society's Club, vol. II, 1924–5, pp. 9–27

WARD

JULIA FRANKAU, *William Ward and James Ward*, 1904
G. E. FUSSELL, *James Ward, R.A.*, 1974

WEST

(*see under Flaxman;* IRWIN)
JAMES GALT, *Life, Studies and Works of Benjamin West*, 1820
GROSE EVANS, *Benjamin West and the Taste of his Times*, 1959
RUTH S. KRAEMER, *Drawings by Benjamin West and his Son, Raphael Lamar West*, Pierpont Morgan Library, 1975

WHEATLEY

MARY WEBSTER, *Francis Wheatley*, 1970

WILSON

BRINSLEY FORD, *The Drawings of Richard Wilson*, 1951
W. G. CONSTABLE, *Richard Wilson*, 1953

The Plates

A note on each plate will be found under the biography of the relevant artist. These biographies are arranged in alphabetical order at the end of the book.

1 EDWARD DAYES (1763–1804): *Ely Cathedral from the south-east* (detail of Plate 26)

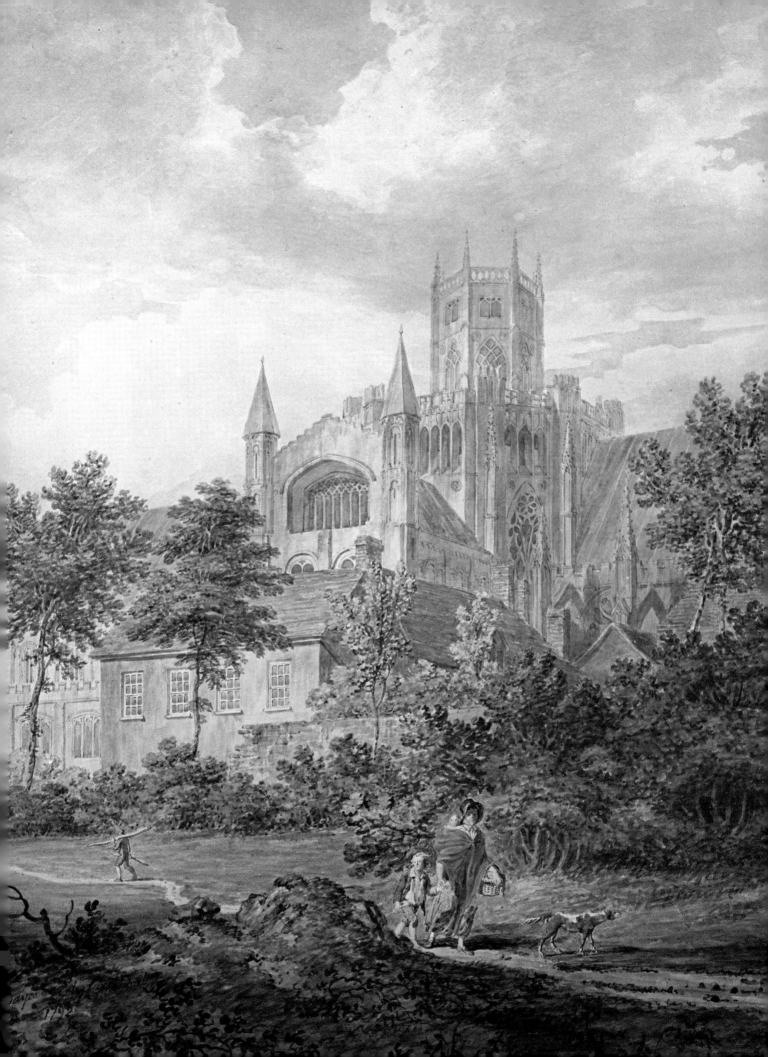

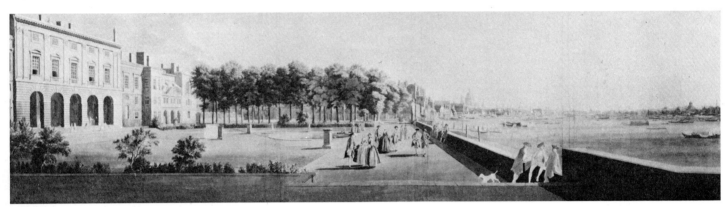

2 THOMAS SANDBY (1723–98): *View from the terrace of Somerset House looking east.* About 1755. Watercolour with some pen and ink over pencil, $20 \times 74\frac{3}{4}$ in. London, British Museum, Crowle Collection

3 ANTONIO CANALETTO (1697–1768): *London: view of the City from the terrace of Somerset House.* About 1747. Pen and grey ink and wash over pencil, $7\frac{7}{8} \times 19\frac{1}{16}$ in. Windsor, Her Majesty the Queen

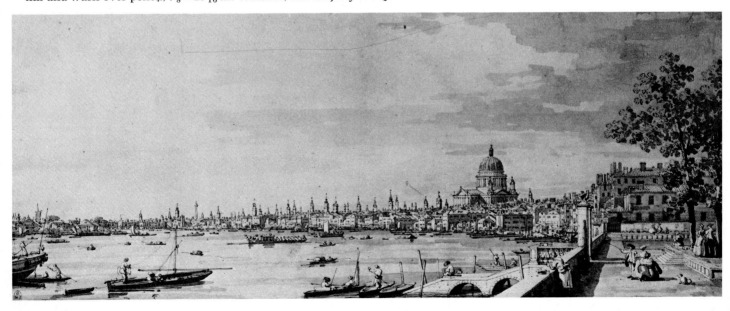

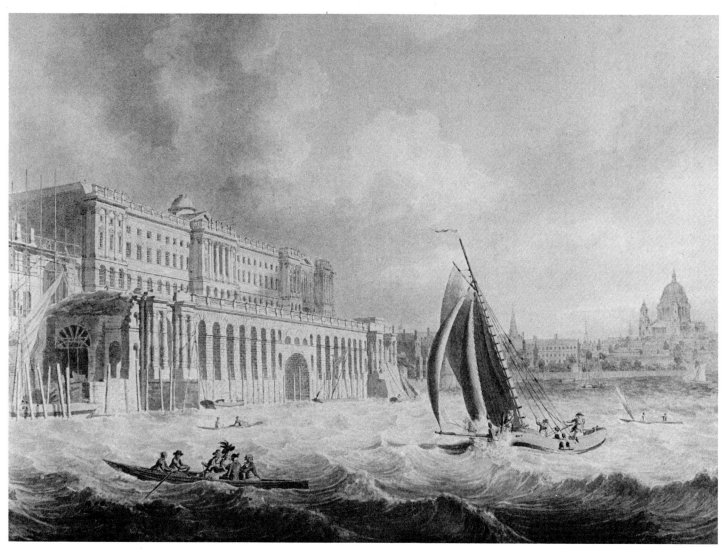

4 EDWARD DAYES (1763–1804): *Somerset House from the Thames.* 1788. Watercolour, pen and black ink, $16\frac{3}{4} \times 22\frac{5}{8}$ in. London, Courtauld Institute of Art, Spooner Bequest

5 PAUL SANDBY (1730–1809): *Sheet of studies of figures.* About 1750. Pen and ink and watercolour, $4\frac{5}{8} \times 9$ in. London, British Museum, Nn 6-19-38

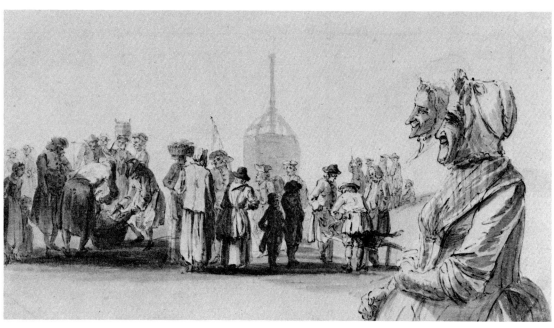

6 PAUL SANDBY
(1730–1809): *Hackwood
Park.* 1775. Watercolour,
pen and ink, $5\frac{1}{4} \times 7\frac{5}{16}$ in.
London, British Museum,
1904-8-19-148

7 PAUL SANDBY (1730–1809): *The artist's studio, 4 St George's Row, Bayswater.* About 1800. Watercolour and bodycolour on blue paper. 9×11 in. London, British Museum, 1904-8-19-63

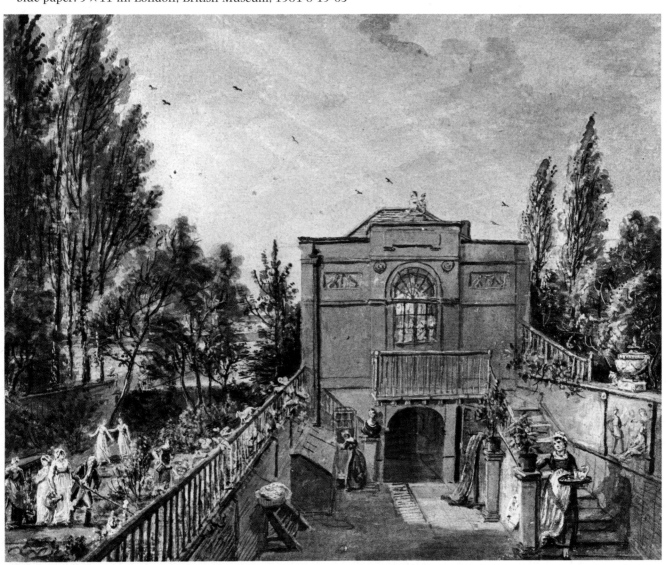

8 PAUL SANDBY (1730–1809): *Study of a sunset*. About 1790?. Bodycolour on blue paper, 5 × 4 in. London, British Museum, 1904-8-19-108

9 MICHAEL ANGELO ROOKER (1743 or 6 –1801): *The interior of the ruins of Buildwas Abbey, Shropshire*. About 1785. Watercolour, $9\frac{7}{16} \times 11\frac{7}{10}$ in. Oxford, Ashmolean Museum

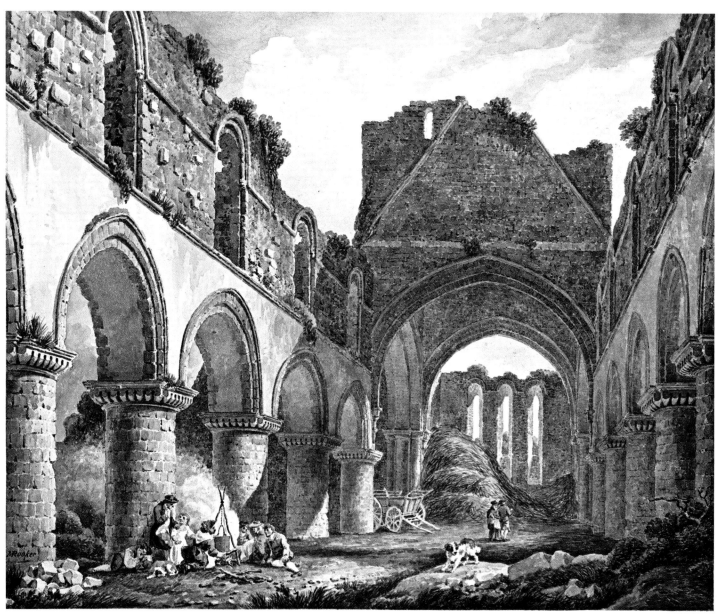

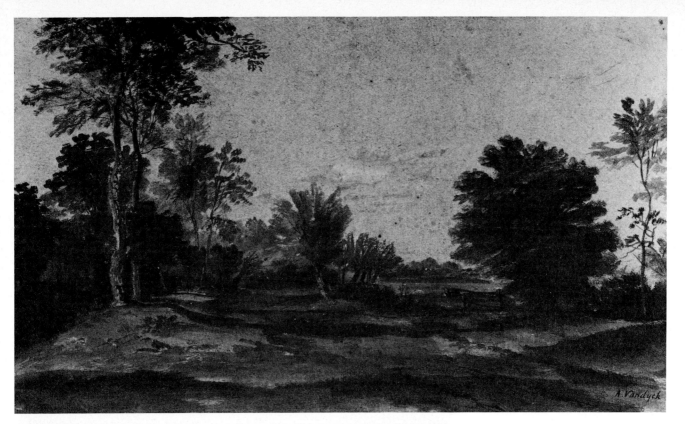

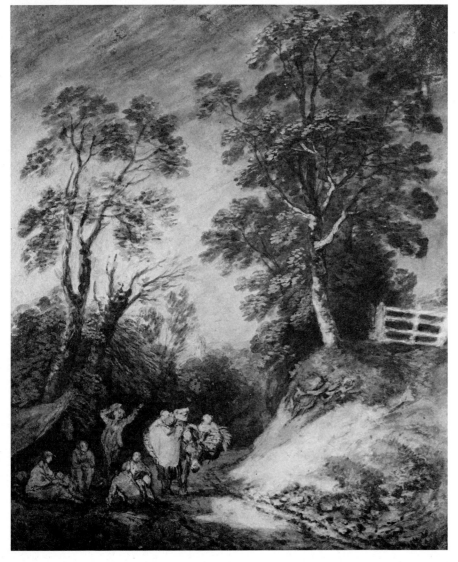

10 SIR ANTHONY VAN DYCK
(1599–1641): *Landscape study.*
About 1635. Watercolour and
bodycolour on grey paper,
$9\frac{5}{8} \times 15\frac{5}{8}$ in. London, British
Museum, 1895-9-15-1067

11 THOMAS GAINSBOROUGH (1727–88): *Wooded
landscape with gipsies.* About 1765.
Watercolour and bodycolour over pencil
on pale brown prepared paper, $11\frac{1}{4} \times 9\frac{1}{4}$ in.
United States, Yale Center for British
Art, Paul Mellon Collection

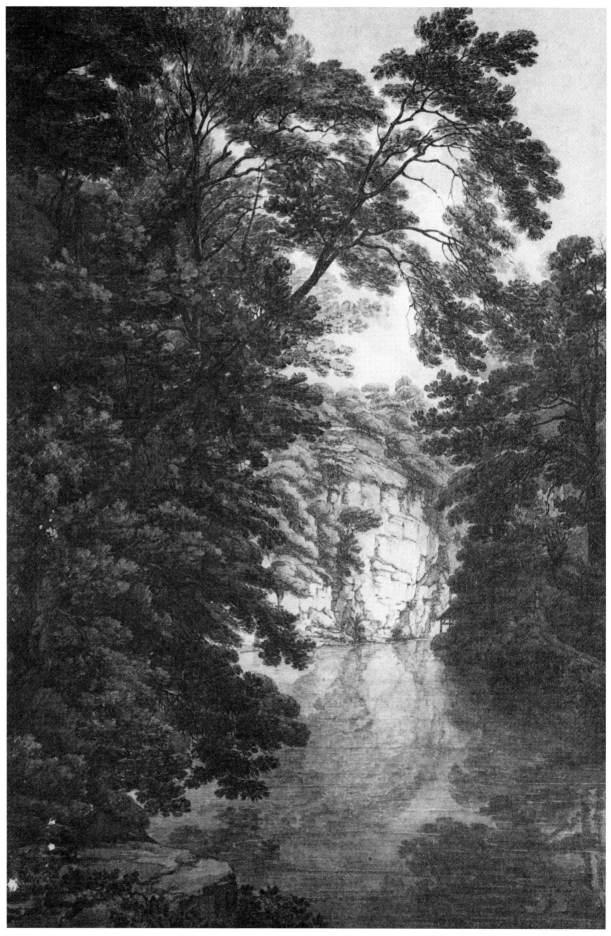

12 THOMAS HEARNE (1744–1806): *View of a river with overhanging trees*. About 1790. Watercolour over pencil, size unknown. Ireland, Private Collection

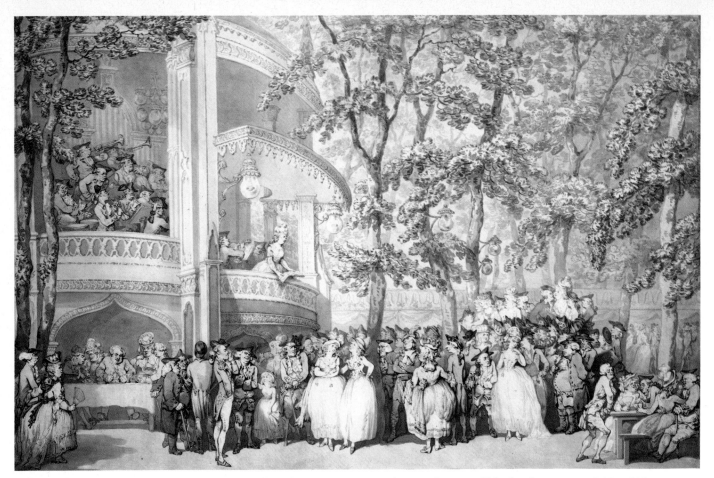

13 THOMAS ROWLANDSON (1756–1827): *Vauxhall Gardens*. 1784. Watercolour with pen and black ink over pencil, 19 × 29½ in. London, Victoria and Albert Museum, P13-1967

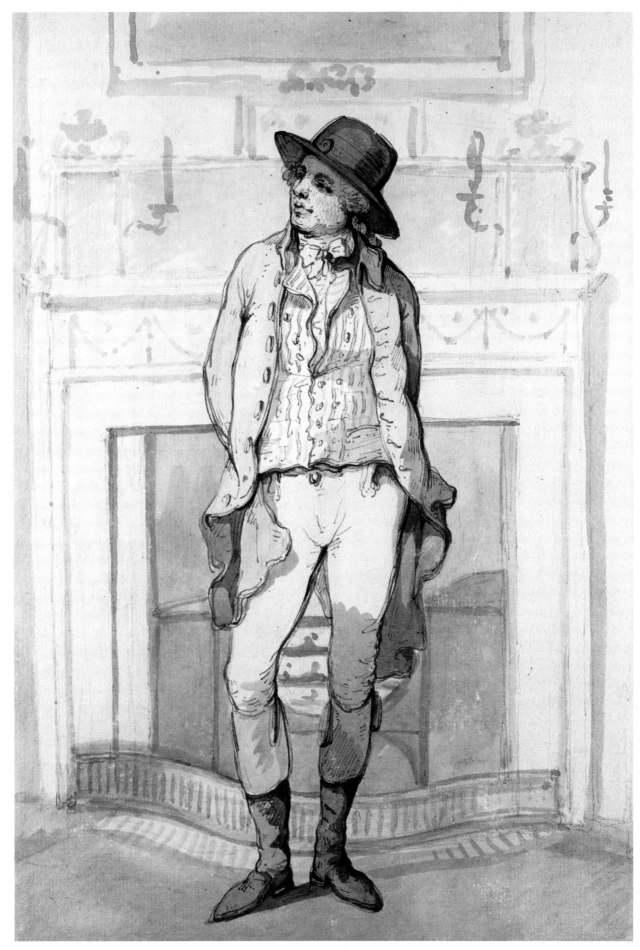

14 THOMAS ROWLANDSON (1756–1827): *George Morland*. About 1785. Pen and watercolour over pencil, $12\frac{5}{16} \times 8\frac{3}{8}$ in. London, British Museum, 1886-3-28-335

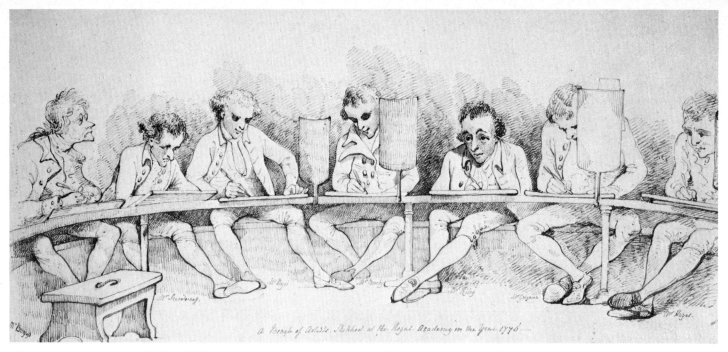

15 THOMAS ROWLANDSON (1756–1827): *A bench of artists.* 1776. Pen and black ink over pencil, 10 × 21 in. England, Private Collection

16 JOHN HAMILTON MORTIMER (1740–79): *Iphigenia's late procession from Kingston to Bristol.* 1776. Pen and black ink, $10\frac{1}{8} \times 13\frac{5}{8}$ in. England, Private Collection

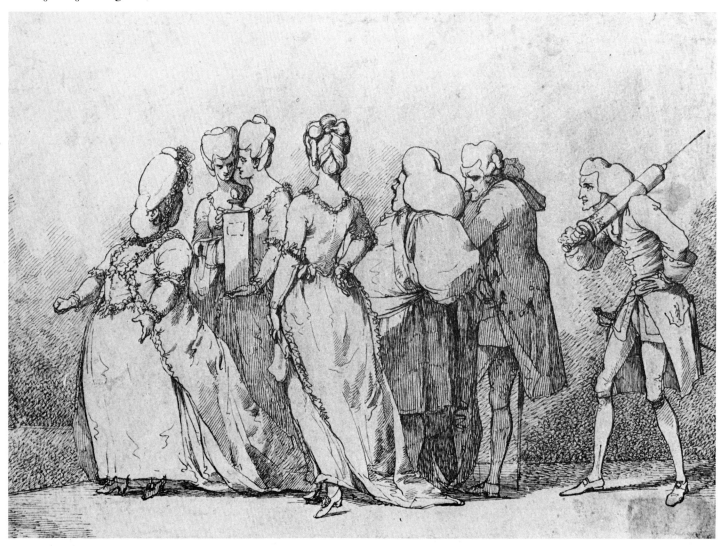

17 THOMAS ROWLANDSON (1756–1827): *An accident outside a cobbler's shop.* About 1778. Pen and black ink and watercolour over pencil, $8\frac{1}{4} \times 12\frac{5}{8}$ in. London, British Museum, 1970-5-30-7

18 WILLIAM HOGARTH (1697–1764): *Strolling actresses dressing in a barn.* 1738. Engraving $16\frac{3}{4} \times 21\frac{1}{4}$ in. Paulson No. 156

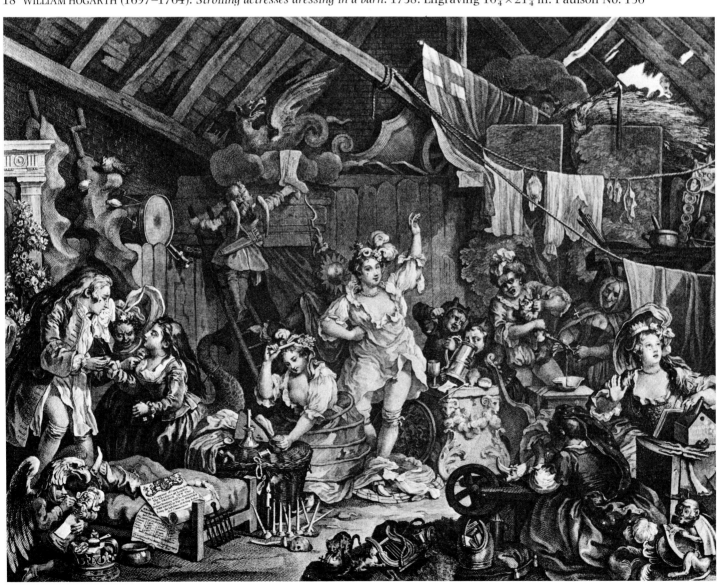

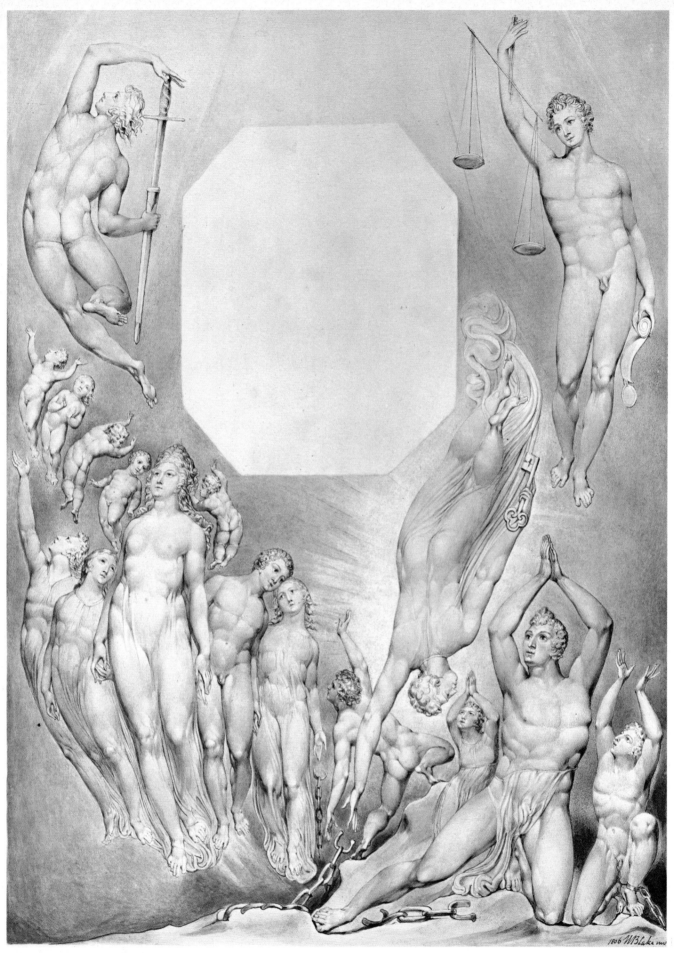

19 WILLIAM BLAKE (1757–1827): *The Resurrection of Pious Souls*. 1806. Watercolour over pencil, $16\frac{5}{8} \times 12\frac{3}{16}$ in.
London, British Museum, 1856-7-12-208

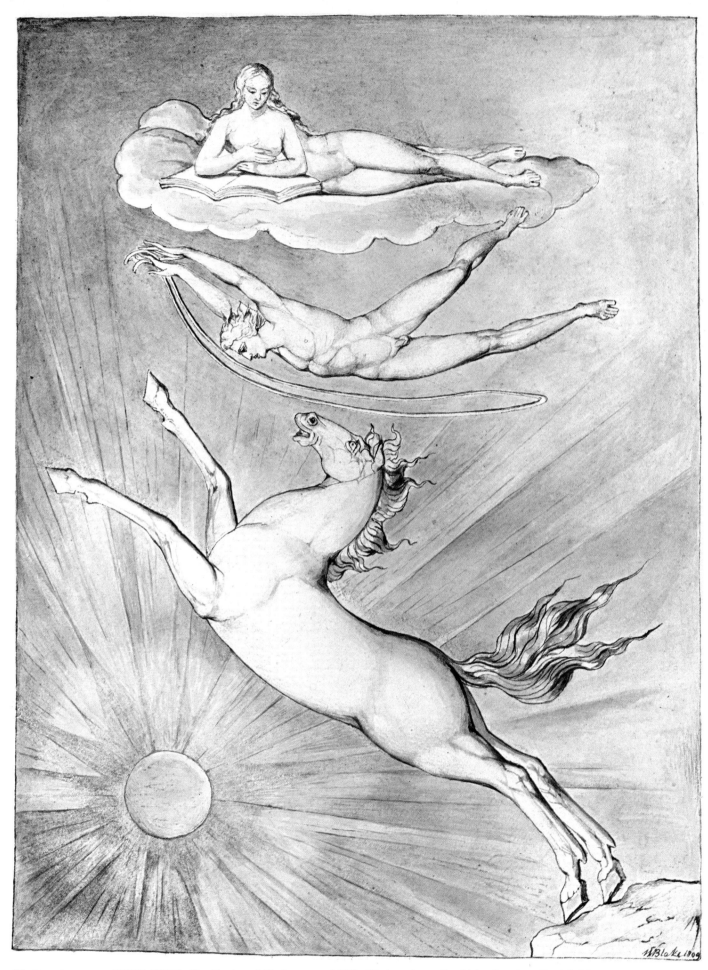

20 WILLIAM BLAKE (1757–1827): *The Genius of Shakespeare.* 1809. Watercolour, $9 \times 6\frac{3}{4}$ in. London, British Museum, 1954-11-13-1 (37)

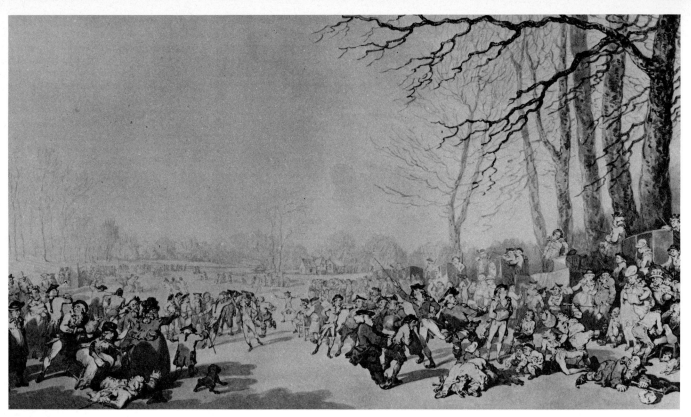

21 THOMAS ROWLANDSON (1756–1827): *Skating on the Serpentine*. About 1785. Watercolour, pen and black ink over pencil, $16\frac{11}{16} \times 29\frac{1}{8}$ in. Cardiff, National Museum of Wales

22 FRANCIS WHEATLEY (1747–1801): *A scene at an Irish fair*. 1783. Watercolour with some pen and ink, $15 \times 21\frac{1}{4}$ in. London, Victoria and Albert Museum, P45-1923

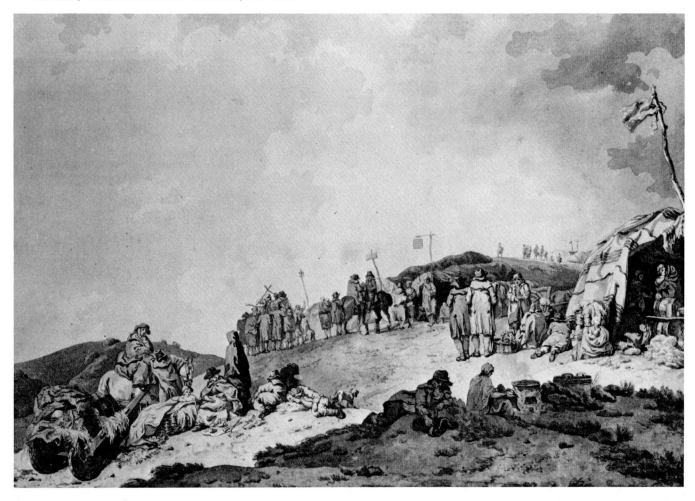

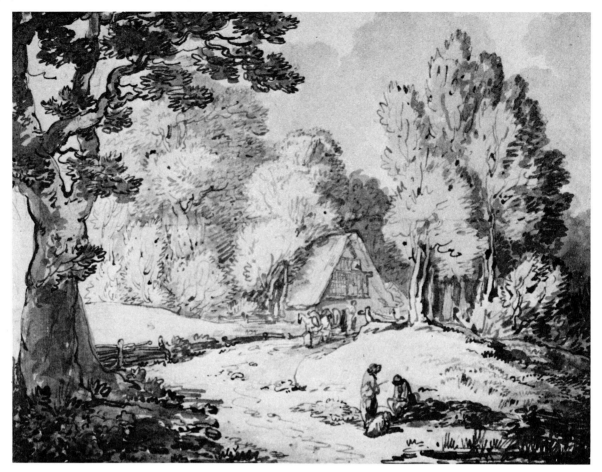

23 THOMAS ROWLANDSON (1756–1827): *Landscape composition.* About 1795. Brush and brown ink and wash, $7\frac{1}{4} \times 9\frac{1}{2}$ in. London, British Museum, 1863-1-10-248

24 THOMAS ROWLANDSON (1756–1827): *Three cavalrymen at a parade.* About 1787. Watercolour with brush and black ink, $6\frac{5}{16} \times 9\frac{1}{4}$ in. London, British Museum, 1939-12-9-31

25 WILLIAM BLAKE (1757–1827): *Beatrice on the car.* 1825. Pen and ink and watercolour over pencil. $14\frac{3}{8} \times 20\frac{1}{2}$ in. London, Tate Gallery, 3369

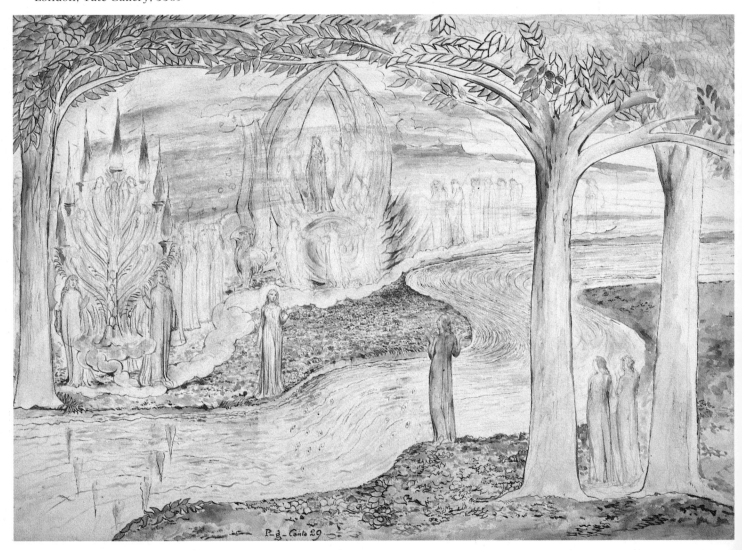

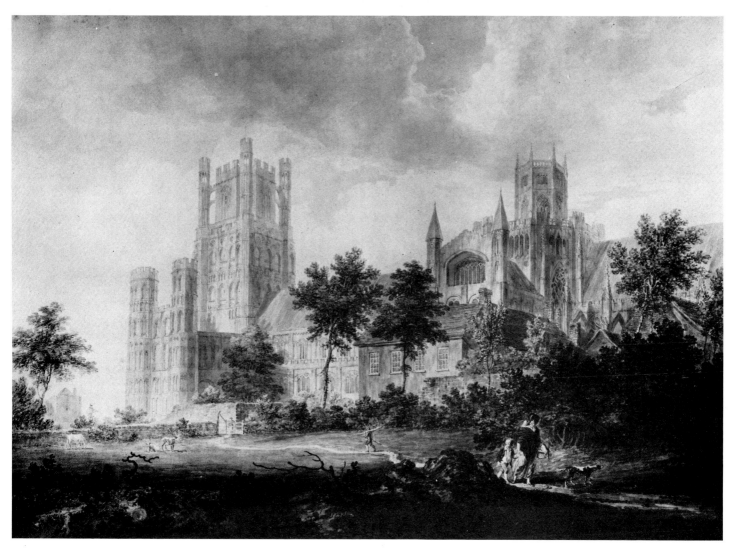

26 EDWARD DAYES (1763–1804): *Ely Cathedral from the south-east.* 1792. Watercolour over pencil, $26\frac{5}{8} \times 36\frac{3}{8}$ in. London, Victoria and Albert Museum, FA 674

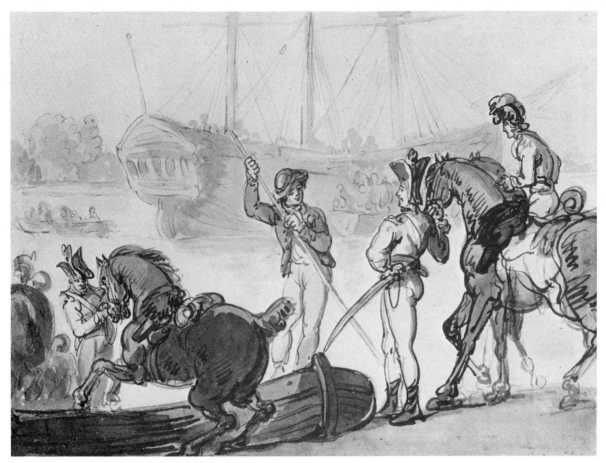

27 THOMAS ROWLANDSON (1756–1827): *Harbour scene with figures embarking in a ship's boat.* About 1815.
Pen and black ink and watercolour, $8\frac{1}{4} \times 10\frac{7}{8}$ in. London, Somerville & Simpson Ltd

28 THOMAS ROWLANDSON (1756–1827): *The historian animating the mind of the young painter.* 1784. Etching,
$7\frac{1}{2} \times 10\frac{7}{8}$ in. London, British Museum, Sat. No. 6724

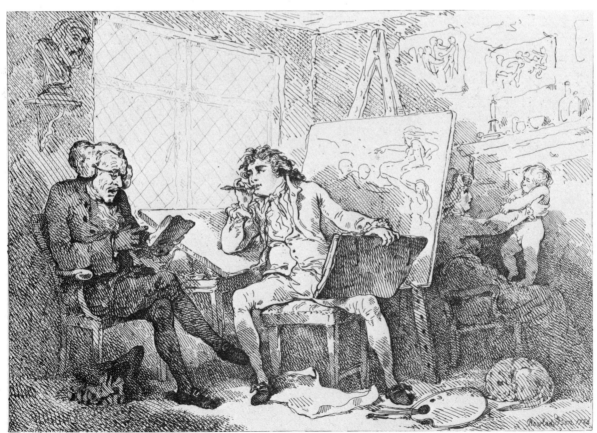

29 JAMES GILLRAY (1756–1815): *The fall of Icarus*. 1807. Pen and black and red ink, $13\frac{15}{16} \times 8\frac{9}{16}$ in. London, British Museum, 1867-10-12-603

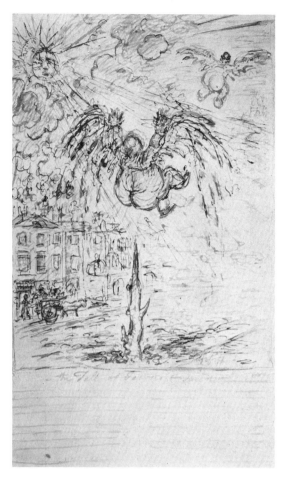

30 EDWARD FRANCIS BURNEY (1760–1848): *Amateurs of tye-wig music*. About 1810. Pen and ink and watercolour, $18\frac{1}{4} \times 27\frac{3}{4}$ in. United States, Yale Center for British Art, Paul Mellon Collection

31 THOMAS STOTHARD (1755–1834): *Illustration to the Decameron of Boccaccio in Pickering's edition*, 1825. Watercolour, 10¾×8 in. England, Private Collection

32 JOHN FLAXMAN (1755–1826): *Deliver the captive.* About 1790. Pen and wash, $7\frac{3}{4} \times 12\frac{7}{8}$ in. London, British Museum, 1888-5-3-66

33 BENJAMIN WEST (1738–1820): *Children at play.* About 1780. Bodycolour, $11\frac{3}{8} \times 12\frac{7}{8}$ in. London, British Museum, 1871-6-10-755

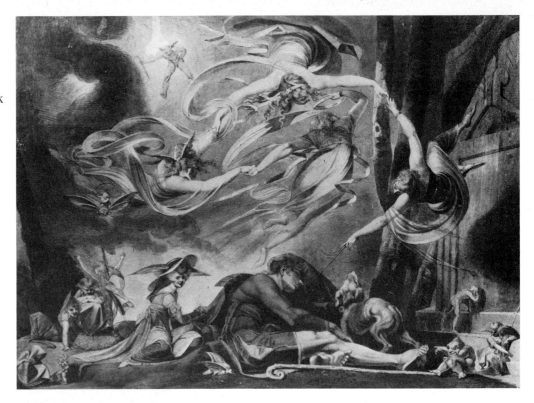

34 JOHANN HEINRICH FUSELI (1741–1825): *The shepherd's dream.* 1786. Pencil, red chalk and wash, $12\frac{3}{4} \times 15\frac{3}{4}$ in. Vienna, Albertina

35 JOHANN HEINRICH FUSELI (1741–1825): *A woman at her toilet.* About 1806. Pencil and watercolour, $17\frac{1}{2} \times 11\frac{1}{2}$ in. England, Private Collection

36 RICHARD WESTALL (1765–1836): *Boreas and Orytheia.* About 1795?. Watercolour and bodycolour, $24 \times 19\frac{1}{16}$ in. Oxford, Ashmolean Museum

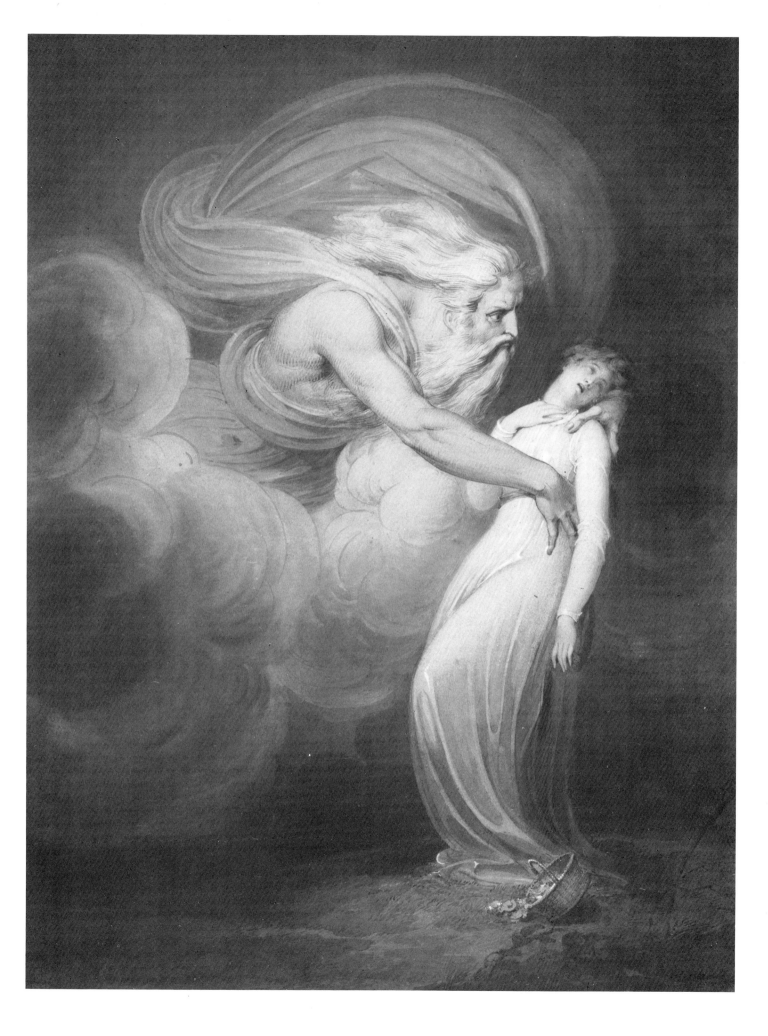

37 WILLIAM BLAKE (1757–1827): *Naomi entreating Ruth and Orpah to return to the Land of Moab.* About 1795. Colour printed drawing, 17 × 23 in. London, Victoria and Albert Museum, 69-1894

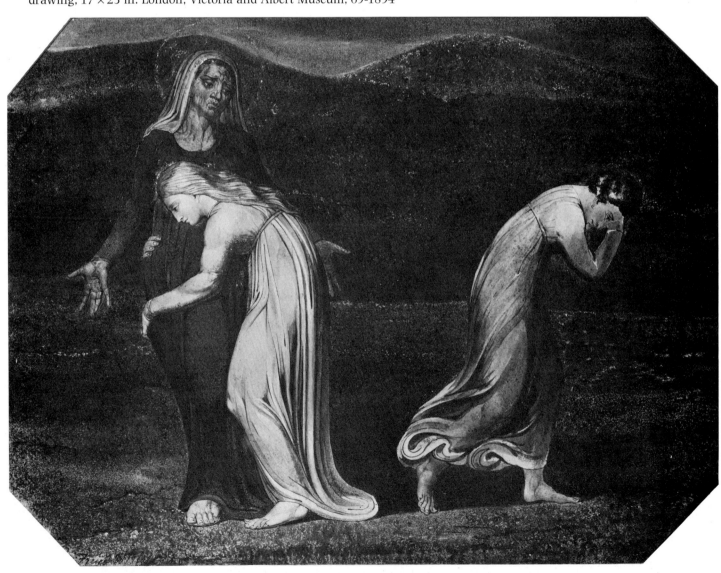

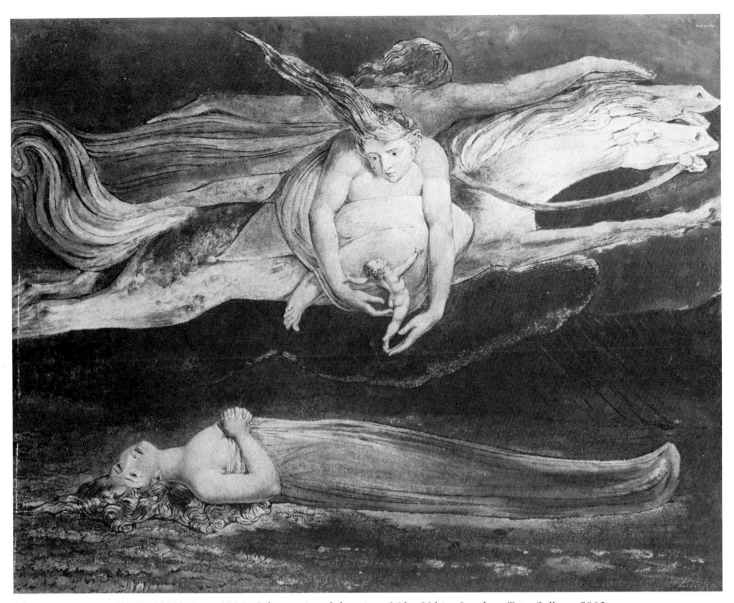

38 WILLIAM BLAKE (1757–1827): *Pity.* 1795. Colour printed drawing, $16\frac{3}{4} \times 21\frac{1}{4}$ in. London, Tate Gallery, 5062

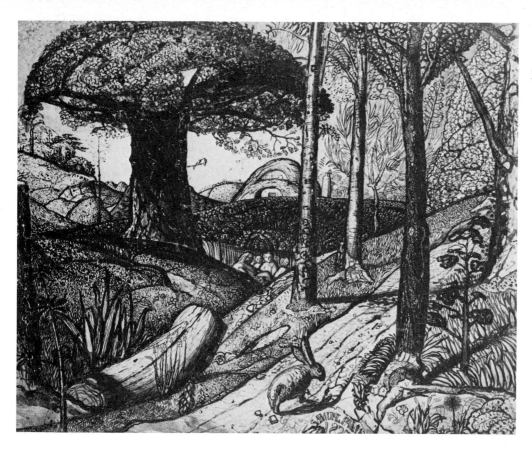

39 SAMUEL PALMER (1805–81):
Early morning. 1825. Pen and
wash and brown ink, with
gum. $7\frac{3}{4} \times 9\frac{1}{8}$ in. Oxford,
Ashmolean Museum

40 SAMUEL PALMER (1805–81): *Sepham Barn ('The Valley of Vision').* About 1830. Pen and brown ink and grey wash
heightened with white bodycolour, $11 \times 17\frac{1}{2}$ in. United States, Yale Center for British Art, Paul Mellon Collection

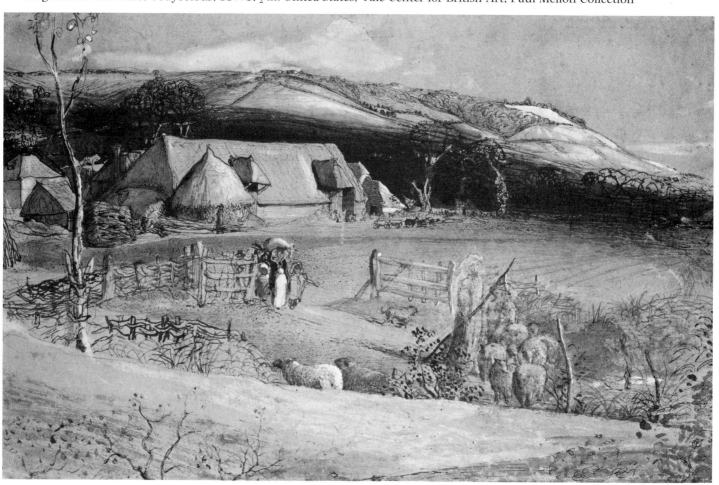

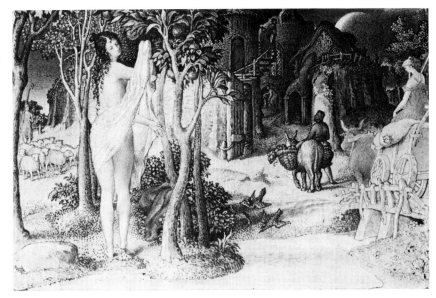

41 EDWARD CALVERT (1799–1883): *The primitive city.* 1822. Watercolour with pen and ink, $3\frac{1}{8} \times 4\frac{1}{2}$ in. London, British Museum, 1947-2-17-1

42 JOHN LINNELL (1792–1882): *Pike Pool on the River Dove, Derbyshire.* 1814. Watercolour, $8\frac{1}{8} \times 9\frac{3}{8}$ in. Cambridge, Fitzwilliam Museum

43 SAMUEL PALMER (1805–81): *The lonely tower.* About 1870. Watercolour and bodycolour on board, $20 \times 27\frac{3}{4}$ in. United States, Yale Center for British Art, Paul Mellon Collection

44 ALEXANDER COZENS (*c*.1717–86): *Landscape with a woman seated by a dark pool.* About 1770. Brown and grey washes, circular, 11×11 in. United States, Private Collection

45 JONATHAN SKELTON (*c*.1735–59): *Scene at Blackheath, with Vanbrugh's Castle*. 1757. Pencil and watercolour, 9 × 21 in. Greenwich, Local History Library

46 WILLIAM TAVERNER (1703–72): *Landscape with a distant view of an Italian town*. About 1750?. Watercolour over pencil, $8\frac{7}{8} \times 15\frac{1}{2}$ in. Cambridge, Fitzwilliam Museum

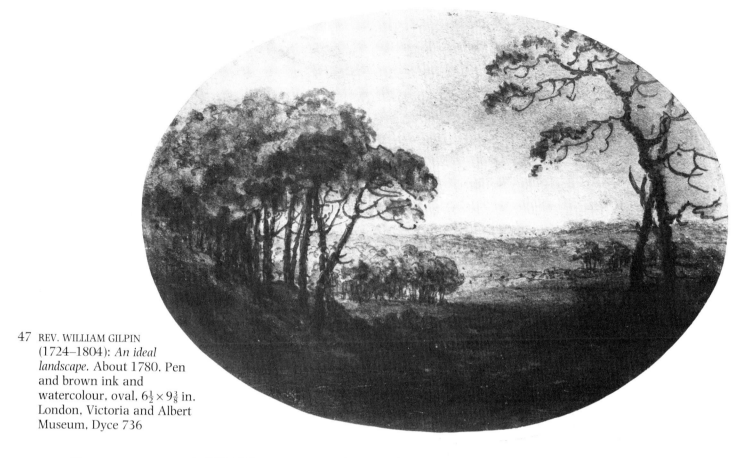

47 REV. WILLIAM GILPIN
(1724–1804): *An ideal
landscape.* About 1780. Pen
and brown ink and
watercolour, oval, $6\frac{1}{2} \times 9\frac{3}{8}$ in.
London, Victoria and Albert
Museum, Dyce 736

48 ALEXANDER COZENS (*c*.1717–86): *Distant view of Greenwich.* 1766. Pen and brown wash and watercolour with some
bodycolour, $16\frac{7}{8} \times 22\frac{1}{8}$ in. England, Private Collection

49 ALEXANDER COZENS (*c.*1717–86): *Mountain peaks* (*'Blot'*). About 1786. Etching and aquatint, $9\frac{3}{8} \times 12\frac{3}{8}$ in. London, British Museum, 1920-5-12-101

50 ALEXANDER COZENS (*c.*1717–86): *Mountain peaks.* About 1780–5. Brown wash on pale brown prepared paper, $9\frac{1}{16} \times 11\frac{15}{16}$ in. London, British Museum, 1928-4-17-4

51 JOHN ROBERT COZENS (1752–97): *The Aiguille Verte.* About 1780. Watercolour, $17\frac{1}{8} \times 24\frac{1}{4}$ in. England. Private Collection

52 JOHN ROBERT COZENS (1752–97): *The Reichenbach between Grindelwald and Oberhaslital.* About 1776. Pen and brown ink and grey wash, $9\frac{1}{8} \times 14$ in. London, British Museum, 1900-4-11-14

53 JOHN ROBERT COZENS (1752–97): *Windsor Castle from the south-west.* About 1790. Watercolour, $19\frac{3}{8} \times 27\frac{3}{8}$ in. Bedford, Cecil Higgins Art Gallery

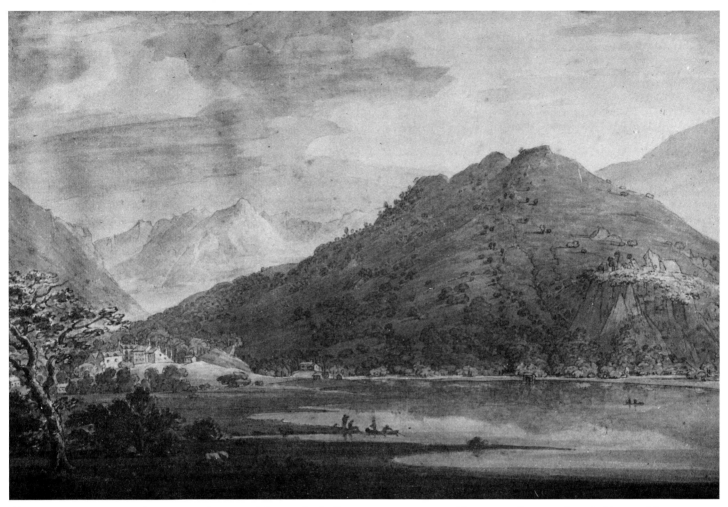

54 THOMAS SUNDERLAND (1744–1823): *View of the Head of Ullswater.* 1789. Pen and brown and grey ink with blue and brown wash, $10\frac{1}{4} \times 14$ in. England, Private Collection

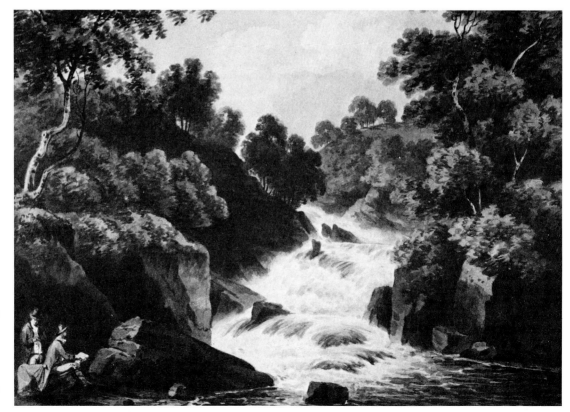

55 JOHN 'WARWICK' SMITH (1749–1831): *The waterfall at Rhaider-y-Wenol, north Wales.* 1791. Watercolour, $6\frac{5}{8} \times 9\frac{3}{4}$ in. England, Private Collection

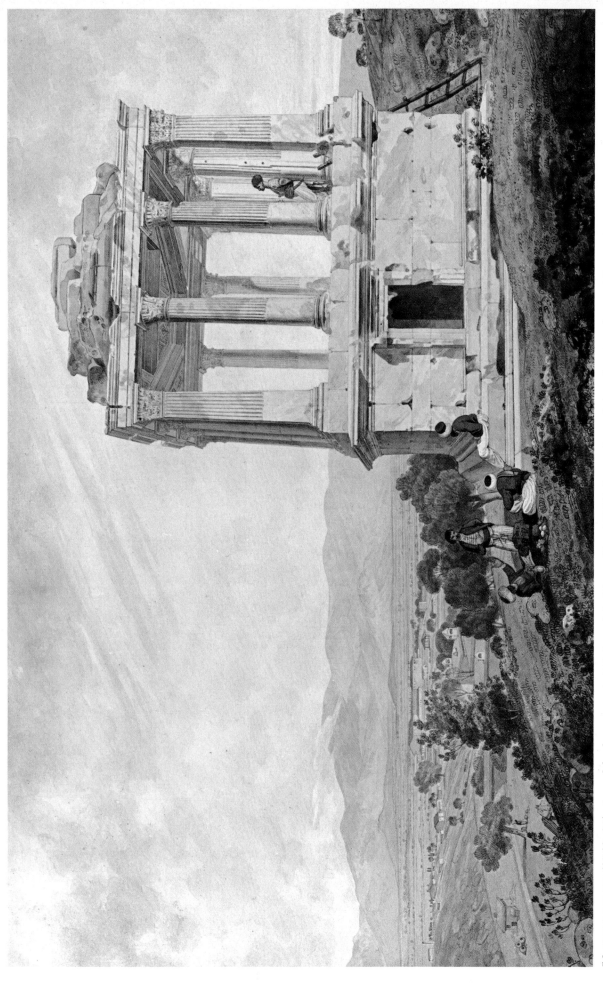

56 WILLIAM PARS (1742–82): *A sepulchral monument at Mylasa, Asia Minor. About 1765. Pen and grey ink and watercolour, with some bodycolour and gum.* $11\frac{1}{4} \times 18\frac{1}{2}$ in. London, British Museum. Mm 11-73

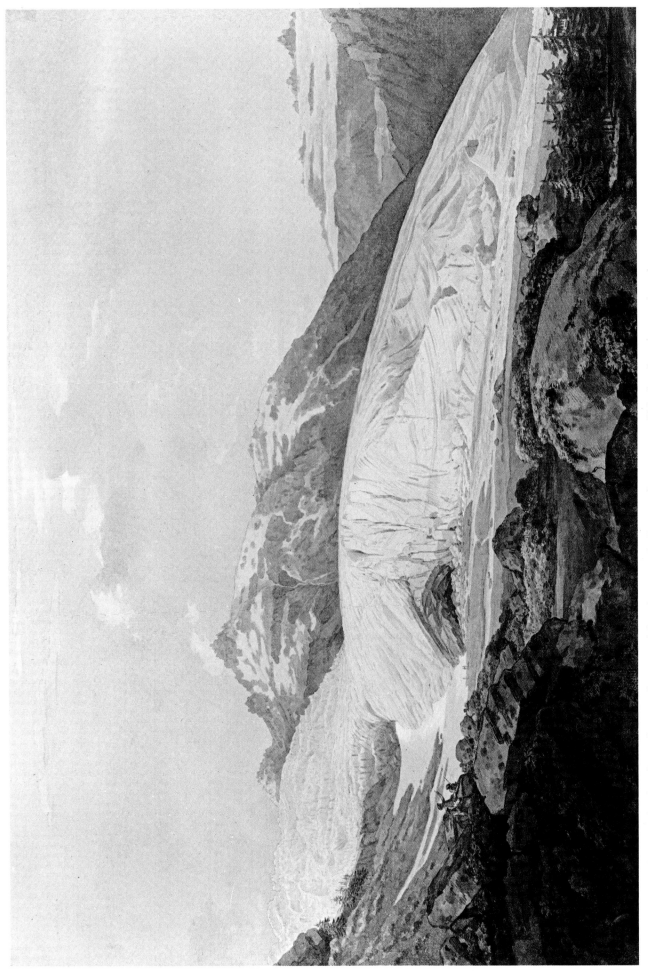

57 WILLIAM PARS (1742–82): *The Rhone glacier and source of the Rhone*. 1770. Watercolour, pen and black ink over pencil, with some gum, 13 × 19¼ in. London, British Museum, 1870-5-14-1219

58 THOMAS MONRO (1759–1833): *A landscape composition with cart.* About 1790?. Black ink and wash, $7 \times 6\frac{1}{4}$ in. England, Private Collection

59 JOSEPH FARINGTON (1747–1821): *The Ouse Bridge, York.* 1783. Pen and brown ink and grey wash, $17\frac{1}{2} \times 29\frac{1}{2}$ in. York, City Art Gallery, 668/1953

60 HENRY EDRIDGE (1769–1821): *A farm near Bushey.* 1811. Watercolour, $12\frac{3}{8} \times 18\frac{7}{16}$ in. London, British Museum, 1845-8-18-7

61 HENRY MONRO (1791–1814): *Bellis's Farm.* 1812. Pen and brown ink and white chalk on buff paper, $11\frac{3}{4} \times 16\frac{1}{2}$ in. England, Private Collection

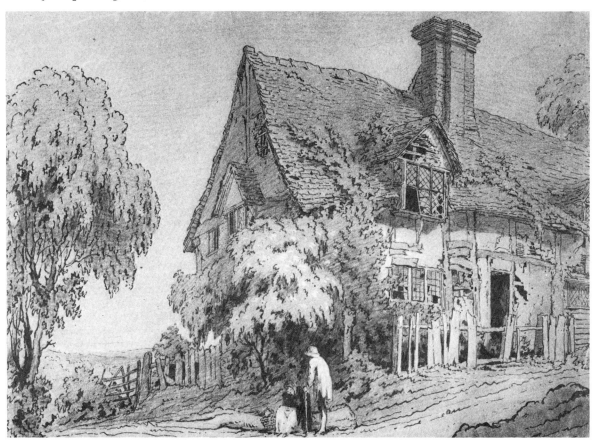

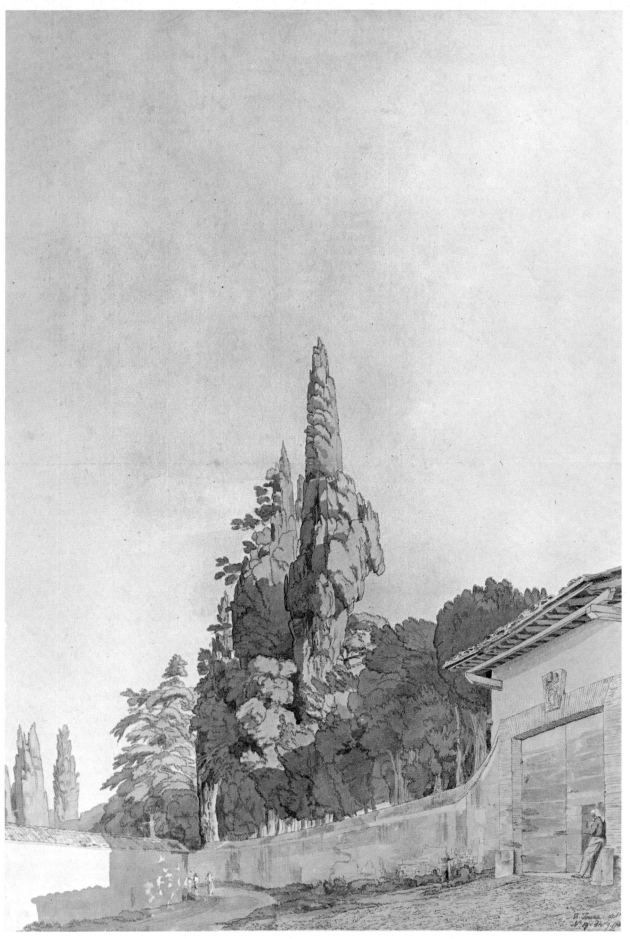

62 FRANCIS TOWNE (1739/40–1816): *The gateway to the Villa Ludovisi*. 1780. Pen and black ink and watercolour,
$18\frac{1}{4} \times 12\frac{5}{8}$ in. London, British Museum, U.731

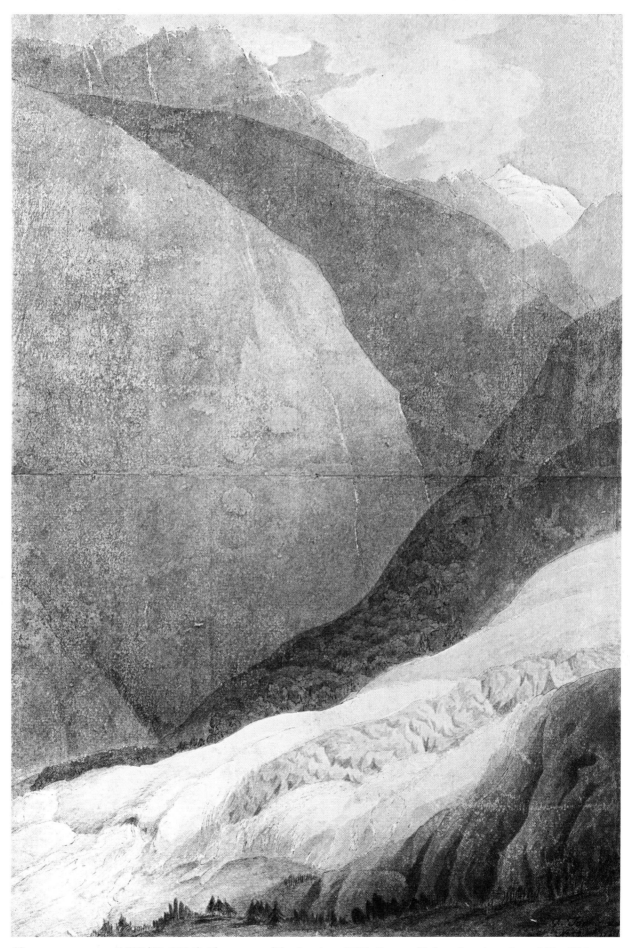

63 FRANCIS TOWNE (1739/40–1816): *The source of the Arveiron*. 1781. Pen and ink and watercolour, $12\frac{1}{4} \times 8\frac{3}{8}$ in. England, Private Collection

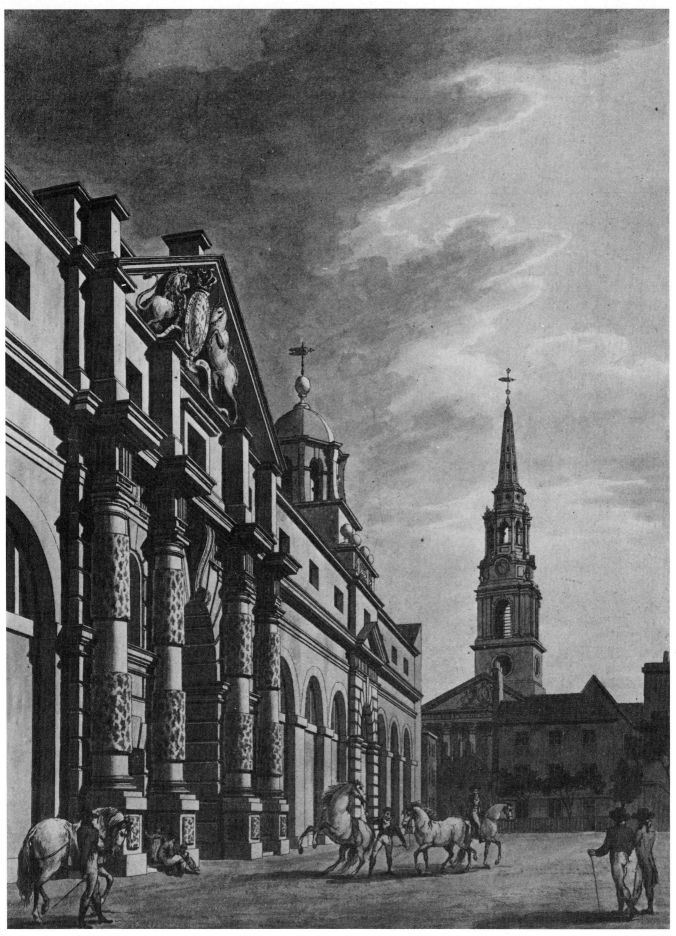

64 THOMAS MALTON the Younger (1748–1804): *King's Mews, Charing Cross.* About 1792. Etched outline with watercolour, 11¾ × 8¾ in. London, British Museum, 1871-12-9-996

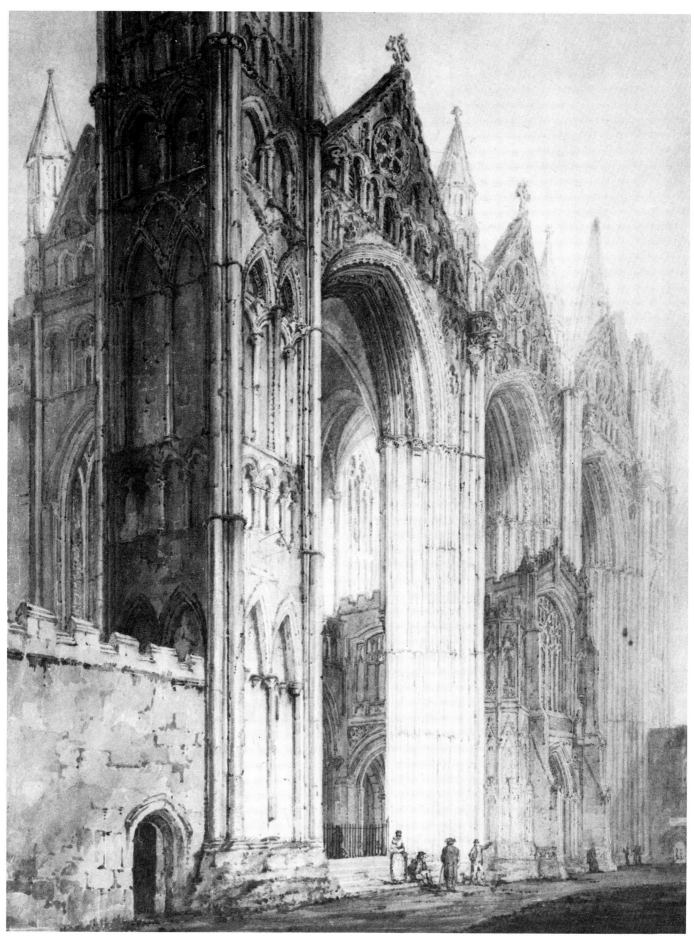

65 THOMAS GIRTIN (1775–1802): *The west front of Peterborough Cathedral.* 1794. Watercolour over pencil, $17\frac{3}{4} \times 14$ in. University of Manchester, Whitworth Art Gallery

66 WILLIAM PARS (1742–82): *Ariccia, with the Palazzo Chigi.* About 1780. Watercolour with some pen over traces of pencil, $19\frac{1}{4} \times 23\frac{1}{8}$ in. London, Victoria and Albert Museum, AL 5725

67 JOHN 'WARWICK' SMITH (1749–1831): *The Roman Forum.* About 1780. Watercolour, $13\frac{3}{4} \times 21\frac{5}{16}$ in. London, British Museum, 1936-7-4-19

68 FRANCIS TOWNE (1739/40–1816): *Ariccia.* 1781. Pen and ink and watercolour, $12\frac{3}{4} \times 18\frac{1}{2}$ in. London, British Museum, U.1348

69 THOMAS GIRTIN (1775–1802): *View of Rochester from the north.* 1790. Watercolour over pencil, $12\frac{5}{8} \times 18\frac{3}{8}$ in. United States, Yale Center for British Art, Paul Mellon Collection

70 THOMAS GIRTIN (1775–1802): *The Thames from Westminster to Somerset House.* About 1800. Watercolour, $9\frac{1}{2} \times 21\frac{1}{4}$ in. London, British Museum, 1855-2-14-27

71 THOMAS GIRTIN (1775–1802): *View on the Wharfe, near Farnley, Yorkshire.* About 1801. Watercolour, $12\frac{1}{2} \times 20\frac{3}{4}$ in. England, Private Collection

72 THOMAS GIRTIN (1775–1802): *Jedburgh.* 1800. Watercolour, $11\frac{3}{8} \times 20\frac{1}{2}$ in. England, Private Collection

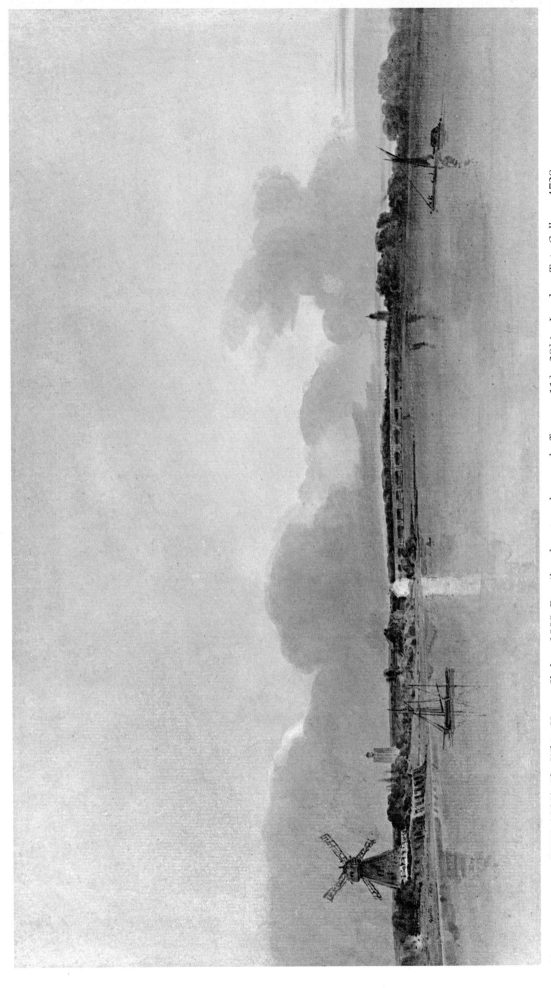

73 THOMAS GIRTIN (1775–1802): *The White House, Chelsea.* 1800. Pencil and watercolour on buff paper, $11\frac{3}{4} \times 20\frac{1}{4}$ in. London, Tate Gallery. 4728

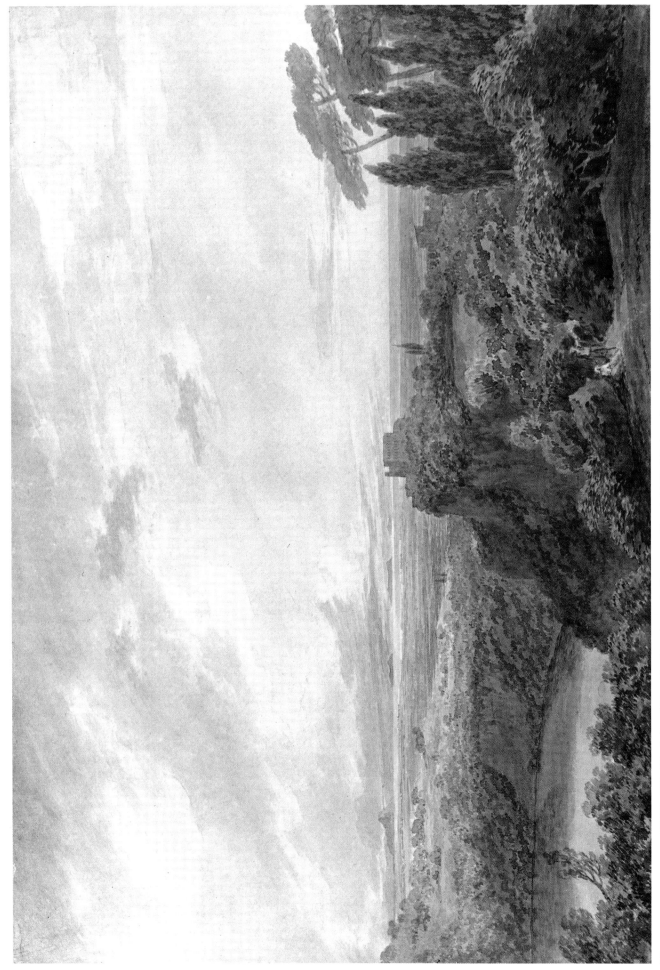

74 JOHN ROBERT COZENS (1752–97): *The Lake of Nemi looking towards Genzano*. About 1785. Watercolour over pencil. $14\frac{3}{16} \times 21$ in. London. British Museum. Gg 3-395

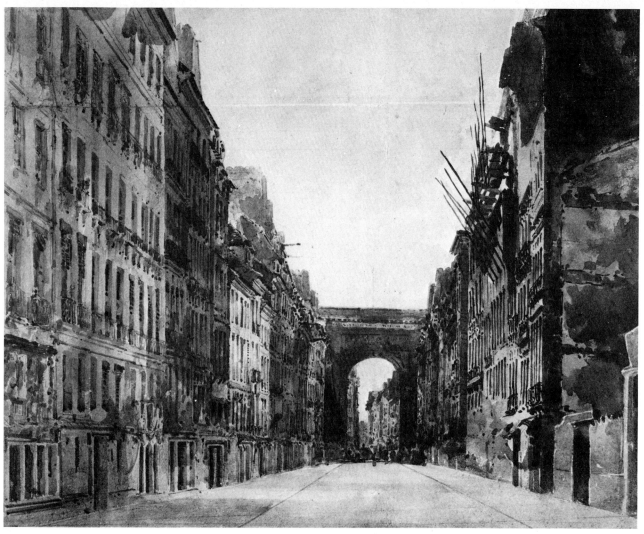

75 THOMAS GIRTIN (1775–1802): *The Rue St Denis, Paris.* 1802. Watercolour, $15\frac{1}{2} \times 19\frac{1}{4}$ in. England, Private Collection

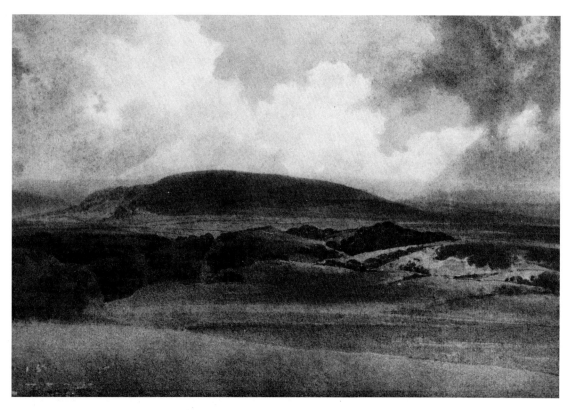

76 THOMAS GIRTIN (1775–1802): *Storiths Heights, Wharfedale, Yorkshire.* 1802. Watercolour, $11\frac{1}{8} \times 16\frac{3}{8}$ in. England, Private Collection

77 JAMES WARD (1769–1859):*Landscape near Cheadle*. About 1805?. Watercolour, $9\frac{1}{2} \times 12\frac{3}{8}$ in. London, British Museum, 1941-12-13-714

78 WILLIAM DANIELL (1769–1837): *Durham*. 1805. Watercolour, $15\frac{3}{4} \times 25\frac{5}{8}$ in. London, Victoria and Albert Museum, 1744-1871

79 JOHN VARLEY (1778–1842): *View of Snowdon across Llyn Padarn.* 1813. Watercolour, $11\frac{3}{8} \times 17$ in. London, Albany Gallery

80 JOHN VARLEY (1778–1842): *A castle on the coast.* About 1820?. Watercolour over pencil, $5\frac{3}{8} \times 7\frac{1}{8}$ in. From the collection of the late C. E. Hughes

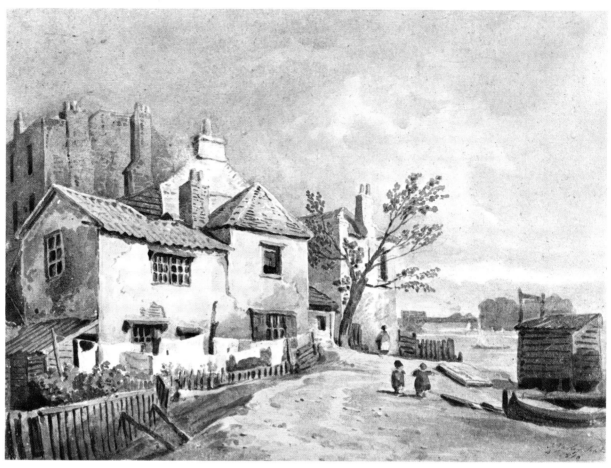

81 JOHN VARLEY (1778–1842): *The horse-ferry, Millbank.* 1816. Watercolour, $10\frac{11}{16} \times 14\frac{3}{16}$ in. London, British Museum, 1880-11-13-1246

82 CORNELIUS VARLEY (1781–1873): *Snowdon from Llanllyfni.* 1805. Watercolour over pencil, $8\frac{1}{4} \times 11\frac{7}{8}$ in. Birmingham, City Museum and Art Gallery

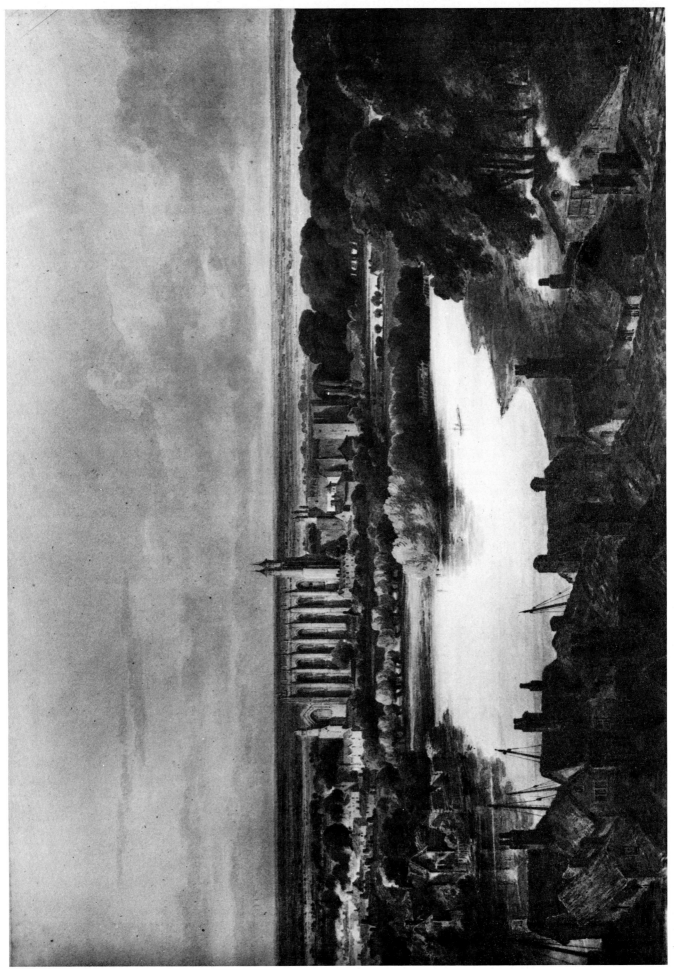

83 PETER DE WINT (1784–1849): *Eton: twilight*. About 1805. Watercolour, 19½ × 28 in. Birmingham, City Museum and Art Gallery

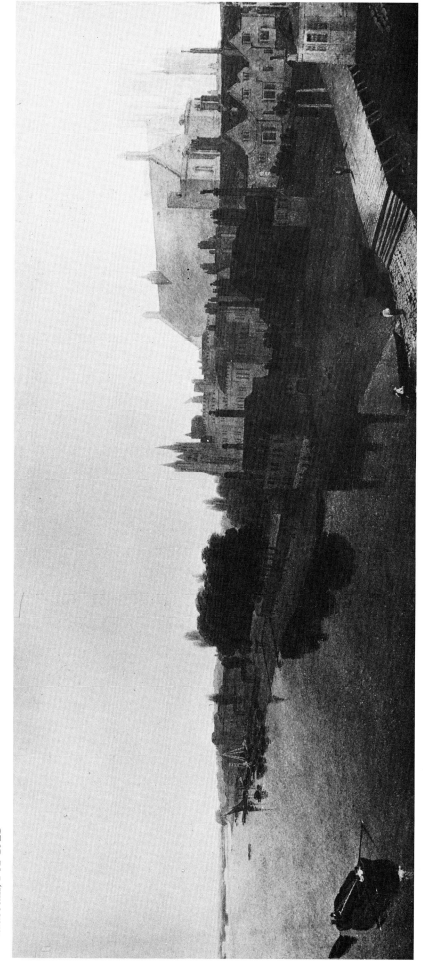

84 PETER DE WINT (1784–1849): *Westminster Palace, Hall and Abbey.* About 1815. Watercolour, $13\frac{3}{4} \times 31\frac{5}{8}$ in. London, Victoria and Albert Museum, P61-1921

85 PETER DE WINT
(1784–1849): *Still-life
with a ginger jar and
mushrooms.* About
1820?. Pencil and
watercolour, $8\frac{3}{8} \times 11\frac{1}{2}$ in.
London, British
Museum, 1890-5-12-61

86 PETER DE WINT (1784–1849): *Landscape with harvesters and a stormcloud.* About 1820. Watercolour, $10\frac{7}{8} \times 17\frac{7}{16}$ in.
London, British Museum, 1910-2-12-246

87 PETER DE WINT (1748–1849): *Travellers resting outside an inn.* About 1825. Watercolour, $12\frac{5}{8} \times 17\frac{3}{8}$ in. London, Spink and Son

88 FRANCIS NICHOLSON (1753–1844): *Stourhead: view looking towards King Alfred's Tower.* About 1816. Watercolour over pencil, $16\frac{3}{16} \times 22$ in. London, British Museum, 1944-10-14-143

89 JOHN GLOVER (1767–1849): *Landscape with cattle.* About 1820. Watercolour, $7\frac{1}{4} \times 10\frac{1}{4}$ in. Newcastle upon Tyne, Laing Art Gallery

90 ROBERT HILLS (1769–1844): *A village in snow.* 1819. Watercolour, $12\frac{1}{2} \times 16\frac{3}{4}$ in. England, Private Collection

91 WILLIAM TURNER OF OXFORD (1789–1862): *The Vale of Gloucester from Birdlip Hill.* About 1840?. Watercolour over pencil, $23\frac{3}{8} \times 35\frac{5}{8}$ in. England, Private Collection

92 WILLIAM HAVELL
(1782–1857): *A road under
trees in Knole Park, Kent.*
About 1810. Watercolour.
England, Private Collection

93 JOHN SELL COTMAN (1782–1842): *The market place, Norwich.* 1807. Pencil and watercolour, 14 × 22 in. Kendal, Abbot Hall Art Gallery

94 JOSHUA CRISTALL (1768–1847): *Sunset with fishing boats on Loch Fyne, Inverary.* About 1807. Pencil and watercolour, $9\frac{1}{8} \times 15\frac{1}{8}$ in. Oxford, Ashmolean Museum

95 JOHN SELL COTMAN (1782–1842): *The dismasted brig.* 1823. Watercolour over pencil, $7\frac{7}{8} \times 12\frac{1}{4}$ in. London, British Museum, 1902-5-14-32

96 JOHN SELL COTMAN (1782–1842): *Street scene in Alençon.* 1828. Watercolour, $16\frac{1}{2} \times 22\frac{3}{8}$ in. Birmingham City Museum and Art Gallery

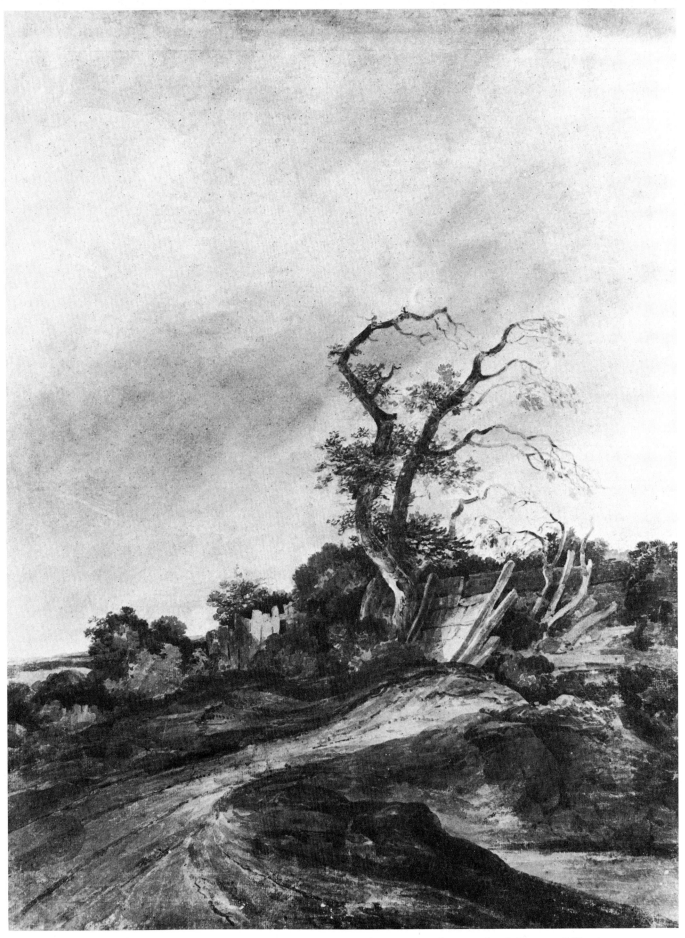

97 JOHN CROME (1768–1821): *The blasted oak.* About 1800. Watercolour, 23 × 17¼ in. England, Private Collection

98 JOHN SELL COTMAN (1782–1842): *The drop-gate, Duncombe Park.* 1803. Pencil and watercolour, $13 \times 9\frac{1}{8}$ in. London, British Museum, 1902-5-14-14

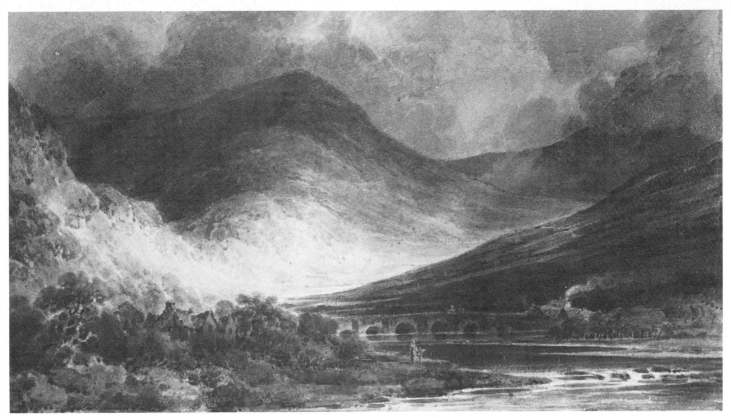

99 PAUL SANDBY MUNN (1773–1845): *Tan-y-Bwlch*. 1802. Watercolour and scraping-out, $7\frac{3}{4} \times 12\frac{7}{8}$ in. London, Victoria and
Albert Museum, P87-1938

100 and 101 JOHN SELL COTMAN (1782–1842): *Croyland Abbey*. 1802. Watercolour, $11\frac{7}{16} \times 21\frac{1}{8}$ in. London, British Museum,
1859-5-28-118

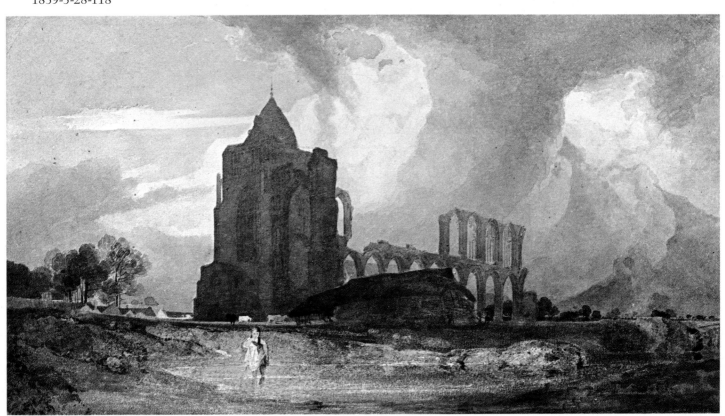

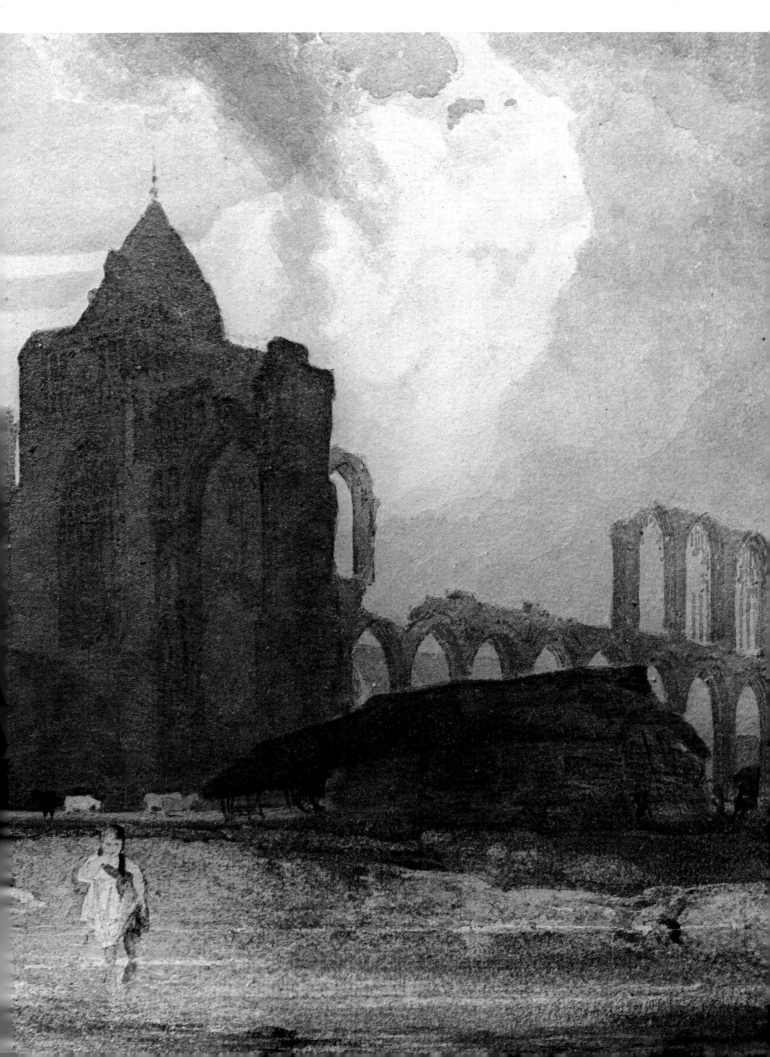

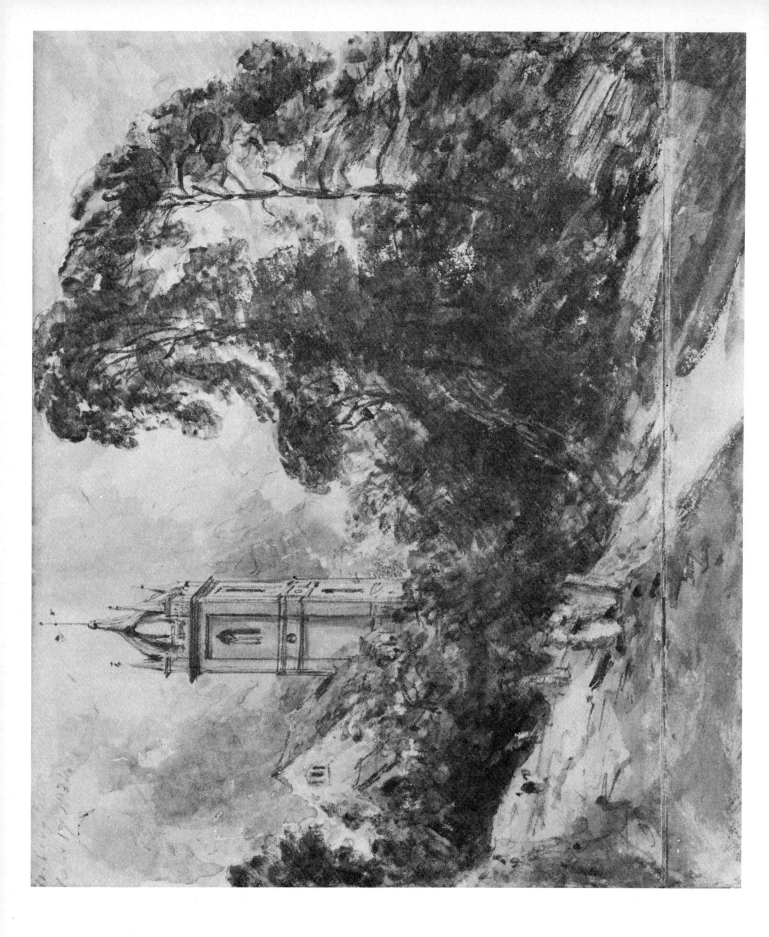

102 JOHN CONSTABLE (1776–1837): *Tillington Church*. 1834. Pencil and watercolour with some black ink applied with a brush. $9\frac{1}{8} \times 10\frac{7}{16}$ in. (An additional strip of paper attached to the bottom of the sheet.) London, British Museum, 1888-2-15-49

103 JOHN CONSTABLE (1776–1837): *Stonehenge*. About 1836. Pencil and watercolour, squared for enlargement. $6\frac{1}{8} \times 10$ in. London, Victoria and Albert Museum, 800-1888

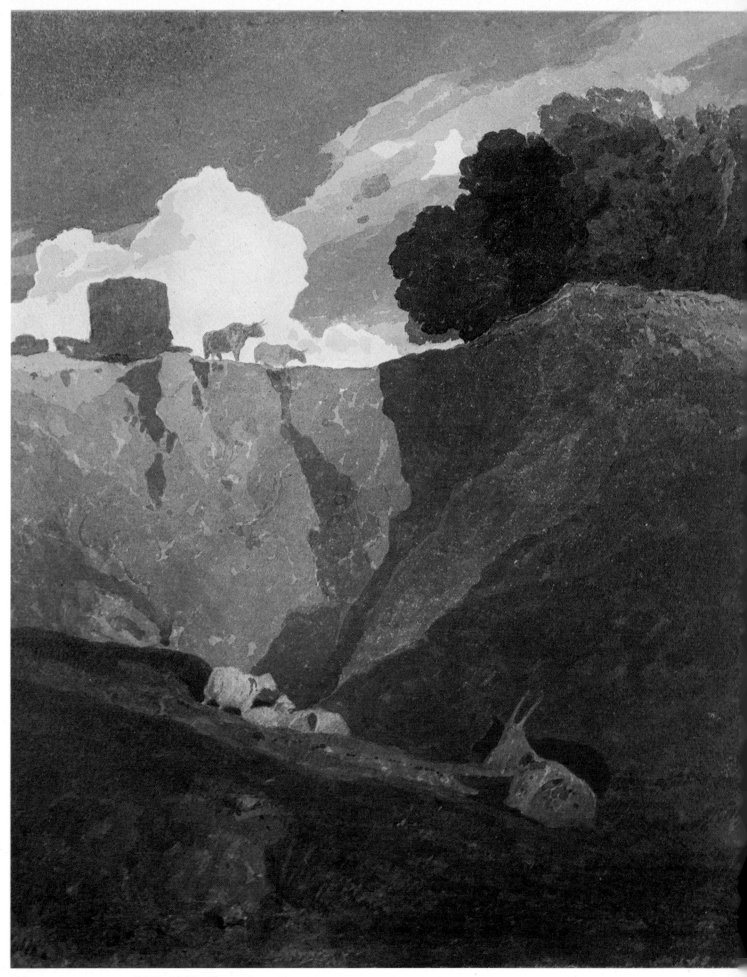

104 JOHN SELL COTMAN (1782–1842): *The marl pit.* About 1809. Watercolour, $11\frac{3}{8} \times 10\frac{1}{8}$ in. Norwich, Castle Museum

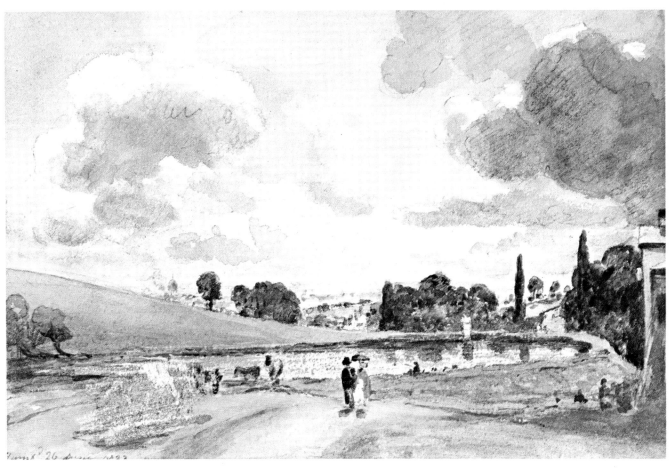

105 JOHN CONSTABLE (1776–1837): *The Lower Pond, Hampstead.* 1823. Pencil and watercolour, $6\frac{11}{16} \times 10$ in. London, British Museum, 1888-2-15-58

106 JOHN CONSTABLE (1776–1837): *Littlehampton: stormy sky.* 1835. Watercolour and scraping-out, $4\frac{1}{2} \times 7\frac{5}{16}$ in. London, British Museum, 1888-2-15-36

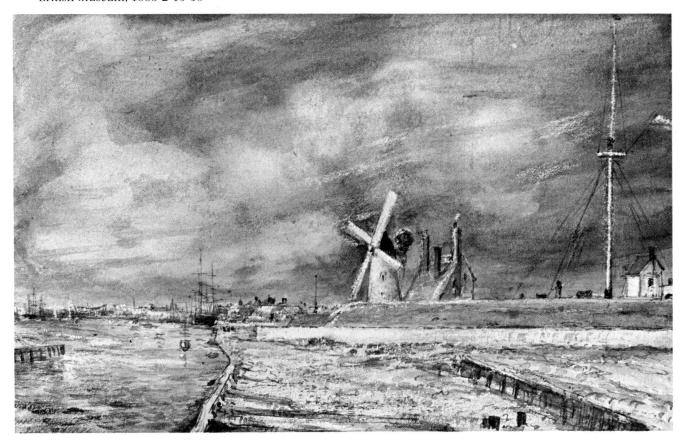

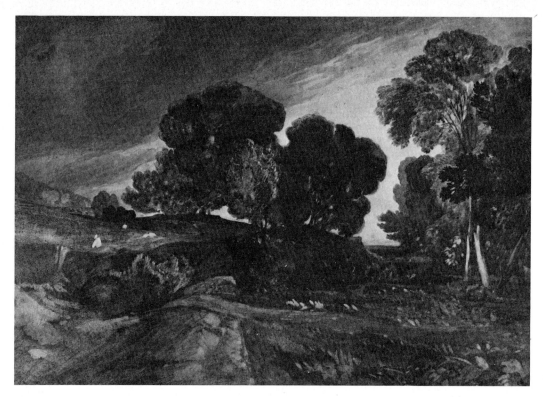

107 JOHN SELL COTMAN (1782–1842): *Landscape at Whitlingham.* About 1835. Watercolour, $11\frac{5}{18} \times 16\frac{5}{16}$ in. London, British Museum, 1902-5-14-35

108 JOHN CONSTABLE (1776–1837): *Borrowdale: looking towards Glaramara.* 1806. Pencil and watercolour, $13\frac{1}{2} \times 17\frac{1}{2}$ in. London, Victoria and Albert Museum, 181-1888

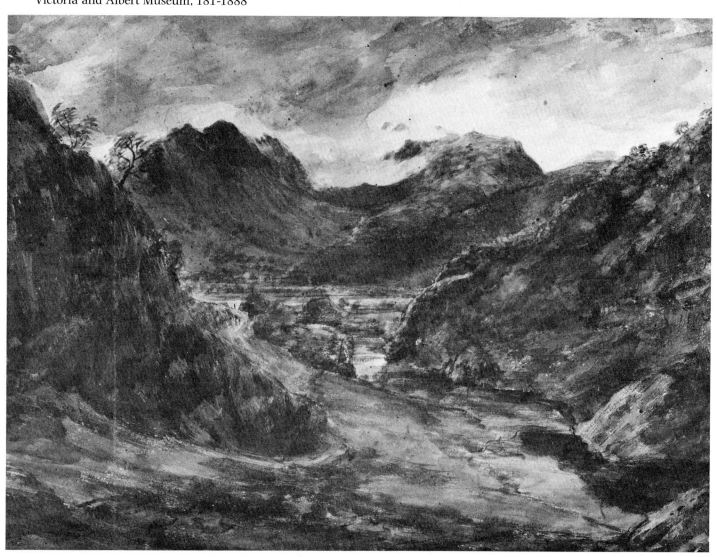

109 DAVID COX (1783–1859): *The Brocas, Eton*. About 1812. Watercolour, $8\frac{1}{2} \times 13\frac{1}{8}$ in. London, British Museum, 1900-8-24-492

110 DAVID COX (1783–1859): *Hay-on-Wye*. About 1820. Watercolour, $9\frac{11}{16} \times 14$ in. London, British Museum, 1915-3-13-6

111 JOHN CONSTABLE (1776–1837): *View over London with a double rainbow.* 1831. Watercolour with scraping-out, $7\frac{3}{4} \times 12\frac{3}{4}$ in. London, British Museum, 1888-2-15-55

112 JOHN CONSTABLE (1776–1837): *Old Sarum.* 1834. Watercolour and scraping-out, $11\frac{7}{8} \times 19\frac{1}{8}$ in. London, Victoria and Albert Museum, 1628-1888

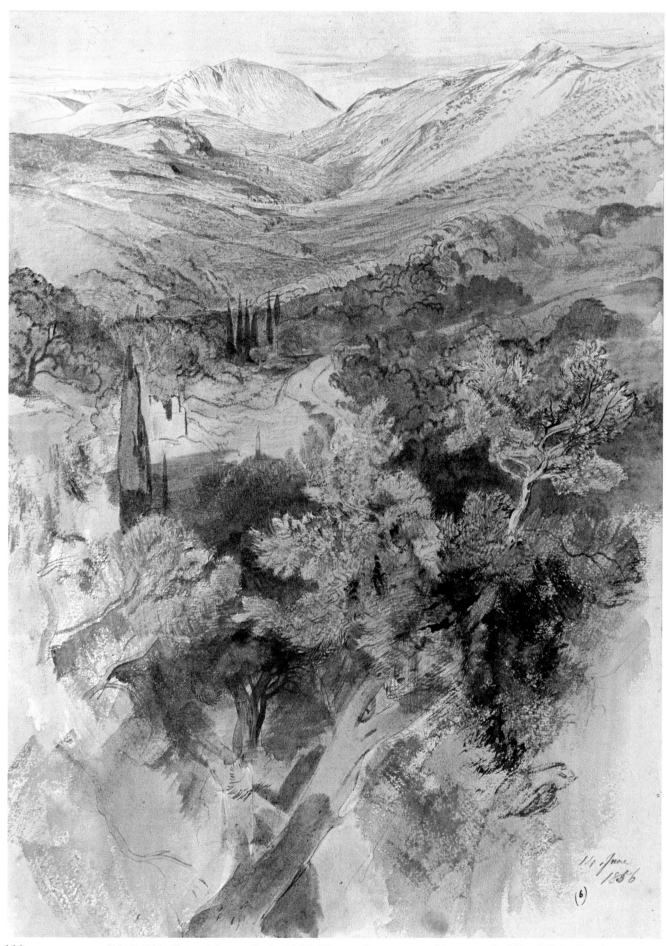

113 EDWARD LEAR (1812–88): *Choropiskeros, Corfu.* 1856. Watercolour, pen and brown ink, $18\frac{7}{8} \times 13\frac{3}{4}$ in. London, British Museum, 1929-6-11-70

114 THOMAS SHOTTER BOYS (1803–74): *A windmill at sunset*. About 1830?. Watercolour, $3\frac{3}{8} \times 4\frac{13}{16}$ in. London, British Museum, 1858-4-25-1

115 WILLIAM CALLOW (1812–1908): *The Neu Münster, Würzburg*. 1846. Pencil and watercolour with some pen, size unknown. England, Private Collection

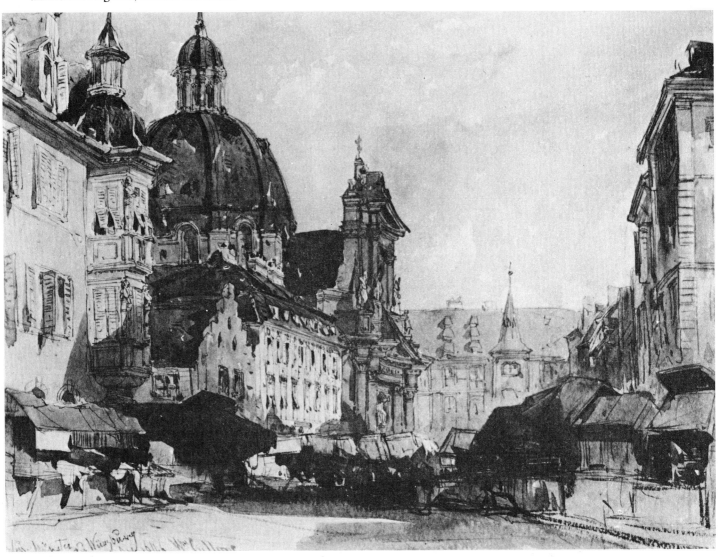

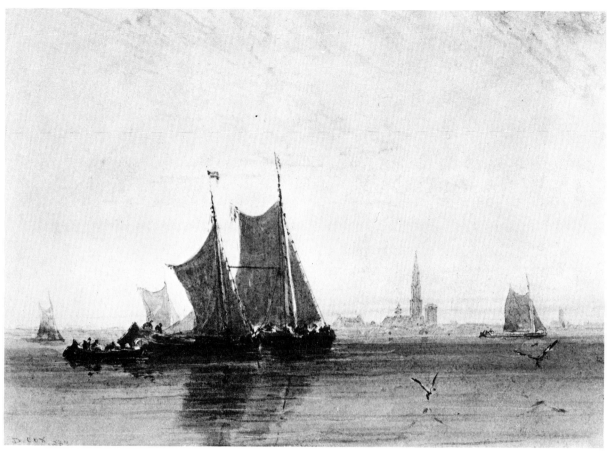

116 DAVID COX (1783–1859): *Antwerp – morning.* 1832. Watercolour over pencil, $7\frac{1}{4} \times 10$ in. United States, Yale Center for British Art, Paul Mellon Collection

117 DAVID COX (1783–1859): *Going to market.* About 1840. Watercolour over pencil, $13\frac{3}{4} \times 19\frac{1}{4}$ in. Amsterdam, Rijksmuseum

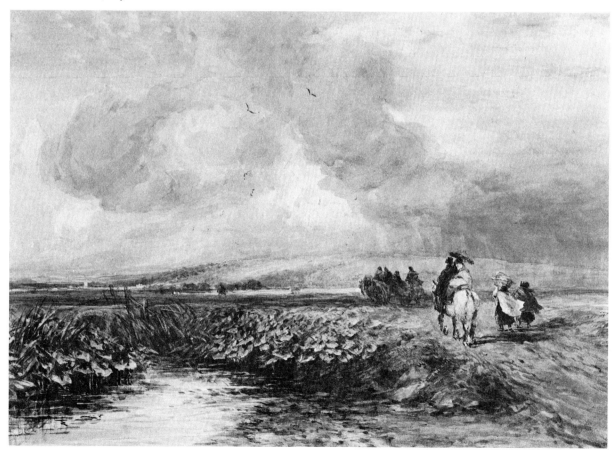

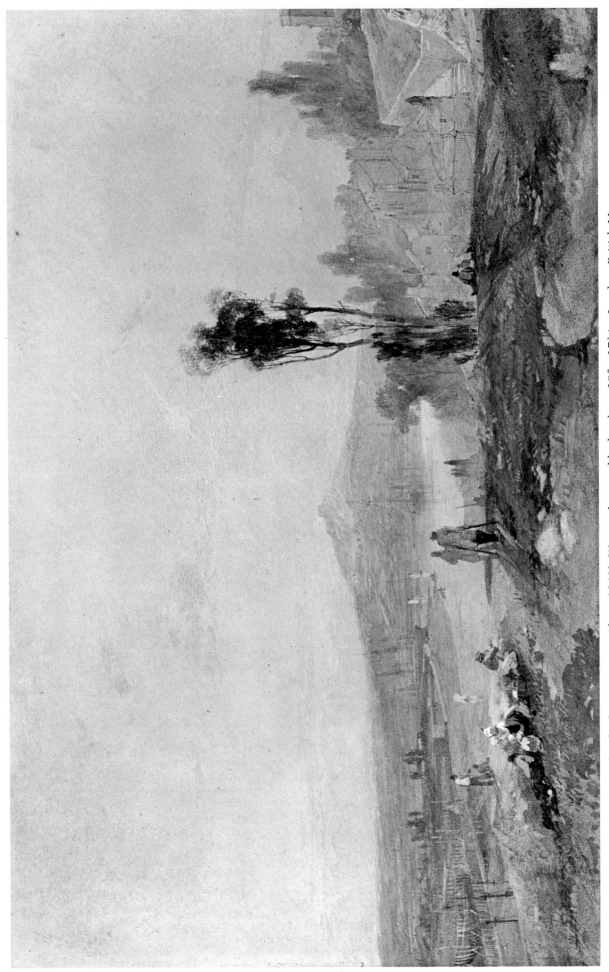

118 JAMES BAKER PYNE (1800–70): *Italian landscape: evening*. About 1840?. Watercolour and bodycolour. $10\frac{7}{8} \times 17\frac{1}{8}$ in. London. British Museum
1958-7-12-365

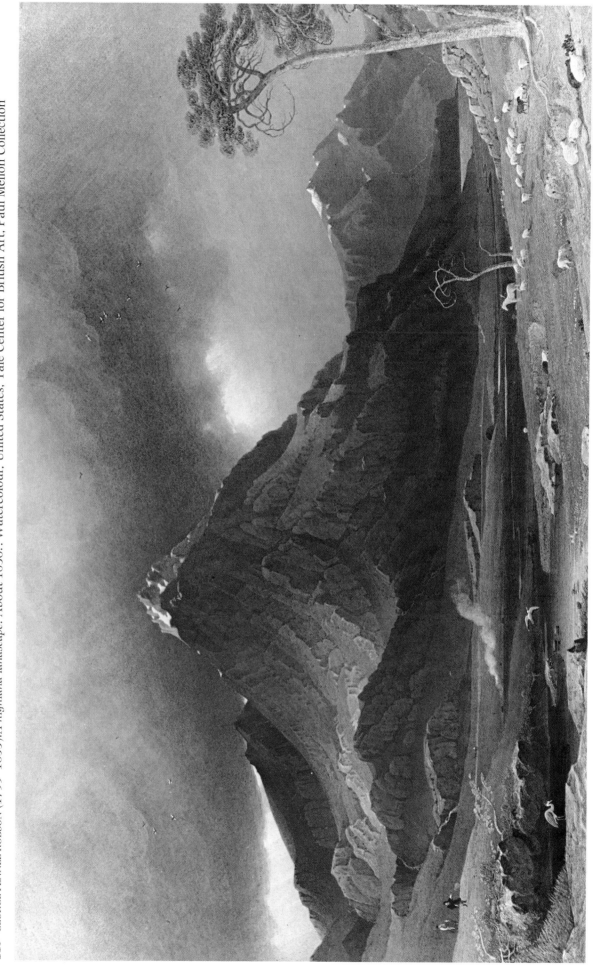

119 GEORGE FENNEL ROBSON (1799–1833):*A highland landscape*. About 1830? Watercolour. United States, Yale Center for British Art, Paul Mellon Collection

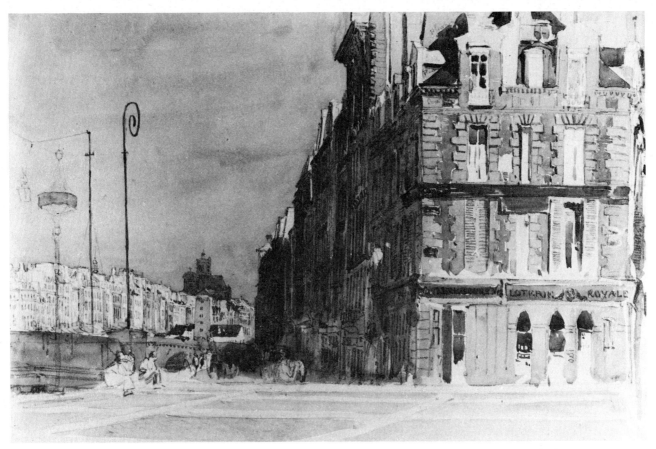

120 DAVID COX (1783–1859): *A street in Paris, near the Pont d'Arcole with the Church of St Gervais(?) in the distance.* 1832?. Pencil and watercolour, $9\frac{5}{8} \times 14\frac{1}{2}$ in. London, Tate Gallery, 4302

121 DAVID COX (1783–1859): *Lancaster Sands, low tide.* About 1850. Pencil and watercolour, $5\frac{3}{4} \times 8\frac{3}{4}$ in. England, Private Collection

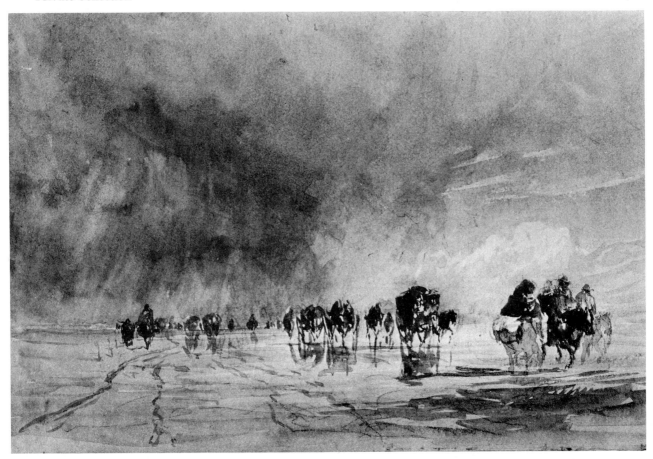

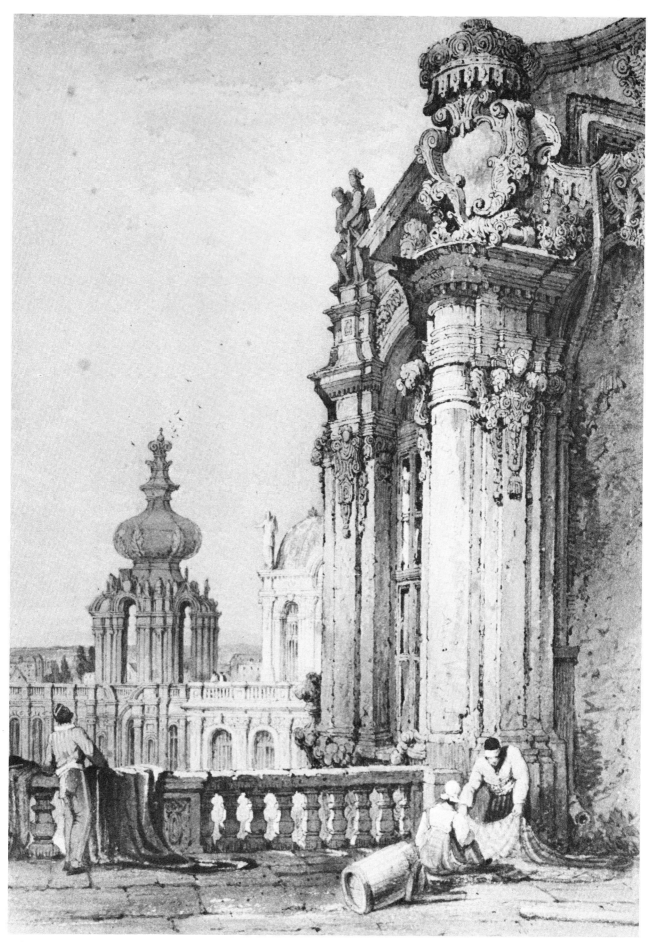

122 SAMUEL PROUT (1783–1852): *Dresden: part of the Zwinger*. About 1830?. Pen and brown ink and watercolour with some bodycolour, $17\frac{5}{8} \times 12\frac{3}{8}$ in. From the collection of the late C. E. Hughes

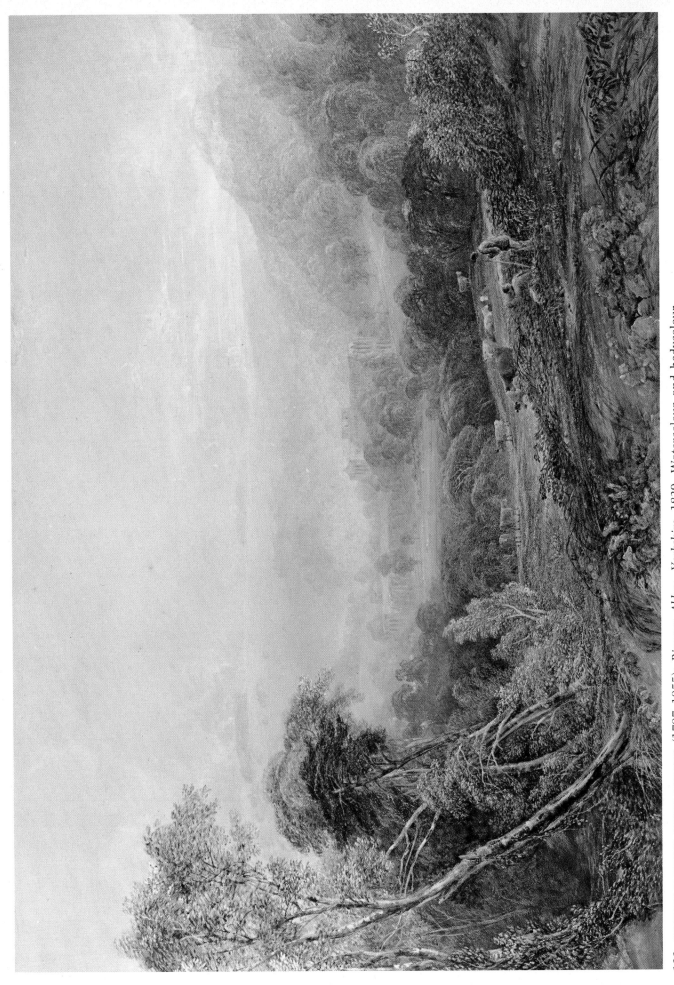

123 ANTHONY VANDYKE COPLEY FIELDING (1787–1855): *Rievaux Abbey, Yorkshire.* 1839. Watercolour and bodycolour, $24\frac{1}{2} \times 35\frac{3}{4}$ in. London, Victoria and Albert Museum, 1136-1886

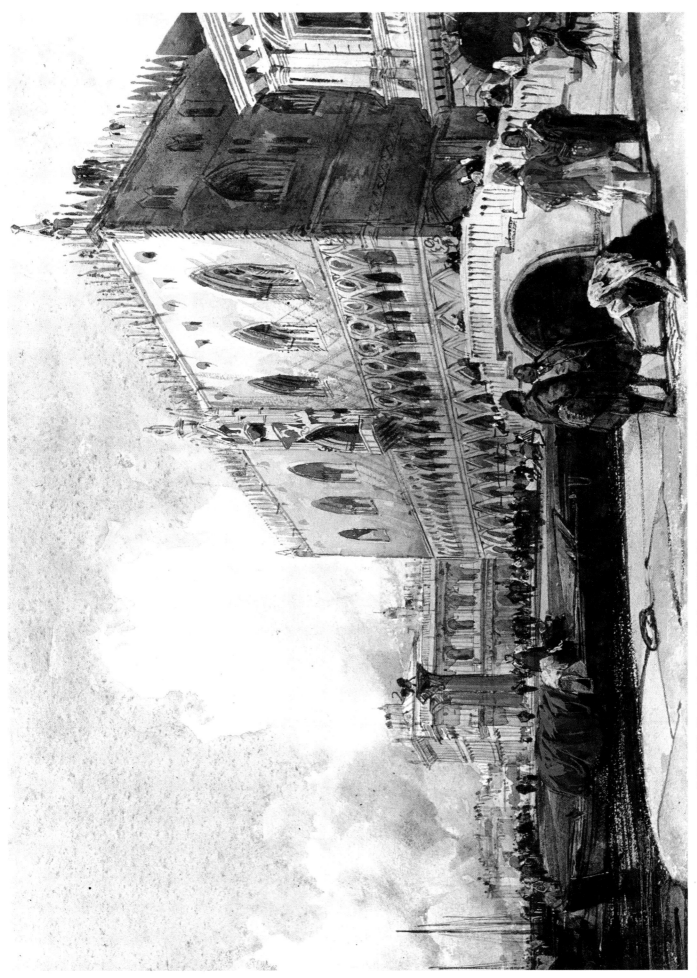

124 RICHARD PARKES BONINGTON (1802–28): *Venice: the Doges' Palace*. 1828. Watercolour, $7\frac{5}{8} \times 10\frac{1}{2}$ in. London, Wallace Collection

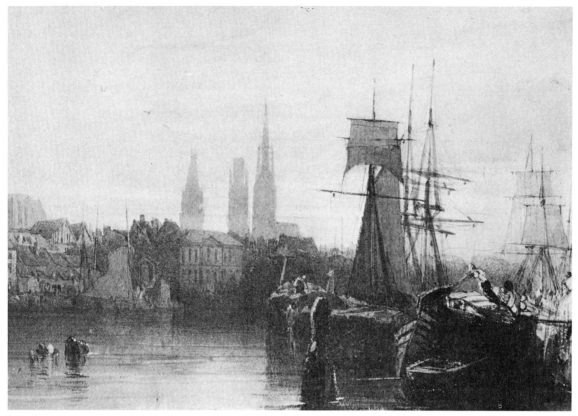

125 RICHARD PARKES BONINGTON (1802–28): *Shipping at Rouen.* About 1823. Watercolour, $6\frac{7}{8} \times 9\frac{1}{8}$ in. London, Wallace Collection

126 RICHARD PARKES BONINGTON (1802–28): *The Château of the Duchesse de Berri.* About 1825. Watercolour, $8 \times 10\frac{3}{4}$ in. London, British Museum, 1910-2-12-223

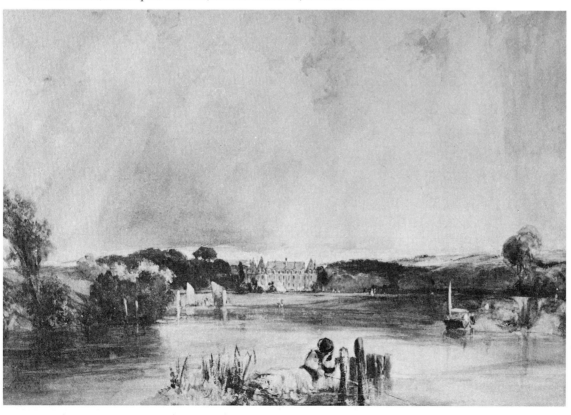

127 RICHARD PARKES BONINGTON (1802–28): *Two figures in an interior.* About 1827. Watercolour and bodycolour with some gum arabic, *c.* $5\frac{1}{2} \times 7$ in. Leningrad, Hermitage, 22786

128 FRANCOIS LOUIS THOMAS FRANCIA (1772–1839): *Calais Beach.* 1823. Watercolour, $12\frac{5}{8} \times 23\frac{3}{4}$ in. England, Private Collection

130 RICHARD PARKES BONINGTON (1802–28): *The interior of the Church of S. Ambrogio, Milan.* 1828. Watercolour and bodycolour, $8\frac{5}{8} \times 11\frac{1}{4}$ in. London, Wallace Collection

129 RICHARD PARKES BONINGTON (1802–28): *Rouen from the quais.* About 1821. Watercolour, $15\frac{7}{8} \times 10\frac{13}{16}$ in. London, British Museum, 1859-7-9-3251

131 CLARKSON STANFIELD (1793–1867): *Cavalrymen near a beached ship, with a fort in the distance.* About 1830. Pencil and watercolour, 7 × 10½ in. From the collection of the late C. E. Hughes

132 DAVID ROBERTS (1796–1864): *Rome: the Piazza Navona.* 1854. Pencil, watercolour and bodycolour on buff paper, 13¾ × 19¼ in. United States, Private Collection

133 JAMES HOLLAND (1799–1870): *Venice: the Salute and St Mark's from S. Giorgio Maggiore.* About 1850. Watercolour and bodycolour, $19\frac{1}{8} \times 23\frac{3}{8}$ in. Courtesy of Christies

134 WILLIAM JAMES MULLER (1812–45): *A view on the River Xanthus.* 1844. Pencil and watercolour, $14\frac{3}{8} \times 21\frac{1}{8}$ in. London, British Museum, 1878-12-28-103

135 WILLIAM HENRY HUNT (1790–1864): *The portico of St Martin's-in-the-Fields.* About 1820. Watercolour, with
pen and brown ink, $19\frac{1}{2} \times 13\frac{1}{2}$ in. United States, Yale Center for British Art, Paul Mellon Collection

136 WILLIAM HENRY HUNT (1790–1864): *A little girl reading.* About 1825. Watercolour, $12 \times 8\frac{5}{8}$ in. United States, Private Collection

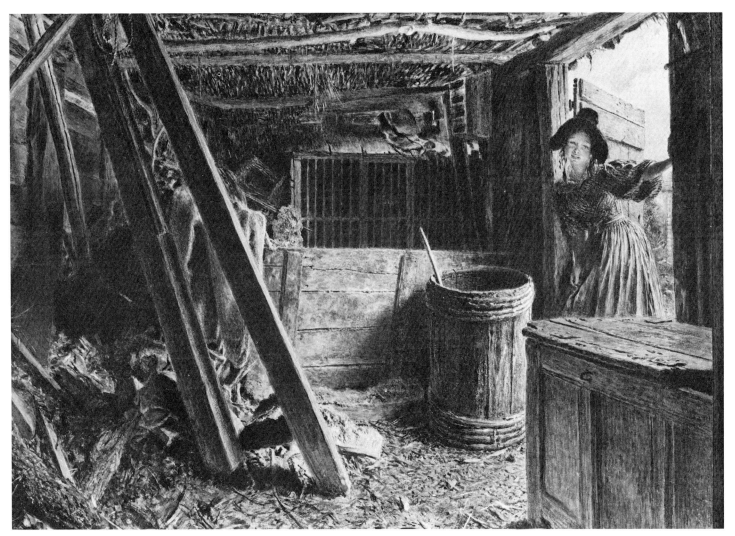

139 WILLIAM HENRY HUNT (1790–1864): *The outhouse.* About 1830. Watercolour, $21\frac{1}{4} \times 29\frac{1}{2}$ in. Cambridge, Fitzwilliam Museum

137 WILLIAM HENRY HUNT (1790–1864): *Still-life with a cauliflour.* About 1835. Watercolour, $6\frac{3}{8} \times 9\frac{1}{8}$ in. London, British Museum, 1944-10-14-109

138 WILLIAM HENRY HUNT (1790–1864): *Still-life with bird's-nest and apple-blossom.* About 1840. Watercolour and bodycolour, 9×11 in. Liverpool, Walker Art Gallery

140 JOHN RUSKIN (1819–1900): *The Glacier des Bossons, Chamonix*. 1844?. Pen and brown and grey inks and wash with bodycolour and scraping-out, 13¼ × 18¾ in. Oxford, Ashmolean Museum

141 MYLES BIRKET FOSTER (1825–99): *Driving home the cattle*. About 1860?. Watercolour and bodycolour, 6⅜ × 9⅝ in. Courtesy of the Bourne Gallery, Reigate

142 JOHN FREDERICK LEWIS (1805–76): *Girl in an interior*. About 1830. Watercolour and bodycolour, $11\frac{3}{4} \times 14\frac{1}{2}$ in. England, Private Collection

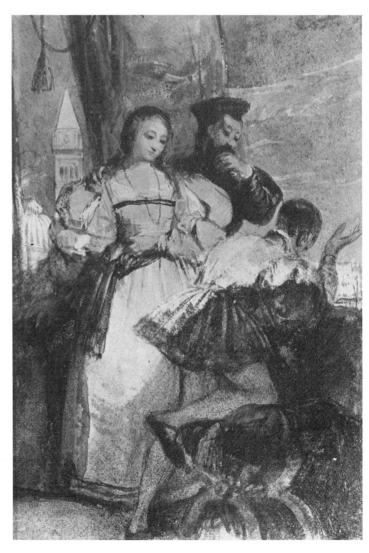

143 RICHARD PARKES BONINGTON (1802–28): *Figures on a Venetian balcony*. About 1828. Watercolour, $6\frac{3}{8} \times 4\frac{3}{8}$ in. Glasgow Art Gallery and Museum

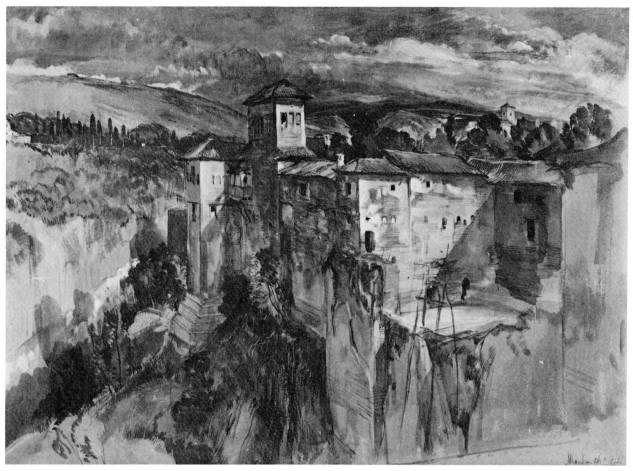

144 JOHN FREDERICK LEWIS (1805–76): *The Alhambra.* 1832. Watercolour and bodycolour, $10\frac{3}{16} \times 14\frac{3}{16}$ in. London, British Museum, 1885-5-9-1644

145 JOHN FREDERICK LEWIS (1805–76): *A Frank encampment in the desert of Mount Sinai, 1842 – The Convent of St Catherine in the distance.* 1856. Watercolour and bodycolour, $25\frac{1}{2} \times 52\frac{1}{8}$ in. London, The Fine Art Society Ltd

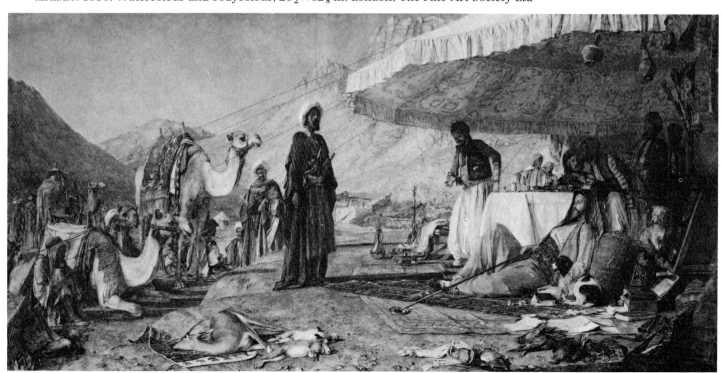

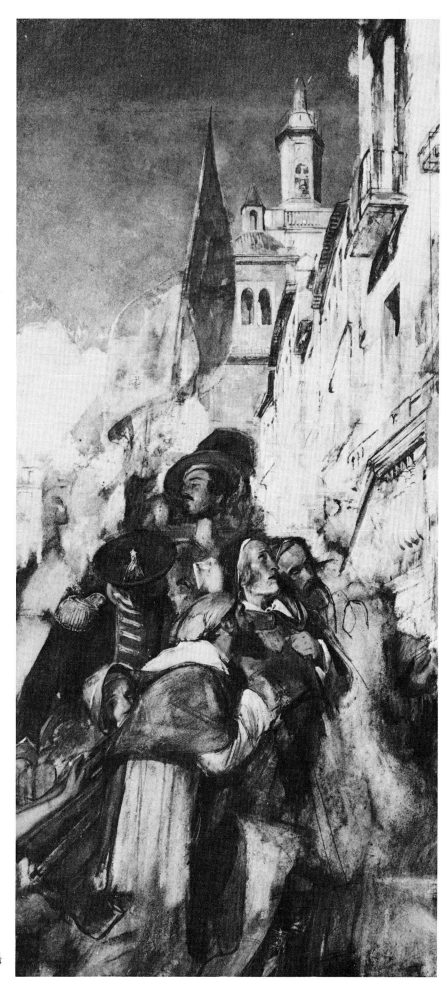

146 JOHN FREDERICK LEWIS (1805–76): *Study for 'The proclamation of Don Carlos'*. About 1835. Watercolour and bodycolour with pencil on a prepared buff ground, $23\frac{3}{4} \times 11\frac{1}{4}$ in. Oxford, Ashmolean Museum

147 JOHN FREDERICK LEWIS (1805–76): *Study of a jaguar.* About 1820.
Watercolour and bodycolour over pencil on grey paper, $8\frac{1}{16} \times 7$ in.
London, British Museum, 1937-3-8-24

149 JOHN FREDERICK LEWIS (1805–76): *A Frank
encampment in the desert of Mount Sinai* (detail
of Plate 145)

148 JOHN FREDERICK LEWIS (1805–76): *An old mill.* About 1830.
Watercolour, $9\frac{1}{2} \times 13\frac{1}{2}$ in. Blackburn, Corporation Art Gallery

150 JOHN FREDERICK LEWIS (1805–76): *Hhareem life – Constantinople.* 1857. Watercolour and bodycolour, $24\frac{1}{2} \times 18\frac{3}{4}$ in. Newcastle upon Tyne, Laing Art Gallery

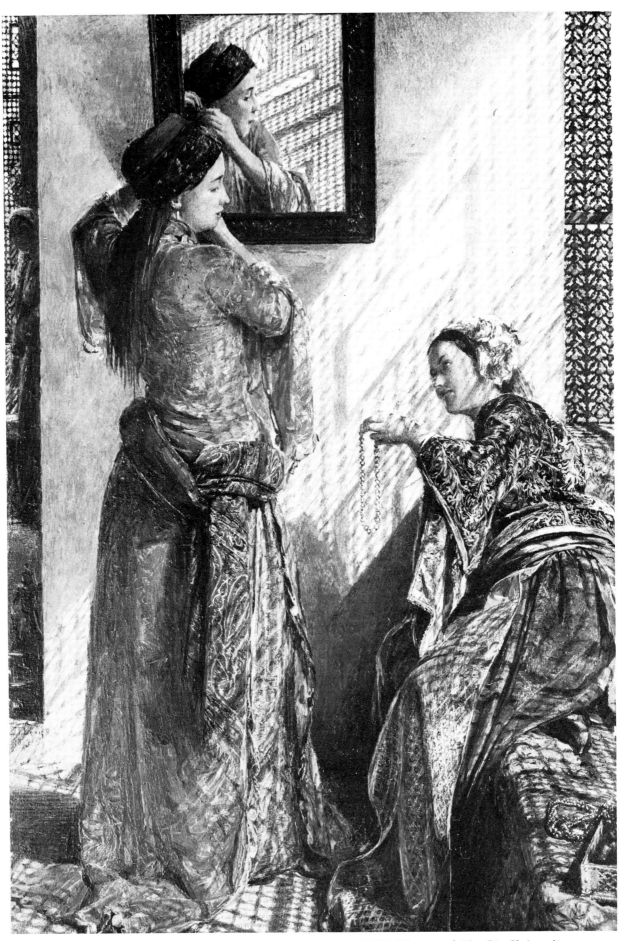

151 JOHN FREDERICK LEWIS (1805–76): *Indoor gossip (Hareem), Cairo.* 1873. Oil on panel, 12 × 8 in. University of Manchester, Whitworth Art Gallery

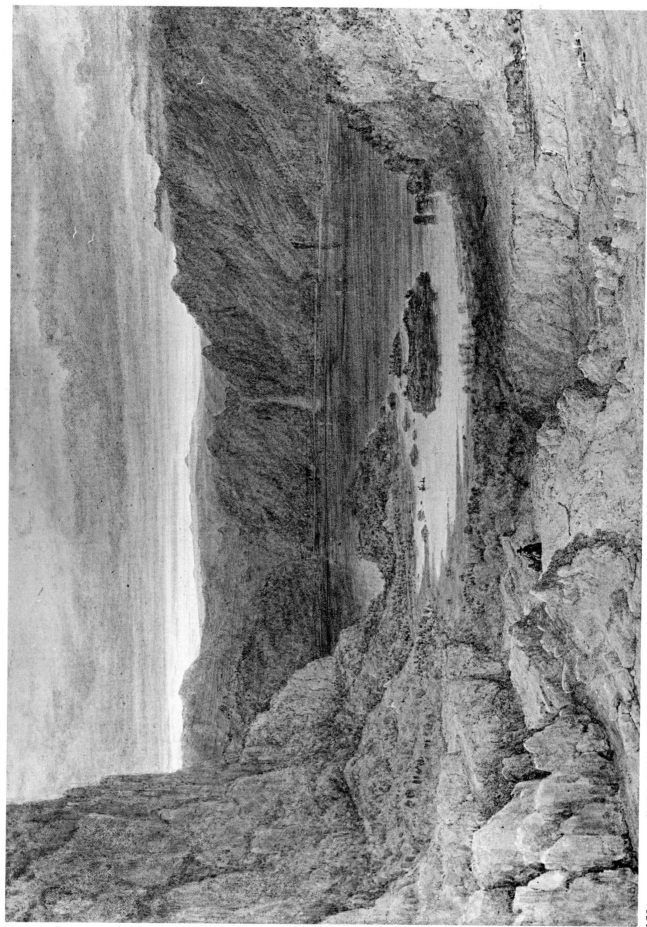

152 FRANCIS DANBY (1793–1861): *A mountain lake.* About 1830. Watercolour and bodycolour, $7\frac{1}{2} \times 10\frac{3}{8}$ in. Middlesex, Harrow School

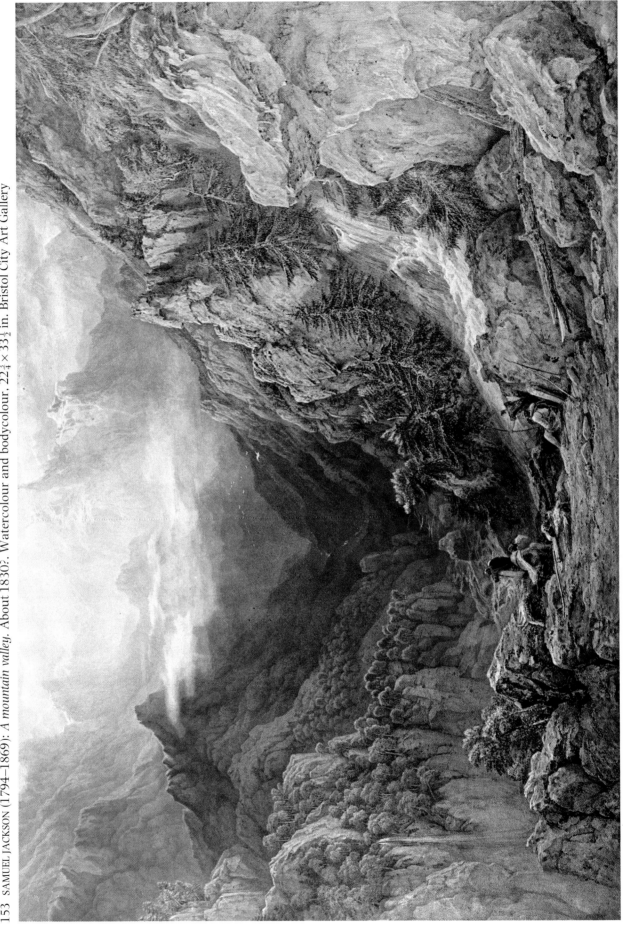

153 SAMUEL JACKSON (1794–1869): *A mountain valley.* About 1830?. Watercolour and bodycolour. $22\frac{3}{4} \times 33\frac{1}{2}$ in. Bristol City Art Gallery

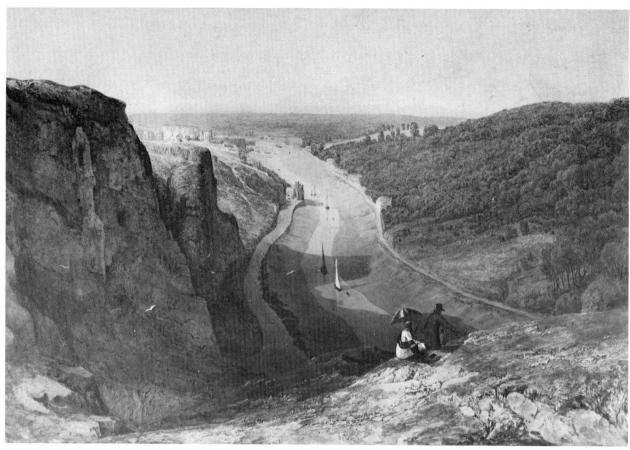

154 FRANCIS DANBY (1793–1861): *The Avon Gorge, looking towards Clifton*. About 1820. Watercolour and bodycolour, 19 × 29 in. United States, Yale Center for British Art, Paul Mellon Collection

155 THOMAS MILES RICHARDSON (1813–90): *Durham*. 1859. Watercolour and bodycolour, $16\frac{1}{8} \times 24\frac{3}{8}$ in. London, Polak Gallery

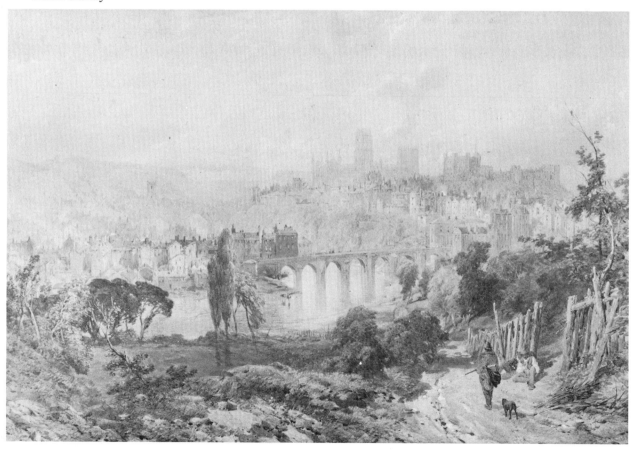

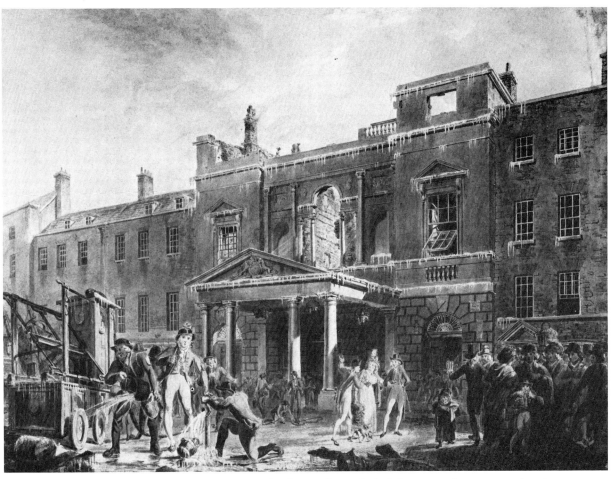

156 JOSEPH MALLORD WILLIAM TURNER (1775–1851): *The Pantheon, Oxford Street, on the morning after the fire*. 1792. Watercolour over pencil, $15\frac{9}{16} \times 20\frac{1}{4}$ in. London, British Museum, Turner Bequest IX-A

157 JOSEPH MALLORD WILLIAM TURNER (1775–1851): *View of Edinburgh from St Anthony's Chapel*. 1801. Pencil and watercolour, $5 \times 7\frac{3}{4}$ in. London, British Museum, Turner Bequest, LV-10

158 JOSEPH MALLORD WILLIAM TURNER (1775–1851): *Venice: looking east from the Giudecca: sunrise.* 1819. Watercolour, $8\frac{3}{4} \times 11\frac{5}{16}$ in. London, British Museum, Turner Bequest CLXXXI-5

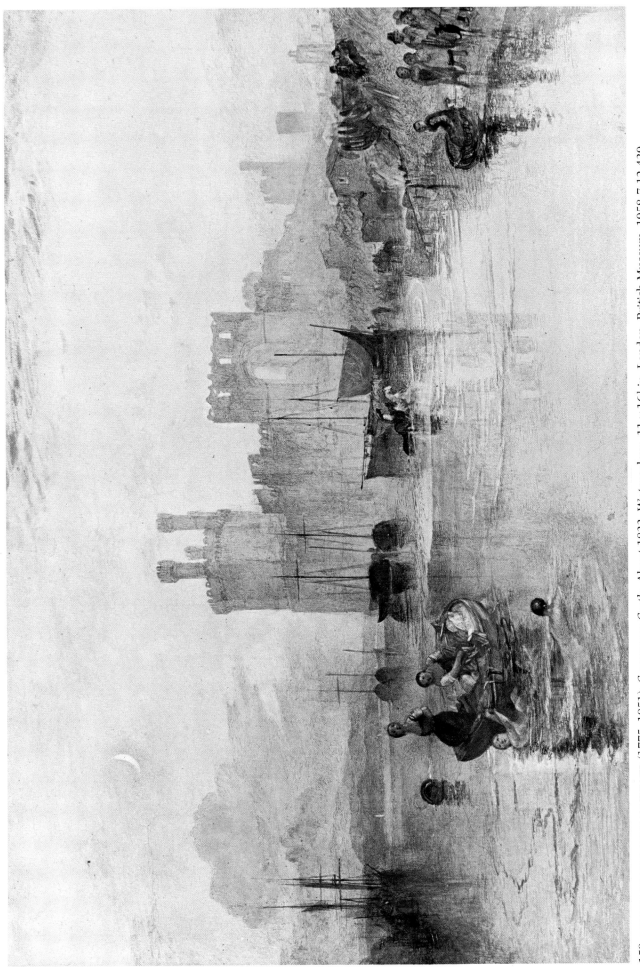

159 JOSEPH MALLORD WILLIAM TURNER (1775–1851): *Caernarvon Castle*. About 1833. Watercolour, 11 × 16¼ in. London. British Museum, 1958-7-12-439

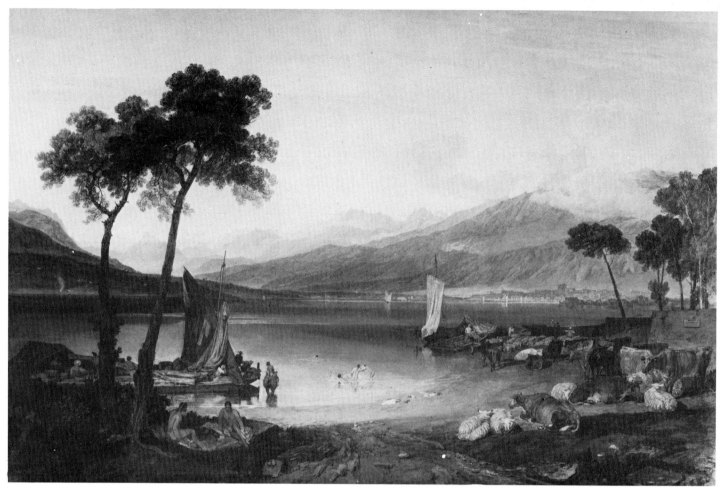

160 JOSEPH MALLORD WILLIAM TURNER (1775–1851): *The Lake of Geneva with Mont Blanc from the Lake.* About 1805. Watercolour with scraping-out, $28\frac{1}{8} \times 44\frac{1}{2}$ in. United States, Yale Center for British Art, Paul Mellon Collection

161 JOSEPH MALLORD WILLIAM TURNER (1775–1851): *Scene on the Thames*, About 1806. Watercolour, $10 \times 14\frac{1}{2}$ in. London, British Museum, Turner Bequest XCIII-40a

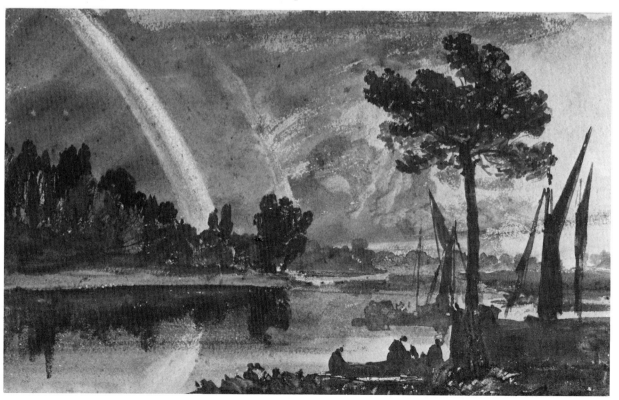

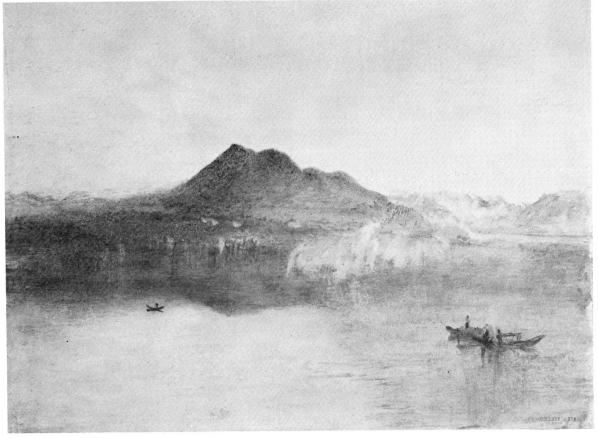

162 JOSEPH MALLORD WILLIAM TURNER (1775–1851): *Study for 'The Dark Rigi'*. About 1841. Watercolour, 9 × 12¾ in. London, British Museum, Turner Bequest CCCLXIV-279

163 JOSEPH MALLORD WILLIAM TURNER (1775–1851): *The Crook of Lune, looking towards Hornby Castle*. About 1818. Watercolour and scraping-out, 11 × 16½ in. London, Courtauld Institute

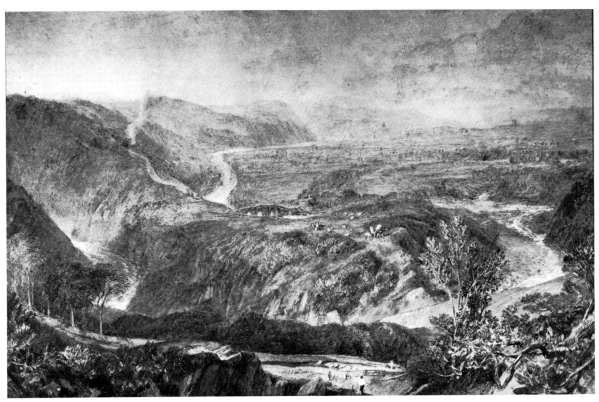

164 JOSEPH MALLORD WILLIAM TURNER (1775–1851): *The burning of the Houses of Parliament*. 1834. Watercolour, $9\frac{1}{4} \times 12\frac{3}{4}$ in. London, British Museum, Turner Bequest CCLXXXIII-2

165 JOSEPH MALLORD WILLIAM TURNER (1775–1851): *Heidelberg from the opposite bank of the Neckar*. About 1850. Watercolour with scraping-out. 15 × 21⅜ in. Edinburgh. National Gallery of Scotland

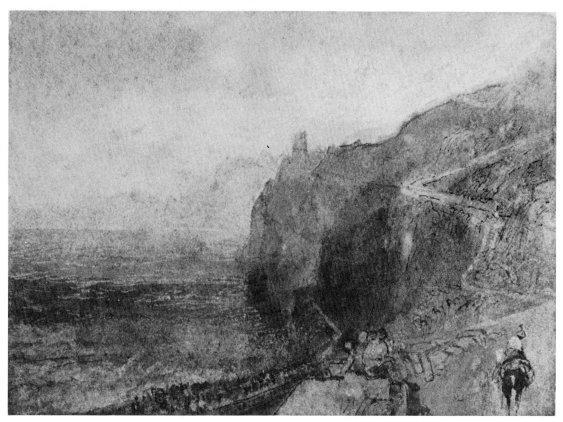

166 JOSEPH MALLORD WILLIAM TURNER (1775–1851): *A view on the south coast of France.* About 1829. Pencil, watercolour and bodycolour with pen and ink on blue paper, $5\frac{3}{8} \times 7\frac{1}{2}$ in. England, Private Collection

167 JOSEPH MALLORD WILLIAM TURNER (1775–1851): *The Seine between Mantes and Vernon.* About 1834. Bodycolour with some pen on blue paper, $5\frac{1}{2} \times 7\frac{5}{8}$ in. London, British Museum, Turner Bequest CCLIX-114

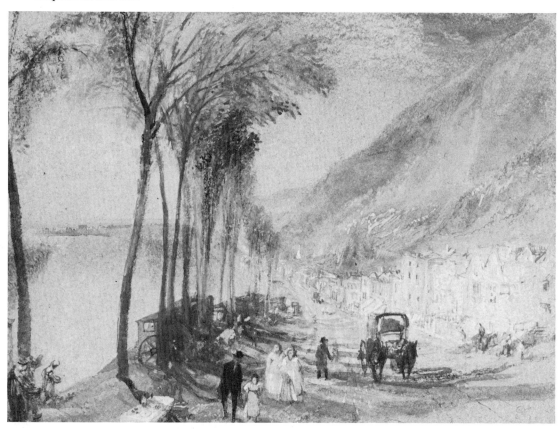

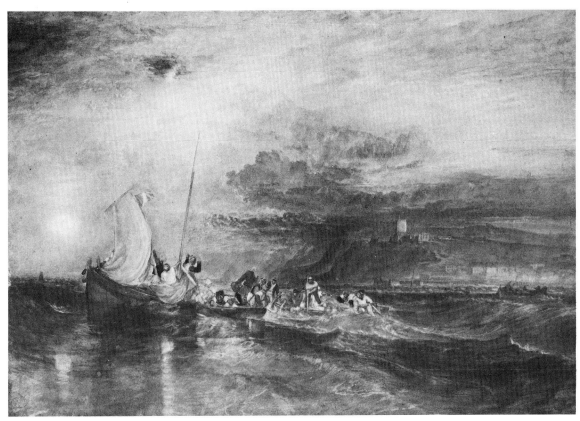

168 JOSEPH MALLORD WILLIAM TURNER (1775–1851): *Folkestone from the sea*. About 1835. Watercolour and bodycolour, $19\frac{1}{4} \times 27\frac{1}{4}$ in. London, British Museum, Turner Bequest CCVIII-Y

169 JOSEPH MALLORD WILLIAM TURNER (1775–1851): *Venice: moonrise*. About 1840. Watercolour, $8\frac{3}{4} \times 12\frac{1}{2}$ in. London, British Museum, Turner Bequest CCCXV-10

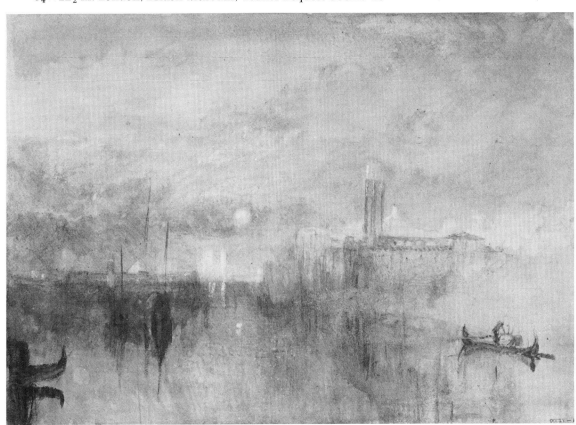

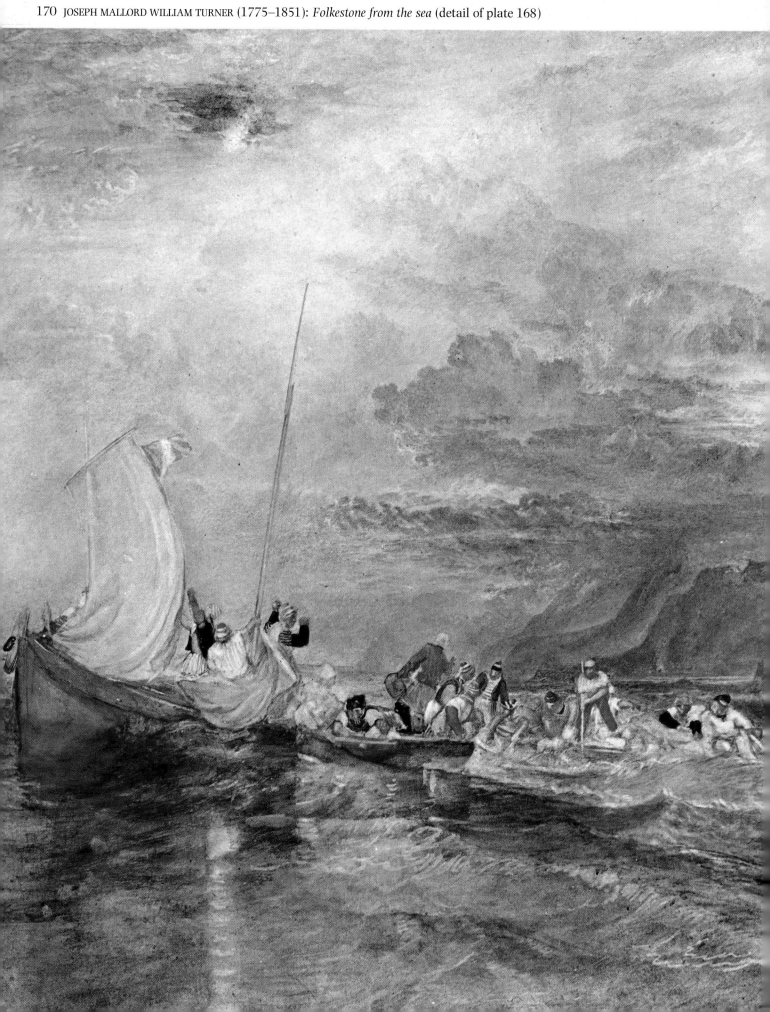

William Blake (1757–1827)

Blake's father was a hosier in Broad Street, Golden Square. His son was sent to study under Henry Pars at the old Shipley's School in 1767; in 1772 he entered on seven years apprenticeship to the engraver James Basire, after which he studied at the Royal Academy Schools. His first exhibited work appeared at the Academy in 1780, in which year he became acquainted with Fuseli. He married in 1782. He printed his *Songs of Innocence* by a process of 'illuminated printing' – his own invention – in 1788, and in 1794 issued them together with the companion poems, *Songs of Experience*. During the 1790s he produced a number of 'Prophetic Books' by this process; later he added *Milton* and *Jerusalem*, both printed about 1818. For three years he lived at Felpham, Sussex, working for the poet William Hayley. A public exhibition of his works, largely in tempera or 'fresco', was held in 1809. The young John Linnell commissioned from him sets of illustrations to the Book of Job and Dante's *Divine Comedy*, which he executed in the early 1820s.

19. The Resurrection of Pious Souls

This watercolour is a project for the border to a page of text, and appears to be an unused design for one of the set of illustrations to Blair's poem *The Grave*, on which Blake was working in 1805 to 1806. Contrary to the promise of his employer, Robert Hartley Cromek, Blake himself was not allowed to engrave the designs, which were interpreted on copper by Louis Schiavonetti. The work was published in 1808, and contains some of Blake's most splendid and moving designs; he made many variants on them at different times and evidently regarded them as important in the context of his own work. Although it was not used, this scene of *Resurrection* is one of the loveliest, with its insistent, flamelike rhythm surging upwards and its shimmering colour applied in minute and delicately modulated touches.

20. The Genius of Shakespeare

Blake contributed six drawings to an extra-illustrated second folio of Shakespeare belonging to the Rev. Joseph Thomas; but this one goes far beyond the task of illustrating a specific line of text and expresses Blake's response to creative genius at the highest level. The untrammelled swinging rhythms which counterpoint each other across the drawing show Blake's compositional power at its finest; the direct, clear colouring of blue and gold perfectly establishes the atmosphere in which such rarefied mysteries can freely occur.

25. Beatrice on the car

In 1825, Blake, detained in bed with a scalded foot, worked on over a hundred folio-size drawings illustrating the *Divine Comedy* of Dante. Not all were finished, some being left in the form of rough pencil sketches with hints of colour. Others, however, were taken to a high degree of elaboration, and this sheet is one of the finest and most splendid both in its conception and in its handling of the medium of watercolour. Although Blake cannot be said to have partaken in the technical revolution that overtook watercolour during his lifetime, and generally used the medium in his own idiosyncratic way, he availed himself, consciously or unconsciously, of some of the experimental methods current. Here, within the framework of an essentially linear invention, he applies pure colour in delicate touches which reverberate and interact to create a flickering otherworldly iridescence through which the vision glows impressively. Compare the relatively much tighter handling of paint in the *Resurrection of Pious Souls* (Plate 19).

37. Naomi entreating Ruth and Orpah to return to the Land of Moab

This is one of the set of twelve designs that Blake produced by his process of colour printing, painting with watercolour mixed with a thickening agent (tempera) on millboard and working up an impression from this by hand. The word 'fresco', inscribed with Blake's signature in the lower left-hand corner, indicates that he was employing the tempera medium, which was his answer to the problem of how to give watercolour greater weight and carrying power on the walls of a gallery. Like more conventional water-colourists, he wanted the medium to express all that could be expressed in oil. His subject, too, is cast in the grand, historical mode: the faces are invented to convey the psychological drama of the story, and Blake makes much use of gesture and the movement of stately draperies to reinforce his meaning. The background is deliberately restrained so that the figures stand out before it with the stark clarity of a Greek frieze. One other impression of the subject is known.

38. Pity

An illustration to *Macbeth* (I, vii, 21):

> And Pity, like a naked new-born babe,
> Striding the blast, or heaven's cherubim, horsed
> Upon the sightless couriers of the air,
> Shall blow the horrid deed in every eye,
> That tears shall drown the wind.

This example of Blake's colour printing process (*see Plate 37*) is especially powerful as a vivid visual counterpart to the very elaborate verbal imagery of Shakespeare, and a fine instance of Blake's capacity to translate ideas from one medium into the other without literariness.

Richard Parkes Bonington (1802–28)

Bonington was born near Nottingham and went with his family to Calais in 1817; in 1818 he met Francia there, who offered to give him lessons in watercolour. After his family had moved to Paris, he attended Gros's classes in drawing at the Ecole des Beaux-Arts from 1820 to 1822, in which year he exhibited two works at the Salon. In 1821 he toured the Normandy coast with Alexandre Colin; he was in Normandy again with Samuel Prout in 1822, also visiting Belgium. In 1824 lithographs by him appeared in *Restes et Fragmens d'Architecture du Moyen Age* and *Voyages Pittoresques et Romantiques dans l'Ancienne France*. In 1825 he visited England and in 1826 exhibited at the British Institution; he sent work to the Royal Academy in 1827. He returned from England with Delacroix, whose studio in Paris he shared. In 1826 he visited Italy, and in the two following years made further visits to England, where he died of consumption in 1828.

124. Venice: the Doges' Palace

As it had done for so many artists before him, Venice burst on Bonington as a revelation of light and colour. His watercolours and oil paintings alike began to be pitched in a higher, brighter key, and to throb with warm rich colours. Drawings like this one set a standard of architectural topography that was to prevail for decades; their technique was imitated sedulously by a whole generation of tourist-draughtsmen. Compare Callow and Holland (*Plates 115 and 133*). At this date, Turner had not yet begun to exhibit Venetian subjects, and Bonington's may well have struck a new, romantic note, especially in England.

125. Shipping at Rouen

An instructive contrast with the slightly earlier Rouen view (*Plate 129*). Only a few years later, Bonington has completely reversed the dramatic principle on which he had based his study of the cathedral from the quais: here, it is the masts of the boats in the foreground which provide a focus, and the skyline beyond is half-broken in the

evening haze, against which the masts rise with touching matter-of-factness. In spite of the real poetry of this mellow subject, it is largely impressive for the wonderful suavity of its treatment, and the perfectly judged freedom of the brushwork.

126. The Château of the Duchesse de Berri

One of Bonington's most astonishing works, in which a typically high, pale sky is invested with unusual significance. Rain and sunlight alternate as Constable might have shown them, and the luminosity of the sky pervades – indeed, is – almost the whole subject. The horizon is low and flat, as is common in works of about 1825, but the sky offers a complex interplay of structural elements which sustains the movement of the eye throughout. It is interesting to compare Bonington's loose, flowing construction in this upper space with the very different solution to a similar problem by Cotman in his *Dismasted brig* (*Plate 95*).

127. Two figures in an interior

The richly-coloured, densely-wrought little historical watercolours that Bonington loved to make during the last four or five years of his life exemplify his delight in sheer execution. These figures in their Italian Renaissance costume are not portraits, nor are they engaged in any particular activity; the scene breathes no strong air of poetry or drama. The vague evocation of the paintings of Bronzino or Titian is an excuse for a *jeu d'esprit*, in which the artist simply enjoys creating a harmony of strong colours and contrasts: the young man is wearing a brown doublet, and the girl a bright yellow dress, she carries a black fan. They emerge from Bonington's imagination, fired as it was with the love of other works of art, and with his own facility in handling watercolour.

129. Rouen from the quais

The dramatic elevation of the cathedral in this composition belongs to a world rather different from that of Bonington's maturity, when unemphatic, horizontal stresses predominate. Here, in this comparatively early work, there is a reminiscence of the architectural grandeurs of Girtin, whose influence may also be felt behind the choice of a slightly granular textured paper and muted colours applied in broad, rather flat and disjunct areas. Similar features characterize the watercolours of Francia, who presumably carried them directly from his association with Girtin and John Varley through Dr Monro.

130. The interior of the Church of S. Ambrogio, Milan

Most of the architectural records that Bonington made of his visit to Italy take the form of brilliantly sunlit exteriors, reflecting the bright light of Canaletto and all Mediterranean landscape. This one is exceptional in fusing his interest in architecture with his love of jewel-like historical interiors: the spacious and solemn atmosphere of the church is rendered in a range of sombre greys, concentrating towards the centre of the design to an intense black against which the sunlight flashes on an iron grille and through a distant opening. It illustrates clearly the strength which Bonington could impart to his firm, assured drawing and accurate washes of colour. At the same time, it succeeds in suggesting a precise mood far more effectively than do most of the architectural interiors by his fashionable contemporaries and followers.

143. Figures on a Venetian balcony

Just as his architectural subjects gained in brilliance and variety of colour after the Italian journey of 1826, so Bonington's little figure pieces also reflected a change of mood. The golden colouring of Veronese, in particular, gives the drawings of this late phase an added glow of warmth. This example is apparently the drawing that Lewis shows in his *Girl in an interior* (*Plate 142*), and provides evidence that even such comparatively small-scale and unostentatious works were thought of as 'paintings' – it is seen there in an elaborate gilt frame, of the type much loved by the exhibitors at the Water-Colour Society.

Thomas Shotter Boys (1803–74)

Boys was born in Pentonville and in 1817 apprenticed to the engraver George Cooke. By 1825 he was settled in Paris and closely associated with Bonington, who encouraged him to give up his work as an engraver and take up watercolour. He made lithographs for Baron Taylor's *Voyages Pittoresques et Romantiques dans l'Ancienne France* from 1835, and in 1839 published his own *Picturesque Architecture in Paris, Ghent, Antwerp, Rouen, etc.* printed in several colours. He returned to London in 1837 and in 1842 produced his *Original Views of London As It Is*. He was an exhibitor at the New Water-Colour Society from 1832 onwards and became an associate in 1840, full member in 1841. He travelled in England and Wales and abroad, but the quality of his work steadily declined. He died in London.

114. A windmill at sunset

While Boys is generally thought of as a rather close imitator of Bonington, whose merits lie in his workmanlike depictions of buildings, it is sometimes overlooked that he developed a certain aspect of Bonington's art as a landscapist further than Bonington himself had done. This was the evocation of poetic evening or twilight effects by means of overlapping translucent washes of colour; in Bonington's case these washes were nearly always in a restrained gamut of colours – cream and brown being the most usual. Boys, inspired perhaps by the jewel-like colouring of Bonington's interiors, sought to obtain similar effects with the richer hues of storms and sunsets. Such studies by him are very small as a rule, and sometimes make use of a single brightly-coloured figure to set off a sonorous background. In this specimen, he achieves great intensity within a tiny area, and cannot be accused of plagiarizing Bonington.

Edward Francis Burney (1760–1848)

Burney, a cousin of Fanny Burney the novelist, was born in Worcester; he entered the Royal Academy Schools in 1777, gaining the silver medal for drawing in 1780. In that year he began to exhibit at the Academy, and continued to to so until 1803, when he turned to book illustration, producing a large quantity of work.

30. Amateurs of tye-wig music

The crowded incident of Hogarth's compositions remained a characteristic of comic draughtsmanship until well into the nineteenth century. In his large, elaborate satires of musical gatherings – a country dancing school, a glee club, or this evening of serious music-making – Burney combines a Hogarthian welter of lively detail with rotund, Rowlandsonian forms; but he executes them with a care and smoothness of finish quite unlike most satirists. He represents an unusually sophisticated and urbane branch of the tradition.

William Callow (1812–1908)

Born in Greenwich, Callow entered the studio of Theodore Fielding (1781–1851; elder brother of Copley Fielding) at eleven, and became his articled apprentice in 1825. In that year he met Charles Bentley (1806–54), with whose work in watercolour Callow's was to have much in common. In 1829 he moved to Paris, first working with Newton Fielding (1799–1856), and later sharing a studio with Boys. The example of Newton Fielding and of Boys turned him from his work as engraver to watercolour. By 1835 he was a highly accomplished practitioner in the medium, exhibiting at the Paris Salon and gaining several gold medals in French exhibitions. In that year he began a series of walking tours which took him through the whole of central Europe; in 1840 he was in Italy where he met Turner. In 1838 he was elected associate of the Old Water-Colour Society and in 1848 a full member. He exhibited regularly with the society until his death at Great Missenden, Bucks, where he had lived since 1855.

115. The Neu Münster, Würzburg

Callow, one of the artists who most closely followed Bonington in the 1830s, rapidly developed a manner of great breadth and proficiency, which, in examples like this, is similar to the work of Cox and Holland. It is founded on a firm, brisk pencil line like theirs, and the colour is added with comparable dash; though it is more strikingly Boningtoniste in areas like the richly flooded shadows in the bottom centre of this sheet. The outlines strengthened with a pen in the same area also reflect Bonington's manner. Callow made views of architectural subjects, usually taken from European cities, throughout his long career, and they adhere broadly to the style and mood of this example; but he frequently aimed at a splendour of size, subject or effect which is very different from the simpler and more casual approach that is apparent in nearly all of Cox's work. Here, however, he achieves monumental scale by a familiar trick of presenting the subject in steep perspective, and allows the heavy grandeur of the central Baroque church to speak for itself.

Edward Calvert (1799–1883)

Born at Appledore, Devon, Calvert entered the navy, following his father's profession, but quickly left to study art in Plymouth. He moved to London in 1824 and entered the Royal Academy Schools, first exhibiting at the Academy in the following year. He produced his only major watercolour, *The primitive city*, in 1822, but after meeting Palmer and becoming one of 'The Ancients' in 1826, executed a series of engravings both on wood and on copper, which are of the same intensity as that drawing. After 1836 he ceased to exhibit at the Royal Academy; his art became less intense and his later work is of little interest.

41. The primitive city

While Palmer's early landscapes seem to be composed of elements borrowed from the works of Blake, Calvert's work of the same period expresses his debt to Blake more indirectly. As in the woodcuts and engravings which form a group with this unique watercolour, we can pick out details, such as the huge moon or the distant shepherd with his flock, that evoke Blake; but the main subject is more obviously dependent on other sources: the female figure derives from Italian or Flemish Renaissance prints, while the odd buildings in the background remind us of Rembrandt's landscapes, and the general jewel-like effect is similar to that of a fifteenth-century book of hours. These disparate features are blended together, however, with an intensity, a vividness of apprehension, which marks the drawing as a product of the school inspired by Blake's visionary illumination.

Antonio Canaletto (1697–1768)

Canaletto was born in Venice and turned from theatrical scene painting to become a successful *vedutista*, patronized by the British consul Sir Joseph Smith. He came to England in 1746 and found much patronage, notably under the Dukes of Richmond and Northumberland. He returned to Italy briefly in 1750 or 1751, but then came back to England where he stayed until about 1755. Among his English followers and imitators were Samuel Scott (c. 1702–72) and William Marlow (1740–1813).

3. London: view of the City from the terrace of Somerset house

A painting of this subject, executed in 1751, is also in the Royal Collection. But this is not a preparatory study: it is a fully-evolved and finished drawing in its own right. Canaletto's influence on English artists was far-reaching: this composition was repeated by many others, such as the Sandbys (*Plate 2*), and the drawing style, with its lively, curling outlines made with a reed pen, can be seen in endless variations in the work of Farington, Rowlandson, Sunderland, W. H. Hunt, and Prout.

John Constable (1776–1837)

Constable was the son of a Suffolk miller and was born at East Bergholt, where he was inspired to draw by the surrounding countryside. In 1795 he met Sir George Beaumont, whose collection, including Claude and Girtin, much influenced him. He came to London in 1799 and entered the Royal Academy Schools in 1800, exhibiting for the first time in 1802. He worked for the antiquarian J. T. Smith (1766–1833); visited Derbyshire in 1801 and the Lakes in 1806, but 'the solitude of mountains oppressed his spirits'. After a long courtship he married Maria Bicknell in 1816, visiting Osmington, Dorset, on their honeymoon. In 1819 he was elected A.R.A and showed his first large canvas, *The White Horse*. That summer he rented a house at Hampstead where the family stayed every year. In the 1820s his wife's ill-health occasioned several holidays at Brighton; she died in 1828. His *Hay Wain*, among other pictures, obtained him a gold medal at the Paris Salon in 1824, and he became a Royal Academician in 1829. In that year he began work on his *English Landscape Scenery* with the mezzotinter David Lucas. He lectured on landscape painting to the Literary and Scientific Society of Hampstead in 1834, and at the Royal Institution in 1836.

102. Tillington Church

In the later years of his life Constable made a number of visits to the region of Sussex around Arundel and Petworth; this drawing, dated 'Tillington Sepʳ 14 1834', shows the church tower that rises on the edge of Petworth Park. It is typical of the loving and confident freedom with which Constable came to express many of his most personal ideas in watercolour, at a time when oil-painting had become for him a matter of grand and serious projects that were often rather outside the range of what most interested and inspired him.

103. Stonehenge

A colour study developed from the pencil sketch made on the spot in 1820, and used for the large finished drawing of Stonehenge which Constable exhibited at the Academy in 1836 (No. 581). Another and rather similar study is in the British Museum. The simple statement of the original sketch is elaborated by the introduction of the dramatic sky with its double rainbow. The exhibited work was a kind of complement to the earlier *Old Sarum* (*Plate 112*), with its message of destruction and oblivion: here, Constable presents the permanence of monuments from the remote past. He quoted a description of Stonehenge in the Academy's catalogue: 'The mysterious monument of Stonehenge, standing remote on a bare and boundless heath, as much unconnected with the events of past ages as it is with the uses of the present, carries you back beyond all historical records into the obscurity of a totally unknown period.' Once again, in this subject conceived as an exhibition piece, Constable unites his direct personal vision of landscape with a broader, historical idea implying a popular moral very different from the 'moral feeling of landscape' as he conceived it in his more spontaneous works.

105. The Lower Pond, Hampstead

This drawing, dated 26 June 1823, appears to have been based on a little pencil note made on the spot in a diminutive sketchbook dated 1819, which is now in the British Museum. Even so, it is not a finished, or public, watercolour and preserves much of the spontaneous atmosphere of the little sketch. As usual with Constable the pencil alone supplies a complete design; but here he has added colouring of exceptional strength to give the whole sheet a completeness that we do not often find in his watercolours before the 1830s.

106. Littlehampton: stormy sky

Constable's inscription on this drawing, *Little Hampton July 8 1835*, places it as one of the last of his small watercolours, and shows how much he had developed and varied his technique, uniting his accustomed freshness with more solid colour, carefully modified by

extensive scratching-out. This is, it should be noticed, Constable's method both in small, private studies like this one, and in the larger watercolours that he showed at the Academy.

108. Borrowdale: looking towards Glaramara

Constable's drawings of the scenery of the Lake District, made on his tour of 1806, are often cited as particularly striking evidence of Girtin's influence on his style. Their sublime subject-matter and predominantly sombre colour are indeed qualities that Constable's admiration for Girtin would naturally engender; but in fact these views are handled with a spontaneity and directness of response that is typical of Constable's mature approach. There is even some similarity to the mountain studies that Turner made in the closing years of the century, where colour is frequently applied with the breadth that Constable displays here. Whether he had had any opportunity to see Turner's Welsh studies it is difficult to say; he would certainly have looked closely at his exhibited watercolours, in which, however, the particular qualities that mark Constable's own drawings are less evident.

111. View over London with a double rainbow

Throughout his life Constable was in the habit of noting on his drawings the time and date at which they were executed. This one is inscribed: 'between 6. & 7. oclock Evening [?June] 1831', and is obviously a record of an exceptional effect, seen from Hampstead, where, from 1819 onwards, he constantly made such notes of the weather and changing skies over London. Leslie records that Constable made specific reference to the phenomenon of the sun's rays 'sometimes seen *converging* in perspective towards the opposite horizon'. Here the strange effect is combined with a double rainbow and very dark cloud, creating a very dramatic climatic incident. It is interesting that Constable should have seen and drawn such an effect at this date, the year in which his great picture of *Salisbury Cathedral from the meadows*, under a storm cloud and with a rainbow, was shown at the Royal Academy, since at this time his concern for grand pictorial effects was at its height – perhaps in response to his election as Academician in 1829.

112. Old Sarum

This impressive sheet was exhibited at the Royal Academy in 1834 as *The Mound of the City of Old Sarum, from the south*; it appears to be based on drawings made while Constable was staying at Salisbury with his friends the Fishers in 1829, the year following his wife's death. The ancient earthworks seem to have exerted a special fascination on Constable; he included the subject in his series of designs of *English Landscape Scenery*, where Lucas's mezzotint was published with the caption: 'Here we have no continuing city.' During the work on the plate Constable urged Lucas not to 'lose solemnity'. Even so, the large finished watercolour, which was the first work of the kind that he ever showed at a Royal Academy exhibition, is in no way laboured or over-dramatic. It preserves the directness of Constable's most intimate colour sketches, and presents its subject without artificiality or distortion. Constable seems never to have employed bodycolour to enhance or strengthen his watercolour, but relied on scraping-out alone to obtain those surface lights with which, by scumbling with white paint, he gave 'dewy freshness' to his paintings. The absence of figures is deliberate: in his note on the plate in the second edition of the *Landscape Scenery* Constable pointed out that 'the present appearance of Old Sarum – wild, desolate, and dreary – contrasts strongly with its former greatness'. Apart from the relevance of such ideas to Constable's state of mind in his later years, there is a direct connection between this theme and that of much romantic landscape painting, in which the idea of the decay of civilizations was a recurrent inspiration; it was frequently expressed, for example, by Turner.

John Sell Cotman (1782–1842)

Cotman was born in Norwich and came to London in 1798. He was employed colouring prints at Rudolph Ackermann's Repository of the Arts. In the following year he left Ackermann's to work with Dr Monro. In 1800 he showed six drawings at the Royal Academy, and was awarded the larger Silver Palette by the Society of Arts. He visited Bristol in 1800, making a tour of south Wales; he travelled in north Wales in 1801, and probably met Girtin and Sir George Beaumont there. When Girtin left for Paris in 1801, Cotman became a leading member of his sketching club. He toured north Wales with Munn in 1802, and both artists visited Lincolnshire and Yorkshire in 1803. He became tutor in drawing to the Cholmeley family of Brandsby, whom he visited again in 1804 and 1805, also staying with John Morrit at Rokeby on the Greta. In 1806 he moved to Norwich and joined the Norwich Society of Artists. Probably in 1812 he was employed by Dawson Turner at Yarmouth making archaeological and architectural drawings. He visited Normandy to make similar drawings for Turner in 1817, 1818 and 1820. In the ensuing years he tried to establish himself in Norwich as a drawing master and as a painter in oils. In 1834 he became drawing master at King's College School in London, where he died.

93. The market place, Norwich

One of Cotman's most elaborate compositions, foreshadowing his late watercolours of picturesque architecture in French towns (*see Plate 96*). Here the intense mood of the Yorkshire drawings has somewhat abated and we are struck mainly by Cotman's virtuoso ability to bring so much detail to order, to present a jumble of buildings and a throng of figures as a lucid, elegantly wrought pattern, which at the same time fully expresses the characteristic life of the market place.

95. The dismasted brig

A classic example of Cotman's pictorial architecture. He applies the disciplines which served him in delineating the buildings of Norfolk or Normandy to the portrayal of weather, showing us the massive vaults of the stormy sky, and the structure of the wind-blown sea. Even so, the sense of natural flux is preserved, and the composition is founded on a pattern of swaying lines which embodies the tossing movement of the subject.

96. Street scene in Alençon

The drawings that Cotman made on his three journeys to northern France around 1820 provided him with the material for many watercolours executed during the remaining years of his life. Whereas the majority of those drawings were in pencil or ink wash, the watercolours are often richly coloured, with strong accents of viridian or scarlet. The similarity of his clearly-outlined buildings and groups of stocky figures to those in the work of Samuel Prout (*Plate 122*) is probably not entirely coincidental, since Cotman was anxious at this date to demonstrate his abilities in the same field as Prout. But even in his most elaborate works, Cotman retains his incisive understanding of picture construction and gives us a purer, more elegant view of topographical reality than does Prout.

98. The drop-gate, Duncombe Park

One of the 'Greta' drawings of 1803–5, this study has been thought to exhibit too much evidence of considered organization to be a study direct from nature, as Cotman himself suggested many of the series were. But the informality of the subject, with the rough pencil notes which show under the broad washes of colour, implies that there can have been little in the way of intermediate reworking between the original sketch and this drawing, which seems 'finished' more by reason of the extraordinary finality and completeness of Cotman's vision than because it is actually worked up into a finished state. As the unfinished foreground detail and the blank wash in the top left corner show, the design has in fact been left at the point at which it

was unnecessary to add more. All this lends weight to the view that the sheet was both drawn and coloured on the spot.

100 and 101. Croyland Abbey
Girtin was the master from whom Cotman learnt to endow the sky with monumental grandeur, and in the works of 1800 to 1803, when he was working most closely under Girtin's influence, the sublime effect of lowering storm-clouds frequently recurs. Here they are punctuated by bursts of light and patches of bright blue sky, so that the fascinating silhouette of the ruined abbey is given an elaborate and beautiful natural foil. Already Cotman has substituted for Girtin's evocatively rugged treatment of architecture a firmer, more precise method of delineation which lays greater emphasis upon the formal values of the outlines themselves, and allows them to create counterpoints of their own within the picture.

104. The marl pit
Cotman's concern for the surface pattern created by his compositions leads him to divide the picture space in surprising ways, rather as Towne did in his Roman and alpine views. Here the placing of the irregular yet refined line of the horizon is decisive, self-conscious and dictated wholly by abstract considerations; the contrast of the white cloud with the mass of dark foliage, and the careful disposition of other details, all follow logically from this. The drawing has all the characteristics of the work which Cotman produced in the years immediately after the formative Yorkshire period, 1803–6: the element of boldness has increased, and delicate detail is largely suppressed; colour is stronger and plays a dominant part in the establishment of a striking image. In spite of these important and typically Cotmanesque qualities, the drawing, dealing as it does with an informal corner of pastoral countryside, betrays the artist's association with the tradition of rustic painting exemplified by Crome.

107. Landscape at Whitlingham
During the 1830s Cotman's technical procedures became more complex; his manipulation of the watercolour in this drawing is considerably more involved than the simple flat washes that characterize his work of the 1810s and 1820s; there is greater richness and movement in the pigment itself, and Cotman uses this to give a new atmosphere to landscapes which he would previously have treated more abstractly. The trees and undulating land are seen rather in the formal terms of Cotman's favourite, Poussin, but are imbued with an organic life of their own and exist in a stormier climate than Poussin's Arcadia. In landscapes such as this, with its subdued emotion and autumnal colouring of russets and brownish-greens, Cotman anticipates the disturbed and tragic works of his last years.

David Cox (1783–1859)
Born at Deritend near Birmingham; studied under a miniaturist and later was employed as a scene-painter at the Birmingham Theatre Royal. In 1804 he came to London and took lessons from John Varley. In 1809 he became a member of the Associated Artists in Water-Colour and was their president from 1810 to 1812, when he became an associate of the Old Water-Colour Society, progressing to full membership in 1813. He published a *Treatise on Landscape Painting* in 1814, and *Progressive Lessons in Landscape* in 1816. A further manual, *The Young Artist's Companion*, appeared in 1825. From 1815 to 1827 he lived in Hereford teaching drawing, and visited the Low Countries in 1826. He returned to London in 1827 and visited northern France in 1829 and 1832. He began to paint in oils in 1839, and took lessons from W. J. Müller. In 1841 he moved finally to Harbourne near Birmingham, where he died. Between 1844 and 1856 he made regular annual visits to Bettws-y-Coed in north Wales.

109. The Brocas, Eton
Views on the Thames featuring Windsor or Eton on the skyline beyond a group of dark, silhouetted trees figure commonly in the work of John Varley and many of his pupils and followers. In his early years, Cox drew such subjects almost indistinguishably from Varley; but as he developed he was able to give them a fresh life that transforms them from somewhat staid, classicizing performances into brilliantly fresh comments on the real world. Cox's control of watercolour already has a pungency and briskness that was to develop into the astonishingly free work of his later years. He combines clear, bright colours with solid modelling to produce a remarkable *tour de force* on a very modest scale.

110. Hay-on-Wye
Unlike De Wint, on whose style the rich sonorous washes of Girtin had a permanent influence, Cox was able, early in his career, to translate the lessons of Girtin and Varley into an altogether lighter, freer and more delicate language. He retained their capacity to apply colour richly and to suggest broad spaces; but by working on a smaller scale with smaller strokes of the brush he evolved a process which was more expressive of the open delightfulness of English scenery. His splendid expanses of countryside, like this one, are often presented on a few square inches of paper, and with a disarming simplicity, so that we are moved by the ease with which natural events occur before our eyes. The freshness of Cox's colour and the unaffectedness of his composition here contrast sharply with the more grandiose performances of his contemporaries in their works for public exhibition. Even so, this may be counted among the characteristic 'finished works' of Cox's Herefordshire period.

116. Antwerp – morning
A subject derived from notes made by Cox during his tour of the Low Countries in 1826, this drawing was shown at the Water-Colour Society in 1832, which date is inscribed on the sheet. Cox, an immensely varied and versatile artist, was as great a marine painter as any of his contemporaries; the restraint and simplicity of his compositions lend them a soft poetry that is lacking from the noisier seascapes of Copley Fielding or Charles Bentley (1806–54). In this tranquil scene, the arrangement of the silhouettes against a glowing sunset is clearly inspired by Bonington, whose work Cox admired and copied.

117. Going to market
Although this is only one of many types of subject regularly tackled by Cox, it is perhaps the kind most readily associated with him. The cloudy, windy sky, the low-lying marshy land (perhaps near Portmadoc in north Wales), the dyke with its brick bridge and weedy banks, and the receding train of figures, recur in landscapes by Cox of almost any period in his career. A subject like this might be repeated by him numerous times, but the artist always maintains the spontaneity of effect that is essential to his view of such scenes. In spite of the rapidity of his touch and the over-all freshness and looseness of handling, he treats the recession of the flat landscape with great delicacy and precision.

120. A street in Paris, near the Pont d'Arcole, with the Church of St Gervais (?) in the distance
This assured 'snapshot' view of an unexpected corner of Paris is drawn with amazingly rapid yet firm lines which establish only the essentials of the architecture: the reticent colour is beautifully judged to give weight and poise to the design. While it is in many ways close to the work of such Boningtonistes as Callow and Holland, this view has a lack of self-consciousness that marks it as Cox's work, and makes it quite unlike the virtuoso drawings of that school.

121. Lancaster sands, low tide
A larger version of this drawing is in the Yale Center for British Art. Like this one, it is treated very broadly, the colour washed on in liquid sweeps over a jagged and disintegrated pencil underdrawing. The wetness, the movement of air and light and of every detail in the

scene, are representative of the extremes to which Cox's art took him in exploiting the medium of watercolour. It was for such statements as this, we feel today, that watercolour was created; yet most of Cox's contemporaries were more concerned to load watercolour with the dignity of oil-paint. Cox himself, in his larger works for exhibition, sometimes betrayed ambitions along the same lines, and, thanks to the essential simplicity of his approach, often succeeded as well as he did in his more direct work.

Alexander Cozens (c.1717–86)

Cozens was born in Russia, the son of a shipbuilder to Peter the Great. He visited England in about 1742 and was in Rome by 1746, in which year he returned to England. From 1749 to 1754 he was drawing master in landscape at Christ's Hospital; from 1763 to 1768 he taught drawing at Eton. Later he was instructor in drawing to the royal princes. He taught many individuals including William Beckford, with whom he frequently stayed at Fonthill. He exhibited in London from 1760, at the Royal Academy from 1772, executing a number of oil-paintings in addition to his many drawings. He published *The Shape, Skeleton and Foliage of Thirty-Two Species of Trees . . .* in 1771, and *The Principles of Beauty relative to the Human Head* in 1778. *A New Method of Assisting the Invention in Drawing Original Compositions of Landscape* appeared in 1784 or shortly afterwards.

44. Landscape with a woman seated by a dark pool
A design which marks the transition in Cozens's development from idealization based on the classic landscapes of the seventeenth century, to abstraction on the lines of the 'New Method'. The composition of this landscape is derived from a print by the seventeenth-century Bolognese artist Giovanni Battista Grimaldi; but Cozens has invested the simple idea with an atmosphere entirely personal, which he creates by the heaping together of various technical devices, almost as if the drawing were an exercise, contrasting the thatched roof and pale silhouettes of trees against the luminous sky with the dark reflective surface of the water beneath different sorts of shrubs.

47. Distant view of Greenwich
This drawing is dated 1766, considerably later than Cozens's stay in Italy in the 1740s, but it shares with the drawings that he made then a general reliance on the classical formulas which he found in seventeenth-century landscape prints (*see note to Plate 44*). In particular the group of trees at the left belongs to that convention. But the expansive treatment, in progressive tones, of the central landscape, foreshadows the atmospheric subtleties of Cozens's son, John Robert. The realism of the foreground figures is most unusual in Alexander's work, as is the use of watercolour instead of monochrome wash.

49. Mountain peaks ('Blot')
A plate from Cozens's *New Method* in which he illustrates the principle of beginning with marks made at random on paper and progressing from them to a landscape which is abstract rather than specific in conception. We might compare the game of drawing human figures so that head, hands and feet fit into five arbitrary points – a game played frequently by Fuseli, who experimented with the expressive possibilities of the human body along lines not unlike those pursued by Cozens with landscape. Here we feel, just as we do sometimes with Fuseli, that a boundary of visual potential is being crossed – that fresh ground is about to be opened up in the field of expression.

50. Mountain peaks
The plate from the *New Method* illustrated in *Plate 49* is Cozens's permanent record of the 'blot' from which he developed this dreamlike view of mountain peaks – a remote, rarefied world in which landscape is divorced completely from the points of reference supplied by ordinary experience. It is possible that by the time this

composition was invented Alexander had absorbed the lessons of his son's alpine scenes – compare *Plate 51*, for example. The essential quality of Alexander's late work, its poetic remoteness, was evolving at about the time when John Robert's career began.

John Robert Cozens (1752–97)

Cozens was probably born in London and became the pupil of his father, Alexander. He exhibited at the Society of Artists from 1767 to 1771, and showed a painting, *Hannibal in his march over the Alps showing to his army the fertile plains of Italy*, at the Royal Academy in 1776. In that year he accompanied Richard Payne Knight through Switzerland to Rome, returning to London by early 1779. He made a similar journey with William Beckford in 1782, and stayed with Sir William Hamilton at Naples. Later in Rome he gave lessons in drawing to Sir George Beaumont. He returned to England in 1783, and produced many watercolours based on his Swiss and Italian drawings. A prey to melancholia, he became progressively more insane, and by 1794 was in Dr Monro's asylum.

51. The Aiguille Verte
A large and richly coloured watercolour developed from the drawing in pen and brown ink and grey wash, now in the Yale Center for British Art, which Cozens made on his journey through Switzerland to Italy with Richard Payne Knight in 1776. Although the palette is limited to blue, brown and grey, Cozens achieves a dramatic power which is immediate and striking; the strange shapes of the peaks projecting through clouds above their covering of snow make for a composition that is oddly whimsical, reminiscent of the pure fantasies of Alexander Cozens. At the same time the forms have a crisp definition, perhaps modelled on the style of William Pars, which Cozens was later to modify in favour of a more atmospheric approach. Two other full-scale versions of this subject are known.

52. The Reichenbach between Grindelwald and Oberhaslital
In all probability Cozens made only pencil outline notes while he was touring with Richard Payne Knight through Switzerland to Italy in 1776; but he may have made the series of more elaborate drawings, of which this is one, in the course of the journey; though it is also possible that they were executed after his return to England in 1779. They are however very different in conception and technique from the larger watercolours that Cozens made of the more interesting subjects for patrons in England, relying as they do on a firm pen drawing which militates against the soft, melting and ambiguous forms of the watercolours and naturally gives prominence to more concrete features such as the dead trees and tumbled rocks which contribute largely to the sublime quality of Swiss scenery. Even so, Cozens's handling of a limited range of greys is often very subtle, and anticipates the atmospheric achievements of his great watercolours.

53. Windsor Castle from the south-west
One of Cozens's comparatively rare English subjects, and probably executed towards the end of his active life. The composition, with its *repoussoir* of dark trees contrasting with the distant view of the castle, borrows something from one of the most famous and successful of Cozens's subjects, his view of Lake Albano and Castel Gandolfo, of which there are versions in the Tate Gallery, the Paul Mellon collection, and elsewhere. Cozens deliberately chooses a viewpoint which allows a maximum of recession, from a hill near the top of the Long Walk (seen in the middle distance a little to the right and in front of the castle), across the distant valley of the Thames. The watercolour provides a fine illustration of his mastery of recession, which is suggested by an economical distribution of specific objects, bushes, trees etc., over the surface of the park.

74. The Lake of Nemi looking towards Genzano
It is very difficult to date the various versions which Cozens made of

his Italian and Swiss subjects in response to commissions from patrons. This composition, derived from a study in an album in the Soane Museum, exists in at least two other versions; other subjects were repeated as many as ten or more times and might be taken up at any date after the original sketch was made. The design is typical of Cozens's reticence, which is apparent as much in the organization of the view as in the delicate grey-greens and blues with which he evokes the whole scene. The play of contrasting, counterpointed lines is a discreet reinforcement of the quiet, meditative mood: across the rather bare, horizontal landscape the sloping streaks of cloud and tilted pine trees at the right give added force to the slope of the far hills; the sunlight floats gently over the tops of the foreground bushes to intensify only in the reflection of the lake and distant plain.

Joshua Cristall (1768–1847)

Cristall was born at Camborne, Cornwall, the son of a Cornishwoman and a Scottish sailmaker who moved his business to Rotherhithe, and sent Joshua to work as a painter on china, first in Aldgate, later in Shropshire. In 1792 he joined the Royal Academy Schools; in the 1790s he attended Monro's drawing academy, and came into contact with the Varleys. In 1802 he toured north Wales, returning there in the following year with Cornelius Varley; in 1803 he showed a portrait at the Royal Academy, but thereafter almost invariably exhibited landscapes and figure subjects with the Old Water-Colour Society, starting to do so in 1805. In that year he visited the Lake District, and in 1807, for reasons of health, stayed for some time at Hastings, producing many drawings. In 1818 he went to Scotland; in 1820 to Wales; by 1822 he had moved to Herefordshire, in spite of his election as president of the Water-Colour Society in 1820. He returned to London in 1841, having lost contact with much of artistic life there, but continuing to show his work at exhibitions.

94. Sunset with fishing boats on Loch Fyne, Inverary

In Cristall the suave, classical style of painting in watercolour achieves its most characteristic form. Washes are applied with great breadth and simplicity while richness of tone and colour are maintained. Cristall's draughtsmanship is clear and precise, and his figures often have a statuesque quality which enables him to transform even his favourite groups of fishermen or dairy-girls into noble and universal types. It is no accident that he executed a large number of finished watercolours with explicitly classical, usually mythological subjects; but even in his sketches and studies he attained a cool poise and monumental dignity. In this he shows a spirit akin to that of Cotman.

John Crome (1768–1821)

Crome was born at Norwich where his father was an innkeeper. In 1783 he was apprenticed to Francis Whisler, a house and coach painter. He was able to form an acquaintance with the great masters of landscape, especially Hobbema and Richard Wilson, in the collection of Thomas Hardy of Catton. He became a drawing master and in 1798 became teacher to the daughters of John Gurney, Richenda and Elizabeth (later Fry). With the Gurneys he visited the Lake District in 1802 and subsequent years. He was a founder member of the Norwich Society, inaugurated in 1803, and regularly exhibited with them from their first exhibition in 1805. He also showed pictures at the Royal Academy. His etchings were published in 1834 by his widow and son, John Berney Crome (1794–1842).

97. The blasted oak

Although a considerable number of drawings have been attributed to Crome, few can be ascribed to him with certainty, and many works are inferred to be by him from the evidence furnished by his etchings, and the few drawings related to them. In this watercolour, the idiosyncratic handling of a typically picturesque motif, such as Gainsborough might have chosen, is reminiscent of Crome's treatment of gnarled and broken trees in the etched plates. The composition is exceptional, however, in its uncompromising concentration on the single tree, whose leafless boughs and gawky shape are unsoftened by any background, and stand out dramatically against the bare sky. This feeling of deliberate drama, together with the muted colouring – the drawing has faded to a very restricted range of greys and browns – suggest that Crome had seen and admired the work of Girtin in the late 1790s.

Francis Danby (1793–1861)

Danby was born near Wexford, the son of a country squire who moved to Dublin in 1807. He entered the drawing school of the Royal Dublin Society and studied with James Arthur O'Connor (1792–1841), 'the Irish Claude', with whom he came to London in 1813. Having spent all his money he walked to Bristol and became a drawing master there. He became the centre of a group of artists who sketched and exhibited together. He showed work at the British Institution in 1820 and at the Royal Academy in 1821. He was elected A.R.A. in 1825. He had moved to London by 1824, and in 1825 visited Norway. In 1829 he fled from his creditors to Paris leaving his wife and family. He was later joined by Miss Evans, his mistress, with whom he wandered about Europe, settling in Switzerland in 1832, but returning to Paris in 1836. After Miss Evans's death in 1837 he came to London again, but settled in Exmouth in 1847.

152. A mountain lake

Probably executed after Danby's visit to Norway in 1825, this watercolour, while it may record a scene that Danby actually saw among the Norwegian mountains, carries the artist's interest in grandiose effects of sublime nature a stage further than the *Avon Gorge* (Plate 154) towards the realm of purely imaginary, nightmare landscapes of fire, flood and universal destruction that he explored in his most famous paintings. Whereas the drama of the Avon Gorge is explicitly related to the easily appreciated wonder of local middle-class sightseers, these wild crags are presented as weird, frightening in their desolation and distance from the ordinary pursuits of men: they may be the setting for some unearthly, surreal drama that is yet to take place. A comparison of Danby's methods in constructing the subject with those of G. F. Robson in his *Highland landscape* (Plate 119) will show how far Danby had emancipated himself from the rather strict forms imposed on romantic landscape by the followers of Varley: there is here little of the classical order and harmonious simplification that characterizes their work.

154. The Avon Gorge, looking towards Clifton

The panoramas and precipices of the Avon Gorge outside Bristol provided the inspiration for many of the drawings and paintings of Danby and his circle in the 1820s. This is a particularly splendid example, showing a view that Samuel Jackson was to treat many times with almost equal success. Danby's use of the watercolour techniques of Girtin (who had himself made a fine drawing of the gorge), Nicholson and others is refined by his exquisite draughtsmanship and the controlled romanticism of his approach to a sublime subject. He combines breadth of vision with the ability to invent ravishing detail – the two ships passing the shadow of the rock, for example – so that the scene is presented with a vivid realism that makes the natural drama breathtaking.

William Daniell (1769–1837)

Daniell became pupil and assistant to his uncle Thomas (1749–1840), with whom he travelled to Canton and through India, 1785 to 1793. Their *Oriental Scenery* was published in parts between 1795 and 1808;

many Indian views were exhibited at the Royal Academy. He became an associate of the Royal Academy in 1807 and full Academician in 1822. He toured widely in England and in 1812 and 1813 made a journey round the coast which resulted in a series of 308 aquatinted plates for Richard Ayrton's *Voyage round Great Britain*, published in eight volumes between 1814 and 1825.

78. Durham
Although William Daniell is best known for his collaboration with his uncle, Thomas Daniell, in drawings of India, there can be no doubt that his most distinguished work was executed in England later in his life, when he had absorbed the lessons of Girtin. This example shows how powerfully he could compose, and how suavely construct a scene with smoothly applied washes. His colour is sombre and sublime, and avoids the clotted effects of Girtin, but Daniell often achieves similar textural variety by means of expert scraping- or scratching-out.

Edward Dayes (1763–1804)

Dayes trained under the mezzotinter William Pether and, from 1780, at the Royal Academy Schools. He practised as a miniaturist and as a painter of subject pictures, as well as a topographer and book illustrator. He exhibited at the Royal Academy from 1786 onwards, and showed work at the Society of Artists in 1790 and 1791. He was responsible for an account of *An Excursion through Derbyshire and Yorkshire*, and also wrote *Instructions for Drawing and Colouring Landscapes*. These were published, together with his brief biographical *Professional Sketches of Modern Artists*, in one volume in 1805. In the previous year he had committed suicide.

1 and 26. Ely Cathedral from the south-east
A very large example of Dayes's work as architectural topographer, in which his naturally open, frank style of drawing and colouring with simple green and blue palette strengthened with black is employed on a grandiose scale to convey the awe-inspiring qualities of a great cathedral. The drawing epitomizes the head-on collision between a traditional technique and a revolutionary vision: the principles of the sublime have been applied only to the size of the drawing and not yet to the method of colouring. The need to find a watercolour technique strong enough to support such lavish drawings was one of the direct causes of the technical revolution of the 1790s. By 1795 Dayes himself had begun to work in a more complex way, with superimposed layers of colour building up local tone; in 1792, works like this one still only expressed the inevitability of the change that was so soon to come.

4. Somerset House from the Thames
Technically, Dayes's work marks no great advance from that of Sandby: this drawing is executed in the same gentle colour range as Sandby's, with penwork like his to strengthen detail; but these simple resources are made to express a more dramatic view of the subject than Sandby's typical serenity of vision ever allowed. Here, in a comparatively early work, he lends a traditional subject extra force by depicting the river in a strong wind, with fitful light playing on the buildings beyond. Even so, the figures convey hardly any additional sense of drama, and are evidently not intended to engage our interest in a scene of sublime danger or distress. The building shown in this drawing is that built by Sir William Chambers from 1775 to replace the seventeenth-century house seen in Thomas Sandby's view (*Plate 2*).

Peter De Wint (1784–1849)

De Wint was born of Dutch parentage at Stone, Staffordshire, and in 1802 apprenticed to John Raphael Smith (1752–1812), who exchanged four years of his indenture for eighteen oil-paintings by his pupil. With Smith he met the history painter, William Hilton (1786–1839), whose sister he married in 1810. Hilton's family lived at Lincoln, and De Wint spent much time there. He entered the Royal Academy Schools in 1809, and was also a member of Dr Monro's circle. He became an associate of the Old Water-Colour Society in 1810, and a full member in 1811, exhibiting a large number of works, often of considerable size. He continued also to paint in oils; but was occupied with teaching many private pupils. In 1828 he visited Normandy, but concluded that England contained sufficient material for his art. He travelled extensively through England and Wales, but lived all his life in London.

83. Eton: twilight
The impact of Girtin's art on De Wint can be seen vividly in this ambitious early drawing, which has much in common with the work of other Girtin followers, such as Lady Farnborough (1762–1837). The foreground roofscape with its smoking chimneys and sombre lighting is evidently inspired by similar effects in Girtin's *Jedburgh* (*Plate 72*), for example, or the studies for the 'Eidometropolis' (*see Plate 70*). The firm, not to say insistent, horizontal stress in this design anticipates De Wint's lifelong fascination with flat landscapes; but here, he dwells with loving minuteness on the intricacies of a long recession through patches of light and shade into the far distance. Although this watercolour has now faded badly, a black and white photograph can still show the vigour and sureness of the over-all tonal plan by which the artist brings order to a complex subject.

84. Westminster Palace, Hall and Abbey
De Wint's great accomplishment with the brush, and the fact that he executed a large quantity of drawings in colour alone, using a very broad technique, have somewhat obscured his powers as a draughtsman. These are evident in the beautiful chalk studies that he was in the habit of making from nature, and in his drawings of architecture. This ambitious architectural subject shows him at his most disciplined, but it is also strongly atmospheric. The drawing belongs to the body of fine romantic topographical works inspired by Girtin's 'Eidometropolis' which artists like William Daniell and William Havell produced in the early years of the nineteenth century, creating highly expressive designs from subject-matter derived from the urban scene.

85. Still-life with a ginger jar and mushrooms
De Wint's Dutch ancestry reveals itself in his recurrent concern for the details of country life, and in the accomplished watercolour studies that he made of groups of domestic objects, which, however, rarely play any part in his finished works, except as occasional accessories at harvesters' picnics. He is known to have made oil studies of similar arrangements of pots and baskets.

86. Landscape with harvesters and a stormcloud
This subject may serve to represent a very large number of De Wint's watercolours, both exhibited and otherwise; he produced many celebrations of the broad flat farming country round Lincoln, and showed a preference for such landscape wherever he drew. The sweep of these fertile plains suited his generalizing brush, and his love of warm golden browns and deep greens was appropriately applied to harvest scenes. Here, he introduces an element of drama in the approaching storm, which gives the composition an added movement and provides a colour contrast in the dead grey of the thunder-cloud. As usual with these mature pieces, there is little to indicate exactly when the drawing was made, but the relative definition of detail suggests that this example belongs to a period not later than the 1820s.

87. Travellers resting outside an inn
De Wint and Cox began their careers together and even when their individual geniuses had taken them along distinctively different paths striking points of likeness continued to appear. In this drawing, where

the picturesque architecture of the inn and the masses of rich foliage are unmistakably De Wint's, the figures belong to much the same world as Cox's travellers, gossiping on their white horses, or riding away from us as they do in the paintings of Dutchmen such as Wouwermans and Berchem. De Wint's broad, easy mature style, in which the rich pigments of Girtin are given an endearing warmth and brightness, is well exemplified in this relaxed and pleasing composition.

Henry Edridge (1769–1821)

Edridge was born in London and apprenticed to William Pether, a mezzotinter. He entered the Royal Academy Schools in 1784 and began to exhibit miniature portraits at the Academy in 1795. He was a member of the Sketching Society and became a close associate of Girtin, Hearne and Dr Monro, making landscape and architectural drawings, as well as portraits, in their company. In 1817 and 1819 he visited Normandy, where he produced many architectural studies. He was elected an associate of the Royal Academy in 1820 and died the following year. He is buried near Monro and Hearne in Bushey churchyard.

60. A farm near Bushey

A copy of this subject, attributed to William Henry Hunt, is in the collection of the Yale Center for British Art. Edridge's workmanlike and direct style of drawing and colouring played a considerable part in the formation of the 'Monro school' style, and is a distinct variation on the manner practised by Girtin and Turner. His pencil work is similar to theirs, though less supple and delicate, and his colour is dominated by russets and yellow-greens unlike the cooler palette of most of his contemporaries. The subject is known as 'Singer's farm'; it is clearly identical to the building in Henry Monro's drawing (*Plate 61*) known as 'Bellis's farm'.

Joseph Farington (1747–1821)

Farington was born at Leigh, Lancashire, the son of a clergyman. In 1763 he became a pupil of Richard Wilson in London and from 1765 exhibited at the Society of Artists. He entered the Royal Academy Schools in 1769. From 1773 for three years he worked with his younger brother, George, in drawing the pictures in Lord Orford's collection at Houghton in Norfolk. Between 1776 and 1780 he lived in the Lake District; his *Views of the Lakes, etc. in Cumberland and Westmoreland* was published in 1789. From 1778 onwards he showed work at the Royal Academy, of which he became an associate in 1786, and full member in 1787. He drew the illustrations to Boydell's *History of the River Thames*, 1794 and 1796, and contributed to several other topographical works. He is best known for his diary, kept from 1793 until his death, recording his very wide acquaintance among London artists, to whom he was known as 'the Dictator of the Royal Academy'.

59. The Ouse Bridge, York

A subject very popular with the picturesque draughtsmen who visited Yorkshire in the later eighteenth century, and a favourite of Girtin's, the Ouse Bridge, like the old Welsh Bridge at Shrewsbury, the Monnow Bridge at Monmouth or the bridge at Bridgenorth, provided artists with an irresistible combination of ancient masonry, with arches over water which caught and reflected light, framed by dark piers and the masts of boats, ideal for picture-making. Farington did not, like Girtin, exploit the more dramatic effects of such a spot, but his broken, Canaletto-inspired pen line was well suited to the rendering of crumbling stonework and the general roughness of the picturesque detail. This large and ambitious composition is among the finest that Farington produced, a perfectly satisfying amalgamation of the varied elements of the scene.

Anthony Vandyke Copley Fielding (1787–1855)

Fielding, one of four sons of a portrait painter who all practised in watercolour, was born at East Sowerby, Yorkshire. His parents moved to London, and when he was sixteen to Westmorland. By 1807 he was teaching drawing in Liverpool. He toured Wales in 1808 and moved to London in 1809, where he was taught by John Varley, whose sister-in-law he married in 1813. He became an associate of the Old Water-Colour Society in 1810, full member in 1812, and president in 1831, exhibiting 1,748 works there during his life. In 1829 he moved to Brighton and in 1831 to Sandgate. He died in Worthing.

123. Rievaulx Abbey, Yorkshire

This drawing appeared in the Water-Colour Society's exhibition of 1839. Reivaulx was a theme treated frequently by Fielding, whose favourite subjects recur constantly among his many exhibited watercolours. Here the influence of Varley, which is the backbone of Fielding's style, can be seen mixed with that of Turner, whose atmospheric effects Fielding often very successfully imitated: a picturesque and pastoral scene is given nobility and power rather as Turner would have treated it, and transformed into an exercise in 'high art'.

John Flaxman (1755–1826)

Flaxman was born in York, but taken to London in infancy by his father, a maker of plaster casts who worked for the sculptors Roubiliac and Scheemakers. He first exhibited at the Free Society of Artists in 1767, and at the Royal Academy from 1770, in which year he entered its Schools. He made designs for Thomas Wedgwood, and was a friend of George Romney (1734–1802), Stothard, Blake and Fuseli. From 1787 to 1794 he was in Rome where he began to be patronized as one of the foremost sculptors of his generation. In 1793 his outline illustrations to Homer and Dante appeared and were immediately influential throughout Europe. Similar illustrations to Aeschylus were published in 1795 and a further series illustrating Hesiod, engraved by Blake, in 1817. He was elected A.R.A in 1797 and R.A in 1800, becoming professor of sculpture at the Academy in 1810.

32. Deliver the captive

A study for one of a set of groups depicting the seven Acts of Mercy. Flaxman's characteristic economy is evident here, not only in the cramming of the forms into a very bare inclusive outline but also in his evocation of a fully felt human predicament. Such simplification was practised by most of the Neo-classicists, and notably by Blake; few artists used it as expressively as Flaxman.

Myles Birket Foster (1825–99)

Born at North Shields, Birket Foster was brought up in London as a Quaker and apprenticed to a wood engraver, Peter Landells, a pupil of Bewick. He set up as an illustrator in 1846, but by 1859 had ceased work as an engraver himself. He travelled on the Continent in 1852, 1853 and 1861; in 1868 he was in Venice, which he revisited several times. He became an associate of the Old Water-Colour Society in 1860 and a full member in 1862.

141. Driving home the cattle

Although he made many studies in a loose, spontaneous manner, Birket Foster's mature finished watercolours are generally executed in a tight style which derives from the precisely-measured hatching and stippling in bright colour that Turner developed. It enabled Foster to achieve effects of dappled light and rich skies, like this one, which enjoyed great popularity. But Foster's work is small-scale in every sense, and his subjects are usually intimate rustic scenes without

drama. It may be, however, that he transmitted useful lessons in handling the medium to a superior artist, Albert Goodwin (1845–1932) – the last, perhaps, of real distinction to work in the spirit of Turner.

François Louis Thomas Francia (1772–1839)

Born in Calais, Francia came to England when young, and became assistant in the drawing school of John (?) Charles Barrow (*fl.* 1789–1802). He joined the 'academy' of Dr Monro at his home in the Adelphi. He was a member of Girtin's sketching club, and its secretary in 1799. He showed work regularly at the Royal Academy between 1795 and 1821, and was apparently appointed painter in watercolour to the Duchess of York. A series of soft-ground etchings by him were published in 1810 as *Studies of Landscape, Imitated from the Originals* (by Girtin, Gainsborough and Hoppner, as well as by himself). He joined the Associated Artists in 1810, and was their secretary in 1811 and 1812. He returned to Calais in 1817, and was associated with Bonington there in the immediately following years; and it was there that he died.

128. Calais Beach
This drawing, signed and dated by Francia in 1823, marks the transition of his style from the manner that he derived from his years in England and connection with Girtin, to a fresher, clearer approach that is close to Bonington's. It is an interesting document in that it dates Francia's change of style to almost the same moment as that of Bonington, and suggests that it may not be at all obvious which of the two men was the first to explore this new ground. It may be that they developed in the same direction simultaneously, but it is tempting to imagine that the rapidly moving genius of the younger artist who was so soon to die was responsible for the initial impulse towards these broad, horizontal compositions of open beaches and pale skies. Note how much less poetic capital Francia makes of the motif of boat-masts against a distant horizon than does Bonington (*see Plate 125*).

Henry Fuseli (1741–1825)

Fuseli was born in Zurich, the son of a landscape and portrait painter. He was ordained in 1761. He travelled to Berlin in 1763 and in the following year to England, where he worked as an illustrator until 1769 when he went to Rome. There he probably met Anton Raphael Mengs (1728–79) and met a circle of Neo-classical artists including Alexander Runciman (1736–85), and the Swedish sculptor, Johan Tobias Sergel (1740–1814). He began to exhibit at the Royal Academy in 1774; he left Italy in 1778 and was back in London in the next year. He became A.R.A in 1778 and R.A in 1790, being appointed professor of painting in 1799, in which capacity he delivered a series of important lectures on the history and theory of art. In 1786 he was commissioned by Boydell to paint nine subjects for his Shakspeare Gallery. Forty-seven paintings by Fuseli of Miltonic subjects were exhibited at Johnson's Milton Gallery in 1800.

34. The shepherd's dream
Fuseli was fond of depicting the revels of fairies, and was chosen by Boydell to paint the illustrations to *A Midsummer Night's Dream* for his Shakspeare Gallery. For this scene, the artist picked a passage from Milton's *Paradise Lost* which would afford a similar opportunity:
> . . . fairy elves,
> Whose midnight revels by a forest side
> Or fountain some belated peasant sees,
> Or dreams he sees, while overhead the moon
> Sits arbitress . . . (Book I, 781 ff)

The contorted pose of the sleeping shepherd is typical of Fuseli's

nervous exaggeration, but at the same time has something in common with the tightly-knit, crouching figures of Flaxman's *Deliver the captive* (*Plate 32*). The other figures, which fill the composition with a whirl of activity, illustrate Fuseli's inventiveness when evoking the supernatural.

35. A woman at her toilet
Fuseli's art is not primarily that of a colourist. His drawings are essentially vigorous essays in outline, and colour is used almost solely to reinforce dramatic contrasts of tone. Even a domestic scene like this one becomes a drama, in which the main figure possesses the authority of presence and gesture that we associate with, say, Mrs Siddons in Reynolds's portrait of her. For Fuseli, pictorial space was a stage with greater potentiality for sensation than that of the theatre. This subject was also treated on a larger scale as a painting illustrating William Cowper's 'The Progress of Error':
> That pleasures, therefore, or what such we call,
> Are hurtful, is a truth confess'd by all;
> And some, that seem to threaten virtue less,
> Still hurtful in th' abuse, or by th' excess.

Corruption through excess is a recurrent idea conveyed, usually incidentally, by Fuseli's work.

Thomas Gainsborough (1727–88)

In 1740 Gainsborough moved from his Suffolk birthplace to train in London under Francis Hayman (1708–76) and Gravelot (1699–1773). He returned to Suffolk in about 1748 to practise portrait painting in Ipswich. In 1759 he established himself at Bath where he became highly successful; his work was exhibited in London at the Society of Artists, and he was a founder member of the Royal Academy in 1768, though on account of a quarrel he showed no work there between 1773 and 1777. In 1774 he left Bath for London where he became a fashionable rival to Reynolds (1723–92). He also painted many landscapes and fancy subjects.

11. Wooded landscape with gipsies
In contrast to the specific recording of the topographers, picturesque landscape, like sublime historical painting, required judicious generalization on the part of the artist. Gainsborough was a master of such generalization when handling elements of natural scenery which he had originally studied at first hand. Here, we are convinced of the reality and individuality of the trees and sandy bank, but Gainsborough is already, at this comparatively early stage in his development, presenting them in an ideal form – not ideally elegant or perfect, but ideally broken and irregular. The figures share the same status, half observed, half abstracted as an expression of the quintessential rural life. Gainsborough owed much to Teniers, Ruysdael and Wynants in evolving such scenes; but his technique is entirely his own. He uses watercolour and bodycolour in an exceptionally liquid, easily manipulated combination which allows him to depict his figures with considerable detail, and at the same time to wash in a luminous sky behind feathery foliage with great rapidity and assurance.

James Gillray (1756–1815)

The son of Moravian parents, Gillray was born in Chelsea, and apprenticed to an engraver, Harry Ashby, from whom he ran away to join a company of strolling players. By 1775 he had probably returned to London; his first satirical prints appeared in that year. He entered the Royal Academy Schools in 1778 and came under the influence of Mortimer, whose style is reflected in his work. Although he worked as a painter and executed watercolours, his reputation was founded on an immense output of political satires issued as coloured engravings. He suffered from manic depression and was insane by 1810.

29. The fall of Icarus

This preparatory study for one of Gillray's satirical etchings, published on 20 April 1807, is inscribed with various notes of the artist's intentions, and has more sketches, in pencil, on the back. The design is a comment on a trivial political incident involving Lord Temple and his father, Lord Buckingham. Gillray was indebted to an amateur friend for the initial idea, but transformed it into a riveting and memorable image, in which gross distortion assumes an aesthetic value of its own. The quivering, nervous lines with which Gillray works out his idea are very different from the incisive etched outlines of the final print, which would often have been coloured with simple bright washes of watercolour prior to sale.

William Gilpin (1724–1804)

Gilpin, brother of the animal painter Sawrey Gilpin (1733–1807), was born near Carlisle. While still a student at Oxford he began to travel round England, drawing and forming his theory of 'Picturesque Beauty' in landscape, first suggested in his *Dialogue upon the Gardens at Stowe*, 1748. An *Essay on Prints* appeared in 1768. He became vicar of Boldre in the New Forest in 1777, and was later prebendary of Salisbury. His principal works on the Picturesque are: *Observations on the River Wye*, 1782; *Observations on the Lakes of Cumberland* and *Observations relative chiefly to Picturesque Beauty*, 1785; and *Remarks on Forest Scenery*, 1791.

47. An ideal landscape

Gilpin worked in a consistent style, making hundreds of small landscape drawings in the same manner as this one during the course of his life, but rarely recording any specific scene. Many of them were reproduced as etchings with aquatint in his various works on picturesque scenery.

Thomas Girtin (1775–1802)

Girtin was born in Southwark, the son of a brush-maker. He is said to have coloured prints with Turner for John Raphael Smith, and in 1788 became an apprentice to Edward Dayes. His first dated watercolours are of 1791; in 1794 he exhibited at the Royal Academy for the first time and made a tour in the midlands with James Moore. In this or the following year he entered Monro's Academy. In 1796 he toured the north of England and Scottish border country, and in 1797 visited Devonshire, Dorset and Somerset. He toured north Wales and first stayed at Harewood giving lessons to Edward Lascelles in 1798. He was again in north Wales in 1800. At about the same time he was probably working on his 'Eidometropolis', and in 1801 he went to Paris with the idea of making a similar panorama of that city. The 'Eidometropolis' was exhibited in London in 1802, and was still on show when he died from tuberculosis in November of that year.

65. The west front of Peterborough Cathedral

The pencil drawing for this watercolour was made while Girtin was touring the midlands with James Moore in 1794; at least four finished works were based on it, including a subject shown at the Royal Academy in 1795. The Maltonesque composition, showing the architecture in steep perspective from below, is particularly striking in this version, where Girtin has carried the top of the left-hand tower out of sight beyond the edge of the sheet, adding to the grandeur of the soaring façade. Girtin's technique is very different from Malton's, exploiting the roughness and richness of the weathered stonework and using the play of light to enhance its variety. At this point topographical draughtsmanship and romantic expression are fully fused for the first time.

69. View of Rochester from the north

An early work in which Girtin's debt to Edward Dayes is apparent in every detail: the fresh blue and green colouring, the bright figures, the formulas used for the foreground plants. But this is an ambitious composition, involving as it does the distant perspective of fields and hills seen through a squall of rain, as well as the view of the city by the river Medway. Although naïve in detail, its presentation is almost identical to that of many comparable designs by Dayes himself. A small version of the subject, signed and dated 1791, is also at Yale.

70. The Thames from Westminster to Somerset House

This is one of Girtin's watercolour studies for the 'Eidometropolis', showing the Shot Tower on the left, with beyond it the Water Tower below the Adelphi with St Martin-in-the-Fields beyond, and, to the right, Somerset House and St Mary-le-Strand. Girtin's generalization of the scene is as apt and effective here as in his views of mountain landscape, and he suggests the smoky atmosphere of the city as well as giving an easily identifiable account of the buildings along the Thames. The object of the finished panorama was, of course, to offer the public a recognizable facsimile of what they knew; Girtin's realism is revolutionary only in that it takes full account of climate and light. There is controversy as to the exact date of the studies for the 'Eidometropolis', with an early reference to 1797–8 as the year of their execution. It seems likely, however, that they belong to a slightly later time, since they have all the mastery that we find in Girtin's work of 1799 onwards: they are surely the productions of his full maturity. The panorama was ready before he went abroad in 1801, and the studies probably immediately pre-date it.

71. View on the Wharfe, near Farnley, Yorkshire

The subject of this impressive work, probably produced during the last year or so of Girtin's life, is at the opposite pole from the specific architectural studies with which he began his career: it is concerned not with objects or location but with the atmosphere of an expanse of open country, in which the mood created by a lowering cloud and distant column of smoke is more important than any precisely identifiable place. Girtin leads the eye into this broad theatre of sheer sensation by a succession of serpentine diagonals, letting us pause momentarily on insignificant objects which supply a sense of scale. The brightly illuminated cloud of smoke repeats the motif of *The White House, Chelsea (Plate 73)*, again producing an effect of solemnity and great breadth. As usual in such works either of Girtin or Turner, the palette is 'sublime': deep greens and browns resonating between blackish grey and brilliant white.

72. Jedburgh

One of the most impressive of Girtin's compositions, this powerful view is a second version of the subject which he drew in pencil on a visit to the Scottish border in 1796 – it is dated 11 October of that year. The first watercolour of 1796 or a little after comprehends a wider panorama, including the abbey and a wide tract of country to the right. In this later version the whole of the right-hand side of the scene is eliminated, and the perspective down the village street becomes the single axis, round which a rich and complex sequence of visual events is gathered. The building up of detail, rough walls, thatched roofs, smoking chimneys, figures and animals, round the muddy street on which the light falls in a single flood, is a monumental demonstration of Girtin's ability to combine diversity with boldness, and the union of such a mass of incident with the calm and majestic sweep of the hills beyond perfectly illustrates the genius that could transmute the picturesque into the sublime.

73. The White House, Chelsea

This was one of Girtin's most celebrated drawings in his own day, and was much admired by Turner who fully appreciated and sometimes copied its central motif: the heightened reflection of light on the wall of the White House, creating an artificial – that is, unnatural – but poignant effect. The success of the whole composition, however, depends far more on the exquisite subtlety of Girtin's handling of the

cool range of browns, greys and blues that he uses to summon up the broad Thames twilight. The style and format of the view have led to its being associated with Girtin's 'Eidometropolis', but it does not relate directly to the plans for that work, and is indeed suffused with a stronger and more specific mood than any of the surviving studies for the panorama. A pencil outline sketch of the *White House* is in a sketchbook which has been recently rediscovered.

75. The Rue St Denis, Paris

This watercolour is based on a pen and wash drawing in the Musée Carnavalet, Paris, made in Paris during Girtin's visit to the city in 1801–2. The subject was also included in his set of *Twenty of the most Picturesque Views in Paris*, etched in soft-ground in the autumn of 1802. It has been suggested that the *Rue St Denis* was made as a design for a backdrop to be used in a London theatre, and the emptiness of the street and general layout of the composition support such an idea; but the somewhat larger and unfinished though otherwise very similar watercolour of the *Porte St Denis*, in the Victoria and Albert Museum, also has an empty foreground which was clearly intended to be peopled with figures; Girtin's washes leave spaces into which they were to be inserted. This would be inconsistent with any theatrical purpose, but it is odd to associate one of the two drawings with such a role and not the other.

76. Storiths Heights, Wharfedale, Yorkshire

In this famous drawing, Girtin's evolution into the complete artist of the sublime is seen accomplished. The landscape is reduced to a few essential elements which suggest the grandeur of a wild north-country scene. Much is left to the imagination, and that relies on sombre colour and the evocative form of the bare hill rising like a whale out of the countryside. The perfection of this as it were final statement must, however, owe something to the fact that it was never finished. There can be little doubt that Girtin would not have left the foreground in its present unspecific state, if only because, despite its emptiness, it does not fulfil its function of leading us into the distance as it would when properly articulated. It may be that the whole design would have been given greater circumstantial concreteness and that the drawing we now see misrepresents Girtin's intentions in what was probably one of the last works on which he was engaged.

John Glover (1767–1849)

Glover was born at Houghton-on-the-Hill, Leicestershire, the son of a farmer. He was a pupil, briefly, of John 'Warwick' Smith, and of the influential drawing master, William Payne (c.1760–c.1830) of Plymouth. He taught drawing at Lichfield from 1794, and in the following year began to send work to the Royal Academy. He was a founder member of the Old Water-Colour Society, and its president in 1813, an enthusiastic advocate of the inclusion of works in oil at its exhibitions. He resigned in 1817 and unsuccessfully sought election to the Royal Academy. In 1824 he was involved in the founding of the Society of British Artists. He had many pupils and followers whose work borrows his own characteristic mannerisms. He emigrated to Tasmania in 1831, but continued to exhibit in London.

89. Landscape with cattle

Glover's watercolour landscapes, like those he did in oil, aim at a generalized expression of natural beauty which stems partly from the 'abstract' formulas of Alexander Cozens and William Gilpin. He was, however, particularly successful in giving life and conviction to his scenes, largely by means of his ingenious use of a dry brush to build up masses with feathery strokes suggesting the dappled and moving play of light, so that even his most solid and academic conceptions have a certain charm. In this example, the monumental forms of the trees and hillsides are alive with the flicker of light, so that in spite of its formality the design preserves something of the freshness and unexpectedness of Glover's many small-scale sketches and studies.

William Havell (1782–1857)

Havell was born into a large family of active artists. He met John and Cornelius Varley in 1802 at Dolgelly, and quickly contracted associations with many of the leading watercolourists of his generation, including Cristall and Cox. He first exhibited at the Royal Academy in 1804, and was a founder-member of the Old Water-Colour Society, inaugurated in the same year. In 1812 his series of *Picturesque Views of the River Thames* was published by Robert Havell, who, with Daniel Havell, engraved the plates. This was the first of many publications to which William contributed. In 1816 he sailed on Lord Amherst's Embassy for China and returned via India where he spent eight years. In 1828 to 1829 he was in Italy. After about 1830 he worked almost solely in oil, and continued to exhibit regularly in London and elsewhere. His career ended in ill-health and poverty.

92. A road under trees in Knole Park, Kent

An unpretentious subject of traditional rustic and picturesque interest, perhaps recalling the woodland scenes of Hobbema, deliberately recast in a monumental mould as an exhibition piece. But this is not simply an enlargement of a small-scale composition: Havell creates truly noble trees and places them in a grand, towering mass above the little figures, which are, however, unaffectedly rural and make no concessions to public art. Havell's solid, rich colouring and careful massing of parts help to give the picture real dignity. Technically it is handled with considerable variety, the artist having absorbed lessons not only from Girtin and his own fellow members of the Water-Colour Society, but also from Turner, whose inventive approach to the medium he admired.

Thomas Hearne (1744–1806)

Hearne was born at Brinkworth near Malmesbury in Wiltshire. Moving to London he became apprenticed to William Woollett, the engraver, from 1765 to 1771, in which year he was appointed draughtsman to the governor of the Leeward Islands, Sir Ralph Payne. After three and a half years he returned to England to publish his views. Thereafter he confined his topography to English and Welsh scenery. In 1777 he began work with William Byrne on *The Antiquities of Great Britain*, published in 1807. He was a close friend of Sir George Beaumont and Dr Monro. He is buried near Monro in the churchyard at Bushey, Herts.

12. View of a river with overhanging trees

In Hearne's hands the elements of the typical picturesque scene were given a new formal significance: the variegated masses of the foliage in this example are perceived as richly textured forms, and even the smooth surface of the water has acquired a palpable structure. The composition as a whole is far from being an elegantly arranged collection of rural scraps – it is a carefully planned and organized design both on the plane of the paper and in three dimensions, from which a restricted range of muted greens does not distract the eye.

Robert Hills (1769–1844)

Hills was born in Islington and received lessons in drawing from J. A. Gresse (1741–94). He seems to have begun as a painter on glass. He entered the Royal Academy Schools in 1788, and first exhibited in 1791. His series of etchings of different types of animals issued between 1798 and 1815 gained him a considerable reputation. From 1804 he exhibited animal subjects with the Old Water-Colour Society, of which he was the first secretary. He often contributed animals to the landscapes of other artists, notably George Fennel Robson and George Barret Jr (1767–1842). James Ward, with whom he may have toured many parts of England, was a close associate. He visited the Low Countries in 1815, and in about 1831 he went to Jersey, making a further visit there in 1833 with Robson.

90. A village in snow

Hills's specialization in animal subjects did not prevent him, as a member of the Water-Colour Society, from aspiring to create watercolours that were like oil-paintings. Indeed, he was particularly fond of overt pastiche, as this drawing shows: it is very similar in both subject and general design to Rubens's picture of a *Barn in winter* in the Royal Collection, and it recalls, in addition, the snow scenes of Pieter Bruegel the Elder. The execution of such a subject in watercolour involves a virtuoso use of exposed white paper combined with scraping-out, and perfectly illustrates the dramatic possibilities in watercolour of leaving the paper bare. Hills made at least one other drawing on the same theme (now at Yale).

William Hogarth (1697–1764)

Hogarth was born in London, the son of a schoolmaster; he was bound apprentice to the silversmith Ellis Gamble. He began work as an illustrator and painter of conversation pieces, but later achieved fame as a satirist, through the engravings which he made of his own pictures after the publication in 1733 of *The Harlot's Progress*. He married the daughter of Sir James Thornhill in 1730. The pirating of his work led to his successful campaign for an Artists' Copyright Act, passed in 1736. In addition to portraits and social satire, Hogarth executed some large-scale religious subjects, notably the decorations for the staircase of St Bartholomew's Hospital, and an altarpiece at St Mary Redcliffe, Bristol.

18. Strolling actresses dressing in a barn

An example of Hogarth's 'humour through confusion', which is perhaps the pictorial equivalent of the bedroom farce. The disentangling of the parts of such an intricate design as this is an essential aspect of the entertainment that it provides, and it was this type of comic human muddle that Rowlandson used repeatedly as a motif in his own work. There is however a greater element of intellectual control in Hogarth's management of these subjects, and his accumulation of detail upon detail makes for a richer and more complex commentary on humanity than we generally find in Rowlandson.

James Holland (1800–70)

Holland's grandmother was a porcelain painter at Burslem, Staffordshire, where he was born and followed in the business, continuing to do so after he moved to London in 1819. He became a teacher of drawing, and from 1824 onwards showed flower paintings at the Royal Academy, though he was already varying his subject-matter to include architectural and marine views. In 1831 he went to France and thereafter travelled widely in Europe, working particularly frequently in Venice. He became an associate of the Old Water-Colour Society in 1835, but left it to concentrate on oil-painting in 1843; however, he returned in 1856 and became a full member of the society in the following year.

133. Venice: the Salute and St Mark's from S. Giorgio Maggiore

In spite of the great emotional significance that Venice had for English artists who visited it in the early nineteenth century, it inspired few of them to produce works which do not in some way betray the fact that they saw it through other artists' eyes. In the distortion that Holland indulges in here, placing the island of S. Giorgio much further to the north than it in fact is, and exaggerating the height of the Campanile of St Mark's, we may perhaps detect a reminiscence of Turner; but in its technique this work is closer to Bonington, who would not, however, have conceived anything on so grand a scale. Many of Holland's Venetian studies, in pencil with bold washes of colour, have the spontaneity of Cox's architectural drawings (*Plate 120*). Sometimes he used heavy applications of vivid bodycolour to finish his designs, which are decorated with brightly-coloured groups of figures.

William Henry Hunt (1790–1864)

William Hunt's father was a tinman of Covent Garden who sent him as a pupil to John Varley in about 1804, because the boy was a cripple with an aptitude for drawing. Through Varley he met Linnell and Mulready (1786–1863), who encouraged him to enter the Academy Schools in 1808; he had shown three oil-paintings at the Royal Academy in the previous year. He worked at the Drury Lane Theatre in 1809. The Duke of Devonshire and the Earl of Essex commissioned him to make drawings, and at the latter's house, Cassiobury, he met Dr Monro, with whom he frequently stayed at Bushey. In 1824 he became an associate of the Old Water-Colour Society, and was a full member in 1826. From 1827 he began to specialize in still-life.

135. The portico of St Martin's-in-the-Fields

Hunt's powers as a draughtsman are well illustrated in this drawing, which shows him in the earlier part of his career (it is difficult to date precisely) as a fully-fledged exponent of the tradition of architectural topography going back to Malton and Canaletto. Hunt's sensitive, changeable pen outlines (which he abandoned in his later work) were taken up by Samuel Prout, and developed into a still more elaborate system of notation; it is interesting to compare this drawing with Prout's view of the Zwinger (*Plate 122*). While Prout infuses vitality into his architecture, Hunt conveys more impressively the life that surrounds and makes use of the buildings. Although he does not, like Prout, draw individual figures, he more convincingly suggests the bustle of city life in the entrance to St Martin's Lane on the left.

136. A little girl reading

Some of Hunt's early work was in the form of miniature portraits, and he remained fond of drawing the likenesses of those around him, and adapted the tight handling of miniature work to these freer, more informal expressions of domestic affection. In studies like this one, which may show a young relation of Hunt's, Sophy Steadman, there is considerable variety of touch, from the careful stippling of lights and shadows on the flesh to the soft hatching of the background and the broadly indicated armchair. Hunt was a master of interior lighting effects, capturing very beautifully the glimmer of daylight on fabrics, or the flash of candlelight on faces.

137. Still-life with a cauliflour

Hunt's ability to render still-life had been evident in details of his work from an early date, but it was not until 1827 that he began to send specifically still-life subjects to the exhibitions of the Old Water-Colour Society. At first they seem to be an extension of his interest in all kinds of interior scenes, and he approaches vegetables and domestic utensils with much the same informal affection that he shows for his friends (*see Plate 136*), bathing them in soft light and revelling in his own very personal harmonies of gentle colour.

138. Still-life with bird's-nest and apple-blossom

It is an irony that Hunt's command of realism in his delicate and subtle still-lifes of the 1830s should have so attracted the public that he was impelled to exaggerate the effects he so naturally achieved and revert to the miniature techniques of his youth in order to create works of progressively greater minuteness, substituting virtuoso *trompe-l'œil* for the unaffected mastery of drawings like that illustrated here in *Plate 137*. It is significant that the element of soft light that so distinguishes his earlier portraits and still-lifes was dispensed with in favour of a hard, comprehensive and colourless light that plays no part in creating the image but permits total objectivity and accuracy of vision. This development was confirmed by the practice of the Pre-Raphaelites and can be traced in several other artists of the period, including Samuel Palmer.

139. The outhouse

A superb example of Hunt's achievement as a painter of rustic genre, in which his capacity both for still-life and for portraiture is employed in a single unified design. Although he later introduced a somewhat sentimental note into such subjects, making them arch, wistful, or simply over-pretty, he is here seen at his most direct, depicting details with loving accuracy and subordinating each to the mood of the whole drawing. It has been suggested that Hunt's stylistic development falls into two distinct phases, the first represented by the open, fresh work of his youth (see Plate 135), the second by the tighter manner of his later years. In fact we must distinguish a third period, between these two, in which the best aspects of both appear: this drawing is a highly developed specimen of the middle period, and the drawings in Plates 136 and 137 also belong to it.

Samuel Jackson (1794–1869)

Jackson was born in Bristol, the son of a drysalter. He early came into contact with Francis Danby, with whom he sketched in the countryside around Bristol. In 1823 he was elected associate of the Old Water-Colour Society, from which he resigned in 1848. He travelled in England and Wales and visited the West Indies in 1827 for the sake of his health. In 1832 he was active in the foundation of the Society of Bristol Artists. He was in Switzerland in 1855 and 1858. He painted a few works in oils, but his output is principally in watercolour.

153. A mountain valley

A particularly fine specimen of the elaborate watercolours submitted by Jackson to the exhibitions of the Old Water-Colour Society, showing the artificial subject-matter that such occasions inspired. The grandeur of the scenery is appropriate to the public nature of the work. To this extent, Jackson followed the example of Turner; but his harder, conventionally sublime colouring is in the tradition of Varley, and achieves effects similar to those of George Fennel Robson in his large-scale works (see Plate 119).

Edward Lear (1812–88)

Lear was born of Danish parents at Highgate, the youngest of twenty-one children. He suffered from epilepsy from childhood. An interest in natural history led him to work as a draughtsman at the zoological gardens in 1831, and in 1832 he published an important ornithological work, The Family of the Psittacidae, which was followed by other studies of birds, many made for Lord Derby at Knowsley. He travelled in England and Ireland in 1835 and 1836 and in the following year went to Italy, which he revisited several times, publishing his first book of views in 1841. In 1846 he gave drawing lessons to Queen Victoria. He made visits to the Middle East, especially to Greece and Egypt, in 1848 and 1849. His Journals of a Landscape Painter in Greece and Albania appeared in 1851 and Southern Calabria in 1852. From 1846 he also published his books of Nonsense. In 1850 he showed a picture at the Royal Academy and became a pupil at the Academy Schools. For reasons of health he usually wintered abroad, and eventually settled at San Remo, where he died.

113. Choropiskeros, Corfu

Lear's analytical method of drawing – usually beginning with pencil outlines carefully annotated with memoranda of colour and effect – lent itself to the delineation of broad views containing a variety of natural incident. Here, his clear penwork, tracing out the principal forms, establishes a path for the eye through a complex succession of planes involving dense foliage, rocks, rivers and mountains. Although Lear often indicates figures in his landscapes they rarely serve any but the simplest auxiliary function. His colour is frequently somewhat harsh, with contrasts of mauve, green and ochre; here he achieves a lovely iridescence which suggests the play of warm light across the countryside. He returned again and again to Greece and its islands, where the combination of wilderness and Mediterranean cultivation seems to have provided him with a perfectly congenial range of subjects.

John Frederick Lewis (1805–76)

Lewis's father was an engraver, Frederick Christian Lewis, and his determination to be an artist was apparent at an early date. In 1820 he exhibited and sold A donkey's head at the British Institution, and thereafter devoted himself to the drawing of animals, which he drew in the menagerie at Exeter 'Change with Edwin Landseer (1802–73). He made etchings and paintings of animal subjects, which proved successful, and attracted the support of Sir Thomas Lawrence. He was patronized by George IV and exhibited regularly at the Academy and the British Institution. In 1827 he appears to have made a journey along the Rhine and through Switzerland to Venice. He was made an associate of the Old Water-Colour Society in that year, and a full member in 1830; after this he ceased to paint in oils until the 1850s. He visited Spain in 1832 to 1833, and published Lewis's Sketches and Drawings of the Alhambra, lithographed by J. D. Harding and others, in 1835. His own lithographs of Lewis's Sketches of Spain and Spanish Character appeared in 1836. In 1837 he travelled through Europe to Constantinople, which he reached in 1840. He settled in Cairo in 1841, and remained there until 1851, when he returned to England, and caused a sensation with his watercolours of oriental subjects. He was president of the Old Water-Colour Society in 1855 and 1857, but resigned his membership in 1858 to concentrate on oil-painting; he became an associate of the Royal Academy in 1859 and a full Academician in 1865.

142. Girl in an interior

Lewis's debt to Bonington is celebrated here not only by the explicit quotation in the form of the framed drawing on the floor, which is Bonington's own Venetian balcony (Plate 143), but in many details of technique, including the use of a dry brush, and outline drawing with brown colour, and in the subject-matter: this figure in an interior is one of a large number executed by artists such as George Cattermole (1800–68) in the spirit of Bonington's costume studies; though in this case the scene is a contemporary one, with perhaps a suggestion of the popular genre subjects of David Wilkie (1785–1841) and Lewis's friend Edwin Landseer.

144. The Alhambra

While he was on his travels Lewis was in the habit of making pencil drawings of buildings and people individually; to these he usually added some washes of tone and white bodycolour heightening. In this instance, the colour is applied direct to the paper with no pencil outline. Often he coloured the drawing, at least partially, as he has done here with notes of the reddish roof-tiles, green surrounding landscape, and blue sky. Subsequently, such records were referred to in the construction of Lewis's large-scale subject pictures.

145 and 149. A Frank encampment in the desert of Mount Sinai, 1842 – the Convent of St Catherine in the distance

Ruskin was deeply impressed by this watercolour when it appeared at the Old Water-Colour Society's exhibition of 1856. He wrote to Lewis: 'I can't tell you how glorious I think it – Are you sure of your material – If one of those bits of white hairstroke fade – where are you? – Why don't you paint in oil only, now?' It is difficult to imagine Ruskin asking Turner to do the same when confronted by one of his late Swiss watercolours: there is a distinctly un-watercolourish quality in such works as this – a feeling they do not require to be executed in that medium and that medium alone. The scene, as Lewis's title makes clear, is taken from life: 'The picture comprises portraits of an English Nobleman [?Lord Prudhoe, later Duke of Northumberland] and his

suite, Mahmoud, the Dragoman, etc., etc., etc., Hussein, Scheikh of Gebel Tor, etc., etc.'

146. Study for 'The Proclamation of Don Carlos'

Lewis's method of constructing one of his large subject pictures in watercolour was precisely analogous to the method of preparing an oil-painting: studies of figures taken from the life, and drawings working out details of the design were made in some numbers while the work was in gestation. At the sale of Lewis's effects after his death four lots were taken up by studies for *The Proclamation of Don Carlos*, an elaborate work, which, however, he apparently never completed. It was one of many subjects derived from his experiences in Spain in 1832–3, and would have reflected the brilliance of light and colour, the sparkle and variety of life, that he found there. Even though this sheet is a study, parts of which are left unworked, much of the detail has been put in with the same painstaking minuteness that Lewis applied to his finished pictures.

147. Study of a jaguar

A vivid presentation of one of the animals that Lewis loved to draw at the Exeter Menagerie. He endows the beast, with its compact shape and fine, brilliant colouring, with something of the quality of a carved gem. This capacity to see all objects as jewels, intense, purely formed and essentially static, is typical of Lewis's vision, and the secret of his appeal for Ruskin.

148. An old mill

This drawing has been supposed to be that exhibited at the Old Water-Colour Society in 1830 (No. 60) as *Water Mill in the North of Devon*. Simple rustic subjects such as this were not to occupy Lewis's attention for very long; but for a few years early in his career he applied his meticulous draughtsmanship to the unkempt pictur-esqueness of the English countryside, and showed his mastery of the medium of watercolour in the depiction of thatch, foliage, weathered woodwork, stony paths and grassy banks, variegated and dappled with sunlight, just as later he was to be fascinated by the play of sunshine through oriental screens and trellises. The dry brushstrokes visible in the thatch and foreground grass are characteristic of Lewis's style at this period.

150. Hhareem life – Constantinople

Apparently the work shown at the Old Water-Colour Society's exhibition of 1857 (No. 302) on which Ruskin commented: 'It seems to me a mere waste of intellect to bestow so much labour on a single drawing.' There is, however, a perfect balance of detail which allows all the parts, rich and intricate as they are, to cohere and harmonize, rather as they would do in an interior by, say, Matisse. Furthermore, the composition is extremely lucid, relying on a simple geometrical division of the space which recalls the quiet domestic scenes of Vermeer. The perspective of the latticed window and reflection in the mirror also seem to be borrowed from a seventeenth-century Dutch painting. Such formal restraint is not common in Lewis's work. Here, it provides room for all the exuberant decoration to find a natural and comfortable place.

151. Indoor gossip (Hareem), Cairo

This oil-painting and a companion work, *Outdoor gossip*, were shown at the Royal Academy in 1873; Lewis takes up again the theme of *Hhareem life* (Plate 150) and treats it in a similar way. It is to be noted that this panel is small, the size, in fact, of a normal watercolour; but Lewis worked on a much larger scale in both media.

John Linnell (1792–1882)

Linnell was born in Bloomsbury, the son of a general art dealer. He studied under John Varley with William Henry Hunt and William Mulready (1786–1863). In 1805 he entered the Royal Academy Schools and, like Hunt, became a protégé of Monro. He became a member of the Old Water-Colour Society in 1812, exhibiting watercolour landscapes and small-scale portraits. He resigned in 1820, preferring to work in oil. He continued to work both as a landscapist and a portraitist, his paintings becoming progressively larger. From 1807 he exhibited regularly at the Academy. Although he became a friend of William Blake in about 1818, his work owes little to Blake's influence. His daughter, Hannah, married Samuel Palmer in 1837.

42. Pike Pool on the River Dove, Derbyshire

In spite of his close friendship with Blake and admiration for his achievement, Linnell did not come under his influence in the way that Palmer and Calvert did. His early work reflects the style of Varley, but is pervaded by a quiet richness and delicacy of handling which place it above much contemporary watercolour. This unaffected view of a popular beauty spot, dated 1814, shows him as a purposeful recorder of nature with a strong personal sense of the mood of the scene, rather like Constable's.

Thomas Malton (1748–1804)

The son of an architectural draughtsman and lecturer on perspective also called Thomas (1728–1808), Malton was taught by him and at the Royal Academy Schools, where he won a gold medal in 1782. He exhibited at the Academy between 1773 and 1803, specializing in architectural subjects; he also painted scenery for Covent Garden. He set up as a drawing master and published many of his designs as aquatints, notably in his *Picturesque Tour through London and Westminster*, 1792. Turner briefly studied under him. His younger brother, James (?1766–1803), also an architectural draughtsman, moved to Dublin with their father in about 1785, and produced work similar to that of his brother.

64. King's Mews, Charing Cross

A typical example of the hand-coloured etchings by which Malton made his reputation. In his drawings, Malton's outline is coarser than here; the etched line perfectly suited his needs and, enhanced by his delicate washes of watercolour, beautifully expresses his clear-cut approach to London architecture. The imaginative use of a low viewpoint to add interest to the composition recurs often in his work, and was taken over by Turner and Girtin for more romantic ends in their architectural subjects of the 1790s. This subject, with added aquatint, formed plate XXI of Malton's *Picturesque Tour through London and Westminster*, which was published in 1792 and subsequent years.

Henry Monro (1791–1814)

The most talented of Dr Thomas Monro's sons, Henry embarked on the career of serious professional artist at about the age of seventeen; he joined the Royal Academy Schools in 1807, and exhibited works on the Academy's walls from 1812. In 1814 his history painting, the *Disgrace of Wolsey*, earned him a posthumous premium of 100 guineas, awarded by the British Institution.

61. Bellis's Farm

One of a number of landscape drawings by the youthful Henry Monro which reflect the influence of Henry Edridge, a close associate of Dr Thomas Monro's, and suggest also the work in pen and brown ink, partially influenced by Canaletto and Farington, of William Henry Hunt. Although Dr Monro's principal interest was in expressive arrangements of tone in the manner of Gainsborough, it is significant that the best work of his students belongs to this linear tradition, and is rarely affected by the abstract picturesqueness of Gainsborough's work. It is interesting to compare Edridge's treatment of the same building (Plate 60).

Thomas Monro (1759–1833)

Monro was born in Red Lion Square, the son of Dr John Monro, physician to Bethlem Hospital, whose assistant he became in 1787. He became principal physician there in 1792, and in the following year or early in 1794 acquired the house at 8 Adelphi Terrace in which he established his 'academy'. Among the artists who frequented this informal evening class were Girtin, Turner, Edridge, Varley, Cotman, Francia, the Varleys, De Wint and W. H. Hunt. He rented Fetcham Cottage, near Leatherhead, from 1795 to 1805, and from 1807 took a house near Bushey, Hertfordshire, for the summer each year; in 1820 he moved there permanently. He collected works of art all his life, and fostered an interest in painting and drawing not only in his protégés, but also in his sons, Alexander, John, and Henry.

58. A landscape composition with cart

Monro's method of working with an indian ink stick was a quick, facile means of producing landscape effects based on simple picturesque principles aided by the kind of generalization sanctioned by Alexander Cozens and brilliantly used by Gainsborough. The salient feature of such drawings as this, in which Gainsborough is closely aped, is the pleasing and dramatic one of a dark silhouette against a pale sky.

John Hamilton Mortimer (1741–79)

Mortimer's father was a customs collector at Eastbourne, and sent him to study under the portrait painter Thomas Hudson (1701–79). Mortimer was also taught by Cipriani (1727–85) and Reynolds. He exhibited with the Society of Artists, of which he became vice president in 1773; he was elected A.R.A. in 1778, the year in which he exhibited for the first time at the Academy. He collaborated with Wheatley and others in painting a ceiling for Lord Melbourne at Brocket Hall in 1771. In 1775 he settled at Aylesbury. He enjoyed a considerable reputation but led a dissolute life; he died of a fever in London.

16. Iphigenia's late procession from Kingston to Bristol

Mortimer's use of line for humorous purposes can be seen in this drawing for an etched plate lampooning Lord Bristol's wife Elizabeth Chudleigh, tried for bigamy. Although Mortimer owed much to Hogarth, he adopted an altogether different rhythm, which is apparently related to the caricature style of Pier Leone Ghezzi and, indeed, suggests in several respects the opulent penwork of Venetian draughtsmen like the Tiepolos. Many of the technical details recur in Rowlandson's early work, but the over-all mood and pace of the two artists are quite distinct.

William James Müller (1812–45)

Müller's father was a refugee from Danzig, who became curator of the Bristol Museum and married an Englishwoman, who educated William herself. He made drawings of objects in his father's museum and in 1827 was apprenticed to James Baker Pyne for two years. In 1831 he made a tour of East Anglia and came into contact with the work of Cotman. The following year he was one of the founders of a Bristol sketching club, based on that of Girtin and Cotman. In 1833 he toured Wales with Samuel Jackson and Skinner Prout (1806–76), and in 1834 he travelled through Germany and Switzerland to Italy. Another journey, in 1838, to Greece and Egypt, provided further material for paintings and watercolours, which he produced in abundance. He worked in France on illustrations for a volume of lithographs, *The Age of Francis I of France*, influenced by Bonington; this was published in 1841. In 1843 he joined Sir Charles Fellows's expedition to Lycia, returning in May 1844. Between his foreign journeys he toured in various parts of England.

134. A view on the River Xanthus

During his last important burst of creativity, fired by his tour of the Middle East in 1843–4, Müller made a long series of watercolour views in Lycia, Asia Minor. These are typical of his mature style at its best, unencumbered by any object save that of recording what he saw, and using the medium with great power and purity. Although he was in the habit, like many of his contemporaries, of heightening his watercolour work with opaque white bodycolour, he did not do so in the case of these drawings, since he found that the bodycolour darkened in the bottles he carried it in. His favourite gamut of oranges, browns, and ochres with some Prussian blue is accordingly displayed unalloyed, a subtly changing sequence of colours applied in firm, squarish masses which imply both the solidity of the rock forms and the extent of the space between them. There is something confident and muscular about Müller's handling of watercolour which is particularly well suited to the large, rocky landscapes of Turkey and Egypt.

Paul Sandby Munn (1773–1845)

Born at Greenwich, the son of a landscape painter and coach-decorator, Munn was taught both by his father and by his godfather Paul Sandby. He showed his first landscape at the Academy in 1799, and in the same year was associated with Girtin's sketching society. He made drawings as models for students to copy, for sale by his brothers, who were printsellers in Bond Street. In 1802 and 1803 he sketched in north Wales and Yorkshire with Cotman. He exhibited with the Old Water-Colour Society after he became an associate in 1805. He settled at Hastings as a drawing master some time before 1811.

99. Tan-y-Bwlch

This drawing is signed and dated to the year in which Munn toured north Wales with John Sell Cotman; it shows Munn at his best, perhaps inspired by his travelling companion, and preoccupied with the same sombre colour harmonies and lowering mountainous compositions that Cotman produced in the years 1800–2. In view of the great similarities between the two artists' work at this time, it is interesting that Munn's colour is instantly recognizable as his – the dull green of these mountains, combined with a flat grey, is a characteristic of much of his work, though it rarely achieved such expressive force. Cotman's colours, on the other hand, are blacker, revolving round a very dark grey and brown. Like Cotman's at this time, Munn's colour is applied in disjointed, flat areas; but, again, the patterns that he thereby creates are easily distinguishable from those of Cotman.

Francis Nicholson (1753–1844)

Nicholson's schoolmaster at Pickering, Yorkshire, where he was born, told him that he would go to London and become a famous draughtsman, like Cozens. After studying painting at Scarborough for three years, he began as an animal portraitist in Pickering, but visited London twice for periods of study, working under Conrad Martin Metz (1755–1827). In 1783 he settled at Whitby, painting portraits and topographical watercolours. He produced numerous drawings with the aid of a reprinted soft-ground outline. He first showed at the Royal Academy in 1789. By 1803 he had settled in London; he joined in the foundation of the Old Water-Colour Society and became fashionable; his tuition was much in demand. His manual *The Practice of Drawing and Painting Landscapes from Nature, in Water Colours* appeared in 1820.

88. Stourhead: view looking towards King Alfred's Tower

Nicholson made a long series of elaborate views showing *Rural Scenery at Stourhead* for Sir Richard Colt Hoare in 1813–16. All are

now in the British Museum, and in its rich, bright colouring this one shows the artist as a highly effective technician and able designer of decorative views. Despite his proficiency, however, and the acclaim accorded to his methods of working, Nicholson was temperamentally a traditional artist, whose work always retained the picturesqueness of the 1780s and 1790s, and seems slight by the side of his fellow members of the Water-Colour Society, who applied a similar technical acumen to bolder and grander schemes – compare examples by Glover and Havell (*Plates 89 and 92*).

Samuel Palmer (1805–81)

Palmer was born in Newington, London, and exhibited landscape drawings at the Royal Academy and at the British Gallery, Pall Mall, when he was fourteen. In 1822 he met John Linnell, who introduced him to other artists including Blake, whose achievement profoundly influenced him. Linnell also encouraged him to study Dürer and the early German masters. He produced his first series of great drawings in 1824 and 1825; shortly after that period he moved to Shoreham and became leader of 'The Ancients' – a group of artists inspired by Blake, including Calvert and Linnell, George Richmond and Francis Oliver Finch. In 1837 he married Linnell's daughter with whom he visited France and Italy, returning to England in 1839. He became an associate of the Old Water-Colour Society in 1850 and full member in 1854. After a period of decline he turned in his late years to etching, in which a return of his youthful inspiration is apparent. He moved to Redhill in 1862 and is buried in Reigate churchyard.

39. Early morning
Palmer's fierce, almost obsessive consciousness of natural phenomena is at its freshest and finest in the monochrome drawings that he made in and around Dulwich in 1824–5. Every line is pregnant with the significance which he perceived in things, and the effect of such intensity is slightly naïve, the inspired vision of early youth. A certain technical gaucheness seems almost a necessary prerequisite of such immediacy.

40. Sepham Barn ('The Valley of Vision')
The vivid inwardness and intensity of Palmer's work of the earlier 1820s had become somewhat blunted by the end of the decade; in this drawing more open space is suggested and the details of nature do not crowd so thickly into our view, compared with *Early morning*. But Palmer's passionate involvement with country life betrays itself in the lovingly realized structure and texture of the thatched roof of the great tithe barn, or in the firmly modelled formation of the background hills. Both in his interests and in his manner of handling them, Palmer is here a direct precursor of the natural investigations of John Ruskin in the 1840s. Both artists brought to their close analysis of the components of landscape a belief in the overwhelming presence of God. It was probably Palmer himself who designated this subject 'Part of the Valley of Vision'.

43. The lonely tower
One of a group of large and very elaborate watercolours completed by Palmer towards the end of his life as illustrations to Milton, this subject illustrates lines from *Il Penseroso*:

> Or let my lamp at midnight hour,
> Be seen in some high lofty tower,
> Where I may oft outwatch the Bear . . .

It was used again for one of Palmer's etchings. The love of richly-textured pastoral detail that characterized Palmer's work of the 1820s finds grander expression here in a design that harks back to the classical tradition of landscape. Palmer seems to blend the essentially private and visionary mood of the Shoreham 'Ancients' with the more public language of the Old Water-Colour Society exhibitors – G. F. Robson, for instance – or of Turner himself.

William Pars (1742–82)

Probably born in London, the son of a metal chaser, Pars studied at Shipley's drawing school and later assisted his brother Henry in teaching there. He exhibited at the Society of Artists in 1760, and won a Society of Arts premium for history painting in 1764. In that year he was sent by the Society of Dilettanti with Richard Chandler's expedition to Asia Minor; he made drawings there and in Greece, returning in 1766. His work was published in *Antiquities of Ionia*, 1769 and 1797, and *Antiquities of Athens, Volume II*, 1789. In 1770 he accompanied Lord Palmerston to Switzerland and became an associate of the Royal Academy, where his Swiss views were exhibited the following year. He accompanied Palmerston to Ireland and the Lake District, and was employed by Horace Walpole to make views of Strawberry Hill. In 1775 the Dilettanti awarded him a studentship to Italy where he worked in association with Towne, Smith, and others, until his death from pneumonia contracted while standing in water to draw at Tivoli.

56. A sepulchral monument at Mylasa, Asia Minor
One of the drawings made on Pars's journey to Asia Minor and Greece with Richard Chandler and Nicholas Revett in 1764–6. The scrupulously accurate delineation of the architecture indicates the talent for which Pars was employed; the original and effective composition also enables him to demonstrate his sensitive response to foreign landscape, which he renders with a subtle blend of watercolour and bodycolour suggesting the dryness and heat of the climate as well as the rugged nature of the terrain. In his observation of figures Pars ranks with the liveliest topographers of his time, integrating them into a total view of the place depicted.

57. The Rhone glacier and source of the Rhone
The group of Swiss watercolours that Pars exhibited at the Royal Academy in 1770 were the first views specifically of the Alps to have been seen publicly in England. They were, like his Greek and Turkish subjects, exceptionally sensitive records of foreign and, at that time, still very novel scenery. Pars combined the clarity of the scientific recorder with a rare expressiveness, and this drawing in particular presents a new world with wonderful precision in lucid, beautifully harmonized colours and boldly unconventional patterns conveying the geological formations of the subject. Pars provided an important precedent for J. R. Cozens in the following decade, but also anticipated the fresh alpine subjects of Swiss artists such as Aberli in the later years of the century.

66. Ariccia, with the Palazzo Chigi
Over the course of his career, Pars's art changed its direction from the production of accurate and useful records of little-known places historically or otherwise important, to the evocation of scenes well-known to the tourist and frequently drawn by other artists. In the watercolours of Italy that he made in the final decade of his life he often allows the interests of picture construction to usurp those of art history or topography. Here, for example, the value of the scene is assessed as much in terms of a picturesque pattern of sunlit foliage as in the specific place of the title. In this he was doing no less than his contemporaries, and may well have been influenced by the practice of sketching companions such as 'Warwick' Smith and Francis Towne. His acute sense of subtle tonal and chromatic harmonies, which was responsible for the vividness of his earlier views, now leads him to a proliferation of forms and colours in which the unity of the subject is lost. Nevertheless, Pars's Italian drawings convey better than those of almost any of his colleagues the sunny warmth of the Mediterranean.

Samuel Prout (1783–1852)

Prout was born in Plymouth and suffered from ill-health from early childhood. In 1801 he was employed by the antiquary John Britton in

making drawings for his compendious *Beauties of England and Wales*. By determination he overcame problems of drawing architecture that defeated him initially. He went to live with Britton in London, making drawing tours of south-eastern counties in 1803 and 1804. Ill-health forced him to return to Devonshire in 1805, but by 1808 he had returned to London. From 1803 onwards he exhibited at the Royal Academy and elsewhere, joining the Associated Artists in Water-Colours in 1810. In 1813 he published *Rudiments of Landscape in Progressive Studies* and in 1820 a *Series of Easy Lessons in Landscape Drawing*. In 1819 he became a member of the Old Water-Colour Society, and in that year he made his first journey abroad, visiting northern France. In 1821 he toured through Belgium and along the Rhine, and in 1824 he visited Italy for the first time. He later travelled through Germany and Switzerland, and exhibited many water-colours, often of considerable size, which were engraved in a number of publications.

122. Dresden: part of the Zwinger

A splendid example of Prout's work as a draughtsman of picturesque architecture, in which the scale of the building is admirably evoked, with figures employed economically to provide contrast and a suggestion of life amid the convoluted stonework. The disciplined yet varied rhythms of Prout's line, which Ruskin praised as the perfect means of expressing ancient stonework, run through the composition imparting movement and energy to what would otherwise be an essentially static subject. Prout made his continental journeys mostly in the 1820s; he visited Dresden on a journey to Prague in 1821. Thereafter he worked up drawings made on the spot, often repeating compositions many times. He seldom dated his work and as it settled into a steady and uniform type the precise period of any individual drawing is difficult to determine.

James Baker Pyne (1800–70)

Pyne was born in Bristol; having been articled to an attorney he taught himself to paint, working as an artist in his native town. He taught Müller to paint in oil and watercolour. In 1835 he settled in London. He travelled on the Continent and in England, and enjoyed a high reputation. He became a member of the Society of British Artists in 1841 and was later elected its vice president. He died in London.

118. Italian landscape: evening

Pyne is an interesting phenomenon among the artists of his generation: a self-taught painter who became an impressive exponent of the virtuoso watercolour techniques of the early nineteenth century, and whose art combines many of the qualities of sheer professionalism that are to be found in both Turner and Bonington. He was, in addition, the first teacher of a conspicuously professional artist, both in oil and watercolour – W. J. Müller. In this characteristic scene of hazy sunlight, Pyne's debt to the vision of Turner is obvious; but in his deft handling of the dark tree against the bright creamy sky, which erodes the foreground forms with its brilliance, he obtains a Bonington-like effect, and indeed the whole scene is not dissimiliar to some of Bonington's early Rouen sunset subjects. It has been called *'A view in Italy'*, but seems intended only to suggest the warm South, and not to represent a specific place.

Thomas Miles Richardson (1813–90)

Richardson was born at Newcastle the son of a landscape artist of the same name (1784–1848). He exhibited in London from 1832 and settled there in 1843 when he became an associate of the Old Water-Colour Society, of which he was elected a full member in 1851. He exhibited regularly, showing landscape subjects in England and Scotland, and later in Switzerland and Italy, which he visited in about 1842.

155. Durham

The 'panoptic' layout of this extensive view seems to derive from Turner's method of constructing his watercolours showing particular places. The foreground slopes away steeply to a bright focus of light on the river, whose banks rise sharply, covered with buildings which contribute their smoke to the haze of the distance, and the eye is led by an undulating and zigzagging line to the climax-point of the mistily-seen cathedral. In order to bring these elements together into a coherent and dramatic composition, Richardson employs a subtle distortion of reality which, again, owes much to the example of Turner. Richardson's colour, however, is applied very differently from Turner's, with the sharp, rather coarse touches characteristic of the Bonington school in its later stages.

David Roberts (1796–1864)

Roberts was the son of a cobbler of Stockbridge near Edinburgh. He was apprenticed to a house-painter, and later worked as a theatrical scene painter for a travelling circus and theatre, with which he toured the north of England. Subsequently he worked in theatres at Edinburgh and Glasgow, moving to Drury Lane in 1822, where he worked with Stanfield, painting sets for the first London production of Mozart's *Il Seraglio* in 1827. He was first vice president of the Society of British Artists in 1823 and president in 1830; honorary member of the Royal Scottish Academy in 1829. He was elected A.R.A. in 1838 and R.A. in 1841. He was on the Board of Commissioners for the Great Exhibition of 1851, in which year he visited Italy. He had travelled to Spain in 1832 and in 1838 to Egypt and Syria. He published *Picturesque Sketches in Spain*, and *Views in the Holy Land, Syria, Idumea, Arabia, Egypt and Nubia*, as a result of the work he had done on these journeys.

132. Rome: the Piazza Navona

Roberts's mature style is one of great consistency, and this splendid drawing sums up its characteristics: the relation of figures to buildings is similar to that of Boys and Callow, and the whole composition is of a type that can, perhaps, be said to stem from Thomas Malton. Roberts works with a freedom, combined with the precision of his drawing of architecture, that marks him as one of the great professionals of his generation. The generalized handling of the crowds in the square is typical of him, and the whole design reminds us of his training as a theatrical scene painter. In spite of its uneven finish – note the concentration of specific detail in the area of the obelisk and the façade of Sant' Agnese in Agone – this is a completed drawing: Roberts has fully signed and dated it 'July 4th 1854'.

George Fennel Robson (1788–1833)

Born in Durham the son of a wine-merchant, Robson received some tuition from a local drawing master and made copies of Bewick's woodcuts. In 1807 he exhibited at the Royal Academy. In 1810 he toured Scotland and became a member of the Associated Artists, and in 1813 of the Old Water-Colour Society, of which he was elected president in 1820. He published *Scenery of the Grampian Mountains*, forty soft-ground etchings, in 1814.

119. A highland landscape

The grandeur that Robson achieved in his most ambitious exhibition pieces owes much to the generalized classicism of John Varley, both with regard to composition and in the matter of technique. Robson's rich masses of vibrant colour are inherited directly from Varley; but he uses them to achieve a drama of contrast and scale which is very different from Varley's rather sedate effects, and brings him closer to the more personal and impassioned mountain views of Danby and Jackson (*see Plates 152 and 153*).

Michael Angelo Rooker
(1743 or 1746–1801)

Rooker's father Edward was an engraver, and an actor at Drury Lane. Paul Sandby was Michael's first master, and gave him the nickname Michael Angelo. He entered the Royal Academy Schools in 1769 and began to exhibit at the Academy in that year, having already shown work at the Incorporated Society of Artists in 1767; in 1770 he was elected A.R.A. Although at first he worked both as a draughtsman and an engraver, he quickly abandoned engraving in favour of scene painting, and was regularly employed at Colman's Theatre, Haymarket, under the name of 'Signor Rookerini'. He produced a large amount of topographical work, based on material gathered during walking tours in various parts of England and Wales. His later career, however, was unsuccessful, and professional disappointment impaired his health.

9. The interior of the ruins of Buildwas Abbey, Shropshire
The increasing interest in antiquities among collectors and artists of the late eighteenth century was fortunately met by a steady movement towards the presentation of ruined buildings not as dry historical facts but as aesthetically fascinating objects – fascinating not only for the connotations of their original condition but for their present dilapidation and the variety of life that they still harboured. Rooker's watercolour style developed to accommodate this interest, and a drawing like this one is like a mosaic of bright colour, the broken masonry and ragged group of figures, the random bric-à-brac of a ruin used as a rural shelter, all contributing movement to the painted surface, which seems to disintegrate in sympathy. This is achieved within the modest framework of a neat, charming topographical view, which however, taking us *inside* the ruins (an idea taken from Piranesi's etchings of Paestum?), was to be employed to great effect by Girtin and Turner.

Thomas Rowlandson (1756–1827)

Born in Old Jewry, London, Rowlandson entered the Royal Academy Schools in 1772, where he earned a reputation for high spirits. He first exhibited at the Academy in 1775. In 1774 he visited Paris, and probably travelled in France and Italy in 1781–3. He subsequently made several other continental tours. He exhibited at the Academy until 1787. Thereafter his output declined until about 1800 when he became more prolific than ever, both as watercolourist and etcher, working on illustrations to numerous publications, principally for Ackermann.

13. Vauxhall Gardens
This is perhaps the best-known of all Rowlandson's depictions of London society, and, as regards the drawing of the background and the architecture in particular, one of the most thoroughly finished. Although it represents a sizeable crowd of people, it observes a compositional decorum unusual in such subjects: the space is treated rather as if it were a stage, with trees forming wings at each side and dividing the sheet vertically with firm upright stresses. There is little internal movement among the figures, which are grouped in a fairly simple frieze, with a clear focus on the two famous beauties, Lady Bessborough and the Duchess of Devonshire, in the centre, while another white dress to the right marks the actress 'Perdita' Robinson, with the Prince of Wales. The singer on the balcony above is Mrs Weichsel, and it has been supposed that the group at the table in the lower left corner are Dr Johnson, Boswell and their friends. Johnson died in December of 1784, the year in which this watercolour appeared in the Royal Academy exhibition.

14. George Morland
Rowlandson exhibited several portraits at the Royal Academy during the earlier part of his career, and it may be that this is one of them, or at any rate a work of a similar type. When drawing the likeness of a single individual, Rowlandson often worked with great intensity, whether he intended to produce a broadly humourous effect, as in some of his late, heavily worked character heads or, as here, he was making a direct study of a personal friend. George Morland (1783–1804) was himself an important exponent of the genre of rustic sentiment in painting which Rowlandson so often practised in watercolour. His notoriously easygoing personality, which led him to a dissolute and impoverished end, is delightfully suggested in this fresh, direct drawing with its unexpectedly restrained use of gently moving line and soft colour.

15. A bench of artists
This sheet, Rowlandson's earliest dated drawing, is inscribed with his title: *A Bench of Artists. Sketched at the Royal Academy in the Year 1776*, and with the names of the students. It is characteristic of Rowlandson that he was more interested in drawing them than in studying the model the others are drawing. Although it is still rather stiff, the drawing style already shows typical features: the sequence of curving lines with which the row of calves is depicted has a strong Rowlandsonian ring. But this, and the systematic hatching which is a standard feature of Rowlandson's work until the mid 1780s, betray the influence of John Hamilton Mortimer, whose pen drawings and etchings are characterized by such linear patterns.

17. An accident outside a cobbler's shop
A comparatively rare example of a drawing which Rowlandson intended to finish elaborately but only partly completed, this sheet illustrates his working methods at the beginning of his career. Although parts of the initial pencil drawing are only roughly sketched in, other areas, such as the figure with his back to us in the centre of the group, are already presented in terms of an integrated and flowing line. Those areas which are fully worked up have stronger linear rhythms and are laboriously hatched. Later in his life, these differentiations were to disappear, and Rowlandson would work direct on to the paper with a pen, filling in subordinate detail rather in the manner of the two figures in the upper window here.

21. Skating on the Serpentine
One of several versions and variants of the subject that Rowlandson exhibited at the Royal Academy in 1784, and a particularly successful instance of a large-scale subject with numerous figures. Here, the Hogarthian humour that derives from a chaotic interaction of incident is organized into a disciplined composition in which Rowlandson conveys something of the landscape setting by a sparing use of visual pointers – the bare branches of the trees suggest the frosty and slightly foggy sunlight of a London winter afternoon.

23. Landscape composition
Rowlandson's line is not only extremely expressive in itself, it is capable of a surprising number of transformations; here, it broadens and softens to become a medium as delicate and sensitive in suggesting the soft textures of the countryside as Gainsborough's brush technique. Even so, the drawing is made primarily as a most economical outline, filled out by the imaginative use of the brush. Here, Rowlandson uses almost no colour at all beyond the sepia of his ink.

24. Three cavalrymen at a parade
A very simple, aphoristic image in which Rowlandson comments on a human situation by giving his line an unusual rhythm, expressive of the heaviness and languor of the resting horses. Here Rowlandson's favourite asymmetry marks the contrast between the foreground group and the lively, stylized indication of the parade beyond.

27. Harbour scene with figures embarking in a ship's boat
An example of the freedom and vigour of Rowlandson's drawing with a reed pen, which seems to create a composition of its own accord,

inventing figures with an inconsequential pleasure for the sake of doing so. Rowlandson, especially in his later years, felt no compunction to draw subjects of specific significance; he simply gave expression to his own vitality by inventing little scenes like this one out of his general experience of life.

28. The historian animating the mind of the young painter
A vividly etched expression of one of Rowlandson's favourite themes: the contrast between excitable, passionate youth and dry, sterile old age. Here the point is made in the context of the fashionable preoccupation with academically serious subjects, often taking as their inspiration historical incidents of fatuous obscurity: Benjamin West's *Cyrus liberating the family of Astyages* (Royal Collection; 1770) is an example. Rowlandson's pencil drawing of this subject (Yale Center for British Art) has an inscription which identifies the artist as Richard Wilson, and the historian as the poet James Thomson, whose *Seasons* (first published in full in 1730) became a source for numerous subjects, historical, pastoral or sentimental, in the painting of the next hundred years.

John Ruskin (1819–1900)
Ruskin was born in London, the son of a wine-merchant; he began writing verse at the age of eight and shortly afterwards had started to draw. He took lessons in watercolour from Copley Fielding from 1834 and in that year published three articles on geology. In 1836 an article attacking Turner in *Blackwood's Magazine* provoked him to a reply, expanded into *Modern Painters*, published between 1843 and 1860. In 1848 he married Effie Gray, who left him to marry Millais in 1854. He travelled with his parents, and visited Italy in 1840 to 1841. The family were in Switzerland in 1844. *The Seven Lamps of Architecture* appeared in 1849, and *The Stones of Venice* in 1851–3. In 1851 he defended the Pre-Raphaelite Brotherhood against criticism. In later life he became interested in political and economic theory, championing the education of the working class. In 1871 he bought Brantwood on Lake Coniston where he died.

140. The Glacier des Bossons, Chamonix
Ruskin's interests in geology and architecture are clearly expressed in the passionately detailed drawing of this study; but the whole sheet nevertheless has a breadth that overrides any purely analytical intention. Ruskin, who had learned the flexible use of a pen line from his early imitations of Prout, borrowed from Turner the art of uniting such detail and presenting a grand landscape as a whole. Here the powerful diagonal sweep of the glacier is a very dramatic focus for the whole scene; compare a very different evocation of grandeur through detailed description in Danby's *Avon Gorge (Plate 154)*.

Paul Sandby (1730–1809)
Like his brother Thomas, Paul Sandby was born at Nottingham, but early removed to London. In 1747 Thomas obtained for him the post of Military Drawing Officer to the Royal Ordnance in the Tower of London. He worked for the Board of Ordnance on a survey of Scotland undertaken after Culloden, and remained in Edinburgh until 1751, when he went with his brother to Windsor. He worked as a topographer for numerous patrons, and published etchings which were both original works and reproductive illustrations after other artists. In 1760 he moved to Broad Street, Carnaby Market, close to his brother; later, in 1772, he took up residence at 4 St George's Row, Bayswater, where he lived until his death. He was involved in the formation of the Society of Artists in 1760, and in 1768 became a founder member of the Royal Academy. In the same year he was appointed chief drawing master at the Royal Military Academy, Woolwich, a post he retained until 1796 (he was succeeded by his son, Thomas Paul). His *Twelve Views in Aquatinta from Drawings taken on the Spot in South Wales*, of 1775, served to introduce the medium of aquatint to the public for the first time. He was a steady exhibitor at the principal centres in London, especially the Royal Academy, where he showed works regularly from its inception until his death.

5. Sheet of studies of figures
Sandby's interest in people colours all his output, and his prominent use of human incident is one of the elements in his work that place him as a founder of serious landscape in Britain. The studies that he made in Edinburgh of local life and character mark him as a particularly lively observer of human nature, and illustrate his quick, flexible use of the pen – a distinctive feature of much of his work in watercolour during the first part of his career, and a necessary prerequisite for his exercises in the medium of etching, in which he was already proficient in his Edinburgh years.

6. Hackwood Park
A very small drawing, probably intended to be engraved on the same scale, but nevertheless comprising an extensive view. The portrait of the house includes an account of its estate, both park and farmland, and the disposition of hills and valleys in which it is set. Sandby injects an atmosphere of relaxation into what is primarily a topographical document, by an artful use of undulating rococo line, especially in the decorative detail of the large foreground tree, and in the group of figures. As usual in his earlier work, colour is restrained, yet delicately varied to enhance the charm of the whole design.

7. The artist's studio, 4 St George's Row, Bayswater
The subject-matter here is personal and the record is for the artist's own, or his family's use. Sandby often used bodycolour, in the latter part of his life, to make such private notes, working rapidly in bright colour. The composition is informal, based on no preconceived pattern, but taking a casually observed view simply as it is. Later, Constable was to treat such views as the subjects for finished pictures – for example, *Golding Constable's kitchen garden*, of 1815; but even he did not exhibit such works publicly.

8. Study of a sunset
The romantic approach to landscape was well established by the end of the eighteenth century, and towards the end of his life Sandby absorbed something of it and incorporated dramatic features such as sunsets and storms into his work. On the whole, they remained alien to his artistic personality and are rarely presented with conviction in finished pictures or drawings. A study such as this, however, is most effective and places Sandby with the many other artists of the period who made observations of natural phenomena out of doors, deliberately breaking their usual custom of working in outline only, and employing colour direct to capture a particular and passing effect. It is not impossible, however, that a study such as this was made indoors from memory or from a brief pencil note.

Thomas Sandby (1723–98)
Thomas, the elder brother of Paul Sandby, was born in Nottingham, but in about 1741 came to London and was employed by the Duke of Cumberland as Ordnance Draughtsman. When, after the Battle of Culloden in 1746, the duke became ranger of Windsor Great Park, Sandby followed him there to become his deputy, and was responsible for the construction and ornamentation of the lake and park at Virginia Water. He moved with his brother to Great Marlborough Street, in London itself, in 1760, and practised as an architectural draughtsman, making drawings of the old buildings of London and also projecting new ones. He was first professor of architecture to the Royal Academy on its foundation in 1768.

2. View from the terrace of Somerset House looking east
This is a very large panorama to which the companion, showing the view looking west, is also in the British Museum. Both Thomas and

Paul Sandby made drawings of these views, usually on a smaller scale than this pair, and it is possible that in this case, while the buildings were drawn by Thomas, the figures are the work of Paul. The direct recording of architecture with a minimum of atmospheric effect is typical of Thomas's work; yet he succeeds frequently in evoking a mood of sunny freshness reminiscent of, say, the Thames drawings of Samuel Scott. In his numerous paintings of the Thames and its bridges, Scott was influenced by Canaletto, who arrived in England in 1746; but his drawings reflect his friendship with Lambert, Skelton and perhaps Taverner. There are elements of the same style, with its controlled, wiry penwork and neatly expressed buildings with pale colour, in Thomas Sandby's drawings. In this grandly conceived yet unpretentious view, Thomas Sandby unites the approach of the traditional English topographer with the more expansive view-making of Canaletto and, thanks to the elegant figures, with the charm of the French rococo.

Jonathan Skelton (c.1730–59)

Very little is known of Skelton; it is probable that he studied under George Lambert. Dated drawings indicate that he was working in the area of Croydon in 1754. He subsequently worked in South London and in Kent at Rochester and Canterbury. In 1757 he went to Italy; he died in Rome.

45. Scene at Blackheath, with Vanbrugh's Castle

Although Skelton was one of the first English artists to make fully-wrought watercolours on the spot in Italy, the most conspicuous achievement of his very brief career was to bring the art of rendering English country scenery in watercolour to an unprecedented height of delicacy and subtlety. His style is so close in spirit and in details of technique to that of George Lambert (1710–65) that it seems probable that Skelton's references to a Mr Lambert are to him, and denote a close association. Likewise, there are reasons both documentary and stylistic for linking Skelton's work with that of the marine painter Samuel Scott. Skelton's painstaking realism in the face of simple nature is ordered by a fine feeling for compositional breadth, sometimes expressed by dispensing with the traditional grey underdrawing, and shot through with a gentle and undemonstrative poetry. This drawing was originally called *Lord Tyrawley's House upon Greenwich Hill.*

John 'Warwick' Smith (1749–1831)

Smith, the son of a gardener of Irthington, Cumberland, was taught drawing by Captain John Bernard Gilpin, whose sister was his father's employer. Gilpin's sons were the Rev. William, and Sawrey Gilpin, R.A., with whom the young Smith was sent to study. He attracted the interest of Lord Warwick, under whose patronage he went to Italy in 1776. He became a member of the community of English artists in Rome, associating particularly with landscape draughtsmen such as William Pars, and, later, Francis Towne, with whom he returned to England via the Alps in 1781. In 1784 and 1785 he made the first of many tours of Wales; the scenery of Italy and Wales furnished him with much of his subject-matter for the rest of his life. He earned a high reputation as an exponent of the technique of painting with local colour direct, without a foundation of grey.

55. The waterfall at Rhaider-y-Wenol, north Wales

After his visits to Wales in 1784 and 1785, Smith produced an apparently inexhaustible stream of watercolours based on Welsh subjects, which were executed in a very consistent style in which rich, sonorous colour and elegant freedom of execution are well combined. At their best, they are highly poetic evocations of the paradise of the tourists and artists who journeyed in search of sublime scenery at that period, and they represent a half-way point in the development of watercolour technique away from the earlier conventions, towards

the mature use of the medium practised by Girtin in the later 1790s. Smith had a considerable influence on artists of the succeeding generation both as a technician and as a designer: compare this composition with those of the works by Nicholson and Glover in *Plates 88 and 89.*

67. The Roman Forum

Smith was known in his own day not only as 'Warwick' Smith but also as 'Italian' Smith, on account of the large quantity of Italian subjects that he produced, based on the work of his stay in Italy between 1776 and 1781. His large output is uneven in quality, though sometimes reaching peaks of real and very individual excellence. This view of the Forum has almost exact parallels in the output of both Pars and Towne and it is likely that Smith made his drawing in their company. His bold use of colour, applied rather loosely on coarse paper, is very different from Towne's precise designs and anticipates the atmospheric watercolour techniques of Girtin and his generation.

Clarkson Stanfield (1793–1867)

Stanfield was born in Sunderland of Irish parentage and apprenticed to a heraldic painter in Edinburgh at the age of twelve. In 1808 he entered the merchant service and was later pressed into the navy from which he was discharged in 1818. He became a theatrical scene painter first in London, and later in Edinburgh, where he met David Roberts. He exhibited at the Royal Academy in 1827 and his pictures became so successful that he abandoned scenery painting, although he continued to make sets for the amateur productions of Charles Dickens and Wilkie Collins. He became A.R.A. in 1832 and R.A. in 1835. His tours on the Continent, in the Low Countries, the Rhineland, Italy and France, resulted in a large output of watercolours. His work was engraved in Heath's *Picturesque Annual* in 1832, 1833 and 1834, and elsewhere. He made his principal reputation as a marine painter, being considered the successor and even the superior of Turner.

131. Cavalrymen near a beached ship, with a fort in the distance

A watercolour perhaps done either during or just after Stanfield's continental tour of 1829, and showing him in general style, and particularly in colouring, to have much in common with James Duffield Harding (1797–1863). Like Callow and Boys, Stanfield owed much to Bonington; but he developed away from the fresh, virtuoso manner of that school towards a more staid, dense and academic technique. This small drawing is a refreshingly casual note which preserves the informality of a sketch, while being given considerable technical finish in the rendering of its details.

Thomas Stothard (1755–1834)

Born in London, and apprenticed to a Spitalfield's silk designer, who encouraged him to illustrate poetry, Stothard became a student in the Royal Academy Schools in 1777, in which year he first exhibited, showing two landscapes at the Society of Artists. He was employed in making copies of paintings and in designing illustrations for magazines and later for books of all kinds; in the early 1780s he began an association with Blake. He also painted in oils and exhibited regularly at the Royal Academy, becoming A.R.A. in 1791 and R.A. in 1794. His vast output included designs for gold plate, and decorations at Burghley House, at the Advocates Library in Edinburgh, and elsewhere. He visited Paris in 1815 with the sculptor Sir Francis Chantrey.

31. Illustration to the Decameron of Boccaccio in Pickering's edition, 1825

One of a series of similar subjects which Stothard executed in both watercolour and oil in connection with Pickering's edition of

Boccaccio which appeared in 1825. Stothard's art evolved through a phase of rococo, decorative illustration towards a more energetic Neo-classicism in the 1780s and 1790s, but this softened into his enduring, mature style which is typical of all his work after 1800. Here the pretty pinks, greens and blues and simple elegance of the deliberately rather formal design are a conscious imitation of Watteau's fashionable *fêtes champêtres*. In spite of the very much more decorative quality of the work, there are still marks of the artist's ancient sympathy with Blake: the simple and direct stylization and the fresh colour both have parallels even in Blake's latest masterpieces – the Dante illustrations, for example.

Thomas Sunderland (1744–1823)

Born near Kirby Lonsdale, Lancashire, Sunderland was an industrialist, the master of an iron ore foundry at Furness. He held the post of Deputy Lieutenant for the county. He travelled in Britain and on the Continent and was a prolific amateur draughtsman; he probably took lessons from Farington, as well as from one or both of the Cozens. The influence of Farington and J. R. Cozens is very evident in his work. In 1782 he built a house at Ulverston in the Lake District, where Cozens possibly stayed.

54. View of the Head of Ullswater

Sunderland, an assiduous and prolific amateur, made a written note of the features of this scene in detail on the back of the mount which he prepared for the drawing. This is a striking example of his ability to capture something of the scale and misty grandeur that J. R. Cozens had infused into the drawing of mountain scenery. In spite of his evident debt to Cozens, however, Sunderland rarely abandoned the pen outlines that he seems to have learned from Farington, and to which he gave a character which is recognizably his own. His work is nearly always in pale greys, greens and blues, and although he occasionally imitated Cozens's technique of building up masses with small, close touches of the brush, he did not employ it regularly, preferring a broader, looser style.

William Taverner (1703–72)

Born in Canterbury the son of a lawyer, whose profession he followed, by 1733, although only an amateur artist, he had attracted attention for his landscapes both in watercolour and in oils, though his works in the latter medium are not now known. His work often copies or imitates classicizing landscape compositions by seventeenth-century Dutch and Flemish masters.

46. Landscape with a distant view of an Italian town

Taverner's inspiration came from the landscape paintings of Italianate Dutchmen such as Cornelis Poelenbergh (1586–1667), and bears strong marks of the influence of the Italian view-maker, Marco Ricci (1676–1729). He did not visit Italy, but was content to draw invented Italian scenes like this one, in which formal elements, such as buildings, trees and figures, are combined in a simple but often very effective way. Taverner's gentle washes of colour, evoking a generalized landscape, are among the earliest to capture something of the airy freshness of Van Dyck's (*Plate 10*), and had a considerable effect on the development of Gainsborough's technique as a draughtsman of nature.

Francis Towne (1739/40–1816)

Towne was probably born in Exeter, and his work as a landscape artist in oil and watercolour, and as a drawing master, was centred there. He seems to have attended Shipley's School at some time in the late 1750s. He exhibited in London from 1762 onwards, first showing

work at the Royal Academy in 1775. In 1777 he made a tour of Wales and in 1780 visited Italy, working in Rome and Naples with Pars, Thomas Jones (1742–1803), and 'Warwick' Smith, returning with Smith through Switzerland in the following year. He failed several times to be elected to the Royal Academy. In 1805 he exhibited 191 watercolours in London, where he lived permanently from 1807 until his death.

62. The gateway to the Villa Ludovisi

Towne's propensity to choose unorthodox subjects and to present them unorthodoxly is well illustrated in this drawing. The picturesque qualities of the gateway set in its venerable wall are largely ignored, and Towne concentrates on an unexpectedly dispassionate account of the scene, almost as if he had not grasped its precise significance. He realizes it as a pattern of clear bright colours arranged into inconsequential shapes, and placed idiosyncratically on the sheet so as to give prominence to the blue sky against which the group of cypress trees stand grotesquely. The colour, applied over a preparation of grey tone, assumes a flatness and evenness which is the opposite of the richly modelled effect obtained by the 'direct colour' painters of the 1790s.

63. The source of the Arveiron

Towne was familiar with the Swiss views of his friend William Pars, and would certainly have known subjects like that in *Plate 57*. He had also probably seen some of Alexander Cozens's imaginary landscapes, though not the alpine scenes of John Robert's first continental tour. There is hardly any other source for the new, highly romantic and subjective view of the Alps that Towne gives us here. The unconventional arrangement of the forms on the sheet now makes for a strongly dramatic impact, and the contrast of the huge unmodulated mass of rock above with the tiny strip of verdure at the lower edge of the design suggests the overwhelming force of nature in a way that had not been done before, certainly, by an English artist. The power of the image is enhanced by Towne's deliberate restriction of his palette to a scheme of greys, browns and blues; but the careful definition of all the forms, even to the use of pen outline, is the opposite of J. R. Cozens's equally careful disintegration of huge and distant shapes into the atmosphere.

68. Ariccia

In this drawing Towne's propensity to simplify form into large, clearly-defined, flat shapes produces an effect almost like that of a theatrical set, and anticipates some of the decorative design of the early twentieth century. A comparison with Pars's treatment of the same scene (*Plate 66*) shows vividly how individual Towne's vision was; Pars's drawing looks old-fashioned and fussy by contrast.

Joseph Mallord William Turner (1775–1851)

Turner was the son of a Covent Garden barber. He made architectural drawings in the office of Thomas Malton and entered the Royal Academy Schools in 1789, exhibiting his first watercolour in 1790. His first oil-painting was shown in 1796. With Girtin, he attended Dr Monro's 'academy' between about 1794 and 1796, copying drawings by Cozens and others. Throughout the 1790s he toured England and Wales, and he visited Scotland in 1801. He became an associate of the Academy in 1799 and R.A. in 1802. In that year he visited Switzerland and Paris, making studies in the Louvre. From 1804 he exhibited not only at the Academy, but also in his own gallery in Harley Street. He was the Academy's Professor of Perspective from 1807. About 1810 he began to visit his patron, Walter Fawkes, in Yorkshire, where he spent much time. He made a tour of the Rhine in 1817 and visited Italy in 1819 and again in 1828. He made an extensive tour of Europe in 1833, and travelled to the Val d'Aosta with

H. A. J. Munro of Novar in 1836. He visited Venice again in 1840 and Switzerland every year from 1841 to 1844. Although illness prevented him from travelling after about 1845, he continued to work and to exhibit his paintings until 1850.

156. The Pantheon, Oxford Street, on the morning after the fire
No work of Turner's shows more clearly than this the extent of Dayes's influence on his approach to topography: the combination of urban architecture with lively figures is typical of the views of London that Dayes made around 1790. But Turner takes the ideas of Dayes to a new degree of sophistication, choosing to record, not a handsome building in clear daylight, but an icicle-covered ruin in the pink glow of sunrise: a view that is obviously a faithful account of what Turner himself saw, and at the same time an elaborate essay in delicate lighting. But the drawing is no mere exercise: the figures very specifically belong to this particular scene and show that the artist was concerned to convey the mood and atmosphere of a real event.

157. View of Edinburgh from St Anthony's Chapel
This drawing is on a page of the 'Edinburgh' sketchbook, in which Turner made notes during his first visit to Scotland in 1801. On such tours he generally worked simply in pencil, and this colour study is somewhat unusual. It is interesting, however, to see how he chooses to record in colour the most generalized effects of light and atmosphere over a broad and distant panorama; and interesting also to notice that the other colour sketches made in Scotland were of quite different subjects: the costumes of people observed in the streets of Edinburgh.

158. Venice: looking East from the Giudecca; sunrise
Although Turner made many pencil notes on his first visit to Venice, he worked in colour, apparently, only four times: this is one of the studies he made. They concern themselves with aspects of Venice which could be recorded in no other way than with liquid washes of pure colour, and, indeed, seem to record a new and formative experience of broad effects of light. The depth and space that Turner achieves so simply here can hardly be paralleled in his earlier work, though the steady movement of his technique towards the point at which such a revelation could be absorbed and stated like this had for a long time been evident. In spite of the great developments of Turner's style during the remainder of his life, he never surpassed the breathtaking economy of this study.

159. Caernarvon Castle
One of the *Picturesque Views in England and Wales* on which Turner worked between 1826 and 1837, this lovely specimen is in fact a wholly fresh restatement of the composition of one of his large early Academy pieces in watercolour, the *Caernarvon Castle* exhibited in 1799. Here, instead of treating the castle as a tall silhouette looming against a golden sunset, Turner involves the whole scene in an envelope of light, which is based on a schematic division of the paper into three clearly marked sections, blue, orange and green – between which the colours echo and reverberate. The intention of the design, however, is to convey the fragile calm of a warm summer evening, and this is beautifully reinforced by the motif of the girls bathing.

160. The Lake of Geneva with Mont Blanc from the Lake
Most of the Swiss watercolours that Turner elaborated from the notes he made on his 1802 tour are composed according to the demands of mountain subjects – with sharp diagonals or dramatic verticals. This example is exceptional in its classical balance and serenely tranquil atmosphere. It is in fact close, both in technique and in conception, to the large views in north Wales and Scotland that Turner made in the years 1800–5, and may be the last of his early watercolour exercises in the manner of Claude.

161. Scene on the Thames
One of the pages from a sketchbook probably used by Turner shortly after he had begun to live at Sion Ferry House, Isleworth,

in 1804 or 1805. In a series of similar studies in the 'Thames from Reading to Walton' sketchbook (TB XCV) he noted down what he saw of the English landscape with a simplicity and directness that remind us of Constable; but here there are touches of formality that betray his constant preoccupation with the ultimate pictorial value of his material, and in other sketchbooks views like these alternate with classical compositions in which the elements of the Thameside scene are converted into the furniture of an ideal landscape. The use of a grey toned ground for this study also suggests that Turner was working with a picture or finished watercolour in mind – a work perhaps like the *Lake of Geneva* (Plate 160).

162. Study for 'The Dark Rigi'
The Dark Rigi was one of the ten finished watercolours made in 1842 on commission from patrons through Turner's agent, Thomas Griffith. This is the completed study, or 'sample' that Turner presented to give an idea of the subject and mood of the final work. Although it is drawn on a much smaller sheet of paper, it captures much of the spacious atmosphere of the final watercolour. Turner always greatly intensified the content of his late Swiss watercolours when transferring the subjects to their larger format, but the comparison of sample studies with finished drawings is a particularly illuminating way of determining the quality that Turner deemed appropriate to a public work of art. The finished watercolour is now in an English private collection.

163. The Crook of Lune, looking towards Hornby Castle
One of a set of North Country views drawn by Turner for Dr Whitaker's *History of Richmondshire* and engraved for that work in 1821, this watercolour is typical in colour and handling of the period in which Turner first attained a wholly evolved style and technique. The panoramic spaciousness of the subject is an invitation to the artist to call on all his resources in the suggestion of light and air, and although the range of colours is simple, being principally greens, browns and blues, the technical means by which they are made to shift and change through the landscape are very varied. The device of using a meandering river to create a compositional structure in an otherwise rather featureless view was a favourite of Turner's all his life.

164. The burning of the Houses of Parliament
This is one of nine sheets on which Turner rapidly sketched in colour his impressions of the great conflagration that destroyed the old Houses of Parliament at Westminster on 16 October 1834. He made a few rapid pencil notes on the spot, but it must have been difficult for him to do more than look in the darkness; as soon as he returned home he no doubt made these studies from memory, though the suggestion has been made that they were done on the spot. Later he made a larger, more finished watercolour which does not, however, rely on any of the sketches for either composition or detail; and in 1835 he exhibited two oil-paintings of the scene (now in the Philadelphia and Cleveland Museums of Art).

165. Heidelberg from the opposite bank of the Neckar
This dazzling watercolour is the last of a series of variations on the view of Heidelberg from across the river Neckar, of which other examples are in a Scottish private collection and the City Art Gallery, Manchester. All have been dated to the late 1830s or to about 1840. It is clear from a comparison with the others, however, that this one shows Turner's watercolour style at a later phase of evolution, and it seems to correspond in treatment and dimensions with a set of large watercolours of European subjects on which Turner was apparently working in the later 1840s, and on which he may still have been engaged when he died. The orange haze in which all objects of the scene are enveloped is comparable with the effects to be observed in Turner's oil-painting of the same late date, and, indeed, in this work he has virtually demolished the barrier between the two different media.

166. A view on the south coast of France

This study, with its rich colouring of purples, pinks and ochres on a small sheet of blue paper, belongs to a large group of similar drawings made about 1830, when Turner was working on a project to illustrate the scenery of the great rivers of Europe. Some of these show rocky coasts, which may have been noted when he was travelling to Italy in 1829, but the exact location is not known. In their concentration of resonant and hyper-real colour into a tiny space they are among the most expressionistic of all Turner's works. Only the scenes on the Loire and Seine were ever brought to a finished state and engraved (see Plate 167); the remainder must all be classed as preparatory or exploratory studies.

167. The Seine between Mantes and Vernon

An example of the small drawings on blue paper that Turner finished for engraving as plates in his 'Annual Tour', Wanderings by the Seine, 1834 and 1835; this subject appeared in the second volume. It contains in little many of his characteristic preoccupations, including the delight in human activity revealed by the detail of the table laid for a meal on the verge of the road, and the division of the composition into two parts, contrasting perspectives of land and water, with the line of trees forming a partial screen between them. The elaborate detail of buildings along the road indicates the extent to which, even on so small a scale, Turner denied any distinction between the expressive potential of oil and that of watercolour: in either case, a picture, full of particularities or broadly atmospheric, was equally possible.

168 and 170. Folkestone from the sea

This drawing, one of the many views of Folkestone by Turner, has previously been dated to the early 1820s; technically however it should perhaps be placed about ten years later. Although it seems never to have left the artist's studio, it is a fine example of the finished watercolours of that period, and is a particularly subtle and beautiful rendering of a moonlight effect at sea. The invention and organization of the figures (smugglers fishing up casks of gin) is typical of Turner's interest in the affairs of sailors and fishermen, and provides a restrained but dramatic contrast with the serene majesty of the sky with its intricately dappled clouds and hazy moon. The various components of the subject – whether figures, clouds, or distant shore – are clearly observed and rendered, but the most remarkable quality of this drawing, as of much of Turner's watercolour work in the 1830s, is the subordination of all detail to atmospheric truth: the artist conveys precision while in fact offering us the indistinctness that naturally accompanies such a view. For the purpose he employs a very liquid bodycolour, which, mingled with pure watercolour, seems to shed the bloom of moonlight over the whole scene.

169. Venice: moonrise

This study at Venice, one of dozens probably made during Turner's visit of 1840 or just afterwards, should be compared with that from his 1819 journey (Plate 158). The evocation of subtle atmosphere is as effective in both, but the approach to the subject is here more complex, and no longer a simple record of a certain fleeting condition of the light: there is a conscious pictorial intention behind the disposition of blocks of colour, blue, green and pink, and the whole sheet has a balance and repose, a completeness, that was not part of the conception of the 1819 drawing.

William Turner of Oxford (1789–1862)

Turner was born in Oxfordshire but came to London to study with John Varley. At the age of eighteen he became an associate of the Old Water-Colour Society, of which he became a country member, settling in Oxford as a teacher with many pupils. He travelled extensively in England, and in 1838 visited Scotland for the first time; but many of his landscapes are of Oxfordshire scenery.

91. The Vale of Gloucester from Birdlip Hill

An impressive, large 'exhibition' watercolour, in which Turner has characteristically resisted the temptation to overload his design, and allows a vast flat panorama to speak for itself, articulated only with small, delicately indicated details and balanced by a lovely, free pattern of clouds in the sky above. The pointing figure on horseback is a conscious borrowing from the work of Wouwermans, and the whole ambitious design must have been inspired by the broad flat landscapes of Philips Koninck (1619–88).

Sir Anthony Van Dyck (1599–1641)

Van Dyck, who had studied under Rubens, came to England from the Low Countries in 1621, and again in 1632; in the latter year he made a drawing of Rye in Sussex. His other landscape drawings, in watercolour and bodycolour alone, may have been made in England during his stay from 1632 to 1641, or in the Netherlands. He also painted a few landscape subjects in oils, but worked primarily as a painter of portraits and religious pieces.

10. Landscape study

The signature in the lower right corner of this drawing is not in Van Dyck's own hand, but the sheet is one of a series generally thought to be by him. Nothing like these watercolours was produced by English artists at that period; Van Dyck's reliance on washes of colour without outline, with a consequent softness of atmosphere and convincing evocation of space, was not to be practised by native artists for a hundred years.

Cornelius Varley (1781–1873)

Cornelius was the younger brother of John Varley; he did not begin to draw until about 1800, when with John he joined Monro's circle. In the next few years he made several sketching tours, in Norfolk and Suffolk in 1801, and in Wales in 1802, 1803 and 1805. He was a founder member of the Old Water-Colour Society, but also showed works at the Royal Academy between 1803 and 1859, and in 1808 helped to found the Society for the Study of Epic and Pastoral Design, with Turner of Oxford, his brother John and others. In that year he visited Ireland. In about 1809 he invented his Patent Graphic Telescope for assisting drawing. It was patented in 1811 and shown at the Great Exhibition of 1851.

82. Snowdon from Llanllyfni

Although Cornelius Varley very frequently signed and dated his drawings, as he did here, they are rarely finished works. This study is typical of his notes made during excursions in Wales and elsewhere in the first decade of the nineteenth century, and shows him at his best: a spontaneous though scrupulously careful recorder of his impressions of sublime nature. The delicate suggestion of the clouds that break across the flank of the distant mountain is characteristic of his sophisticated watercolour technique at its most successful. In Cornelius Varley's Narrative written by Himself he described the scene of this drawing under the title 'A Commencement of Clouds and Then of Rain': 'In 1805 while seated on the North bank of the Vale of Llanllyfni . . . Snowdon to the East. The whole sky was clear except a line of a few small separate clouds floating over the southern range there were moving eastwards and following each other correctly over the same summits & the foremost led the way & passed direct over the Peak of Snowdon & then it assumed a peculiar definite and stratified form, showing some decided action between the two though they did not touch the second and third followed exactly the same path and paid the same peculiar respect as they passed Snowdon Peak . . .'

John Varley (1778–1842)

Varley was born in Hackney, London, and first apprenticed to a silversmith, but by 1793 he was pupil at a drawing school run by J. C. Barrow, with assistance from Francia. Varley went on a sketching tour with Barrow to Peterborough in 1797. In 1798 he began to exhibit at the Royal Academy; in 1804 he was a founder member of the Old Water-Colour Society. He was associated with Dr Monro in about 1800 and belonged to Girtin's sketching club. He made tours of Wales in 1799 and subsequent years, and visited the north of England in 1803. His considerable influence as a teacher of drawing was increased by three publications: *A Practical Treatise on the Art of Drawing in Perspective*, *Precepts of Landscape Drawing*, and *A Treatise on the Principles of Landscape Design*; all appeared between 1815 and 1821.

79. View of Snowdon across Llyn Padarn

Although J. R. Cozens had shown the way towards a style of mountain landscape composition in which conventional patterns were replaced by more irregular, nature-inspired designs, the following generation of watercolourists showed a strong tendency to make use of stylized views in the tradition of Claude and Richard Wilson. Turner is a notable example of this, and John Varley was certainly one of the most influential. Here he shows Snowdon rather as Wilson had done in his painting of *Snowdon from Llyn Nantlle* (Liverpool, Walker Art Gallery) of about 1766. This format, and the crisp, neat manner of applying rich colour, lie behind much that was produced by the Water-Colour Society members in the first half of the century. Copley Fielding, in particular, developed a standard composition, which he frequently repeated and which is based on Varley subjects such as this.

80. A castle on the coast

A typical specimen of the small-scale landscape studies that Varley was fond of making, and of encouraging his pupils to make, as an exercise in the construction of ideal landscape compositions. In general, such designs are unrelated to real places, belonging in spirit to the abstract school of Alexander Cozens or William Gilpin; but some are based on views of the Thames near Chiswick and Putney, and this one may well show Flint Castle, on the north coast of Wales.

81. The horse-ferry, Millbank

In gentle topographical watercolours like this one Varley shows a side of his artistic personality very different from that of the classically romantic landscapes for which he was especially famous. Even here, however, his tendency to simplify and balance is evident, and he manages to infuse into such subjects a quiet intensity that is often lacking in his grander works. It is a quality that we also find in the early watercolours of John Linnell, and no doubt Linnell copied examples of this sort by his teacher. These drawings of Varley are characterized by harmonies of soft greys, pinks and greens, which in his grander works are replaced by more sombre or more strident colours.

James Ward (1769–1859)

Ward was born in London, the son of a warehouse manager. He was apprenticed to John Raphael Smith in about 1782, but left after a short time to assist his brother, William, an engraver. He learned from him the process of mezzotint, in which he came to excel. Ward's early work was much influenced by the rustic genre of George Morland (1763–1804), who married his sister. Ward was appointed mezzotinter to the Prince of Wales in 1794. He first showed his own work at the Royal Academy in 1792, and abandoned engraving to paint animals, first livestock portraits, and later animal subject pictures with heroic landscapes. He was elected A.R.A. in 1807, and R.A. in 1811, in which year he began painting his enormous canvas

of *Gordale Scar*. Thereafter his work aspired consistently to the sublime, and he executed many history pictures. He outlived the fashion for his work and died impoverished and neglected.

77. Landscape near Cheadle

Ward was primarily a painter, and his many drawings are usually studies in pencil or pen of landscape, figures or animals, such as might be required for use in pictures. But he made a number of watercolours, which, like this example, reflect the influence of Girtin and achieve a remarkable strength, all the more effective in that they are generally less laboured than his paintings. The rich washes of Girtinesque browns and greens in this drawing show a masterly control of the medium. Like nearly all Ward's drawings, this one is signed with his monogram.

Benjamin West (1738–1820)

West was born of Quaker parents in Pennsylvania, and began to paint at an early age. In 1760 he travelled to Italy where he met Anton Raphael Mengs (1728–79) and applied himself to an assiduous study of Roman antiquities and Italian painting. He came to England in 1763 and married an American. He quickly became a leading exponent of the school of historical painting, exhibiting at the Royal Academy from its inception and becoming historical painter to George III after the success of his *Death of Wolfe* of 1771. He became president of the Royal Academy after the death of Sir Joshua Reynolds in 1792. Towards the end of his life his canvases, previously of modest size, tended to be very large.

33. Children at play

Although history painting was West's special province, he practised in other genres, and made many attractive pen drawings of landscape or rustic subjects. In addition he completed a number of landscape compositions on a small scale in gouache. Here he uses that medium to record an informal glimpse of children playing; but by placing the figures against an austere background of dark wall, and by lighting them rather dramatically – as the bodycolour would lead him to do – West achieves, instead of the prettiness of contemporaries such as Wheatley or Stothard, something of the finish of his oil-paintings, and a bleak and statuesque grandeur which reminds us of his historical subjects, while at the same time striking a perhaps unintentionally ironic note – a purely coincidental overtone of Goya.

Richard Westall (1765–1836)

The elder brother of the topographical watercolourist William Westall (1781–1850), Richard entered the Academy Schools in 1785, became an associate of the Academy in 1792, and full Academician in 1794. He exhibited regularly from 1784 until his death, and worked extensively as an illustrator and painter of rustic genre and historical subjects. James Northcote argued that 'Westall is as much entitled to share in the honour of being one of the founders of the school of painting in watercolours, as his highly-gifted contemporaries Girtin and Turner'.

36. Boreas and Orytheia

The dense pigment and sonorous tonality of Westall's work in watercolour can be seen well in this drawing, which illustrates both the strength of his conceptions and their limitation. Here, he shows himself very much a member of the Neo-classical sublime school, creating a group which has something of the histrionic impact of a Fuseli; Boreas, indeed, belongs to the same class of figure as does Blake's Urizen. But the design is marred by the sentimentality that frequently spoils Westall's drawings and paintings, whether they are grand mythological subjects like this, or rustic genre scenes. He was perhaps most consistently successful when making rapid colour

studies from nature; these are often drawings of real beauty and distinction.

Francis Wheatley (1747–1801)

Wheatley was born in Covent Garden, the son of a tailor. He went first to Shipley's School and in 1769 to the Royal Academy Schools, exhibiting regularly with the Society of Artists from 1765 until 1783. He also began to show work at the Academy, and became an A.R.A. in 1790, full Academician in 1791. In 1779, to escape his creditors, he fled to Ireland with the wife of a fellow artist, John Alexander Gresse (1741–94). This caused a scandal in Dublin and he was forced to return to London in 1783. In 1794 he was declared bankrupt; in 1798 he appealed for financial aid to the Academy, which voted assistance to his widow after his death.

22. A scene at an Irish fair

Wheatley was in Ireland from 1779 to 1783, and began to make watercolours of fairs such as this one during his stay; he continued to produce variations on the theme subsequently. His crisp delineation of form owes much to de Loutherbourg (1740–1812); but the somewhat inconsequential scattering of groups of figures across the composition seems to reflect an interest in the Dutch and Flemish painters of low life, especially Philips Wouwermans. This kind of unbalanced design is often found in Rowlandson as well, but in his case appears to be a result of the sheer speed with which the drawings were made.

Acknowledgements

Plate 3 is reproduced by Gracious Permission of Her Majesty the Queen.

The author and publishers are grateful to all museums, institutions, dealers and private collectors who have given permission for works of art in their possession to be reproduced. Where not listed below photographs were kindly supplied by the owners as given in the captions.

Thos Agnew & Sons: 119
Albany Gallery, London: 128
Borough of Blackburn: 148
British Museum, London: 18
Christie's, London: 135, 141, 153
Courtauld Institute, London: 12, 35, 97
Leger Galleries, London: 55
Tyne and Wear County Museums Service: 89, 150
Yale Center for British Art, United States: 136

The following photographs were taken by A. C. Cooper Ltd for the Phaidon Press: 1, 6, 7, 8, 9, 13, 14, 15, 19, 20, 22, 25, 26, 31, 48, 51, 52, 56, 57, 58, 61, 62, 63, 66, 67, 68, 71, 72, 73, 74, 80, 81, 85, 86, 87, 88, 90, 91, 92, 95, 100, 101, 104, 105, 106, 111, 112, 113, 115, 122, 123, 129, 131, 142, 147, 152, 158, 159, 164, 170

Index